Pro Photographer's
D-SLR
Handbook

Michael Freeman

LARK BOOKS
A Division of Sterling Publishing Co., Inc.
New York / London

Contents

Pro Photographer's D-SLR Handbook

Library of Congress Cataloging-in-Publication Data

Freeman, Michael, 1945-
Pro photographer's D-SLR handbook / Michael H. Freeman.
 p. cm.
Includes index.
ISBN 978-1-60059-422-9 (pb -with deluxe flaps : alk. paper)
1. Photography--Digital techniques--Handbooks, manuals, etc. I.
Title.
TR267.F757 2008
775--dc22

2008016436

10 9 8 7 6 5 4 3 2 1
First Edition

This is an updated first edition of a book originally published under
the title Pro Digital Photographer's Handbook.

Published by Lark Books, A Division of
Sterling Publishing Co., Inc.
387 Park Avenue South, New York, N.Y. 10016

© The Ilex Press Limited 2008

This book was conceived, designed, and produced by:
ILEX, Cambridge, England

Distributed in Canada by Sterling Publishing,
c/o Canadian Manda Group, 165 Dufferin Street
Toronto, Ontario, Canada M6K 3H6

If you have questions or comments about this book, please contact:
Lark Books
67 Broadway
Asheville, NC 28801
(828) 253-0467
Manufactured in China

ISBN 13: 978-1-60059-422-9

For more information on Pro Photographer's D-SLR Handbook see:
http://www.web-linked.com/phhbus

For information about custom editions, special sales, premium
and corporate purchases, please contact Sterling Special Sales
Department at 800-805-5489 or specialsales@sterlingpub.com.

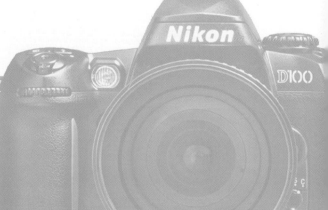

Introduction

The whole business of digital capture has matured rapidly in only a few years, and one of the most significant results has been the settling down of camera design. For a number of good reasons, the professional, high-end digital cameras are SLRs, by the way they look and handle in direct descent from the 35mm SLRs that have dominated photography for more than 40 years. Consumer models are still subject to design changes, whether for fashion, marketing, or experimentation with ergonomics, but serious digital cameras will not now change substantially. The functions will improve, but the form is established.

Previously, it was the physical characteristics of film that determined how cameras operated. Indeed, it was the availability of 35mm motion picture film stock that, beginning with the Leica, led to the basic 35mm camera. But the most important design invention was the single lens reflex, by which the viewfinder displayed an unreversed, through-the-lens image—exactly what was about to be recorded. The first of these was the Zeiss Contax in 1949, but it was the Nikon F in 1959 that established the SLR as the natural way a camera should behave—rugged, fast, and convenient. The key functions are few: an instant-return mirror to redirect the image between viewer and film, a pentaprism viewfinder to rectify it, an automatic diaphragm link to the lens for a bright view between shots, and a focal plane shutter behind the mirror. Fairly simple, highly effective. So effective, in fact, that the design has translated to digital cameras, partly because of familiarity, partly because it simply handles so well. A by-product of the SLR design, hardly less valuable, was that a wide range of interchangeable lenses became feasible (telephotos not being much use on a rangefinder camera without bulky additional magnifying viewers.)

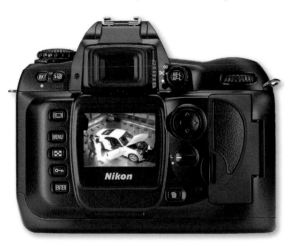

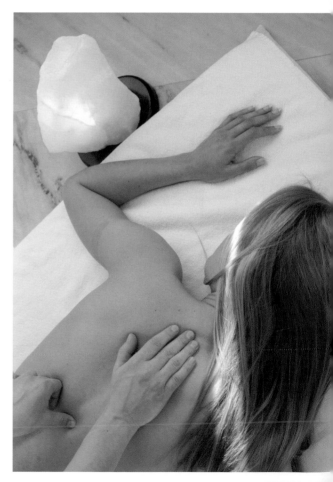

A digital SLR is similar in appearance to its traditional film counterpart, except for the color LCD display and four-way directional control.

This digitally captured image of a woman being massaged shows it's possible to achieve perfect skintones with digital.

The bell tower above the kitchen stairway to the guest deck, and a Chinese ceramic piece set in masonry—seen at Frank Lloyd Wright's Taliesin West. He made considerable use of the local desert stones, set in concrete made from local sand, but partly exposed. The harsh light of the Arizona desert adds to the contrast in this shot.

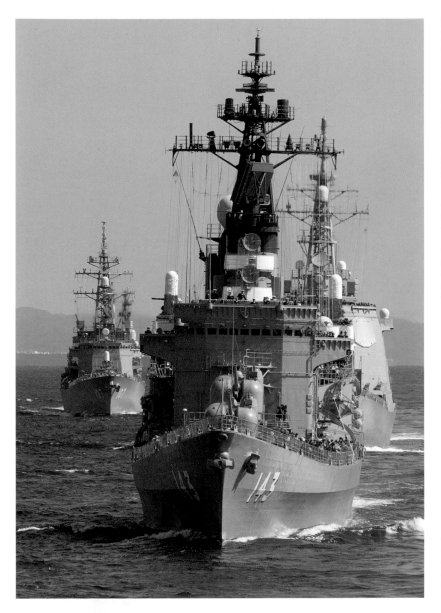

Ships of the Japanese Navy, conducting an exercise in the bay of Tokyo. This photograph has a long depth of field, but the sea haze softens the outlines of the ships in the background.

In the hand, a digital SLR seems an easy replacement for a 35mm SLR. Perhaps a little too easy. The LCD screen on the back is the most obvious new feature, but the functional similarity with film models masks fundamental changes in the entire process of photography. The real heart of the camera is largely unknowable to the user—that is, the combination of sensor and processor that captures, translates, and delivers the digital image. For obvious reasons, these cameras work extremely well by default, without much intervention by the photographer, but they are capable of much more. To get the best out of a digital image, and to use the full possibilities that a digital SLR offers, there is a great deal to learn. Now, you could simply set everything to automatic and you would get pretty much what you expected, but then you would not have bought this book. What I aim to do here is to show not only how to achieve maximum image quality, but how digital capture can change the way you think about shooting. Not all of this is simple, by any means, but this is because of the huge potential of digital capture—both practical and creative.

Introduction

12-13 Changeover 14-15 The digital SLR 28-29 Digital backs 100-101 Planning the workflow

How digital capture changes photography

	SENSOR REPLACES FILM	DIGITAL MEDIA	INSTANT FEEDBACK	FLEXIBLE RESPONSE	IMAGE EDITING	CONSTANT IMPROVEMENT
MECHANICAL The issues of equipment and software, including cost and maintenance. In other words, the unavoidable facts of digital photography.	**Single fixed sensor** In place of removable film there is one reusable digital sensor array embedded in the camera. **More electrical equipment** Providing power and connecting to other devices means cables, plugs, chargers, and adaptors. **Power needs** Digital cameras rely totally on electrical power, requiring battery management and AC power supplies. **New cost equation** Digital cameras cost more than equivalent film cameras and require expenditure on computer hardware and software, but running costs are less because of the absence of film. **Less robust** Large amounts of electronics and circuitry are inherently susceptible to heat, moisture, and shock, requiring extra care	**Fewer media** Smaller weight and volume of image storage compared with film. **Identical copies** Because images can be duplicated exactly, there no longer has to be a unique original to be protected. **Fast delivery** Because images are processed immediately in-camera, they can be delivered right away—and over distance if online.	**Review while shooting** By default, images are displayed on the LCD screen as soon as shot and processed. **Objective measurement** The statistics of each image, such as brightness, hue, and saturation, are easily shown, as, for instance, in the form of a histogram and clipped values	**Adaptable to different lighting** Light sensitivity, color balance, and contrast can all be altered to suit varying conditions. **Less equipment** The alterable settings remove the need for filters and a second or third camera dedicated to a different film type. **Fast switching** Adaptation to different lighting situations is as fast as accessing the menu on the LCD screen	**Link to computer** Digital images are intended to be logged and edited on a computer. **Computer literacy needed** Computer skills, both for basic operation and for image editing, are additional to normal photographic skills and must be learned. The more image editing is used, the higher the level of proficiency needed. **Software needs** Image editing of different kinds, from optimization, to database management, to manipulation, requires software that must be evaluated and purchased	**Better hardware & software** A feature of computing is that devices (which now include cameras) and software are always being improved. **Rapid obsolescence** The downside of constant improvement is that the hardware goes out of date, meaning that digital cameras become superseded more rapidly and more extremely than do film cameras. **Cost of upgrading** Although minor firmware and software improvements are usually free, all else needs to be budgeted for
OPERATIONAL How DC alters the basic practice of photography, particularly in comparison with film photography.	**Noise replaces grain** Images are clean at low sensitivity, though noise increases with speed. **No scratches** No physical defects, although sensor susceptible to dust shadows (which can be retouched)	**Must assess media needs** You will need to work out quantities of memory cards, hard-drive capacity, CDs, DVDs, and other removable media, according to your individual shooting regime. **Keeping track** Because images no longer have physical form (as does film), they need a system of identification and retrievable storage	**Check accuracy** By using the objective measurements, and in particular the histogram, the exposure accuracy can be assessed on the spot. Composition, focus, and motion sharpness can also be checked. **Risk of over-confidence** A quick glance at the small LCD screen may suggest that all is well, but conceal detail faults, such as camera shake or poor focus. It is easy to ignore these by imagining that all is well	**Extends range of situations** Allows shooting without preparation in low light and in artificial lighting with discontinuous spectra (notably vapor lamps). **More forgiving** Post-processing on the computer effectively gives extra latitude by allowing errors to be corrected, particularly with high-quality sensors and Raw format	**Makes photography open-ended** The imagemaking process no longer ends when the shutter is released. All digital images need some degree of editing, and there is no statutory limit to how much is done. **Correction & recovery** Errors and defects of all kinds can be dealt with, from shooting mistakes to problems with the content of the photograph	**Need to keep updated** Upgrades and new equipment and software are posted on websites, and these have to be monitored regularly. **New imaging possibilities** Expect the unexpected. Future digital inventions in hardware or software may bring different ways of taking, editing, or displaying photographs (as happened with QuickTime VR and immersive imaging)

☐ neutral ☐ positive ☐ precautionary ☐ negative

CREATIVE
How to use the mechanical and operational advantages to extend and develop the way you photograph.

Multiple captures in perfect register
A sequence of frames with a fixed camera can later be composited exactly

High quality
Theoretically, image quality can be superior to that of film

Backup & integrity
Digital media is corruptible and digital files are easy to delete unintentionally. A sensible system of archiving is essential

Logging images out
Because limitless copies can be made of any image, it is important to track which have been sent to potential clients, for invoicing and checking unauthorized use

Mixed lighting
White balance and hue adjustment menus can be used when there are light sources of different color

Saves time
The ability to change settings quickly, and use automatic settings, reduces the need to bracket exposures and shoot a variety of color balances. This can make it practical to shoot more set-ups in a given period of time

Optimization procedures
Making the image technically perfect is a standard part of the imaging workflow

Adds to time & workflow
All the many possibilities and opportunities take time and skill to perform, and this can be a hidden cost

Improvement
Feedback can be used to learn, and to improve composition and other camera skills

Improves confidence
The knowledge that the camera and computer have powerful, verifiable tools supports your technical competence

Revisit shooting occasion
Using Raw format isolates image data from camera settings, effectively allowing the settings to be recalculated as if you were back behind the camera at the time of the shot

Stay open-minded
It's no longer (if it ever really was) possible to know a l that there is to know about your particular field of interes: in photography. There will always be something new technically, and this may have new creative possibilities that you can use. Don't close the door on technique

Public relations
When appropriate, images can be shown immediately to subjects, to gain their cooperation, to involve them, or to enliven the atmosphere of a shoot

Tackle uncertain situations
Unusual lighting conditions that would normally be avoided now fall within the range of normal shooting

Forward planning while shooting
By thinking ahead to the later editing possibilities, photographs can be taken to facilitate these. In some cases, this makes it worth taking a shot that would normally be pointless

On-the-spot editing
Instead of waiting until a later occasion to edit, making it a separate activity, the editing can be interleaved with shooting, when decisions are fresh in the mind

Color reportage in low light
Ease of shooting in low light frees the attention to concentrate on the more creative skills of observation and reaction needed for reportage—and in color

Better color analysis & judgment
The process of assessing, optimizing, and correcting image colors inevitably leads to a better understanding and appreciation of color

Experiment
Any unusual procedure, such as deliberate motion blur or a strange lighting technique, is worth trying because it is immediately verifiable

Need manipulation policy
Because there is no technical limit to what can be done to an image on the computer, photographers must set their own limits to editing and manipulation according to personal ethics and creative interests

How digital capture changes photography

digital capture

WITH DIGITAL CAPTURE, PHOTOGRAPHY meets the world of computers, and the model for equipment, technology, and pricing is much more that of computers than of cameras. If you are already completely familiar with desktop computing and software, the transition from film to digital should be almost seamless. If not, it's probably time to start getting up to speed. In the days of film, technological change happened at a much slower pace than now, because there was less room for improvement in an established, heavily mechanical, technology. Now, on the other hand, improvements tend to be much greater, leaving photographers who are committed to one brand, because of lenses, out in the cold when a rival brand launches an advanced new model. On the face of it, this is simply a matter of buying a digital body to use with existing lenses and accessories, and in one sense it is no more complicated than that. Nevertheless, exploiting the enormous capabilities of digital cameras and software to their fullest means immersing yourself in a different world, and, after this initial chapter, starting to shoot intuitively. This means not following the manual—but it will still help to have read it first.

Changeover

While some people are coming new to photography and straight to digital, and others are upgrading from digital compacts, there are special issues for photographers changing from film-based SLRs to digital SLRs. In particular, most SLR users crossing from film to digital will, for a variety of reasons, spend a period of time shooting both. SLR systems encourage this because they are indeed systems rather than self-contained cameras; the various lenses and accessories will, for the most part, work together. An important symptom of the changeover is that most professional camera manufacturers are easing the transition for owners by making it feasible to shoot film and digital interchangeably.

So you can experiment with digital and get to know it while still continuing to shoot with the tried-and-tested films with which you feel comfortable. Professionally, with extra effort and time, you can retain film as a backstop without the risk of failure. During the transition period, you will spend more time and energy doubling up film and digital together, but this is the cost of having a safety net. Gradually, digital will take over, while at the same time you will certainly find that there are situations in which digital will allow you much more freedom to shoot. And there may remain some types of shooting for which film keeps an advantage—for example, high-contrast subjects and those that need high resolution. Digital capture is still a developing technology, and there are a few imaging problems still being worked out, though these tend only to concern professionals in specific fields. At the same rate as the technology develops, digital capture is opening new doors in photography.

If you already own a SLR system, the investment in lenses, in particular, will be an encouragement to stay with the same manufacturer (although you could also argue that if you had been thinking of changing from one make to another, now is a good time). High-end digital SLR bodies are currently more expensive than their film equivalents, so it pays to examine the competing systems carefully. Not only are manufacturers' claims biased, but the comparisons are so complex that even independent reviews have difficulty in being comprehensive. Be cautious in reading the many of these that are posted on the Web—few reviewers have the time to make full and valid comparisons. I certainly don't, and unlike most equipment reviewers, I make my living from photography.

Start with the end-use

In any case, I take a different approach to the matter of choice, which is to start with the end use. First decide on how you will use the photographs, and then the priorities will fall into place. This first chapter of the book goes into considerable hardware detail, and this should equip you to decide which equipment currently on the market will best meet your particular needs. Digital SLRs contain much more complex functionality than a film SLR. I strongly recommend using the changeover period to evaluate the different ways in which film and digital perform.

A word about software. This is the new component in photography, and to make the most of a digital SLR you will need to integrate it into your work. There is now much more choice in settings and image adjustments than there ever was for film, and some of these are better left to the software stage on the computer than performing them in-camera. For example, as we'll see, shooting in Raw format means that you can change your mind later about white balance, brightness, contrast, and so on. We'll deal with software beginning in Section II, but one of the special features of digital capture is that you should know in advance what you will have to do later on the computer. Thinking forward at the time of shooting will certainly influence your choice of camera settings.

The digital SLR

The high end of digital capture is now the province of the SLR. This was inevitable. In film photography, SLRs quickly became the professional choice for very good reasons. First, you can see exactly what you are about to shoot, in every way from framing to focus and depth of field, thanks to the simple idea of using a prism and flip-up mirror to deliver the exact view that is about to be captured. In its computer iteration, this is known as WYSIWYG (what you see is what you get), but photographers have been aware of the benefits of this for decades. Now you might argue that digital compacts with their electronic, non-mechanical shutters also offer this, but it's at the cost of loading more circuitry onto the sensor, with a corresponding reduction of image-gathering ability. And SLRs also have interchangeable lenses, so vastly broadening their capabilities. Indeed, all the major camera manufacturers have invested their best efforts for image quality and operational perfection into SLR bodies—in other words, SLRs are where the good stuff resides.

Ergonomically, 35mm SLR designs became highly refined over the past 70 years, and while digital compacts have produced a chaos of styling, digital

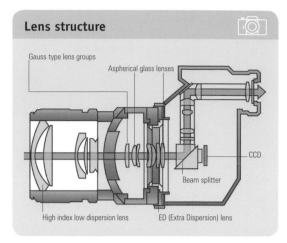

Lens structure

Gauss type lens groups

Aspherical glass lenses

CCD

Beam splitter

High index low dispersion lens

ED (Extra Dispersion) lens

SLRs have followed the good sense of their film predecessors. But, although the principle may be the same as a film camera, the inner workings of a digital camera are quite different, the imaging being performed by a silicon-based chip sensor—either a CCD (charge-coupled device) or CMOS (complementary metal-oxide semiconductor). There are millions of light-sensitive photo-diodes on the sensor and each converts light into a voltage that is proportional to

Sony α100

Canon EOS 30D

Canon EOS-1Ds Mark III

Fujifilm FinePix S5 Pro

Nikon D40x

Nikon D2Xs

Canon EOS 400D (Digital Rebel XTi)

Panasonic Lumix L1

Sigma SD14

the brightness. The charge, amplified, is transferred to an ADC (analogue-to-digital converter). This translates the pattern of charges recorded by the sensor into discrete binary code, which is sent to a DSP (digital signal processor). This performs a variety of operations depending on the needs of the image and the settings chosen by the user, for instance, reducing noise, adjusting brightness, color, contrast, and sharpness, before writing the entire information that defines the image onto the storage medium—a memory card of one kind or another.

This has important structural implications. There are no chambers for either the film cassette or take-up, and no mechanically complex film transport, but the space that is saved is needed for the processor and circuitry, sensor and its circuitry, and the removable memory card. This all fits, just, and by coincidence, the volume of a former 35mm SLR is approximately what is needed for a digital model. Many mechanical parts remain the same—mirror, lens connection, pentaprism,

Phase One Hasselblad

and shutter mechanism. The last, incidentally, takes the place of the all-electronic shutter found in some compacts (which enables a video feed); digital SLRs do not allow a real-time preview of the scene in the LCD screen. The screen itself is always a compromise on a handheld camera, and is necessarily inadequate in size for detailed viewing. Digital backs on what were formerly medium-format cameras can have more sensible LCD screens, but on mainstream SLRs, the screen is for very basic checking. Judging color and image quality by appearance alone is pointless.

Interestingly, on the subject of digital backs, the old divisions between formats (35mm, rollfilm, etc.) are now becoming thoroughly blurred. The only reasons why some differences survive are historical. Most backs are designed to fit the standard range of rollfilm cameras (645 and 6x6cm in particular) and these of course have their own styles of design and ergonomics. However, backs have very little advantage in resolution over the new high-end digital SLRs (*see pages 28-29*).

Compacts

While professional models are SLR, the bulk of the digital camera market is settling out into a range of compacts of varying degrees of sophistication. The main feature that distinguishes the high-end compacts, which sell to the prosumer (high-end consumer) sector, from the professional SLRs is that they have a fixed zoom lens instead of interchangeable lenses. Sensor resolution is not necessarily different, and as most good compacts will now deliver at least the nine megapixels necessary for normal full-page print reproduction, they have their uses for professional photography. Being light and small, they can be carried and used unobtrusively, and so are convenient to have around on the off-chance of a picture opportunity. Build quality, however, is usually not as high as for SLRs.

The digital SLR

Digital SLR lenses

When 35mm SLRs were introduced back in 1936, the single feature that assured their success was their ability to accept a large range of different, interchangeable lenses, from fisheye to super-telephoto. An SLR system is a tool-kit for photography that leans heavily on its lenses, with the facility to see *exactly* how the image will be captured, and this same advantage carries over to digital. Existing lenses for film SLRs can be used with digital SLR cameras with few complications, even though some new camera features will be unavailable with older models of lens. This is all straightforward, except for issues related to the smaller size of sensors and, at a deeper level of performance, the pixel size.

As it stands, camera manufacturers have followed two different routes. A few, notably Canon, have introduced sensors the same size as 35mm film—24×36mm. This makes them totally compatible with the lenses you already have. Others have adopted sensors with a smaller area—typically around 23×15mm—for ease of manufacture. This affects a whole raft of image properties, including some of the standards that photographers are used to, such as using focal length as a way of describing the angle of view—a bad habit, perhaps, in retrospect, but absolutely the norm. "24mm," for example, was a kind of shorthand for the dynamics of one type of wide-angle image. The smaller sensor covers less of the image projected onto it than would a full 24×36mm frame, and so the picture angle is less. Practically, this means that a standard 50mm lens mounted on a digital camera with a sensor area of 23×15mm behaves like a lens of around 78mm focal length on a non-digital camera. Similarly, wide-angle lenses have less of a wide-angle effect, while telephotos appear to be more powerful. This leaves a significant gap at the wide-angle end of the range.

Wide-angle issues

For all cameras except those that follow the Canon full-frame standard, the fact that the sensor is smaller than film makes life more difficult in wide-angle photography. Typically, SLRs built to 35mm camera specifications have sensors around $2/3$ the size of 35mm film, meaning that your old lenses lose $1/3$ of their covering power. On the positive side, this means that telephoto lenses have that much greater magnifying power when fitted to a digital SLR, but you lose out at the wide-angle end of the scale. This limitation has forced manufacturers to introduce new, wider lenses. If dedicated to digital cameras, these can be very wide indeed. A 12mm lens, for example, is the equivalent of something like an 18mm lens for 35mm. And, if you move from film to digital, this is an additional investment. Strong barrel distortion is another potential implication.

Multi-megapixel sensors are making new demands on lenses, with the result that camera manufacturers are now designing lenses optimized for digital. Not only are high-density sensors less tolerant of poor resolution lenses than is film, but the resolution needs to be *smaller than* the active area of the photosite. Using an old, film-optimized set of lenses for the new digital body may sound like a good, economical idea, but the trade-off is likely to be lower image resolution than you could be getting. The other problem is called *cornershading*. Light from a normal camera lens diverges to cover the film or sensor, striking the edges at an angle—and with a wide-angle lens, this angle is more acute. This hardly mattered with film, but as the wells on the sensor are all parallel, light rays striking the furthest photosites—at the corners—may not fully penetrate, causing shading. This again suggests a change in lens design—one solution is a rear element combination that refracts the diverging light rays back to being more nearly parallel.

Dedicated digital designs

These are lenses that *cannot* be used with film SLR bodies. Features can include the following: no mechanical aperture ring, apochromatic (high color correction) glass, and in the case of smaller sensor cameras, very short focal lengths for wide-angle models and a small image circle that covers no more than the sensor. This last feature enables digital photography lenses to be smaller, lighter, and have larger zoom ratios.

Nikon 12-24mm lens photo

Equivalent focal length

Focal length descriptions such as "20mm," "50mm," and "180mm" for 35mm cameras are so embedded in the working language of photography that they will continue to be used for a long time. Indeed, for full-frame 35mm-format digital SLRs, they remain perfectly valid. The variety of sensor sizes, however, leaves us without a convenient way of describing a lens's main characteristics—its angle of view and magnification. One solution is equivalent focal length (efl), which is what the lens would be if the image it delivered were on a 35mm frame. Divide the diagonal of a 35mm film frame (43.3mm) by the diagonal of the sensor, then multiply the lens focal length by this. These are the equivalent focal lengths for typical sensor sizes:

Actual focal length	efl	
	23 x 15mm sensor	24 x 16mm sensor
12mm	18.9mm	18mm
17mm	26.8mm	25.6mm
20mm	31.5mm	30.2mm
24mm	37.8mm	36.2mm
28mm	44.1mm	42.2mm
35mm	55.2mm	52.8mm
50mm	78.8mm	75.4mm
100mm	157.6mm	150.8mm
200mm	315.2mm	301.7mm
300mm	472.8mm	452.5mm

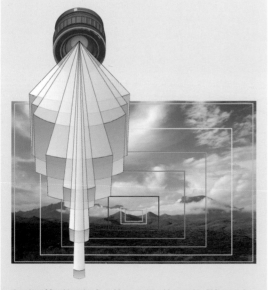

A series of focal lengths, from 20mm at the widest end to 300mm at the longest. (The intervals are 28mm efl, 35mm efl, 50mm efl, 100mm efl, and 200mm efl.)

Smaller circle of confusion

Focused on a point, a lens renders it sharply—as a point. Slightly out of focus, the point appears as a tiny circle. The circle of confusion (CoC) is the smallest that this circle can be and still appear sharp to the eye *at a normal viewing distance*. This is obviously open to interpretation, but traditionally lens manufacturers have accepted between 0.025mm and 0.033mm for 35mm film. When the sensor is smaller than this frame size, the image has to be magnified more, and so the circle of confusion is smaller. This calls for uncompromising lens quality.

Quick calculation
Taking 0.03mm as an acceptable CoC for 35mm, this is $-1/_{1442}$ of the frame diagonal. Use this fraction to calculate the CoC for your digital camera. Thus, for a Nikon D100's 23.7 x 15.6mm CCD, the CoC is 0.02mm.

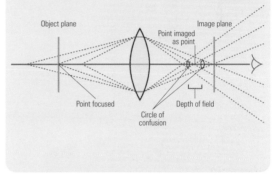

Depth of field is also affected (it is increased), and this has various consequences all the way back to sharpness and circles of confusion. Sharpness is not a precise definition, but depends partly on resolution and partly on perception. High contrast, for example, increases apparent sharpness. As the circle of confusion is smaller for a small sensor (*see Smaller circle of confusion box, above*) and the image is magnified more, depth of field increases. This is generally good to have, but a problem when you need the extremes of selective focus, as in some styles of food photography, for instance.

There is a lower "quantum" limit on sharpness set by the size of the individual pixels on a sensor. A 24 x 16mm sensor that images 3,000 × 2,000 pixels, for example, has photosites measuring 0.008mm (8μm). As semiconductor technology reduces this size further, it increases the demands on lenses. Most high-quality lenses optimized for film can resolve to about 10

Digital SLR lenses

30-33 The sensor 40-41 Resolution 180-183 Correcting lens distortion

microns, while the pixel pitch on new multi-megapixel sensors can be as low as 5 microns. One important effect is that color fringes caused by chromatic aberration must be *smaller* than the size of a pixel. Old lenses often fail in this. A further issue is *corner-shading*—this can be corrected (*see pages 180-183*).

The new zooms

The time has long passed since prime lenses (single focal length) gave a measurably sharper image than zooms. In top-quality zooms, resolution is now just as high, and the new generation has impressively wide ranges, e.g. the Nikon 18-200mm and the Leica D Vario-Elmar 14-150mm from Panasonic, often in compact, lightweight housings. One drawback is that the effective full aperture is smaller at the long end of the zoom range—meaning the lens is "slower." Another is that it is impossible to fully correct lens distortion over the range. A prime lens can be corrected, but a zoom that covers a wide-angle to telephoto range, say 24-120mm, will have barrel distortion at one end and pincushion distortion at the other. This increases the importance of software that will correct distortion in post-production.

Nikon 18-200mm lens with VR (see right-hand box)

Leica D Vario-Elmar 15-150mm from Panasonic

Boke—out-of-focus quality

The overall appearance of the out-of-focus parts of an image, judged aesthetically, varies according to the aperture diaphragm and the amount of spherical aberration correction, among other design features. It comes into play chiefly with telephoto lenses used at wide apertures, and it particularly concerns portrait photographers. This has become fashionably and unnecessarily known in the West by the Japanese word *boke* (pronounced *bok-e*, with a short, flat *e*), which in this context means simply "out-of-focus." A major influence is the shape of the aperture, which tends to be replicated in specular highlights—polygonal in most cases, while a mirror lens produces rings. The more blades to the aperture, the more spherical these soft highlights become. The optics also have a subtle effect.

Anti-shake technology

This enormously useful feature goes by different names according to the manufacturer—VR (vibration reduction) for Nikon, IS (image stabilization) for Canon. Essentially, this is a reactive, mechanical system for reducing camera shake. In the system shown here, motion sensors detect small, jerky movements of the kind associated with holding a camera unsteadily, and pass the information to a set of micro-motors surrounding floating lens elements. These apply small opposite movements virtually instantaneously to cancel out the shake. This kind of lens is claimed to improve the shutter speed at which it can be handheld by up to 3 *f*-stops. Longer, deliberate movements, such as panning, are excluded from-correction. Switch this feature off when the camera is locked down on a tripod. An alternative approach, used by Sony, moves the sensor rather than the lens-elements, with micro-motors.

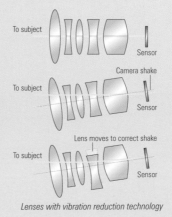

Lenses with vibration reduction technology

Lens filters

With white balance and hue correction now taken care of digitally, there is no longer any need for light-balancing and color correction filters. Three front-of-lens filters do, however, remain valuable: ultraviolet, polarizing, and neutral grad.

Ultraviolet filter Reduces haze effects by cutting some of the short wavelengths. Also valuable for physically protecting the front lens element from scratching.

Grad Filter 1 *Grad Filter 2*

Neutral grads These filters can be raised or lowered in their holder and rotated. With an outdoor scenic, align the transition zone of the filter with the horizon. Although skies can be darkened later during image editing, a grad filter at the time of shooting preserves more tonal data when positioned so that it covers the brighter part of the frame. Neutral grads are available in different strengths—for example, ND0.3 darkens by 1 fstop and ND0.6 by 2 fstops.

Polarizing filter (circular) Cuts polarized light, so particularly useful for darkening blue skies (most strongly at right angles to the sun) and reducing reflections from glass, water, and other non-metallic surfaces. Also has a strong haze-cutting effect. Polarization cannot be replicated by software.

Two grad filters, one inverted.

Iop: a grad filter
Above: a polarizing filter

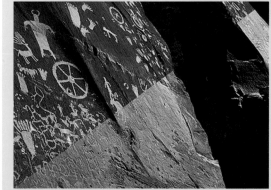

Grad filters are most commonly used on skies and are available in a variety of colors. Here, from left to right: no filter, neutral, blue, yellow.

This combined image shows an effective but unusual example of polarization—a sandstone petroglyph in Arizona which has a natural coating of "desert varnish," which has polarized the sunlight. A polarizing filter (above left) dramatically cuts the reflections.

Digital SLR lenses

Digital SLR lenses

Reducing lens flare

Flare is non-image-forming light, and can appear as a line of bright polygons stretching away from a bright light source (like the sun) or as an overall light fog. Flare control means shielding the lens from any bright light outside the picture frame, and the ideal solution is to mask down the view in front of the lens to the edges of the image. Fitted lens shades do a fairly good job, particularly if they are shaped to suit the image area as shown below. However, they have the disadvantage of being close to the lens and so less precise and on a zoom lens, they can mask accurately only at the widest angle. A professional adjustable lens shade is better, though slower to use, and typically features an extendable bellows and/or movable masks. This is particularly good for the special case in studio photography in which the subject is against a large bright background. The bright surface that surrounds the picture area creates a kind of flare that is not immediately obvious, but which degrades the image nevertheless. Finally, to shield against point sources of light, whether the sun or studio spots, the most precise shading is at a distance from the lens—a black card or flag, or even your own hand held just out of frame.

● Use a lens shade—either a fitted shade designed for the particular lens, or a bellows shade that can mask right down to the image area. Many telephoto lenses have built-in shades that slide forward.

● Check the shadow on the lens. If the camera is on a tripod, stand in front and hold a card so that its shadow just covers the front of the lens.

● Keep the lens clean. A film of grease or dust makes flare much worse. Check and clean.

● Remove any filter. Filters, however good, add another layer of glass that increases the risk of flare. Removing a filter will often help.

● Use a properly coated lens. High-quality, multi-coated lenses give less flare than cheaper ones.

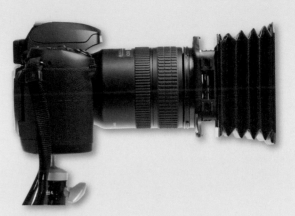

Bellows shade

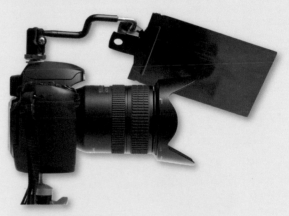

Flag and Arm

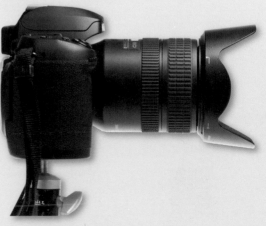

Lens shade

Standard versus wide-angle

Wide-angle and telephoto lenses sit on either side of a notional standard focal length. "Notional" because it in turn depends on perception. The idea of a standard lens is one that gives the same view as the eye, neither wide nor compressed, but in reality, it is imprecise. The usual rule of thumb is that the standard focal length is equal to the diagonal of the film frame or sensor. For a 35mm frame that would be 43mm, but by convention 50mm has become "normal" with 35mm film. The de-restriction of format with digital cameras and replacement of prime lenses with zooms erodes this 50mm "benchmark." This is, in any case, a perceptual issue, and a realistic guide is the focal length at which the view through the viewfinder and the view with your other, unaided eye are the same.

Olympus 11-22mm wide-angle zoom lens

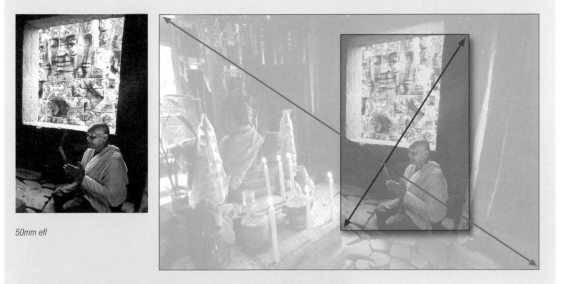

50mm efl

A 20mm efl lens (in this case, 13mm on a Nikon digital camera with a sensor size smaller than 35mm film) has a diagonal angle of view of just over 90°. The vertical crop inside this frame is the 45° coverage of a 50mm efl standard focal length.

20mm efl

58-59 Basic lighting situations 180-183 Correcting lens distortion 186-187 Color adjustment

Digital SLR lenses

Digital close-up and macro

Close-up and macrophotography has always made special demands on lenses, and this is no different for digital cameras. What *has* changed is the ease and precision of shooting at close distances, because the uncertainties introduced by the various optical calculations disappear with the instant feedback from a digital SLR. Digital SLRs are ideal for macro shooting, because the on-board processing of the image can deal with the problems of contrast, color, and even sharpness. Also, by shooting direct to a computer, you can use the larger monitor to check detail and tolerances. Moreover, with digital SLRs that use a sensor smaller than 35mm film, only the center of the lens is used for imaging, and this is relatively free of many aberrations, including spherical aberration, which is worse at close distances.

The two most usual measurements in close-up imaging are *magnification* and *reproduction ratio*, and they are linked. The commonly accepted starting point for close-up photography is between 0.1× magnification (1:10 reproduction ratio, meaning the image is one-tenth life-size) and 0.15× magnification (1:7). At 1.0X, the image is life-size (1:1). Across this range, as the lens racks forward in its barrel, the light-reaching the sensor falls off increasingly, but autoexposure takes care of this. Photomacrography, commonly known as *macro*, extends from 1.0× to 20× (a 1:1-reproduction ratio to about 20:1), at which point the laws of optics make it more sensible to use a microscope. (*Macrophotography*, incidentally, means something else entirely—photography on a large scale.) Photomicrography means photography using a microscope, for which there are a number of off-the-shelf systems for attaching a digital SLR camera.

The most efficient method of magnifying an image is to extend the lens forward, away from the sensor, the way that most lenses are focused for normal photography. However, for close focusing, the lens elements need to move much further than normal, because of the relationship between the two *conjugates*, which are the distances from the principal point of the lens to the subject on one side and to the sensor on the other. When the subject is more than about ten times the focal length distant, the image conjugate stays more or less the same. Closer than this, however, and the image conjugate gets significantly larger. When the two conjugates are equal, you have 1:1 magnification and a life-size image. This makes lens manufacture a little tricky, because most lenses perform best when subjects are distant but not so well when they are close. Aside from the mechanics of moving the glass elements inside the lens barrel, the sharpness suffers and aberrations get worse. A true macro lens is the ideal solution (*see panel, right*).

Close-up lens aberrations

Sharpness tends to suffer at macro distances, where the image conjugate (*see Conjugates box, opposite*) is always greater than the object conjugate. One of the causes, more relevant to macro than to normal photography, is diffraction. This occurs when an opaque edge obstructs the light path, causing it to bend slightly and spread. This is what the aperture blades in the diaphragm inside a lens do, and the result is unsharpness. Unfortunately for close-up photography, diffraction increases when the lens is stopped down and with increasing magnification. Another aberration more prominent in close-up photography is spherical aberration. This is caused by the increasing angle of curvature toward the edges of a lens, which alters the focus slightly. Stopping down the lens helps to reduce it because the smaller aperture allows only the center of the lens to be used; for the same reason, lenses designed for 35mm used on small-sensor digital SLRs are less prone to this.

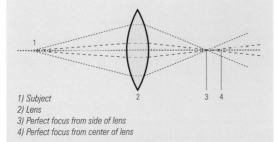

1) Subject
2) Lens
3) Perfect focus from side of lens
4) Perfect focus from center of lens

Reversing the lens

Most camera lenses are designed to perform well when image conjugate is smaller than the object conjugate (*see Conjugates box, opposite*). At magnifications greater than 1× (1 : 1) this is no longer true, and the image is better when the lens is reversed. For optical reasons, this works well only with lenses of symmetrical design and with certain retrofocus lenses. The lens must then be stopped down manually.

Close-up lenses and accessories

Close-focusing lenses
Modern lens design makes it possible for standard lenses to focus down to close distances. The *quality* of the image at close focus, however, varies from make to make, and is likely to be compromised—at least in comparison to a true macro lens. The performance of a standard lens can be disappointing.

Macro lenses
These are designed to deliver their best image quality at close distances, and acceptable quality at normal distances up to infinity. Some manufacturers offer a choice of focal length between normal and long-focus; the advantage of the longer macro lenses is that you can use them at a greater working distance from the subject, which is useful, for example, with insects that might otherwise be frightened off by a close approach.

Extension rings and tubes
A standard method of increasing magnification is to increase the distance between the lens and the sensor, and the simplest way of doing this with an SLR is to fit a ring or tube between the lens and the camera body. The focal length of a lens is the distance between the sensor and the lens when it is focused at infinity. Increasing this distance by half gives a reproduction ratio of 1:2. Doubling the distance gives 1:1, and so on. Some, but not all, extension rings and tubes have linkages that connect the aperture and other lens functions to the camera.

Extension rings

Extension bellows
Flexible bellows moved by rack-and-pinion offer fine control over magnification, and are normally used for extreme close-ups. They are more delicate than extension tubes. Because magnification is relative to the lens focal length, the shorter the lens attached, the more powerful the effect.

This close-up shot reveals the crystaline detail hidden in a frozen stream. The stream itself flows through Turner Ranch, in the heart of Montana's bison country.

Conjugates

The lens focuses each point on the subject to an equally sharp point on the sensor (which is on the *image plane*). In photography at normal distances, the subject conjugate is *much* longer than the image conjugate, which changes very little as you focus. But when the subject is close, the two conjugates become more similar in length.

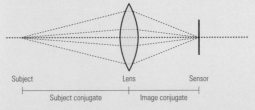

Subject　　　　　　Lens　　　　　Sensor

Subject conjugate　　　　Image conjugate

Digital close-up and macro

16-21 Digital SLR lenses 40-41 Resolution 94-95 Accessories and tools 180-181 Correcting lens distortion

Tiled images

One special and important digital technique is-stitching together overlapping frames to make a larger image. Its most common use is to create panoramas, but there are other applications. Although this is strictly speaking a software matter, it is highly relevant to lens focal length and coverage, because in effect you are creating a wider-angle view. Also, with this kind of imaging, even though it makes heavy use of software, all of the planning needs to be done at the time of shooting—photography and stitching are separate operations. This is known as planar stitching, and the result is a normal digital image, saved usually as a TIFF or JPEG (*see pages 206-207*). A quite different but very important alternative is cylindrical or spherical images saved normally as QuickTime movies (*see pages 210-211*).

In principle, you could combine the overlapping images manually in Photoshop, but there are two obstacles. One is that as you turn the camera to one side for the adjacent frame, objects in the frame change their shape slightly—noticeably so with a wide-angle lens—so that each frame later needs a distortion adjustment. The other is that it is difficult to blend the brightness of adjacent frames when there are large, smooth areas such as a sky—again, particularly with wide-angle lenses. Stitcher software does this automatically, in two steps. The software first finds a number of corresponding points in adjacent images and warps the images so that they fit perfectly, to within one pixel. It then equalizes the images so that there is a seamless blend of brightness at the edges.

How to tile

Shooting a sequence horizontally creates a panorama, with the added advantage of making a larger image file than normal. This is, indeed, the easiest solution to creating a high-quality large image file—take any scene that you have just photographed, switch to a longer focal length and photograph it again in parts, then assemble these into a higher-resolution version. This is known as tiling. It can also fulfill another objective, which is to increase the FOV (field of view). Smaller sensors make wide-angle lenses less effective, and you can increase the coverage by tiling.

Parallax 📷

The same scene viewed from a slightly different position shows differences in the relative position of objects, depending on their distance from the eye. This is parallax, and is the basis of binocular vision and how we judge depth. Unfortunately, it means that if the camera is not in exactly the same position for all the shots in a sequence, there will be differences that the stitching software will resolve as a blur or ghosted image. The problem is acute when there are close foreground objects. This makes it important, when panning between frames, to pivot around the nodal point of the lens—its center—not the camera base. The solution is a QuickTime head (see "Shooting a Sequence.") There is also a software solution based on blending with multi-resolution splines.

The ghosting effect in a composite image.

Shift-lens stitching 📷

A shift lens (aka PC or Perspective Correction) such as this PC-Nikkor 28mm can be used to make an overlapping series of images that will combine, when stitched, to make a larger image file with a wider coverage—one solution for high-resolution interior and architectural photography without investing in a medium-format camera with digital back. The sequence is shot with the lens racked up to its full shift, one frame at a time, rotating it full circle. See page 206 for the post-production sequence. One potential problem is parallax on close objects caused by the movement of the lens between rotations.

Horizontal crop: 9 frames.

Shooting a sequence

Step 1: Decide on the area of the scene you want to cover, and the lens focal length you will use. Longer focal lengths need more frames to complete the same coverage as a wide-angle focal length: this gives a bigger final image file (good for a high-resolution image but takes up more space on the memory card and hard drive, and is more demanding of the processing) and less angular distortion.

Step 2: Mount the camera on the tripod and level the head. Use a QuickTime head, or equivalent, mounting the camera so that the nodal point of the lens is exactly over the axis of rotation. If the scene is distant and you are using a telephoto, taking care to line up frames. Shooting with the camera frame vertical gives a deeper panorama, but leveling the camera may be more difficult.

Step 3: Make a dry run. In the simplest case, pick a short panorama, loosen the tripod's pan head, start at the left (or right), and check the number of frames that you will need, panning to one side, allowing for an overlap of about 30% (between 15% and 40%). Judge the rotation between frames either by using the scale, if there is one, on the pan head, or by eye through the viewfinder. If you have a grid focusing screen, use one of the vertical lines as a guide. Find a detail in the scene that is either centered or on the leading edge of the frame, and pan the camera so that it appears on this grid line (*see right*).

Step 4: Select fixed settings for the exposure and white balance. Check these out for sample frames across the sequence, paying particular attention to the highlight clipping and histogram. You may have to sacrifice some highlight or shadow detail.

Step 5: Check for movement within the scene, such as a passer-by, objects moving in a breeze, or changing light, and try to shoot when there is none (*see page 61*). Shoot the sequence.

Step 6: Check that you have all the frames. Missing a frame in a sequence is easy when you are tiling rather than doing a simple side-to-side panorama.

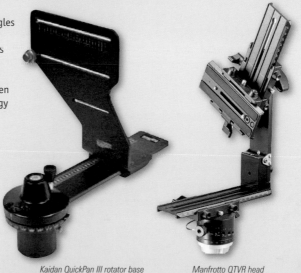

Five images, shown here, were used to create this panorama of Lake Pichola in the heart of Udaipur, Rajasthan. The City Palace (right) dominates.

QuickTime heads

Numerous QuickTime tripod heads are available, designed to assist in taking images at the exact angles required to build up a QuickTime VR scene. These are essentially 360° panoramas, which in some cases also allow the viewer to look up and down (hence the second adjustment on the Manfrotto head). In order to create panoramas, each shot should be taken from exactly the same spot. QuickTime VR technology includes specialized stitching software (*see pages 210-211*).

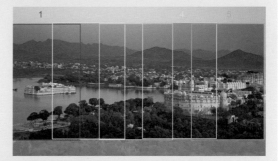

ReallyRightStuff *Kaidan QuickPan III rotator base* *Manfrotto QTVR head*

Tiled images

44-45 Compression and image quality 60-61 Sensitivity and noise 206-207 Stitching 210-211 QuickTime panoramas

Menu structure

The many options and settings offered by the camera call for a menu, viewed on the LCD screen (or if shooting direct to computer, on the-monitor). These options are grouped more or less logically, and a typical division is into set-up, shooting, and playback, in some instances with an extra sub-menu for customized settings. Some of the settings can be accessed via dial and button controls on the camera body for ease and speed of operation—this may be instead of being on the menu or in addition. The menu structure varies from brand to brand, but is likely to cover the following:

Common menu options

Set-up (may be subdivided)	Shooting	Playback
LCD brightness, time on	File format	Image size on screen
Date and time	Image size	Data displayed
Language	White balance	Zoom
Folder creation, assignment	ISO	Delete
Add information	Contrast	Image protection
Mirror lock-up	Hue adjustment	Hide image
Format card	Color mode	Folder selection
Video output	Sharpen	Slide show
Cable connection protocol		Print specification
File numbering		
Noise reduction		
Auto features on/off		
EV steps		
Bracket steps		
Focus settings		
Grid display		
Flash mode		
Assign dials and buttons		
Shoot to computer		

In-camera sharpening

As with everything to do with sharpening, opinions vary. It is, above all, a perceptual issue, to do with the appearance of an image, and this is explained fully later (*see pages 148–149*). Read this first before choosing the amount of in-camera sharpening to select. By exaggerating the contrast between adjacent pixels, sharpening damages the image, and done fiercely introduces noticeable artifacts, such as halos and solid black pixels along edges. If you shoot in Raw format, this is a setting that you can change later when opening the images in Photoshop, but because of the many variables that affect sharpening, it is best applied at the last moment before printing or display. The only argument for using the camera's processor for sharpening rather than Photoshop or a plug-in is that the manufacturer's algorithms may be more precisely tailored to the way the image is captured. There is usually no way of finding this out, however. You could run a test of one scene shot with varying degrees of sharpening, and then compare the results with the other sharpening options (*see pages 148–149*). By default, apply as little sharpening as possible. It does not improve resolution.

Canon EOS-400D (Rebel XTi)

Shooting

📷1 📷2 ▶ 🔧1 🔧2 | DISP | 📷

Quality	◢L
Red-eye On/Off	Off
Beep	Off
Shoot w/o card	On

📷1 **📷2** ▶ 🔧1 🔧2 | DISP | 📷

AEB	.:1..⓪..1.:2
Flash exp comp	.:2..1..⓪..1.:2
WB SHIFT/BKT	
Custom WB	
Color space	sRGB
Picture Style	Standard
Dust Delete Data	

Playback settings

📷1 📷2 **▶** 🔧1 🔧2 | DISP | 📷

Protect	
Rotate	
Print order	
Transfer order	
Auto play	
Review time	2 sec.
Histogram	Brightness

Camera Setup

📷1 📷2 ▶ **🔧1** 🔧2 | DISP | 📷

Auto power off	8 min.
Auto rotate	On
LCD brightness	
LCD auto off	Enable
Date/Time	31/08/06 15:36
File numbering	Continuous
Format	

📷1 📷2 ▶ 🔧1 **🔧2** | DISP | 📷

Language	English
Video system	NTSC
Custom Functions	(C.Fn)
Clear settings	
Sensor cleaning: Auto	
Sensor cleaning: Manual	
Firmware Ver. 1.0.4	

Custom Function

Custom Function	◀ 01 ▶

SET button/Cross keys funct.

0:SET:Picture Style

01 02 03 04 05 06 07 08 09 10 11
0 0 0 0 0 0 0 0 0 1 0

Nikon D40x

Shooting

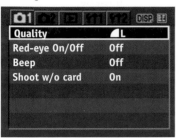

SHOOTING MENU

Optimize image	📷N
Image quality	FINE
Image size	▣
White balance	☀
ISO sensitivity	200
Noise reduction	OFF

SHOOTING MENU

Optimize image	📷N
Image quality	FINE
Image size	▣
White balance	AUTO
ISO sensitivity	200
Noise reduction	OFF

Playback settings

PLAYBACK MENU

Delete	🗑
Playback folder	ND40X
Rotate tall	ON
Slide show	⏱ 2s
Print set (DPOF)	⏁

Camera Setup

SET UP MENU

CSM/Setup menu	▤
Format memory card	--
Info display format	info
Auto shooting info	📺
World time	--
LCD brightness	0
Video mode	NTSC

Custom Function

CUSTOM SETTING MENU

Ⓡ Reset	--
01 Beep	ON
02 Focus mode	AF-A
03 AF-area mode	[⌷]
04 Shooting mode	S
05 Metering	▨
06 No memory card?	LOCK

Built-in retoucking options

RETOUCH MENU

D-lighting	▥
Red-eye correction	👁
Trim	✂
Monochrome	▢
Filter effects	◐
Small picture	▭
Image overlay	▱

Menu structure

Digital backs

The traditional division of cameras and film into 35mm, medium-format, and large-format, with all the attendant implications of resolution and image quality, is no longer relevant. Increasing the area of film meant higher resolution and less visible grain, with a noticeable effect on print quality. In print reproduction, too, this means better quality, although the steady improvement in scanner technology has eroded that advantage. Nevertheless, with large numbers of medium- and large-format cameras owned by professionals, most of them designed to accept removable backs or film holders, it was a natural step to make digital backs for them.

Progress has not, however, been smooth, and the manufacturers have had varied fortunes. The core of the problem is sensor technology. The R & D costs are so high that smaller manufacturers have difficulty keeping up with the major companies, such as Canon and Nikon. There is a constant leapfrogging of sensor resolution, so that some SLRs now deliver more megapixels than some of the mid-range (but-considerably more expensive) backs. The competition for Hasselblad, Mamiya, *et al*, is not other medium-format manufacturers but mainstream digital SLRs.

A point never highlighted by digital back manufacturers is that the sensors, even though larger than those in most digital cameras, are still much smaller than the film format for which the cameras were originally made. Most are in the order of 24×36mm up to 36×48mm, and the largest currently available is

Schneider 28mm Digitar

This medium-format lens is designed for the wider coverage needed with digital backs, and currently has the shortest focal length for this format. The diameter of its image circle is 60mm.

Leaf C-Most

This compact back is similar in size to a 645 film holder: and can be attached in either landscape or portrait orientation. Its 6.6-megapixel sensor, however, is smaller than the equivalent film frame—approximating a 35mm frame at 23.94 x 35.34mm. The relatively large pixel size (11.4μm) allows a dynamic range of more than 11 f-stops and 14-bit color. Depending on the host camera and computer, the capture rate is up to 3 frames per second.

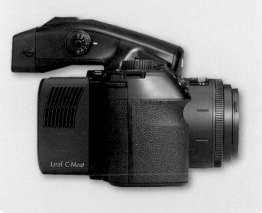

Leaf Aptus touchscreen

The Aptus series offers up to 33 megapixels from a resolution of 6726 x 5040 pixels and an aspect ratio of 3:4 (36 x 48mm). This matches 645 format proportions, although smaller. Color depth is 16 bits, and so file sizes are over 126MBin Raw data format. Capture rate is very high, thanks to an internal buffer memory. The back is intended to be used tethered to a computer using a 30GB Digital Magazine. Older Valeo models included external image display and control unit, based on a PDA. Now touchscreen functions are built in.

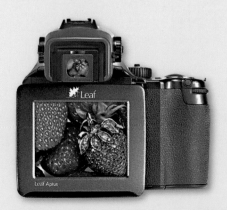

Major digital back comparison

Model	Optical Res (pixels)	Megapixels	Sensor size (mm)	Untethered (storage)	Compatability
Imacon Ixpress 96	4000 × 4000	16	37 × 37	1150 shots	Supports multiple camera
Imacon Ixpress 132C	5300 × 4000	22	49 × 37	850 shots	i-Adapter: One back fits all
Jenoptik Eyelike eMotion	5344 × 4008	22	48 × 36	Compact Flash	Hasselblad V, Hasselblad H1 Mamiya 645 AFD
Kodak DCS Pro Back Plus	4080 × 4080	16	36 × 36	10GB	Hasselblads, Mamiya RZ67 Pro II, Fuji Gge fore
Leaf Cantare	3072 × 2048	6	36 × 24	n/a	Most medium-and large-format cam
Leaf Valeo 22Wi	5356 × 4056	22	48 × 36	20GB	Hasselblads, Mamiya 645
Leaf Aptus 75	6726 × 5040	33	48 × 36	30GB + CF	Hasselblads, Mamiyas 645s
MegaVision FB-32	3072 × 2048	6	36 × 24	n/a	Hasselblad 500 Series
Megavision S4	4000 × 4000	16	36 × 36	Optional pack	Hasselblad 500 Series
Mosaic Imaging Luma	3072 × 2048	6	36 × 24	n/a	Fuji GX 680s, Hasselblad, Mamiya RB, RZ, 4 x 5s
Mosaic Imaging Luma II	4008 × 2672	11	36 × 24	n/a	Fuji GX 680s, Hasselblad, Mamiya RB, RZ, 4 x 5s
Phase One P25+	5436 × 4080	16	49 × 37	CF cards Arca Swiss, nar, Horseman	Hasselblad, Mamiya, Contax,
Phase One P45+	7216 × 5412	39	49 × 37	CF cards Arca, Sinar, Horseman	Hasselblad, Mamiya, Contax,
Sinar Sinarback 22/230	3072 × 2048	6	36 × 24	n/a	Adapters for most cameras

around 40 × 50mm. While this allows a large pixel size (11μm upwards), with the benefit of higher dynamic range (*see pages 48-49*), it also unfortunately adds extra cost to wide-angle photography because new, much wider lenses are needed. With view cameras that accept digital backs there is less of a problem—it is simply a matter of using one of the new lenses specifically designed for digital shooting, such as the Schneider 28mm Digitar—but medium-format SLR manufacturers have not all kept pace.

All of this aside, digital backs have the advantage that you can continue to use medium-format equipment, some of which has such features as camera movements (shifts, tilts, and swings). Still-life and product photography benefit, as does portrait photography, which has little need for wide-angle lenses. Operationally, too, backs have the convenience of large LCD preview screens, and detachability (most can be rotated for landscape or portrait orientation). Prices are considerably higher than for normal digital SLRs.

Phase One P21+ to the P45+

From the Danish manufacturer Phase One, several high-performance backs that can be used untethered as well as tethered for the "645" format—Mamiya, Contax, and Hasselblad cameras. The top of the range P45+ has a 48.9 x 36.7mm 39-megapixel CCD sensor, while the P20+ has a 36.9 x 36.9mm 16 megapixel sensor. Other features are similar, including a 2.2in LCD monitor, Lithium-Ion batteries, CF slot and Firewire port.

Digital backs

12-13 Changeover 14-15 The digital SLR 16-21 Digital SLR lenses 30-33 The sensor 48-51 Dynamic range

The sensor

The sensor is more than just a replacement for film. It feeds or is served by almost all of the camera functions and is an integral part of the camera. As the technology is still evolving—there is a lot of room for improvement even now—new higher-performance sensors appear quite frequently. This inevitably means new cameras, as there is no question at this point of simply upgrading a sensor. It also means that if the sensor is sometimes exposed to the environment, as in an SLR, it needs particular care and attention to avoid particles on the surface and damage (*see pages 82-83*).

A sensor is an array of photoreceptors embedded on a microchip, along with the circuitry and components necessary to record the light values. The circuits are etched into the wafer by repeating the photo-lithographic process of light exposure and chemical treatment, with extreme precision. The width of circuit lines is typically less than $4\mu m$ (4 microns). As an indication of the complexity, Canon's 11.1-megapixel sensor has approximately 700 feet (200 meters) of circuitry. The individual unit of a sensor is the photosite, a minuscule well that is occupied principally, though not exclusively, by a photodiode. The photodiode converts the photons of light striking it into a charge—the more photons, the higher the charge. The charge is then read out, converted to a digital record, and processed. Each signal from each photosite becomes the light and color value for one pixel—which is the basic unit of a digital image.

Photodiodes record light rather than color, so this has to be added by interpolation in the vast majority of sensor designs. The usual method is to overlay the

The Color Filter Array

The photosites on the sensor respond to the quantity of light, not wavelength. Color is added to the image by filtering the light. The entire sensor is covered with a Color Filter Array (CFA)—a mosaic of individual red, green, and blue filters, one for each photosite. The camera's processor must then interpolate the missing two-thirds of color information from the surrounding pixels—at least the neighboring block of eight.
The CFA pattern, as illustrated here, is not an even distribution of the three wavelengths. In order to better correspond with human vision, which is most sensitive to green-yellow, there are usually twice as many green filters as red and blue.

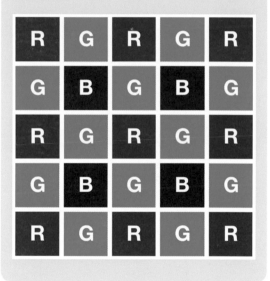

Small and large pixels

In the search for higher resolution, there are two possible directions for manufacturers—smaller photosites or larger sensors. There are special technical challenges for each, and resolution is not the only thing affected. A larger receptor (such as $8\mu m$–8 microns, or 0.008 mm)) is slower to fill up, and this is claimed to give a better dynamic range, as is the case for deeper receptors. Canon, who have committed to the larger-than-normal, full-frame sensor measuring $36 \times 24mm$, claim "the same gradation expression as reversal film" with their latest sensors.

sensor array with a transparent color mosaic of red, blue, and green. As in color film and color monitors, these three colors allow almost all others to be constructed. The difference here, however, is that the color resolution is one-third that of the luminance resolution. Oddly, perhaps, this doesn't matter as much as this figure suggests. Interpolation is used to predict the color for all the pixels, and perceptually it works well. As we'll see later in this book in the color management and optimization sections, color is a complex issue, psychologically as well as physically. The ultimate aim in photography is for the color to *look* right, and this is heavily judgmental. Nevertheless, there is at least one radical sensor design made to improve objective color accuracy (*see page 37*).

The photosite

The individual photosite in a sensor array is commonly compared to a bucket into which light, rather than water, is poured. An absence of light means an empty bucket, therefore no electrical charge, resulting in black. If light continues to be added, the bucket overflows, at which point the result is pure, featureless white. This accounts for the linear response of digital sensors to light rather than the subtle fall-off that allows film to capture a relatively wide dynamic range (*see pages 48-49*).

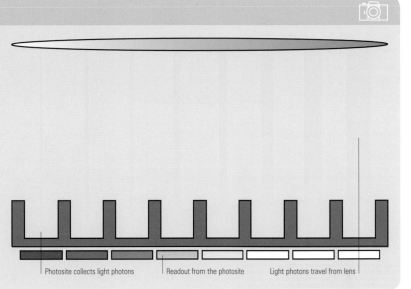

Photosite collects light photons | Readout from the photosite | Light photons travel from lens

The low-pass filter

Ordering the light rays as they enter the sensor is the job of the optical low-pass filter, which covers the entire sensor. This is necessary in order to suppress moiré and such inaccuracies as ghosting and color overlapping, and succeeds by facilitating the light reception by photosites. This results in more accurate data separation. The filter illustrated here is Canon's three-layer filter, in which a phase plate, which converts linearly polarized light into circularly polarized light, is sandwiched between two layers that separate image data into horizontal and vertical directions. Another substrate cuts infrared wavelengths by a combination of reflection and absorption to further improve color accuracy.

While the low-pass filter protects the sensor from direct exposure to the environment, it is also very fragile and should never be touched (*see Care and maintenance, pages 82-83*).

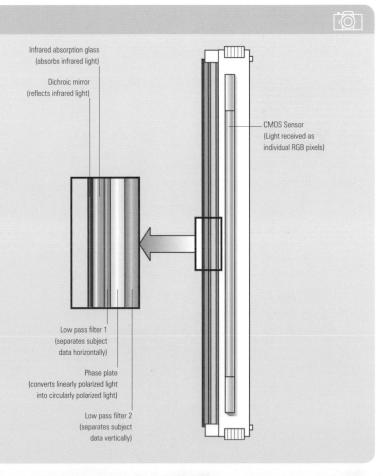

Infrared absorption glass (absorbs infrared light)

Dichroic mirror (reflects infrared light)

CMOS Sensor (Light received as individual RGB pixels)

Low pass filter 1 (separates subject data horizontally)

Phase plate (converts linearly polarized light into circularly polarized light)

Low pass filter 2 (separates subject data vertically)

The sensor

The sensor

CMOS vs CCD

The major competitor to CCD sensors is CMOS (Complementary Metal Oxide Semiconductor), and while the main issue is manufacturing cost, it has implications for performance. Chips of all kinds are made in wafer foundries, and CCDs are a specialized variety, so more costly than other kinds. CMOS foundries, however, can be used to manufacture computer processors and memory, and so CMOS sensors can take advantage of economies of scale. This makes them much cheaper than CCDs to produce, although some of this saving is offset by the need to overcome some performance problems, notably noise, which means additional onboard processing. In other words, CCDs are inherently better for high-quality imaging, but once data processing has been factored in there is little to choose in performance at the top end of digital SLRs. In summary, the CMOS compares to CCD as follows:

1 Individual amplifier, giving a speed advantage in transferring data.

2 Lower power consumption (volts).

3 Simpler and less expensive manufacture (in the order of 1:3).

4 Requires suppression of pixel dispersion.

A CMOS chip

A CCD chip

CMOS chips are produced as part of a silicon wafer, like other computer chips, and are cut into individual chips using a diamond-edged saw.

Once cut into separate pieces, the chips can be placed onto circuits like any other computer chip.

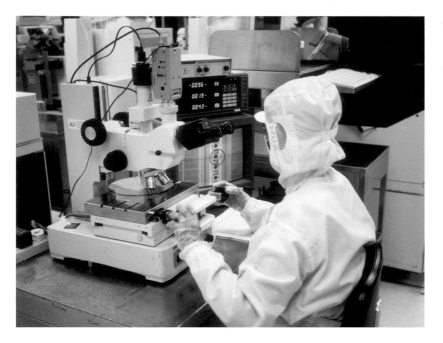

As in all silicon production, silicon wafers are checked very thoroughly for flaws. Here a microscope is used to do that by a staff member at major chip manufacturer Micron.

Moiré

Moiré, which usually appears as parallel multi-colored stripes in wavy patterns, is an interference effect caused by the overlapping of tight, fine patterns. In digital photography, this special kind of artifacting is particularly common because of the grid pattern of photosites on the sensor. If a second pattern with a similar spacing is shot, such as a textile weave, it can interact to create this third, moiré pattern, as shown here. The camera's low-pass filter helps to reduce the effect, although only to a certain degree as strong correction softens the image overall. The lenses, sensor, and software in a digital SLR system are all designed for high sharpness and accuracy, and this makes moiré more likely.

Warning: always inspect for moiré at 100% magnification. At smaller magnifications you can often see a false moiré, which is the interaction of the image with the pixels in a camera's LCD screen or a computer monitor.

To avoid or reduce moiré:

1 Change the camera angle or position.
2 Change the point of focus and/or aperture.
 Moiré is a function of sharp focus and high detail.
3 Vary the lens focal length.
4 Remove with image-editing software (*see page 224*).

Picture suffering from moiré

The sensor

Sensor read-out

Recording the images is only the first stage in the sensor's operation. Transferring the information quickly and in a readable form to the camera's processor is critical, and there are different methods. The original method, which gave the CCD (charge-coupled device) its name, relies on reading out the charges row by row, linking the end of one row to the beginning of the next. In this way, the charges are "coupled."

Three methods

One of the key issues is the speed at which the image data can be moved off the sensor so that it is ready for the next exposure. This decides the shooting speed—an important matter for sports and news photographers in particular—and the baseline that most professionals have become used to is the eight-frames per second common among high-end film-cameras. At the moment, there are three methods used by CCD sensors—interline transfer, full frame transfer, or X-Y addressing—of which interline transfer, reading one column at a time, is the traditional method. All have advantages and disadvantages, and different manufacturers favor one or the other according to how they choose to solve inherent problems (*see below*). The lesson here for photographers is that there is no steady progression of sensor improvement, but a more chaotic world of innovation and secretive independent engineering. Problems that seemed intractable last year can suddenly have a solution—at least from one manufacturer.

Basic interline readout

Following exposure, the charges on the first row of photosites are transferred to the readout register, also embedded on the sensor. From this register the signals are moved to an amplifier, and the boosted data is then transferred to the ADC (analog-to-digital converter) ready for processing. Once the first row has been read, the readout register is cleared, and the second row transferred to it. This sequence continues until all the rows have been read, with the charges on each being coupled to those on the row above. During this process, the charges in each row move down to fill the space on the one below.

Reading out the data

There are currently three methods of transferring the data from an exposed sensor. The emphasis is now on speed, in order to make digital SLRs as fast to use as their film predecessors. This area of sensor technology is currently receiving a great deal of attention.

1 Interline transfer In this basic, original method, which gave CCDs their name, the data from the photosites is shunted to one side of the sensor so that the rows can be read one at a time, the end of one linked to the start of the next. The readout is therefore sequential. Originally developed for video, its disadvantages for still digital capture are the time it takes to shunt the data across the array, and the need for transfer channels adjacent to the photodiodes, which reduces the aperture ratio at the photosite.

2 X-Y addressing Each photosite is read individually, which cuts down the transfer time and offers potential processing advantages. It requires individual switches for each site, which potentially reduces the area available for the photodiode, reducing the aperture ratio. This method is used in CMOS sensors and some others (such as the Nikon LBCAST, which uses buried channels).

3 Full frame transfer All of the data is moved at once down onto an area the same size as the sensor. This adds another layer of the same area as the sensor, but as the transfer channels can be underneath the photosites, the photodiodes can occupy a larger area. It also addresses the issue of transfer speed.

The imaging sequence

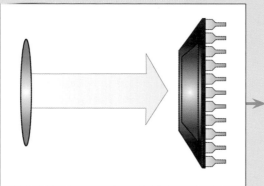

1 Light strikes the active area of the photodiode.

2 The photodiode converts the quantity of light into an accumulated charge.

3 The charge is moved off the sensor (with all the other charges from other photosites) through transfer channels to an amplifier.

4 The amplified charge is moved to the ADC (analog-to-digital converter).

5 The signal is processed by the ADC into digital data.

6 The imaging engine processes the image in a number of ways, including applying user settings, compressing, and reducing noise.

7 The data is transferred to the memory card, microdrive, or direct to the computer's hard drive (if the camera is connected).

Sensor read-out

30-33 The sensor 38-39 The processor 48-49 Dynamic range and exposure 60-61 Sensitivity and noise

Sensor developments

Because sensor technology is at the heart of digital capture, major camera manufacturers have invested heavily in customized sensors. There is an increasing divergence between sensor designs, and off-the-shelf CCDs and CMOS imaging chips are now used in mass-market cameras only. Two very different designs are those used by Fujifilm and Foveon, the latter in Sigma cameras.

Fujifilm have adopted a staggered pattern of photosites that are each octagonal rather than square in plan, and this increases the density of light reception. More than this, it favors resolution in horizontal and vertical directions rather than diagonally, and this corresponds better to the data recognition of human vision. Because of this, Fujifilm claim a real, effective resolution that is *twice* that of the actual number of pixels (currently 11 megapixels equivalent from 6 megapixels actual). Other manufacturers dispute this interpretation.

Another major Fujifilm innovation in the physical layout of the sensor is a double-diode design, aimed at improving the dynamic range (*see pages 48-51 for the importance of this*). Each photosite contains a large and a small photodiode. The larger (primary) photodiode is used for all picture taking situations, while the smaller (secondary) photodiode comes into operation when brightness levels are high. A larger single photodiode offers greater sensitivity and

Interleaved pixels

A sensor design that is substantially more different than it at first appears is Fujifilm's Super-CCD. Technically known as a Pixel Interleaved Array CCD (PIACCD), it maximizes the active area of the sensor by using octagonal photodiodes instead of square, and by interleaving them as shown, arranged in a 45-degree configuration instead of the more usual 90-degree layout. The wiring (that is, the data transfer channels) surround the pixels rather than occupying separate columns as in a conventional Interline CCD, and more efficient packing of photodiodes on the sensor gives a 30% increase in active area. Moreover, the staggered arrangement gives a higher vertical and horizontal resolution at the expense of the diagonal—and human eyesight has higher recognition of detail in the horizontal and vertical. All of this, and an interpolation of the staggered array, enables Fujifilm to claim an effective doubling of the resolution (11 megapixels from an actual 6 megapixels). This pattern is also claimed to give increased sensitivity, an improved signal-to-noise ratio, and wider dynamic range.

Doubled photodiodes

Fujifilm's SuperCCD features a large and a small photo-diode in the same photosite. The function of the secondary photo-diode is to collect more highlight detail, which it does by being less responsive to light than the primary. Thus, once the primary photodiode has filled up, the secondary takes over, capturing detail in brighter conditions than the primary is capable of. For example, when the primary is at 60% saturation, the secondary is still only at 10%, but when the primary is at 100% (blown-out highlights), the secondary still has capacity. The two signals are read out separately, then analyzed and combined, for a single pixel value.

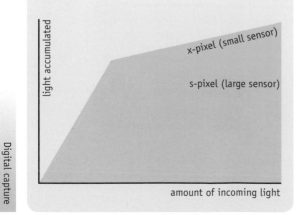

light accumulated

x-pixel (small sensor)

s-pixel (large sensor)

amount of incoming light

dynamic range than a smaller one (*see pages 50-51*), but is still limited. If it were adjusted to accommodate a wide range of brightness (contrasty conditions), in more normal lighting, it would produce a flat-looking image. The primary photodiode in Fujifilm's Super-CCD reaches saturation under normal conditions, but the secondary photodiode, being smaller, has a lower effective speed (sensitivity), and so fills up more slowly. In effect, it extends the dynamic range of the combination into brighter light levels, thus improved highlight detail.

The Foveon sensor takes a completely different approach, attempting to mimic the way in which tri-pack color film works, and so do away with the normal color interpolation. It takes advantage of the fact that silicon (from which chips are constructed) is actually transparent and absorbs different color at different depths. Thus one layer records red, another layer records green, and the third layer records blue. This is an innovative patented technology, but the real gains are hard to measure. While color fidelity—and color management—is now an even more important issue with digital photography than with film-based shooting (*see pages 106-107*), it is also more easily dealt with. As digital capture and processing has shown us, some image qualities are highly perceptual, meaning that—to put it crudely—if it looks right to the eye, then it is right. There are priorities in sensor technology other than total color accuracy.

The top right image is taken using a 6 megapixel Nikon D100, and the lower with the 6 megapixel interleaved CCD (12 megapixel file) Fujifilm S7000.

Foveon

A patented design, the Foveon X3 sensor, launched initially in Sigma cameras, makes use of the transparency of the silica substrate to achieve something similar to the familiar tri-pack structure of color film. There are three photodiodes for each pixel, and they are stacked vertically to give full-color image capture.

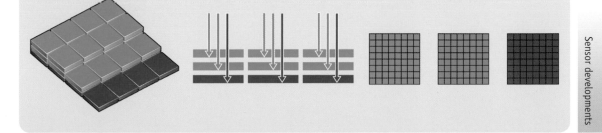

Sensor developments

The processor

For the user, the least accessible but probably most important component in the camera is the processor, or imaging engine. This is responsible for all the computation of the data from the sensor, from the signal received by the ADC (Analog-to-Digital Converter) to the transfer of a completed image to the memory card. There is a great deal of hidden work going on here, not only because you have no direct access to it (other than through the menu settings), but because the proprietary algorithms that are at the heart of the sensor are kept secret. As with software applications used on desktop computers, algorithms are the mathematical procedures for performing actions, and those for imaging are complex. Not only that, but there are differences in the quality of the programming—which can only be judged in the appearance of the final image. There is more to image quality, in all its aspects, than the simple specifications of the sensor.

In high-end cameras, the design of the sensor and the imaging engine proceed in tandem. Major camera manufacturers develop their own sensors and processors, and this alone helps to improve imaging performance. For example, Canon currently use CMOS sensors for their advantages in speed, low power consumption, and lower cost, and address the known higher noise level in two ways: through on-chip

Left *The Canon Digic III processor is an integral part of their EOS-1D Mark III and other models. Faster processors like this reduce shutter lag and increase the number of frames you can take in a "burst."*

Below *Processors on cameras handle the basic operating system of your camera—menus and settings—as well as digital image processing. The circuit board featured here is from a Canon EOS-1D.*

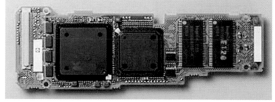

Imaging engine

This is the double imaging engine for Canon 11-megapixel sensors. In this design, the various tasks are split between the two processors, allowing faster processing, which in turn increases the burst limit.

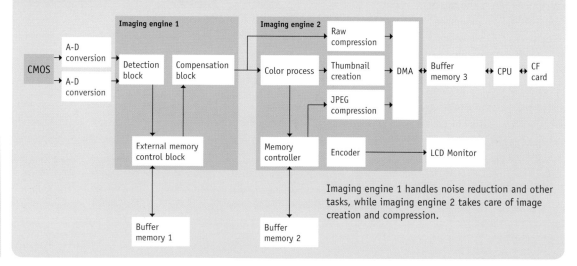

Imaging engine 1 handles noise reduction and other tasks, while imaging engine 2 takes care of image creation and compression.

noise-reduction circuitry and through noise-reducing algorithms in the processor. In another example, Nikon's high-end models use the processor to carry some of the burden of suppressing color aliasing (false coloration), which is normally the job of the optical low-pass filter immediately in front of the sensor. Increasing the birefringent index of this filter suppresses the color artifacts better, but it also lowers resolution. The Nikon filter has a lower birefringent index because the imaging engine takes on some of the task.

A great deal of sensor technology involves compromise, and the imaging engine can solve many of the problems. You can experience something of this in a much more limited way, by shooting in Raw format and optimizing later. It's important not to try to make comparisons between DSLRs based on the very limited specifications that are usually published. Properly designed, a sensor/processor combination with a modest megapixel size can produce images that have a higher resolution and better sharpness than a more primitive larger sensor.

The processor is mainly responsible for the following tasks:

1 Operation of memory buffer As frames are captured they are moved immediately to the buffer, from where they are transferred one at a time for processing. Buffer size has an impact on the shooting speed (capture rate).

2 Color interpolation Pixels are sampled in relation to their neighbors, taking into account the color array pattern, to fill in the missing color information. Color gradation across the image needs to be smoothed, and color artifacts (false colors and fringeing) removed.

3 Resolution and sharpness A number of aspects affect sharpness and resolution, including noise, aliasing (jaggies), and color artifacting.

4 Noise reduction An extremely important operation, as the various kinds of noise (*see pages 174–175*) are obstacles to capturing a clean image from a sensor.

5 User settings Applying the choices offered in the menu to the image.

6 Image creation Combining all the sensor data and processing to produce a readable image in one of several formats.

7 Compression In the case of JPEG and some Raw images, applying compression algorithms.

Firmware updates

Firmware is the description used for various programs already encoded in the camera, and will occasionally need updating as the manufacturer makes new versions available. There will be one window in the menu where you can check the version installed; make a note of this and every few months check the manufacturer's website to see if there are updates. If so, you may be able to perform the operation yourself, depending on the make of camera (with some makes this must be done by an authorized service center). With user-installed updates, pay careful attention to the instructions, as this is an operation that can damage the processor if it goes wrong. In principle, the sequence is:

1 Download the firmware update installer to the computer from the manufacturer's website.

2 Copy the installer to a blank memory card, either on a card reader or in the camera.

3 Run the install operation from the memory card. This takes several minutes, and during this time the camera must under no circumstances be powered down.

4 Erase the installer from the memory card.

The processor

Resolution

Resolution is back as an issue after being largely out of the news for two or three decades. The best way to approach it is from the way the photograph will be used. If you know that, or can at least estimate it, everything else falls into place. Until approximately the 1980s, prepress technology, or rather its limitations, restricted the size at which small film negatives or transparencies could be printed successfully. 35mm color was often a problem, and the preferred answer for publishers was to have a larger original, hence the professional popularity of 120 rollfilm, and 4×5in and 8×10in sheet film. Improvement in prepress technology, in particular scanning, gradually took care of this, but now things have changed once again. Camera sensor technology is still evolving, with the result that for most hand-held cameras, resolution is still not as high as many people would like, while the few high-resolution models are costly. All this will change, but for now we need to be aware of what the limits are—and which techniques are available to help push the envelope.

This view of an old windmill on the beautiful Greek island of Mykonos was shot using a digital camera with a 6-megapixel resolution.

Screen or print?

The way to deal with resolution is to work backward from the end use. What looks good on a 15in monitor will not necessarily look good as a normal print, but if the screen view is all you need, that doesn't matter. Professionally, the main uses are prepress, display prints, and the Web. For both prepress and display prints, digital files should be at twice the resolution at which they will be printed. A high-quality web offset press, for example, has a line-screen resolution of 133

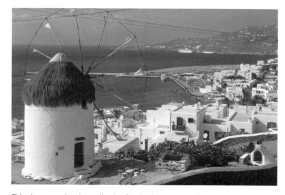

This shot was taken immediately after (in the same conditions) with a traditional film camera. Film is believed to be equivalent to about 20 megapixels of detail.

and 150, so the digital file should be 300 dpi. This is the standard, default resolution for printing.

What ultimately counts, of course, is the number of pixels that goes into making the image. Simply expressed, you need a 22MB file for an 8×10in print, and about the same for a full page in most magazines.

Digital resolution vs film resolution

It is not a simple matter to compare the two, because the measurement systems are different, and because digital images are in principle "cleaner" than film images. Digital images can be measured by the density of pixels, but other factors creep in, particularly the quality of the lens. The usual measurement is pixels per inch or per centimeter along a straight line. A full-frame 36×24mm sensor with 12 megapixels would have a resolution of 4048×3040 pixels.

Digital 100%

Digital 200%

Film 100%

Film 50%

Each camera megapixel gives 3MB of image (that is ×3 for the three RGB channels), which means that 7 megapixels will do the job perfectly and a 6-megapixel camera will be adequate. In terms of use, a full page is one of the most basic professional units, while a double-page spread—twice the size—takes care of any possible use that an editorial client might want to make. Stock libraries are in the best position to know the demands of the market, and Corbis, for instance, set the following specifications for their own images: 40MB for editorial sales, 50MB for commercial. These are, naturally, high professional specifications, but the principle is the same as for less demanding uses—calculate backward from the end-use.

All this is without attempting to improve resolution by upscaling (*see pages 154-155*). How successful this is depends on the algorithm used, and this is highly technical. It also depends on how much deterioration you are prepared to accept. No interpolation method, however sophisticated, can equal a higher resolution original, but on the other hand the differences can be surprisingly small. Resolution, together with sharpness and noise, are also matters of judgment. If you have a unique or important photograph by

virtue of its content, image quality takes second place. This regularly happens in news journalism and in art, too, and always has. Compare, for example, an early Bill Brandt print (many are technically sub-standard) with an Edward Weston print from an 8 × 10in negative (Weston was known for his technical perfection).

SHOOTING MENU

Resolution

Large
Medium
Small

All digital cameras offer the option of saving images at a size other than the CCD's optical resolution. Unless you're especially strapped for memory space, always select the highest resolution available, which (at least on a standard grid pattern sensor chip), will save one pixel per photosite on the chip, giving the best possible read-out from your camera.

Basic specs

Prepress and display prints	Millimeters width x height	Inches width x height	MB @ 300 dpi
A5	148 x 210	5.83 x 8.27	12.7
Magazine full page (*Time* magazine size)	190 x 260	7.5 x 10.1	19.5
US Letter	216 x 279	8.5 x 11	21.2
A4	210 x 297	8.27 x 11.69	25.5
8 x 10in print	203 x 254	8 x 10	21.1
A3	297 x 420	11.69 x 16.54	51.0
A3+	329 x 483	13 x 19	63.4
Magazine double spread (*Time* magazine size)	380 x 260	15 x 20.2	78

Monitor display (pixels)	Millimeters width x height	Inches width x height	MB @ dpi
15-in full screen (800 x 600)	305 x 229	12 x 9	1.4 @ 66 dpi
17-in full screen (1024 x 768)	345 x 259	13.6 x 10.2	2.3 @ 75 dpi
20-in full screen (1280 x 960)	406 x 305	16 x 12	3.5 @ 80 dpi
20-in cinema display (1680 x 1050)	432 x 269	17 x 10.6	5.1 @ 100 dpi
23-in cinema display (1920 x 1200)	495 x 310	19.5 x 12.2	6.6 @ 100 dpi
(Note: software commonly assumes monitors to be either 72 dpi or 96 dpi, though in reality it varies.)			

Resolution

30-33 The sensor 44-45 Compression and image quality 114-115 Daily downloads 116-117 Temporary storage

File format

There are many ways of digitally encoding images, depending on the way in which the code is designed and written. The history of this is long enough to have resulted in a number of different file formats, each with a particular specialty. Some formats are better suited to one kind of image than another—for example, graphic illustration with solid color and hard edges as opposed to photographs containing complex detail and shading. Some formats are aimed at delivery—such as for the Web. By now, a few standard formats are accepted as useful for photographic images, primarily TIFF (Tagged Image File Format) and JPEG (Joint Photographic Experts Group). These two are readable and interchangeable by all imaging software that deals with photographs. In addition, there is the native application format that each type of software uses for its own internal workings. It may or may not be readable by other applications—Photoshop (.psd) is the most widely known.

Most SLRs offer three kinds of format: JPEG, TIFF, and Raw. JPEG, pronounced "jay-peg," is computing's longest-established system for writing images. It has two powerful advantages: it is optimized for transmitting images, and so is the universal format for the Web, and also compresses images so that they occupy less digital space. The amount of compression is chosen by the user—to more than 90%—and typical compression ratios are between 4:1 and 40:1. The compression method used is Discrete Cosine Transformation, which

works on blocks of eight pixels per side and is "lossy," meaning that some of the image information is thrown away. This results in some degradation, but this is quite often undetectable in normal image reproduction. It's important to run tests to assess what compression levels are acceptable to you for different purposes.

TIFF (Tagged Image File Format) was originally developed to save scanned images that needed to be opened and worked on by image-editing software, and is particularly well suited to photographs with their complex gradations and detail. TIFF files support color depths up to 16-bits per channel, although most cameras that save to TIFF use 8-bits. This is still the most widely accepted format for saving and transferring photographic images digitally. TIFF files can be compressed with the lossless LZW system.

For the best image quality and the ability to re-adjust all the camera settings after the event, nothing beats Raw format. This is unique to each make of camera, but what they all have in common is that the settings are recorded and kept separately from the data. The settings

The Raw file is in fact a generic name for the files now produced by high end cameras. Here, a Nikon NEF file is adjusted using Nikon's software, supplied with the camera. Before Raw, the file would have been processed to a TIFF or JPEG by the camera, losing information which might have been useful in editing.

Format recognition by suffix

Each file format has a suffix that designates it. More often than not this is an unnecessary addition to the file-name, but certain applications do require it—meaning that they will not recognize an image without it. These are as follows:

TIFF	.tif
JPEG	.jpg
PICT	.pct
Nikon Raw	.nef
Canon Raw	.crw
Fujifilm Raw	.raf
Olympus Raw	.orf
Pentax Raw	.pef
Minolta Raw	.mrw
Kodak RAW	.dcr

Images per 100MB

Use this table to calculate the image capacity of memory cards. Exact figures may vary according to the camera make.

File format	5 megapixels	6 megapixels	8 megapixels	10 megapixels	12 megapixels
Raw*	12	10	8	6	5
Raw compressed**	27	22	18	13	12
TIFF	6	5	4	3	2
JPEG 1:4	24	23	16	12	11
JPEG 1:8	48	46	28	24	22
JPEG 1:16	96	92	56	48	44

* As this is a proprietary format, it varies between camera makes. This figure is extrapolated from Nikon .NEF

**Depends on the manufacturer's compression algorithm. This figure is extrapolated from Nikon .NEF

Bit-depth and image quality

Bit-depth describes the degree of color precision in a digital image. One bit (a contraction of *bi*nary dig*it*) is the basic unit of computing, and has two states, on or off—black or white. A byte is a group of 8 bits, and as each of these has two states, one byte has a possible 256 combinations—that is, 256 values from black to white. An RGB image has three channels, so at 8 bits per channel has a color accuracy of 256 x 256 x 256—that is, 16.7 million possible colors. This is well beyond the ability of the human eye to discriminate, and is standard. Why then, do higher-end scanners and cameras make much of higher bit-depths, such as 12-, 14-, and 16-bit? This is because, first, it makes smoother and better graduated tones in a gradient (such as the sky), and second, it improves the accuracy of interpolation when images are altered or manipulated, as in Photoshop (*see more detailed explanation on page 220*).

Note that it is usual to refer to bit-depth by channel, as above, but occasionally you'll see it described as the *total*, all-channel bit-depth—24-bit meaning 8-per-channel and 36-bit meaning 12-per-channel.

JPEG compression

JPEG compression can leave noticeable artifacts. The more compression applied, the more obvious the effect.

Basic

Fine *Normal*

include white balance, hue adjustment, sharpening, and so on—in other words, the initial processing applied to the raw data (hence the name). The great advantage of this is that any of these settings can be altered later, during image editing, *with no penalty in image quality*. Another is that the images are available at a higher bit-depth than 8—typically 12 or 14. The disadvantage is that the images *do* need extra work when opening in Photoshop, which may or may not be important, depending on your style of photography.

This detail of a floor was taken with a Nikon D100 and saved as a TIFF file. Unlike the JPEG format, a standard TIFF file describes each pixel in terms of each channel, either red, green, and blue (as in this case) or cyan, magenta, yellow, and black (key). The file sizes can be large.

File format

26-27 Menu structure 64-65 In-camera color management 220-221 Bit-depth and dynamic range

Compression and image quality

With storage space at a premium, there are obvious advantages in being able to compress the data for a photograph, provided that the image is not noticeably degraded. The key word here is "noticeably," and there is a choice of the quality of compression during shooting. The *raison d'être* for JPEG in the camera's menu is that it is both a compression method and a file format, and this is usually the format to choose when it is important to squeeze the maximum number of images onto a memory card. In addition, the recording time will usually be less than from TIFF or Raw, and so the images will move through the frame buffer more quickly—all good for shooting large numbers of images continuously.

Compressing a Raw image is a slightly different matter. The space saving is in the order of 50%, but there is a time penalty, and this becomes important once the frame buffer has filled. For example, a 9.4MB

Lossless and lossy compression

There are two classes of compression: lossless and lossy. As their names imply, one compresses the file size without discarding any data (working instead by writing the data in a more succinct way), while the other throws away some of the information. Compression is sometimes described as a ratio (e.g. 1:4), as a percentage of reduction (e.g. 80%), or as a percentage of the original file size (e.g. 20%). The last two are easily confused.

The leading lossless compression system is LZW (named after its inventors Lempel-Ziv-Welch), used with TIFF images, and the amount of space saved depends on the image content. Typically, file sizes are reduced to about 40% to 50%, though less in high bit-depths. Raw formats can also be compressed without loss, using camera manufacturers' proprietary methods. One disadvantage of lossless compression is that it can add substantially to the recording time.

Lossy compression does degrade the image, but not necessarily to the point where it can be seen. The leading compression system is JPEG, and the amount of compression can be selected by the user. In-camera compression is normally limited to a choice of three settings, which vary among camera makes, but are typically 1:4, 1:8, and 1:16.

Compression and degradation

JPEG compression is usually offered in-camera at three levels, but these are usually referred to in terms of image quality, such as Basic, Normal, and High. The resulting file sizes depend on the image content. If you are going to make significant use of JPEG format, it is essential to run your own tests and judge what degradation you are happy to accept. The images will be slightly degraded, but the key is to choose a setting that makes no *visible* difference. In practice, most people can detect no quality loss at normal viewing distances. Knowing that the image is less than perfect is not the same as being able to see this. JPEG is well-suited to photographic images as opposed to hard-edged illustration, graphics, and type, because photographs tend to have softer and more complex detail. What image degradation there is appears mainly in color artifacts at pixel level.

Original. The lower images show the degree of variation from the previous generation (the darker areas have changed more).

First generation JPEG

Second generation

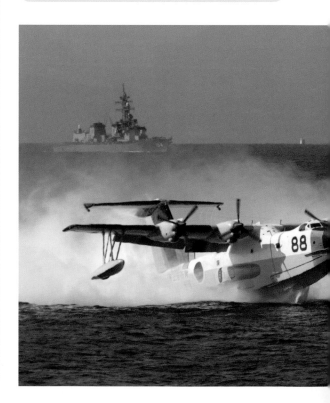

Compression tables

These are representative, averaged examples. Actual sizes of compressed images depends on the image content, and it is recommended to conduct your own tests.

Camera/format	File size (MB)	No. of images per 100MB	Recording time (secs)	Frame capacity of buffer
Nikon D100 Raw uncompressed	9.6	10	96	4
Nikon D100 Raw compressed	4.4	22	178	4
Nikon D100 JPEG Fine, full-size	2.9	34	30	6
Nikon D100 JPEG Normal, full-size	1.5	66	21	6
Nikon D100 JPEG Basic, full-size	0.77	129	10	6

Raw file shot on a Nikon D100 takes about one minute to record *un*compressed, but takes the system an uncomfortable three minutes compressed. This creates a potential problem when choosing whether or not to begin with compressed—you will need to wait for the image(s) to be processed before you can change to uncompressed on the menu.

This photograph of a flying boat taking off is the original image as photographed in TIFF format.

This is the same image compressed at the highest-quality level in JPEG format.

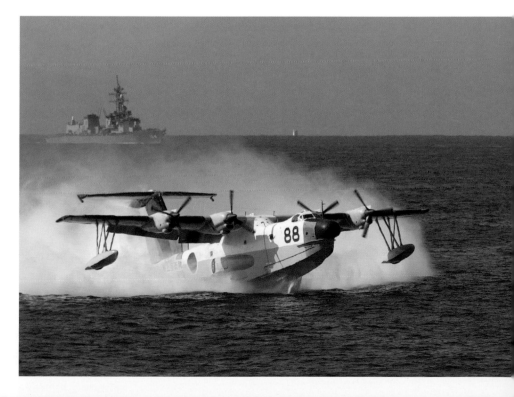

Exposure measurement

The immediate image feedback in digital photography has largely done away with the need for skilled exposure measurement. This may be shocking news for purists and craftsmen, but while there is nothing to stop you taking pains over the measurement with a handheld meter, it hardly matters any more. Even if you insist on using Manual rather than Auto exposure, it is still quicker to guess the settings, shoot, and check the result than to work them out carefully. If this sounds less than conscientious, remember that another set of skills is required—judging good exposure by means of the histogram and clipped highlight warning. As with film SLRs, most cameras offer a choice of matrix/multipattern metering, average readings, and spot readings. Each has its use, but again, it is the result on the LCD display that really demands your attention.

The metering principles are largely the same as for film cameras, with the possibilities of extra precision because each pixel can be measured. There are three principal metering systems used in DSLRs, and different modes that allow you to prioritize shutter speed or aperture and create custom combinations of both. Exposure compensation and exposure bracketing (in which bursts of consecutive frames are exposed at changing increments over and under the metered reading) are standard. Advanced measurement in high-end cameras takes account not just of brightness, but also color, contrast, and the area focused, all in an effort to second-guess which parts of the scene you are likely to want accurately exposed.

Manual

In situations where there is no urgency, many photographers prefer to switch from Auto to Manual, and adjust the aperture or shutter by the readout in the viewfinder. Certainly there is an argument for using Manual when you want to bracket exposures—it can be quicker than working the exposure-compensation dial or buttons. In rapid-reaction situations, however, it is more likely to cause a delay.

Spot metering

Most DSLRs allow you to choose to make readings from a very small central area—often little more than a dot taking up 2% or less of the image area. This is the in-camera equivalent of a spot meter, in which you can measure very small parts of the scene. This is especially useful if you want to base the exposure on a particular precise tone.

In this shot (of a sushi chef at a restaurant in Daikanyama, Tokyo) the metering needed to be based on the subject rather than the background.

Center-weighted metering

Less programmed than matrix metering, this standard method gives extra priority to the central area of the frame, on the reasonable assumption that most images are composed that way. Less attention is paid to the corners and edges. The precise pattern of weighting varies with the make of camera, and some models allow you to choose different weightings.

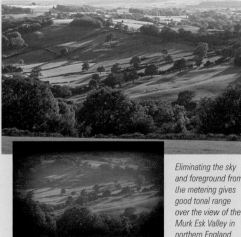

Eliminating the sky and foreground from the metering gives good tonal range over the view of the Murk Esk Valley in northern England.

Center-circle metering

A more concentrated variant of center-weighted metering, using a defined circle in the center of the frame. This is a great solution to shots where the subject takes up much of the frame, though you might find it more appropriate to use spot metering when composing a different kind of image. If you were placing a figure according to the rule of thirds, for example, this would be less than ideal.

Here the subject takes up much of the center of the image, so a larger circle than spot metering is appropriate.

Matrix or multi-pattern metering

This is now the default auto metering method for high-end cameras. It has two components. One is the division of the frame into segments, which are each individually measured. The second is a database of many thousands of picture-taking situations based on either actual shot images or (less accurate), theoretically derived scenes. The pattern of exposure readings is compared with those in the database and the appropriate algorithm is applied. At its simplest, if there is a much brighter strip across the top of a horizontal frame, this will be assumed to be the sky and the exposure will be weighted more to the darker area below. Equally, a compact dark area close to the center of an otherwise light scene will be assumed to be the important subject, and the exposure will be adjusted for that.

The matrix records an average from areas of the image.

Here the dark areas in the top of the image and light ones in the foreground are clearly shown in the matrix.

Exposure measurement

14-15 The digital SLR 30-33 The sensor 48-49 Dynamic range and exposure 134-135 Working with Raw files

Dynamic range and exposure

A major problem with digital sensors is achieving a high dynamic range, at least as good as the tonality of film. Specifically, the difficulty is retaining highlight detail in normal-to-high contrast scenes. The larger the photodiode, the greater the sensitivity and the wider the dynamic range, but this is in conflict with the need for smaller photosites on the sensor to increase the resolution. The photodiode must fit within the total photosite area, and still leave sufficient room for other components. Moreover, typical photodiodes still reach saturation (that is, a full tonal range) faster than is ideal.

Blocked highlights

In these highlight areas, digital sensors tend to compare unfavorably with film because of their linear response. Typical film response to exposure shades off at both ends of the scale, hence the familiar S-shape of the characteristic curve (*see right*). Practically, this means that film has some latitude in the highlights and the shadows. Its response is not linear. Digital sensors, however, *do* have a linear, straight-line response, and this results in easily blocked highlights. Anyone familiar with film is used to there being some hint of detail in most highlights, but this is not so when using digital. Once the charge in the photodiode "well" is filled up, the highlights are blocked, and it is as if you have a hole in the image—or "triple 255" when measured in RGB.

Double-diode photosites

One approach to the highlight problem, adopted first by Fujifilm for high-end compacts, is to use a secondary smaller-aperture photodiode. With several times less sensitivity than the primary diode, it will record highlight detail in conditions when these have been lost by its larger companion. The data from both is combined by the camera's processor. The effective gain in tonal range is in the order of two *f*-stops. A disadvantage is that the asymmetric design of the photosite limits the size of the sensor because of the risk of shading toward the edges (*see pages 38-39*).

Film versus sensor response

The fundamental difference between the way in which film responds to increasing exposure to light and the way in which a digital sensor responds is best shown in the shape of the characteristic curve. This plots the brightness of the image (on a vertical scale) against the brightness of the light striking it (on a horizontal scale). With both film and sensors, most of the middle tones in a scene fall on a straight line—not surprisingly called the "straight-line section"—meaning that the image brightness marches in step with the subject brightness. At either end, however, film reacts in a special way. It falls off in a gentle curve in the shadows (lower left) and highlights (upper right). For example, in the highlights, twice the exposure results in less than twice the brightness, which is very useful, because it tends to hold highlight detail. The same applies to shadow detail. Sensors, however, inherently lack this smoothing out of the curve.

In a normal photograph of a normal scene, the shadows are at the lower left (the "toe") and the highlights at the upper right (the "shoulder"), with most of the tones in the middle, the "straight-line portion" of the curve. Significantly, this means that with film, highlights do not easily blow out—increasing exposure has less and less effect on the density. In other words, with increasing exposure to light, film response starts slowly (shadows) and finishes slowly (highlights). Photodiodes on a sensor, however, lack this cushioning effect. They reach saturation steadily, at which point there is no highlight detail whatsoever. In other words, film tends to be more forgiving of under- and over-exposure, particularly the latter.

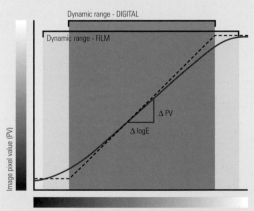

Traditional negative

These images show a negative film image of the ceiling of the Palace of Westminster Cathedral. Black-and-white film has a huge dynamic range, able to discern detail in very dark, or very light areas. This dynamic range is extended significantly by film's response to low and bright light (*see Film versus sensor response box, left*). As yet, digital is not quite as forgiving, so achieving rich tonal information at both ends of the brightness spectrum is more difficult. The technology is improving, however.

Negative (detail) *Print (detail)*

A film negative of the Palace of Westminster

The resulting print

This image is slightly overexposed, which has led to clipped highlights. The histogram reveals these in the form of a tall spike spilling out of the range at the far right-hand end—too much of the image, in other words, is white.

In this alternative shot, the histogram shows both highlights and shadows within the range of the histogram, so there are no areas in the image in which detail has been clipped.

Dynamic range and exposure

Dynamic range in practice

anufacturers are reluctant to release dynamic range figures, partly because the results are not usually flattering, and partly because comparisons are difficult. Most photographers prefer to think in terms of *f*-stops, but for dynamic range, this is a little crude, and depends on how you judge the effective range. One way to appreciate this is to make your own dynamic range test, as shown here. Typically, there are just-measurable but visually insignificant differences at the shadow end of the scale.

When shooting, pay particular attention to the histogram display and to any available warning displays for clipped highlights. As long as the histogram fits comfortably within its left-to-right scale, you will have an average-to-low contrast image that can always be tweaked later. The danger lies in a histogram that spills over left or right, or both.

Clipping by channel

Clipping warnings may come into effect when just one or two channels have become saturated, and this is not a disaster. Thanks to interpolation, even blown highlights in a fully saturated photosite can be given a value of some use by the on-board processor. This is because each photosite measures one of three colors, and interpolation is used to assign full-color values to it. Some digital SLRs display individual channel histograms, with white (the sum of all three) superimposed. The danger is when all three channels are clipped. Here, red and green are saturated, but white is still within the frame.

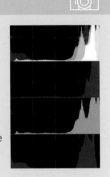

Camera warnings

Two valuable in-camera displays of overexposed areas are the histogram and a highlight indicator. When the right-hand (bright values) edge of the histogram appears like this, at least some of the tones are solid white. A more insistent warning available on some cameras displays the highlights with a flashing border. However, you should always check these in-camera clipping warnings against the values that appear when you have opened the image in Photoshop. Typically, camera manufacturers err on the side of caution, and the clipped highlights displayed in the camera's LCD are likely to be at a value less than 255. In other words, even with some parts of the image apparently clipped, there may actually be sufficient information to recover and edit (*see pages 134-139*).

An on-camera histogram display can reveal clipped highlights.

Alternatively, there might be a flashing warning like this.

Checking the dynamic range

Photograph a gray card or any neutral blank surface at a range of exposures, under consistent lighting. First establish the mid-point by shooting at an average setting, either manually or automatically. Then take subsequent frames at equal intervals darker and lighter, in at least six steps in each direction, under- and overexposed. For greater accuracy, make these steps at one-half or one-third *f*-stop intervals, although for simplicity, the example here is at one-stop intervals. In Photoshop, assemble the images in order, and label each of the steps as shown. Use the cursor and info display to measure the values. Find and mark the step on the left-hand side that measures 5 (anything less is effectively black). Find and mark the step on the right-hand side that measures 250 (anything higher is white). These two extremes define the dynamic range. In this example, a Nikon D100 captures nine distinct steps— that is, a range of 8 stops or 256:1. The test, however, reveals some other important characteristics. One is that the mid-point of this range is not the average exposure, but instead almost one stop underexposed. Not only this, but the increases in exposure reach saturation (255) more quickly than the decreases reach pure black. This confirms what we already expect in terms of a sensor's linear response. Note, though, that the response at the shadowy, underexposed end of the scale, is not exactly linear, but tails off more gently, as does that of film. All of this suggests that for this particular camera, it will be safer to underexpose in contrasty conditions while shooting in Raw format (*see pages 52-53.*)

These are slightly dangerous comparisons to make, not least because the brightness range of a real-life scene is not quite the same thing as the response of sensor and film. Film, as we've already seen, has a soft shoulder and toe to its characteristic curve, meaning that there is not the same sharp cut-off point for recording details in shadows and highlights as with a digital sensor.

Scene/device/medium	ratio	exponent	f-stops	density
Typical high-contrast sunlit scene	2,500:1	2^{11}	11+	not applicable
Typical sunlight-to-shadow range for a gray card	8:1	2^3	3	not applicable
Human eye normal full working range	30,000:1	2^{15}	15	not applicable
Human eye range when fixed on one part of scene	100:1	2^6-2^7	6+	not applicable
B/W negative film	2,048:1	2^{11}	11+	3.4D
Color transparency film	64:1 - 128:1	2^6-2^8	6-8	3.2D-3.6D
Kodachrome transparency film	64:1	2^6	6	3.7D
Color negative film	128:1	2^8+	8+	2.8D
Typical DSLR at base sensitivity	512:1	2^9	9	2.7D
Typical DSLR at high sensitivity (ISO 1000)	128:1	2^7	7	2.1D
Typical digital compact at base sensitivity	256:1	2^8	8	2.4D
Typical CRT monitor	200:1			
Active matrix monitor	350:1	2^8+	8+	
Glossy paper	128:1 - 256:1	2^7-2^8	7 - 8	2.1 - 2.4D
Matte paper	32:1	2^5	5	1.5D

Note:
1. Range in stops is the number of intervals; thus, if 9 stops are captured, the range is 8.
2. Dynamic range reduces at higher sensitivity (ISO) settings, as it does with faster films.
3. Density is used principally for film and film scanners, and is included here for comparison. The optical density of film is the difference between the densest part (D-Max) and the most transparent part (D-Min). The formula is log10: thus a density of 2 = 102 or 100:1.
4. The density of film tends to be greater than the usable, recordable dynamic range, particularly with Kodachrome.
5. Dynamic range for monitor displays is normally expressed as contrast ratio.

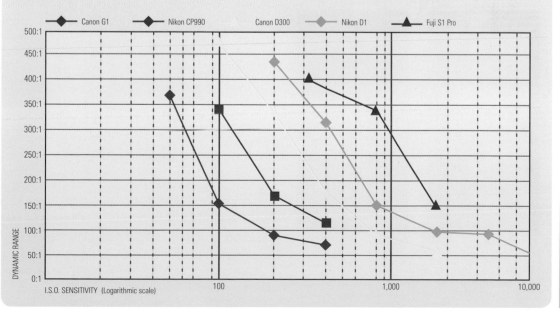

Dynamic range in practice

Dealing with contrast

As we'll see later when we deal with optimization (*page 128*), the ideal exposure for most images is when the values fill the range from dark to light—in other words, a fully expanded histogram. Low contrast presents no difficulties at all, other than perhaps judgment, as it is a simple matter to drag the white and black points out to the edges. High-contrast images, on the other hand, are always in danger of being clipped, and image-editing tools need some image data to work with. This means getting the exposure right—not necessarily the same thing as getting it averaged.

High-contrast scenes always need special care, even more so than with transparency film. As we saw on the previous pages, the response of a sensor to light is linear. Crudely put, it fills up to absolute

Multiple exposures

The quintessential digital solution to extending the dynamic range of the camera is shooting at least two perfectly registered frames, one exposed for the highlights, the other for the shadows. These can then be blended by several means so that nothing is clipped at either end of the scale. Needless to say, this technique works only with static subjects. For convenience, use the camera's bracket setting. This captures a number of frames at different exposures in one burst. (*See Compositing, pages 202-203.*)

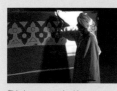

This is a composited image, created by mixing the exposures.

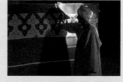

This shot was taken using camera bracketing. This image is the top bracket (longer exposure).

This is the camera's middle bracket (the exposure is 1.4 stops beneath the first).

This is the camera's lower bracket (the exposure is 2 stops beneath the first).

Local contrast vs overall contrast

The importance of dynamic range and contrast depends on the form of the image. The tonal range of the entire image may be different from the range within a small part that you consider important. In the case of the modern office interior here, there are two different interpretations. On the one hand, you might want to retain shadow detail in the large outer part of the image, in which case you would consider the overall contrast. On the other hand, you could legitimately ignore the dark surround exposed just for the brightly lit,-glass box-like corridor in the center. The tonal range within is one stop less than the entire image.

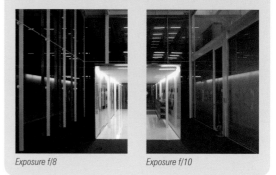

Exposure f/8 *Exposure f/10*

white more readily than does film, and this means being constantly on guard against clipped highlights. In digital imaging, these are usually more critical than clipped shadows, for two reasons: one is that even a very little light generates some response at the darker end of the range, the other is that perceptually most of what catches our attention is in the brighter areas.

Reducing contrast

If you are shooting TIFF or JPEG, contrast and exposure are the only in-camera controls that will help. Lowering the contrast setting is sensible. It is safer to underexpose the bulk of the image to preserve highlights, and then lighten the shadow areas during image-editing. As always, for maximum control over colors and the least loss to the image, shoot in as high a bit-depth as the camera allows. Bracket exposures if you have time, both for safety and in order to be able to combine exposures. Adding fill-in lighting, even if this is just from the camera's built-in flash, will also reduce contrast by raising the values of the shadows.

Knowing in advance that you can optimize the image later on the computer, one of the safest

Average exposure versus fuller range

The image below appears at first glance to be better exposed than the one below right, because the histogram shows the midtones to be fairly central. However, some of the highlights are clipped, and these are unrecoverable in image-editing. The lower exposure below right (one *f*-stop less) gives an image that looks darker, but note that nothing has been lost in the shadows and the highlights are also preserved. Optimized in Photoshop Camera Raw, it has a fuller dynamic range, evidenced by the lower peaks and higher troughs in the histogram.

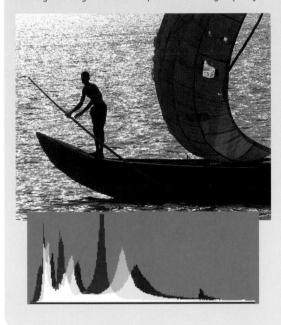

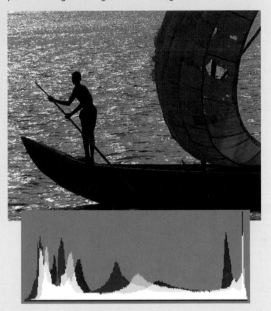

precautions is to avoid clipped highlights, even at the expense of an overall darker image. In conditions that you know to be contrasty, pay most attention to the clipped highlight warning on the LCD display. If the situation allows you time, check this first and then switch to the histogram to make sure that nothing has been clipped at the shadow end. If the entire histogram is within the scale, even if the bulk of it is shifted toward the shadows, then you can usually optimize it satisfactorily, particularly if the image is in a high bit-depth.

For more extreme situations, in which no exposure setting will avoid clipping at one end or the other, there is an image-editing solution. It needs a static scene and a locked-down camera—on a tripod, ideally. Shoot two frames at different exposures, one that holds the highlights, and the other that captures all the shadow detail. Neither will be satisfactory in itself, but they can be combined later to extend the dynamic range greatly (*see pages 196–197*).

Shooting in Raw format

The most useful advice is to shoot Raw, which makes the contrast settings irrelevant as they can be revisited later, and also allows higher color bit-depth, which in turn makes it easier to make strong adjustments without seriously damaging the image. Typically, you can expect to be able to adjust the original exposure by up to two stops darker and four stops lighter, while at the same time changing the contrast. However, Raw format will not help completely lost highlights. Once photodiodes have reached saturation, no processing can recover the data that they *would* have recorded with less exposure. The image-editing technique of combining two exposures, one dark and one light, also works to an extent in Raw format with a single exposure. First open the Raw file and alter the settings so that the highlights are maintained, even at the expense of losing shadow detail. Save this version, then open the same Raw image a second time, adjusting the settings to preserve shadow detail. Then combine the two versions. (*See Compositing, pages 202-203.*)

Dealing with contrast

The Zone System revisited

The Zone System, invented by Ansel Adams, is a method for getting the most satisfactory tonal range in a black-and-white print, and importantly combines measurement and judgment—in other words, technology and opinion. Still highly regarded by some traditional photographers as the meticulous craftsman's approach to considered, unhurried photography, it lost most of its purpose when color took over from black-and-white—particularly transparency film, which allows little to be done with it after exposure. Digital photography, however, returns image control to photographers, and the old Zone System has some valuable lessons to teach in the new context. Of course, it is at its most useful in shooting situations that allow time for reconsideration—landscape and architecture, for example, rather than reportage. However, in digital capture, providing that you are shooting in Raw format, you have the time to reconsider the image later and alter the tonal relationships. Provided of course that in shooting you have not blown out the highlights or lost the shadows, as these are irrecoverable (*see pages 48-49*).

Matching your mental picture

In the system, all the tonal values in a scene are assigned to a simple scale of ten, from solid black to pure white, each one *f*-stop apart. The key to the process is to identify and place the important tones into the appropriate zones, and this demands what Adams called "pre-visualization." This is forward planning by another name, and means the process of thinking ahead to how you want the final image to appear—on-screen and/or in print. The great value of the Zone System, still applicable today, is that it

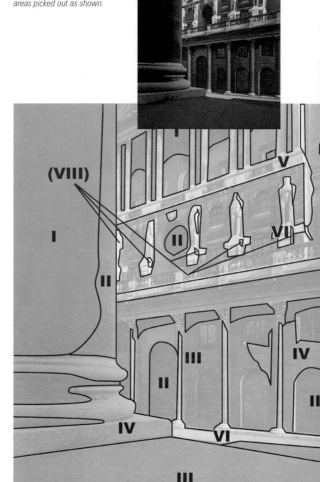

The photograph (right) of the Bank of England is a good example for examination under the Zone System, with the areas picked out as shown.

Making a zone ruler

The ruler shown is made in much the same way as the dynamic range test (*see page 50*), with the addition of texture. Instead of photographing a blank surface, shoot one with texture, such as cloth, unpolished wood, or smooth stone. Alternatively, choose areas from existing images in your stock library that conform to the descriptions of the zones. Arrange them in a stepped scale and adjust the overall brightness values. There is more information on measuring average values of an area under Exposure measurement (*see pages 46-47*).

classifies and describes the tonal structure of any image in a commonsense way. Different photographers have different ideas about how an image should look tonally, and the Zone System allows for this individuality. As White, Zakia, and Lorenz put it in *The New Zone System Manual*, success depends on: "how well the print matches the mental picture, not how well it matches the original scene."

Because the Zone System classifies tones in terms of how they look and what we expect from them, it is *not* the same as tonal range or dynamic range. Instead, it is a tool for making sure that the image has the tones you want for the parts of it that you consider important. The three most useful values are Zones III, V, and VII. Between them they cover the readable parts of most scenes and images—in other words, the five textured zones.

The most important action in the Zone System is called *placement*. This happens when, having decided on the critical area of the scene, the photographer assigns it to a zone. As the examples on the following pages illustrate, this can mean choosing an area of shadowed detail and placing it in Zone III, or a more interpretive choice. In all cases, it then involves exposing accordingly—or with Raw format, adjusting the exposure later.

How many zones?

Although Ansel Adams' original scale has ten zones, as shown here, some photographers who follow the system use nine or eleven zones. The argument for ten is that it follows the original descriptions, but against this Zone V, mid-tone, is not in the center. The argument for an odd number of zones is that Zone V is central, and for 11 zones in particular the spacing is easy to calculate digitally—an increase of exactly 10% each step from black to white. On the other hand, the response of many camera sensors is longer at the shadow end of the scale, which argues more for the original ten zones with Zone V off-centered.

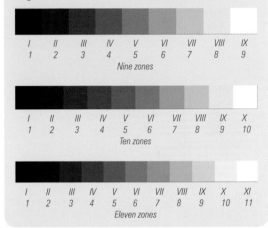

I	II	III	IV	V	VI	VII	VIII	IX
1	2	3	4	5	6	7	8	9

Nine zones

I	II	III	IV	V	VI	VII	VIII	IX	X
1	2	3	4	5	6	7	8	9	10

Ten zones

I	II	III	IV	V	VI	VII	VIII	IX	X	XI
1	2	3	4	5	6	7	8	9	10	11

Eleven zones

The zones

Zone 0	Solid, maximum black. 0,0,0 in RGB. No detail.
Zone I	Almost black, as in deep shadows. No discernible texture.
Zone II	First hint of texture in a shadow. Mysterious, only just visible.
Zone III	TEXTURED SHADOW. A key zone in many scenes and images. Texture and detail are clearly seen, such as the folds and weave of a dark fabric.
Zone IV	Typical shadow value, as in dark foliage, buildings, landscapes, faces.
Zone V	MID-TONE. The pivotal value. Average, mid-gray, an 18% gray card. Dark skin, light foliage.
Zone VI	Average Caucasian skin, concrete in overcast light.
Zone VII	TEXTURED BRIGHTS. Pale skin, light-toned and brightly lit concrete. Yellows, pinks, and other obviously light colors.
Zone VIII	The last hint of texture, bright white.
Zone IX	Solid white, 255,255,255 in RGB. Acceptable for specular highlights only.

| 0 | I | II | III | IV | V | VI | VII | VIII | IX |

The Zone System revisited

The Zone System in practice

The two features of digital capture that make the Zone System practical are easy, accurate measurement and the ability to adjust brightness and contrast after the event. Using it in the run-up to shooting, as was originally intended, is even better, but in real-life situations, this may be an unattainable luxury. To begin with, concentrate on the following three important zones: Zone V (midtones), Zone III (textured shadow), and Zone VII (textured brights). Identify them in the scene and then, if you have the time, measure them with the meter (camera's spot or handheld).

It's important to understand the differences in dynamic range between the camera and the media on which you intend to display the image. Even if a

While shooting

The prerequisites for using the system in real time are that you have sufficient time to experiment, and can measure the zones and tones. This typically restricts it to subjects that move slowly, if at all (landscapes, still-lifes, architecture, interiors, for example), and occasions when you can shoot direct to (or check the results immediately on) a computer.

digital camera has a smaller dynamic range than film, it is still far higher than that of any paper. Basically, from the original scene through digital capture to final print, the range becomes smaller (*see table of Dynamic range compared, page 51*).

Placement in practice

In this dramatic architectural image, the detail in the foreground shadow area was felt to be essential to the overall composition, and so was placed in Zone III. It was also important to retain detail in the well-lit areas in the center of the image, though with a degree of choice: if they were to be only just visible, they could be in Zone

VIII, but to be definite, they would have to be in Zone VII. Settling for Zone VII put the rest of the image into context. There would need to be a five-stop difference between these two areas to give the overall image suitable contrast, so the foreground area was placed in Zone II and the exposure set accordingly for the final result.

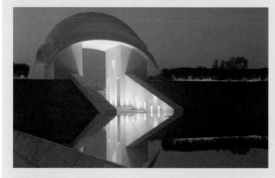

Original exposure

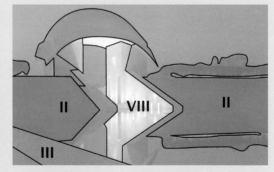

First attempt at a Zone map for the original exposure

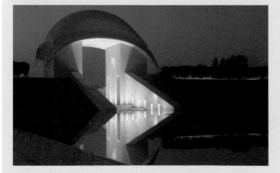

Final exposure a stop below

Final Zone map for exposure a stop below

High-contrast scenes

The Zone System approach to "Overscaled" situations, in which the tonal range is higher than the dynamic range of your sensor, is to identify the important zone and expose for that. Indeed it is a very practical way of thinking through these situations. In practice, there are three possible options:

1 Expose for textured brights (Zone VII), and accept loss of shadow detail.
2 Fxpose for the midtones (Zone V), and split the loss of texture at both ends: shadow and highlight.
3 Expose for textured shadow (Zone III), and let the brighter tones go to featureless white. Visually this is usually the least acceptable option.

...expose for brights *...expose for midtones*

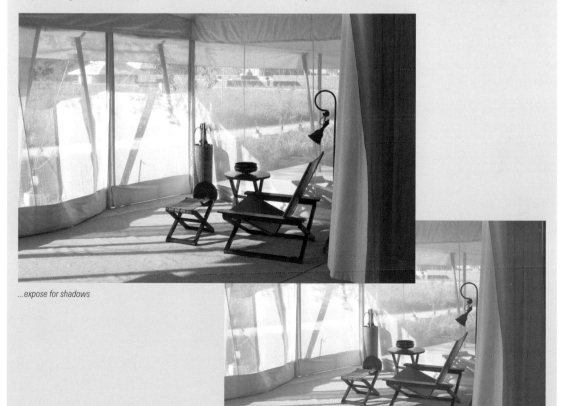

...expose for shadows

<div style="writing-mode: vertical">The Zone System in practice</div>

46-47 Exposure measurement 54-55 The Zone System revisited 144-145 Shadow/highlight adjustment

Basic lighting situations

There are several distinct types of lighting situation into which almost any potential photograph fits. The three main divisions (the three technically most important) are based on contrast, and are Average, Low Contrast, and High Contrast. Of these, the one likely to cause problems is High Contrast, also known as Overscaled. This is particularly so in digital capture, partly because highlights are more easily blown out digitally than with film, and partly because low-contrast images are simple to adjust.

What makes up these lighting situations is a combination of the light (bright sun, spotlight, overcast, and so on) *and* the subject (its color, brightness, shininess) *and* how you identify the subject. This last point is critical. What one photographer identifies as important in the frame may well not be the same as that chosen by someone else. "Subject" doesn't necessarily mean "object," but might instead be a patch of light or an area of shadow. Thus, you might have a scene that measures average for exposure, but the key tones are in the bright areas—say, the texture of some prominent clouds in a landscape.

There are endless sub-divisions possible, but the more there are, the less useful they become. The diagrams here simplify the scheme.

High contrast/Overscaled

Where there is a lot of contrast, it is especially important to identify the subject and key tones, as often something has to give way. Sacrifice detail in the less important areas of your image.

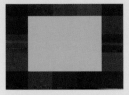
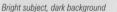
Equal spread of tones

Bright subject, dark background

Edge-lit subject, dark background

Dark subject, light background

Silhouette

Average contrast

Where you're presented with an average level of contrast, it should be no problem to select the correct exposure, bearing in mind all the usual caveats about avoiding blowing highlights as opposed to shadow detail.

Equal spread of tones

Key tones dark

Key tones bright

Key tones average

Low contrast/Underscaled

In situations like this, it is important to decide if contrast should stay low, given how easy it is to increase contrast by setting black and white points.

Average

High key

Low key

Basic lighting situations

46-47 Exposure measurement 90-91 Continuous lighting 140-141 Histograms and levels

Sensitivity and noise

Superficially, noise bears some resemblance to graininess in film, at least to photographers who grew up with the latter. The comparison seems all the stronger because there is also a relationship between sensitivity/film speed and the amount of noise. However, there the similarities end, and not only are the causes different, but so are the treatments. Indeed, the one good thing about noise in digital photographs is that it *can* be dealt with. Not perfectly and not easily, but there are various solutions (*see pages 174-177*).

In order to treat noise, we have to define it, and this turns out not to be as simple as it might seem. Technically, it is artifacts or errors introduced into the image by electrostatic charge, and the scientific approach to it revolves around the signal-to-noise ratio. However, this does not take into account the very important perceptual component. After all, at the pixel level, noise and detail are indistinguishable. In other words, it is largely the eye and mind of the viewer that distinguishes between subject detail (wanted) and noise (unwanted). As a parallel, any retoucher who has worked on scanned film images knows that with some subjects, such as an unswept floor or a rocky landscape, it may be impossible to decide what are dust specks and what is texture.

Noise is detail, but unwanted detail. This immediately creates a problem, because the definition of "unwanted" is completely subjective. This has major implications when it comes to treating a noisy image (see *pages 174-177*), and it also means that there are two distinct stages in digital photography at which noise can be suppressed. One is at capture, the other during image-editing. Noise is heavily dependent on a number of variables, and so can vary from shot to shot according to the camera settings and the conditions. You can expect to encounter noise with long exposures, high sensitivity, high temperatures, and in images with large, smooth shadow areas, but it is difficult and time-consuming to check while shooting. As much as possible is controlled by the camera's processor, and this varies according to the make because it depends on the algorithms used and on the processing techniques chosen by manufacturers. Most camera menus offer the choice of noise reduction.

The origins of noise

Photon noise This is noise caused simply by the way in which light falls on the sensor. Because of the random nature of light photons and sensor electrons, it is inevitable with all digital images. It appears as dark, bright, or colored specks, and is most apparent in plain mid-toned areas, least apparent in highlights.

Readout noise (or amp noise, or bias noise) This is noise caused by the way in which the sensor reacts and the way in which the signal is processed by the camera. Similar to electronic noise in recorded music, this is generated by the processor itself, and the more it is amplified, the more prominent it becomes. Thus, increasing the ISO setting by turning up the amplifier creates more noise. It is to some extent predictable and can be reduced by in-camera processing.

Random noise Caused by unpredictable but inevitable differences in timing and the behavior of electrical components.

Dark noise (also known as fixed-pattern noise and long-exposure noise) Noise caused by imperfections specific to each individual sensor. Increases in proportion to the exposure time and to temperature increase, but is independent of the image, so can be reduced by in-camera processing by means of "dark-frame subtraction." This extra process takes as long again as the original exposure. Cooling also helps.

Reset noise After each shot, the camera resets the sensor to a zero position, ready for the next exposure. Multiple clocks in the processor may cause slight differences in the timing of this, which generates noise.

Dark frame subtraction

Many cameras have a noise reduction option to deal with long exposures. It doubles the processing time, but saves a great deal of work later. This in-camera option tackles the known pattern of noise that occurs with long exposures, by subtracting the predictable behavior of the sensor.

The principle is to make a second exposure at the same long exposure time, but with no image. The pattern of noise will be the same as for the exposed image, and can be subtracted from the noisy image by an appropriate algorithm. You could do this yourself in image editing with a lot of effort, but it is unnecessary if you choose the noise reduction option in the camera's menu—it does the same thing more efficiently.

The appearance of noise

Certain types of noise have a characteristic appearance, as you can see from these enlarged examples.

Luminance noise
Appears as variations in brightness—a basically monochrome, grainy pattern.

Chrominance noise
Variations in hue are prominent.

Luminance noise

Chrominance noise

Hot pixels "Stuck" pixels appear as bright spots—very noticeable and visually disturbing.

JPEG artifacting Blocks of eight pixels are sometimes distinguishable—a result of the compression processing.

JPEG: artifact shows as lines

Original: no artifact

These two images, of the Meroitic pyramid in Sudan, are examples of digital noise and even more extreme digital noise. The noise is caused by one photosite in the sensor picking up significantly more light than its neighbors. Since digital sensor chips are typically arranged in a Color Filter Array (see page 30), the "rogue" pixels also tend toward a single color; red, green, or blue.

Sensitivity and noise

30-33 The sensor 44-45 Compression and image quality 174-177 Noise repair 222-223 Grain

White balance

The color of light varies, and the two most important ways in which this affects photography are color temperature (between reddish and bluish) and the discontinuous spectra found in fluorescent and vapor discharge lamps. To the human eye, white is normal, and any deviation from this appears tinted—not necessarily wrong, but not balanced. Unless you specifically want a color cast for a particular reason (the warm glow of a setting sun on sandstone rocks, for instance), it's normal to strive for lighting that appears white—that is, neutral.

With film cameras, the solution was to use an appropriately balanced film (that is, either daylight or tungsten) and filters. Digital cameras sidestep this by processing the color information according to your choice. With a DSLR you can do this manually, or choose from a number of standard settings, or let the camera find the balance automatically. The manual method, also known as Pre-set, involves aiming the camera at a known neutral surface, such as a piece of white paper or a standard gray card (*see page 67*). The camera's processor then stores this information and applies it to subsequent images, making it the most accurate method when you are shooting for a period of time in a situation with unchanging light. The simpler alternatives are either to choose from one of the standard settings in the white balance menu (*see below*), or to select Auto and let the camera work it out.

Automatic white balance requires the camera's processor to analyze the scene, identify highlights, and adjust the overall balance, and for most situations

White balance bracketing

Some DSLRs offer a bracketing option that works in a way similar to exposure bracketing—a burst of several consecutive frames in which the white balance is altered incrementally. In this example, from a Nikon D2H, the increment in a five-frame bracket is 20 mireds. Mireds (Micro Reciprocal Degrees) are a standard measure of color temperature.

In this shot, a custom white balance was set, with a light temperature of 3,200 degrees Kelvin.

In this variant, the automatic white balance mode was used.

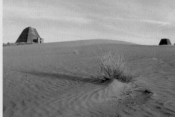

This shot is taken with the white balance set to "sunlight" mode.

Standard settings

Most DSLRs offer a similar range of choices to cover the usual range of lighting conditions, as in the examples here.

The actual descriptions vary from make to make. The precise values can also be adjusted.

| *Auto* | *Sunlight* | *Cloud* | *Shade* | *Incandescent* | *Fluorescent* | *Flash* |

Manual pre-set procedure

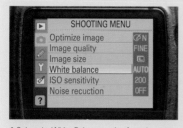

1 Select the White Balance *option from the* Shooting *menu.*

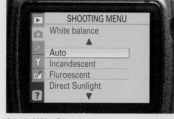

2 In the White Balance *menu, ignore the* Auto *option and scroll down to the* Pre-set *option.*

This varies in practical details according to the make of camera, but what all have in common is the measurement of a reliably neutral target. White paper or card will do, but for greater accuracy consider carrying a standard gray card. This is a typical sequence of steps.

3 Photograph a neutral target large enough or close enough to fill the target area, in this case, an expanse of white wall.

4 Wait for confirmation that this was successful, or repeat if overexposed, underexposed, or out of compensation range (warning message in display). Confirm the setting by selecting OK.

5 Choose Pre-set *from the* White Balance *menu to use this setting.*

is a good choice. Some high-end DSLRs supplement the sensor analysis with built-in, separately operated through the lens (TTL) color meters and with incident light meters mounted on the camera.

Discontinuous spectra (lighting)

Fluorescent and vapor discharge lighting, common in most interiors other than homes, work by passing an electric discharge through a sealed tube containing a vapor. In all but a few specially corrected lamps, the glow that results may look white, but photographs differently, typically greenish or bluish. This has nothing to do with color temperature, but it can be corrected by the camera in the same way, by selecting the appropriate setting from the *White Balance* menu.

Color temperature

The principle of color temperature is that when a material is heated, it first glows red, then yellow, increasing to white at higher temperatures (hence "white-hot") and then blue. This applies to any burning light source, including the sun and tungsten lamps, and it gives a way of calculating the color of light by its temperature (measured in Kelvins, which are similar to Celsius/ centigrade but start at absolute zero). For photography, the normal limits between reddish and bluish are from about 2,000K (flames) to 10,000K (deep blue sky). The mired shift values are a standard measure of the numerical differences between temperatures. You will need to refer to these when using certain image-editing software, such as Photoshop's Camera Raw plug-in (*see pages 134-139*).

White balance

In-camera color management

Maintaining color accuracy—in other words, color management—is an issue for digital capture way beyond its importance for film. In a way this is a little strange, because film photography was just as affected by color temperature and other color differences in lighting. With digital photography, however, it *can* be managed, and so *must* be. There are two sides to color management. One is linking the different ways in which the several devices in the workflow reproduce color, from camera to monitor to printer. The other is staying faithful to the colors of the *subject*.

First, color-managing the devices. This involves all of the equipment, not just the camera, and is dealt with fully later (*see Color management, pages 106-107*). Ultimately, it depends on a description of how a device reads and renders colors. These descriptions, which can be read by other machines, conform to the standards of the International Color Consortium (ICC), and are known as profiles. Every piece of equipment in the workflow should have one, including the camera.

Basically, the ICC profile rules, but fine-tuning it is the key to absolute accuracy. Normally, a generic profile of the camera is automatically embedded in the image file, and major software applications like Photoshop can read it (with the help of additional updates).

Choosing the color space

Somewhere in the camera's menu is the option to select the color space, which may be called something else, such as color mode. A typical choice is between Adobe RGB and sRGB. The differences between these are explained on page 168, but for all serious use, select Adobe RGB. This has a wider gamut, which means that the camera will capture more colors from the scene.

You can adjust the hue from a menu on your camera in much the same way that you can adjust the image later using your image-editing application's Hue/Saturation tool.

Second chance with Raw

Shoot in Raw format and the precise white balance and hue settings do not matter. This is because the Raw format bypasses the processing that normally applies these effects in the camera. All the data is kept separate in Raw format, including the settings, which can be adjusted without penalty later in image-editing.

But device performance is not always consistent, and it can drift with time. Keeping the profile up-to-date is the answer. In principle, for a camera this means checking how it copes with a standard color target and altering the ICC profile accordingly. In practice, this involves profile-building software that can compare an image with stored information. You shoot a target such as the GretagMacbeth ColorChecker under known lighting conditions, and the software does the rest. See the following pages for setting up this procedure.

Test shot with a standard target

Calibration is also affected by the subjects and scenes that you photograph—they may differ wildly in the way they are lit, and this is the second aspect of color management. The eye accommodates so well to different color casts that it may not be a great help. Under skylight from a clear blue sky, it reads what you think should be white as white, even though it actually is a definite blue. With film, even though a slide might have had a color cast, at least the image was locked into the physical transparency, and could be identified. With digital, only the photographer is in a position to say what the colors should be, and if *you* can't remember, then no one else is in a position to say. Setting the white balance to one of the pre-sets, such as *Cloudy* or *Shade*, gets you close, as does a visual check of the LCD screen after shooting, but the only way to *guarantee* the colors is to make a test shot with a standard target—any of the same targets needed for the device calibration above. If you do this just once for any given lighting situation, you have the means to adjust the colors accurately later in image-editing (*see page 68*). Depending on the camera, there may also be a separate hue adjustment control, allowing you to shift hues around the spectrum in a way similar to the *Hue* slider in Photoshop (*see pages 186-187*). Typically, the adjustments are measured in degrees.

In-camera color management

38-39 The processor 66-67 Standard targets 104-105 Color 106-107 Color management

Standard targets

To maintain consistent color, it's essential to have some kind of standard, repeatable reference subject. You could create your own, but there is little point given the existence of the targets shown here. All are well-known and well-used in the imaging industry, but for normal photography, the two most valuable are the Kodak Gray Card and the GretagMacbeth ColorChecker. Their colors are known quantities, and so they can be used to judge and correct your captured colors. At the very least you can use them for visual reference, but the ColorChecker has the more valuable function of helping to create ICC camera profiles (*see pages 68-69*). Under highly controlled conditions, principally a fixed studio lighting set-up, some lighting manufacturers recommend using an IT 8.7/2 target —normally used for scanning (*see page 68*).

GretagMacbeth ColorChecker

A 24-patch mosaic of very accurately printed colors, including neutrals. Based on the Munsell System (the source of the hue, saturation, brightness model), this is the color chart of choice for photography, not only because it is a known industry standard, but also because it contains "real-life" colors such as flesh tones and the complex greens of vegetation. It is expensive, however. Importantly, the colors reflect light the same way in all parts of the visible spectrum, meaning that they are consistent whatever the lighting. They are

printed matte to avoid reflections that would upset the readings. The top row contains memory colors that include skin tones, blue sky, and foliage, the second row medium-saturated colors, the third row the three primaries and secondaries, and the bottom row a gray scale from "white" to "black." Note, however, that the dynamic range of matte printed colors is much less than any of the other color displays you are likely to come across, and the "black" is really a dark gray. For more on this, see page 48. To preserve the color accuracy, avoid fingerprints, high temperatures and high humidity, expose it to light only when using it, and replace it about every four years in any case.

Color data

The first of these color descriptions is the manufacturer's (GretagMacbeth), the second, in parentheses, the ISCC/NBS name (Inter-Society Color Council and the National Bureau of Standards). The published values are in x,y,Y chromaticity, and luminosity according to CIE (1931), and in Munsell hue, value, and chroma. RGB values are also given, but these are of suspect usefulness—the black square is actually far from the 0,0,0 given.

GretagMacbeth ColorChecker DC

This is the newer, more sophisticated version of the basic 24-patch ColorChecker, designed specifically for

The classic GretagMacbeth ColorChecker has applications in graphic design, television, and publishing as well as photography. Its 24 colored inks are prepared accurately in the lab.

GretagMacbeth™ ColorChecker Color Rendition Chart

The ColorChecker DC features 177 colors across 237 squares. It is 8.5 x 14in (22 x 35cm) and is specifically designed to meet the needs of digital photography. It can be used with profiling software to create an ICC camera profile. The large white square in the center is designed to assist digital photographers in setting their white balance.

Gray card

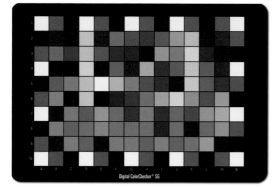

Like the ColorChecker DC, the Digital ColorChecker Semi Gloss is designed for real-life situations. Its 140 patches, in addition to Gretagmacbeth's standard colors, include colors designed to reflect skin, foliage, and blue sky.

digital cameras, and extremely expensive. It could be considered overkill for most photography, and while it covers a wider range of colors, demands more precision in setting up for profiling. The central white patch is larger than the others to facilitate white-balance pre-sets. A strip of glossy primaries and secondaries is controversial—they are intended to increase the range of "knowable" colors but demand an absolute avoidance of any reflections. Some camera profiling software, such as inCamera, has an option to automatically ignore these patches.

Kodak Color Control Patches and Gray Scale
Less useful than the ColorChecker for photography, but better than nothing, this set of two small strips has traditionally been used as a color reference by repro houses and printers. The strips are conveniently sized for placing next to still-life subjects and paintings, and are an approximate guide for printing. The Gray Scale has 20 steps in 0.10 density increments between a nominal "white" of 0.0 density and a practical printing "black" of 1.90 density. The letters A, M, and B represent reflection densities of 0.0, 0.70, and 1.60 respectively. The Color Control Patches are based on web offset printing inks similar to AAAA/MPA standard color references, and include the three primaries, three secondaries, plus brown, white, and black.

Gray Card
The 18% reflectance Gray Card has long been a reference tool in black-and-white photography, being a standard mid-tone. In a digital image, it should measure 50% brightness and R 128, G 128, B128. The reason for 18% as a mid-tone is the non-linear response of the human eye to brightness. It is matte to avoid reflections, and has a reflection density of 0.70, which it maintains across the visible spectrum.

Standard targets

Camera profiling

As explained in a later section, ICC profiles are the basis for color management, and the three most important profiles in a typical workflow are those for the camera, the monitor, and the printer (*see page 168*). The profile is a small text file, readable by the computer, that describes the exact way in which any of these devices displays colors. As everything begins with the digital capture, the camera profile occupies the first place in the chain of events.

Digital SLRs normally have default profiles, also known as "canned" profiles, built in to their systems and attached to the image files they create. Photoshop, for instance, will read the attached profile automati-

cally. So far so good, but the canned profile may only be an approximation for an individual camera working in specific lighting conditions. If, like most photographers, you begin by relying on this default profiling— in other words, doing nothing—you may come to recognize certain peculiarities. With the Nikon D100 used for these sample images, for example, one of its traits is a pink cast to light tones in sunlight. This kind of trait is correctable, of course, in image-editing, but a better solution is to create an exact profile for the camera when shooting in these conditions. The profile, in effect, compensates for the camera's color misbehavior.

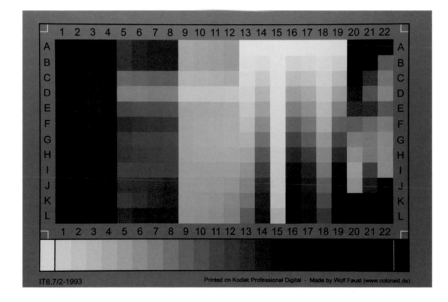

Left *The IT8 target is a standard pattern, with 19 columns of 13 colors, with three additional columns (20-22) which are "vendor independent," in that different manufacturers can place their own colors there. It also features a 24 shade grayscale.*

Bottom left *Shooting the IT8 target to take color readings.*

Below *The GretagMacbeth ColorChecker shot on location.*

The IT8 target shot in studio conditions, once the lighting has been adjusted for the subject.

The GretagMacbeth ColorChecker in use on location.

Two important words of warning, however. One is that camera profiles must be specific to be of any use —specific to one camera and to the kind of lighting. The other is that total accuracy is rarely necessary, and unless you have an exact need, such as in the copying of paintings or the reproduction of a commercial product's brand colors, you may well be wasting your time in fretting over minute differences in color values.

Camera profiles are at their most useful when a photographer works regularly in a repeatable kind of lighting. A studio with photographic lights is the most obvious example. Personally, I do quite a lot of location shooting in low sunlight, and so find it useful to have a profile just for this. The exception is a special lighting condition for an important shot, for which it may be worth making a one-off profile (*see page 71*).

Target care

These are expensive and delicate items. Take the following precautions:

- Handle them carefully to avoid kinks and scratches.
- Remove any protection sleeve before use.
- Return the target to its protective wrapping immediately after use.
- Keep out of strong light, particularly sunlight, because of its high UV content.
- Store in a cool, dry, and dark place, preferably below 70° F (21° C) and below 50% RH. Avoid sudden temperature changes that might cause condensation.
- Clean with a dry, lint-free cloth to clean the surface, and do not use alcohol or any other cleaning fluid.
- The colors of the target will change with time. Ideally, replace the target every couple of years.

Capture the target

1 Place the target so that it is evenly lit and in the illumination that you expect to use. If the light source is concentrated, such as the sun or a flash, make sure that the target is angled to the light to avoid reflections.
2 Make sure that all the camera settings are at average or neutral—for instance, no hue adjustments. Select either the appropriate white balance choice or, better still, create a pre-set white balance by referencing either a white or gray patch (or a larger Gray Card).
3 If you can adjust the capture through the camera exposure control or lighting, aim for a gray scale range that is full but not total. Remember that the "black" on a ColorChecker is by no means zero, but a dark gray instead. InCamera profiling software recommends the following values. Note in particular how much lighter at 52 the black is than "pure" 0 black. You can fine-tune this exposure later in image-editing.
4 An added sophistication recommended by inCamera is to construct and include a light trap—a black box with a small aperture. This will be close to total black. This is probably overkill.
5 Set up the camera perpendicular to the target to avoid perspective distortion.

A light trap is a box, painted entirely with light-absorbing black on the inside and with a small hole cut in it. The black seen through the hole will have no reflections, and be close to total black.

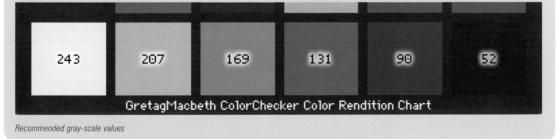

Recommended gray-scale values

Creating the profile

Having captured the target, you will then need to create a profile from it. Although this is a software procedure on the computer, we'll deal with it here in Section I. For this you will need camera-profiling software. Each follows its own procedure, but the example here is the inCamera plug-in for Photoshop. You will need to shoot and create profiles for each major type of lighting that you expect to use—and for each camera.

1 Ensure that no color profiles are attached to the image by checking all the possible opening warnings in the Color Management Policies *section of the* Color Settings *dialog.*

2 Open the image. If the warning dialog reads "Embedded Profile Mismatch," choose "Discard the embedded profile (don't color manage)." If the warning dialog reads "Missing Profile," choose "Leave as is (don't color manage)."

3 Check that the gray scale values are as recommended (see pages 68-69). Adjust Levels *and/or* Curves *to bring them into line. If there is a strong color bias, then the RGB values will be quite different, in which case convert to Lab and aim for the following: White point RGB 243 = Lightness 96, Black Point 52 = Lightness 20.*

4 Launch the profile-building software, in this case a plug-in under the Filter menu: Filter > Pictographics > InCamera.

5 Choose the appropriate target, and its reference file.

6 Align the grid by dragging the corners. This also compensates in case you shot the target at an angle.

Profile naming and renaming

In addition to the name, there is also a Profile Description Tag (a description found inside the profile file) used by some applications to display it as a choice. If you decide to rename a profile, these applications will not recognize the change unless you use a utility to alter the Tag as well. Apple's ProfileRenamer does this.

If you overwrite an existing profile (which you might want to do if, for instance, you made a mistake the first time), Photoshop may need to be restarted before it recognizes the change.

7 *Give the profile a name that you can later identify, e.g. "studioflash_raw.icc." Note that the standard suffixes are .icc and .icm. The software may append these automatically.*

8 *Save the profile in the appropriate folder. This varies according to platform (Windows or Mac), operating system, and Photoshop version. The software will usually suggest the default location.*

Profiles and Raw editing

In principle, do NOT use both Raw editing tools and a custom camera profile. When Photoshop CS opens a Raw file, it does so without asking for profile assignment, and then offers an impressive choice of color adjustment tools. If you make use of these, and then, once the image is open, assign a profile, you can expect strange results. Consistency is the key. To begin with, create the Raw profile by making no adjustments at all—just the default settings—and then do the same when opening all subsequent images. If you vary this by tweaking images in the Raw editor before applying the profile, remember that you are adding an extra level of judgment to a standard procedure. Try to limit the Raw editing to making sure that neither highlights or shadows are clipped. The alternative is to abandon the profiling and work solely in the Raw editor (*see pages 136-139*), and for most photography, outside controlled conditions, this usually works best. (It's what I normally do.)

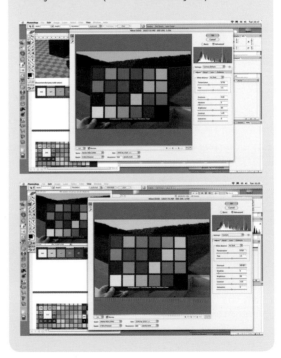

One-off profiles

If the lighting conditions for a single shot are unusual, consider making a profile for that shot alone. Simply shoot the target as part of the take and make the profile as described here—but use it only for that shot.

Creating the profile

Memory cards

Memory cards have been undergoing sustained development and improvement for a number of years, with capacities, reliability, and transfer speeds all increasing constantly. The two major formats are CompactFlash and Secure Digital (SD), with Sony's proprietary Memory Stick a minor third for its own cameras.

Cost is a consideration, as the high-capacity cards are certainly expensive, and the cost per megabyte is much more than it is for desktop or laptop computer memory. In other words, memory cards are for shooting, NOT long-term storage. Calculate your memory card needs by estimating your typical rate of shooting and the file format. With a large megapixel sensor, there is a major difference between JPEG and TIFF, for instance.

Memory cards of whatever capacity are only temporary storage, and you will need to transfer the images from them at regular intervals. How often depends on the capacity of each card, which varies enormously, from 128MB to 16GB. For example, a 128 MB memory card will take about 50 JPEG images shot at normal compression on a 10-megapixel camera, but only about 15 in Raw format compressed. A 16 GB card can store more than 120 times this amount. Considered as digital storage, memory cards are, relatively, much more expensive than computer hard drives and image

There are numerous products on the market for protecting your memory cards—invest in at least one. Losing a film can be a tragedy, losing a memory card containing a set of digital images is a loss of both the images themselves and of the means to record more. If nothing else, you're protecting an expensive investment.

SD and SDHC

The SLR market is less driven by miniaturization than that for compact cameras and mobile phones, but the size of that marketplace has a broader impact. The most successful of the consumer formats is Secure Digital, which has recently been updated to support up to 8GB (SD 2.0 or SDHC), though older cameras and card readers are limited to 2GB and, much like sofware versions on computers, will not recognize the new cards. These cards are increasingly widely supported by DSLR manufacturers, as well as device manufacturers (so, for example, many computers and even DVD players can read them).

CompactFlash

This format of memory card, currently the most widely used, was launched by SanDisk Corporation in 1994. Using flash memory technology, CompactFlash (CF) cards give non-volatile storage

and can retain data without battery power, and do this in a much smaller size than normal flash cards, with 50-pin connections. They measure 43 × 36mm and come in two types with different thicknesses—Type I (CF-I) is 3.3mm, Type II (CF-II) 5mm. DSLRs will accept both. Typical capacities are 256MB, 512MB, 1GB, 2GB, 4MB, 8GB, and 16GB–a vast improvement considering that maximum capacity in 2001 was 512MB. CF cards are sturdy, have a long usage life (around 100 years) and operating temperatures from -13°F to +185°F (-25°C to +85°C). They are PCMCIA-compatible, so easy to read from laptop PC card slots.

Memory Stick

Also launched in 1999 was Sony's Memory Stick, designed for the company's own digital cameras and camcorders. It uses a kind of flash memory and was shaped a bit like a stick of chewing gum, with a 10-pin connector, though newer variants—the most common of which is the PRO Duo—are shorter and smaller.

Other memory cards

Other manufacturers have also developed systems with varying degrees of commercial acceptance, including the XD card. These 20×25×1.8mm cards are found in Fujifilm digital cameras and Olympus's three-quarter sized DSLRs. SmartMedia cards were developed by Toshiba. Measuring 45×37mm but only 0.78mm thick, they use a 22-pin connection but are PCMCIA-compatible. They are less robust than CF, with the contacts exposed, and capacities maxed out at 128MB, so the format is now outdated.

XD Card

SmartMedia

Calculating memory card needs

In principle, you need sufficient memory card capacity to continue shooting until the images can be downloaded to a computer hard drive or portable storage device. This depends on the following:

1 Image file size, taking into account whether you are using compression or not.

2 Rate of shooting and number of shots likely in a session.

3 Whether or not you or an assistant can begin downloading while you are still shooting.

4 Whether you are prepared to delete images from cards *before* you have made a backup (*see page 124*).

5 Cost: memory cards and microdrives are more expensive per MB than a computer hard drive.

Although the camera can itself be connected directly to a computer to download images, it is usually more convenient to use a card reader. Downloading speed depends on the bus, with USB 2 and Firewire the fastest.

Also consider write and read speeds when choosing memory cards. These are partly influenced by the camera processor and the format in which you choose to shoot (compression adds time), but partly also by the make of card—the best incorporate write acceleration. A good speed currently is in the region of 10MB/second. High-end manufacturers such as Lexar produce a "professional" range that is designed to tighten quality controls—in much the same way as pro film used to differ from regular—and has a higher write speed than normal.

banks, but you may be willing to pay for the convenience of being able to continue shooting for long periods without needing to download. A 4GB card, for example, has almost the capacity of a standard DVD. Another consideration, however, is the safety of having so many images without backup in the camera.

Memory cards

Wi-Fi

At the top end of the DSLR market, a wireless transmitter can be attached to the camera for immediate transfer of images from the memory card—as you are shooting. First introduced by Nikon for its D2H, this is an extremely valuable option for any photographer who needs to deliver images quickly but without leaving the shooting location. Sports events are the classic situation.

Wi-Fi, which stands for Wireless Fidelity, is the most widely used standard for wireless networking, and is also known as 802.11n (other common versions are 802.11a/b and 802.11g). It is relatively fast (a bandwidth of 11MB/second, which translates to transmission speeds of 1 to 2MB/second) and has a medium range, which depends on obstructions and on data rate, but is typically up to 100ft (30m) with a standard antenna, and up to 500ft (150m) with large antennae at the camera and base station. This is the standard used for increasingly common small wireless computer networks, such as you might already have at home. If you do, adding a camera to the network is easy.

The basic networking set-up consists of the camera and its transmitter, a Wireless Access Point (WAP), also known as a base station, a router/hub/gateway, and one or more computers. The router distributes the images within the local network (Local Area Network, or LAN) or, through the gateway, to a larger network (Wide Area Network, or WAN). There are many permutations, and setting up the network calls for some experience. The set-up procedure is detailed in the section on Delivery (*see pages 232-233*).

Device addresses

Each component in the network, whether camera, laptop, or hub, has two distinct addresses. One is the IP (Internet Protocol) address, which is assigned by the users, the other is the MAC (Media Access Control) address which is hard-coded into each device, and these are useful for security. Typical IP addresses appear as below, with the first three numbers of the four-number set being the network address and the last number the device address. So, if your network is 192.168.1, you could make the device address of the camera .201, the base station .202, laptop .203, and so on.

Router/hub/gateway	192.168.1.2
Camera	192.168.1.201
WAP/base station	192.168.1.202
Computer 1	192.168.1.203
Computer 2	192.168.1.204

A DHCP (Dynamic Host Controller Protocol) server simplifies addressing by allocating IP addresses automatically within a network.

Basic network

The most basic network of all is camera to WAP/base station to FTP server, by which means you transmit the images to one computer. More advanced is a network which also allows access, via the router/hub/gateway, to the Internet and to several computers. The camera and photographer's laptop can access all of this via the WAP/base station.

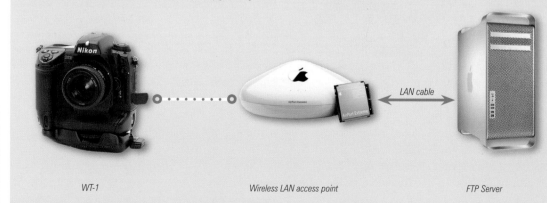

WT-1 Wireless LAN access point LAN cable FTP Server

A typical network

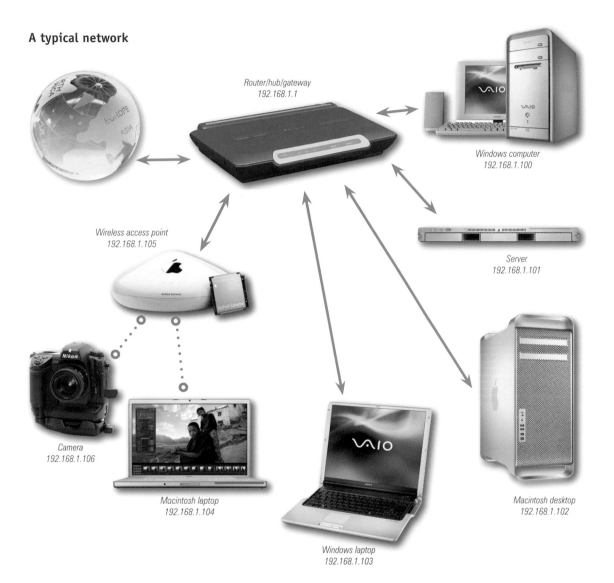

Router/hub/gateway
192.168.1.1

Windows computer
192.168.1.100

Wireless access point
192.168.1.105

Server
192.168.1.101

Camera
192.168.1.106

Macintosh laptop
192.168.1.104

Windows laptop
192.168.1.103

Macintosh desktop
192.168.1.102

Remote editing systems

A system with obvious appeal for news and sports photographers is the Idruna Remote Editing System, which uses a PDA or similar device to be attached to the camera's USB connector. On it images can be swiftly previewed and then sent almost directly to the editor's desk via a Wi-Fi Hotspot, 3G phone system or RBGAN wireless service. The only intervening hardware is the IRES Server, which receives the images and automatically prepares a web page on the fly, so the editor can preview the images using standard software.

Wi-Fi

In-camera editing

The immediate feedback that the LCD display gives is not just a useful accessory—it radically alters the way we shoot. Or rather the way we *can* shoot, because the opportunities it offers for an on-the-spot adjustment to the photography call for a willingness to think in an editorial manner at the same time as shooting. Traditionally, shooting and editing were separate activities, divided by the time it took to process the images. You took the pictures and later reviewed them on a light box or contact sheet, or possibly with a slide projector. The DSLR's playback menu gives you this option right away, for better or worse. The better is that it gives you the certainty of confirming the image and the chance to reshoot and improve if the first frame is not exactly as you would like it to be. The worse is that it can interfere with the flow of shooting and even cause you to miss shots by distraction, and also that it can push you into deleting images before giving them full attention.

The usefulness of in-camera editing depends on the kind of photography and on exactly what image quality you are assessing. In studio and still-life photography—in fact, any situation in which there is no urgency and in which you can repeat a shot— reviewing and deleting until the image is

A typical in-camera editing procedure. Out of a sequence of 10 frames, three were deleted after review: the first when it was decided to include a barman in the background, the other two because of inappropriate expressions. Shooting continued until the 10th frame, which was immediately felt to be the best in terms of expression and movement.

Editing options

Check exposure accuracy

Multiple-frame option
Useful for sequences.

Zoom Check for sharpness and motion blur, and details such as facial expression.

Protection Locking key for safety.

Delete The most dangerous action without an on-screen computer review.

Digital capture

Embedding data

Date and time Always useful in identifying the subject. When traveling, make sure to allow for time zones.

Comments Some DSLRs include the facility to add a short text comment that will later be displayed in the browser.

The comment facility in this Nikon menu is accessed via the Set-up. The comment is added to photos taken afterward, until you ask the camera to stop. It therefore requires regular attention if used.

Since cameras do not feature full keyboards for obvious reasons, text entry is limited to video-game style cursor movement. This takes time, so keep your comments short and helpful.

If you're shooting at a location, you could add its name and grid reference reasonably quickly. This will then apply to all the images you take at that location, and appear in cataloging applications on your computer.

Since you can turn the Attach Comment facility on or off, you can then quickly disable the application of the comment when you move on, or alternatively, enter a new comment if you have the time.

right is a sensible procedure. In unrepeatable situations, however, there is a considerable risk of making a hasty, and wrong, judgment in deletions. The pressure of available space on the memory card is the usual reason for doing this, but it needs to be exercised with caution. More spare memory cards may be a better answer. The camera's LCD screen is a useful guide but is by no means ideal for examining images, and is much less accurate in color, contrast, and resolving detail than a laptop screen or desktop monitor. In particular, checking detail—such as for camera shake or focus

accuracy—involves zooming in, and this takes time that can interfere with shooting.

Data-embedding options enable different kinds of information to be attached to an image file for later use when browsing, building a database, and image editing. Some of this is automatic (e.g. file format, image size, lens and exposure settings), some of it user-adjustable automatic (e.g. date and time), and some manual input (e.g. subject ID and place). So far, no manufacturer offers a built-in GPS for automatic location coordinates, but no doubt this will happen.

In-camera editing

Batteries and power

Not only are digital cameras totally dependent on batteries, they consume power at a high level, considerably more than conventional film cameras. Battery management is important, never more so than when traveling and far from reliable sources. There are a number of issues, but all are to do with ensuring that you have enough power to shoot from day to day.

Depending on the model, digital cameras have either custom batteries or accept AA size. In the case of the former, you have no choice but to buy that manufacturer's design, and the custom charger. The number of spare batteries that you will need depends on how much you intend to shoot and the frequency with which you can recharge. Usually, on location, it should be possible to recharge each

Battery charger

evening. Check the specifications for battery life but do not take the manufacturer's claims at face value; test it for yourself. Some SLRs can accept an additional AA battery pack. Having this along on a trip can be a back-up in case of difficulties in charging the custom batteries.

AA-compatible cameras offer much more choice because of different battery types and manufacturers, though on the whole battery life is likely to be less than custom batteries (usually Li-Ion, *see Battery types box*). High-capacity rechargeable batteries are the ideal, but in an emergency, you can usually find AA alkalines anywhere to keep you going. There is a wide choice of chargers from independent manufacturers. It is important, however, to check the manual for batteries that are NOT recommended. Lithium

Battery types

Alkaline Widely available, not rechargeable, moderate capacity, keeps charge when not used.

Nickel-Cadmium (NiCd) The least expensive type of rechargeable battery, gradually loses charge if not used. Suffers from "memory effect" in that if they are recharged before being fully discharged they "learn" to have a smaller capacity. Smart chargers can solve this problem.

Nickel-Metal Hydride (NiMH) More expensive and higher output than NiCd. Also gradually lose power when not used, but do not suffer from "memory effect."

Lithium (Li) Not rechargeable, light, powerful, long life, expensive.

Lithium-Ion (Li-Ion) Rechargeable, but like Lithium are light and powerful. A popular choice.

Memory effect

NiCd batteries (but not NiMH batteries) are prone to memory problems. "Memory effect," as it is known, is a loss of capacity caused by recharging the battery *before* it has fully discharged. Small gas bubbles reduce the area of the battery cell's plates, and over time, the charge becomes smaller and the battery fails faster. To correct this, the battery needs to be reconditioned.

Recharging strategies

Follow the camera manual, but also bear in mind the following:

● With NiCd and even NiMH, try not to recharge before the battery is fully discharged. With Li-Ion batteries, however, shallow discharge actually increases the cycle life (a cycle is a full charge followed by a full discharge).
● Do not overcharge.
● Smart chargers may be able to do the following: discharge the battery prior to recharging, top-up charging, and switch off once a full charge has been achieved.
● Follow a charging regime that suits the way you work. At minimum, this probably means one spare, with the discharged battery put on charge as soon as possible.

AAs emit heat and may not be suitable for all makes of camera.

Wherever there is a convenient power supply, it may be more convenient to use an AC adapter, usually available separately. It will also save batteries. Whichever AC device you carry with you, charger and/or adapter, you must be prepared for the plug/outlet types in the countries you will visit. The power tables on the following pages list these.

Plug adapters

The most convenient solution to different plug/outlet types around the world is an adapter, and this is essential for a charger or any other device that has a sealed casing. Hot-wiring (attaching bare wires from a local plug with insulating tape to the prongs of the charger or adaptor) is not recommended because of the dangers of electrocution.

Battery rating

The power capacity of a battery is measured in Milliamp-hours (mAh). This indicates the battery's overall charge storage capacity, and the higher the mAh, the longer the performance. Higher capacity batteries are more expensive, but valuable for digital cameras, which have a high drain. A rating of around 1800mAh is considered high.

Label chargers and converters

UK plug to standard "8" plug

US plug to standard 8 plug

If you are carrying more than one device, such as a laptop or stand-alone storage as well as the camera, you are likely to have similar-looking charger units or AC/DC converters. To avoid confusion, and possible damage to circuitry, label each one clearly.

Laptop charger

Overseas power

The world's voltages are divided mainly between 110–120v and 220–240v. Countries with 110–120v are principally the US and those falling under its sphere of influence for reasons of proximity or history (thus Latin America and Japan, for example), while those on 220–240v tend to be European and former colonies. A few countries have both, though not necessarily in the same place. Cycles are in Hertz (Hz), usually either 50 or 60. Almost all of the plug-in electrical equipment associated with cameras and computers (chargers, transformers, and so on) are designed to switch automatically between these voltage ranges, so there should be no problems on that account (but it's worth checking to make sure that you don't have a primitive single-voltage item). More of an issue is the plug-and-socket fitting, as these vary greatly. The basic solution is to always carry an adapter that will handle a good range of sockets. Beyond this, check the fittings in the countries on your itinerary and buy a specific adaptor. The fail-safe is to buy plugs locally and replace your existing ones—but there is a risk here in that equipment often has permanently attached, non-removable plugs. So that you can continue to use existing fitted plugs, carry a simple adapter like the one shown here, with a short cable attached, and leave the wires stripped at the end.

There are four major plug-and-socket types, with variations within each, particularly in the 220–240v "European" group. Note that some countries have more than one plug type. Also that some sockets are incompatible with some plugs even of the same pin type and layout. Particularly obstructive are two-pin recessed sockets—you may have the right configuration of pins on your adaptor, but it won't necessarily fit.

Inverter for cars and aircraft 📷

DC/AC inverters make use of one universal power supply—the lighter socket in an automobile (and also some aircraft power outlets). The output plug is often either figure-of-eight or clover leaf. It may seem odd to convert from DC to AC when devices like cameras, laptops, and accessories need DC anyway, but the variation in the voltage and cycle of transformers makes it potentially damaging to fool around with DC supplies.

This is just a selection of the array of plugs and sockets from the rest of the world that I have collected on my travels.

These socket adapters are designed to accept a number of different kinds of plugs. Neither is entirely universal, but both work with more than one kind of plug type.

Multi-plug adapters

An adapter that accepts two or three of your own country's plugs saves the cost of having more than one foreign-socket adapter.

A fail-safe adapter

With an adapter like this, leave the ends of the wires bare and attach local plugs as necessary. Most chargers and transformers are sealed units and so should not have their plugs cut and changed.

World socket types

Across the world there are four basic mains electricity socket types, and variants within all of these. When traveling it's essential to have the correct adapters. The voltage also varies from around 110v in the Americas and Japan, to the 220-240v systems common in Europe. Many camera chargers can tolerate either, but you must check.

American	British	European	Australasian
	Br(M) Br(G)	Eu(J) Eu(C)	
Am	Br(D)	Eu(F) Eu(E)	Au
		Eu(K)	

American

Canada
Cuba
Haiti
Honduras
Jamaica
Japan
Liberia
Micronesia
Nicaragua
Panama
Puerto Rico
Tahiti
Taiwan
Trinidad & Tobago
United States
Venezuela
Virgin Islands

British

Hong Kong – Br(D, G)
India – Br(D, M)
Ireland – Br(G)
Libya – Br(D)
Malaysia – Br(G)
Myanmar – Br(D, G)
Pakistan – Br(D)
Qatar – Br(D, G)
South Africa – Br(M)
St Lucia – Br(G)
Tanzania – Br(D, G)
U.A.E. – Br(D, G)
United Kingdom – Br(G)
Zimbabwe – Br(D, G)

European

Cameroon – Eu(C, E)
Denmark – (C, K)
Egypt – Eu(C)
France – Eu(E)
Germany – Eu(C, F)
Greece – Eu(C, E, F)
Hungary – Eu(C, F)
Italy – Eu(F)
Norway – (C, F)
Poland – Eu(C, E)
Russian Federation – Eu(C, F)
Spain – Eu(C, F)
Switzerland – Eu(J)

Australasian

Australia
Kiribati
Papua New Guinea
Tajikistan
Tonga
Uruguay
Uzbekistan
Nauru
New Zealand
Western Samoa

(Despite differences, this plug type mates with some used in the People's Republic of China, though China also uses Br(G) and Am types)

Overseas power

78-79 Batteries and power 82-83 Care and maintenance 94-95 Accessories and tools 228-229 Media and format

Care and maintenance

Against the small advantage of fewer moving, mechanical parts than a film camera, digital cameras are overall less robust. Principally this is because the electronics, of which there are far more, are susceptible to heat and humidity, and there is the additional matter of dirt artifacts on the sensor in an SLR. The convenience of not needing boxes of film on a shoot is offset by the extreme care that has to be taken of the sensor. There is only one, and any significant damage renders the camera useless. Gone are the days when a set of jewelers' screwdrivers and long-nosed pliers might get a faulty camera back on the road. When a digital camera goes wrong, you either have a spare body ready or you stop shooting. This places even more importance on basic camera care than in the days of film.

Photographing in desert conditions is especially dusty. The images below show the marked area in close-up, revealing dust on the sensor.

By increasing the contrast, the dust particles become easier to see, though their effect can still be perceived before the effect is applied.

Digital capture

Tools and precautions

Take the important precaution of keeping the backs of lenses and the camera's mirror box interior clean. It is relatively safe to use a compressed air can for this— but use from a distance, and horizontally, to avoid propellant contamination. For cleaning the sensor, invest in a high-pressure hand blower, and use a small battery-powered light, for example a white LED torch.

Swab cleaners *Spaceblanket*

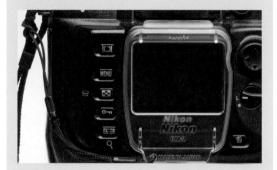

The Nikon LCD screen with its protective cover in place

Regular checks for dust

At regular intervals while shooting (you have to decide how often, depending on how clean the air is and how often you are changing lenses), check for dirt by shooting a featureless subject such as a white wall or the sky. Any particles will be most obvious if the aperture is *stopped down* and the subject *out of focus*. Check initially at 100% magnification, scrolling from one corner across the entire image. When possible, also check the image on a computer screen.

Worst combinations for dirt artifacts

- *Smooth bright areas such as the sky, a studio backdrop, or a white dress.*
- *Wide-angle lenses (because of greater depth of focus).*
- *Small apertures (also because of depth of focus).*

Non-invasive sensor cleaning

The actual sensor surface is protected by a low-pass filter (*see page 31*), but this does little to help. The filter is delicate, and scratching means expensive replacement, hence manufacturers' warnings against touching it. If you detect dirt in an image, clean the sensor as follows:

● Make a mental note of where in the frame are the obvious particle shadows. Because an SLR image is inverted, the actual particles will appear in inverted positions when you examine the sensor.

● Find a clean-air area and remove the lens. Ideally, put the camera body on a tripod so that you can work with two hands.

● Follow the manufacturer's instructions for locking the mirror up to expose the sensor. This is important, because if you simply set the shutter speed to B or T, the sensor will carry a charge that will attract even more dirt. Typically, you would need to connect the camera to an AC adapter.

● Shine a bright light, ideally a point source, onto the sensor and inspect from different angles.

● Use a hand-operated bulb blower as shown. If this weak flow of air fails to remove everything, consider (at your own risk) the next step—compressed air (*see Warning box below*).

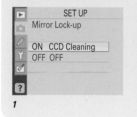
```
        SET UP
Mirror Lock-up

ON   CCD Cleaning
OFF  OFF
```
1

2

3 *4*

A largely unresolved issue is how to keep the sensor clean in a digital SLR. Unlike fixed-lens prosumer models, SLRs are by their nature unsealed, and dirt enters. The sensor is never directly exposed to the air, but that doesn't prevent it from collecting particles, and this happens in two stages: when you change a lens, the mirror box is exposed and if the air is anything less than laboratory-clean, particles can enter; when the mirror flips up for exposure, those particles are free to reach the sensor. The sensor itself carries a charge when in use, so it attracts particles, and if you make slow exposures, there's more time for the particles to slip past the flipped-up mirror. The shadows of small particles may well be undetectable against detailed parts of an image, and also if the aperture is wide open. Any that are noticeable can, of course, be removed with the *Clone Stamp* tool during image-editing, but this takes time.

Most camera manufacturers have still not fully addressed this problem. Their standard advice is *not* to change lenses when there is dirt around, which is impractical professionally, and to restrict cleaning to a hand blower, which is often inadequate. The only solution is to check regularly and then take the inevitable risks of cleaning the sensor yourself. Have it

cleaned by the manufacturer or an accredited repair shop as often as is practical. Solutions are arriving, however. Olympus, for instance, uses a supersonic wave engine and dust filter to blow particles off the sensor surface. Sigma uses a protector screen immediately behind the lens and at a sufficient distance from the sensor that any dirt particles will be well out of focus. There is also a software solution that relies on making a map from the dust pattern which can then be applied to affected images (*see page 173*).

Warning!

● Compressed air is effective but dangerous because of the risk of propellant splattering the sensor. Camera manufacturers do not recommend it, but it may be the only way of removing some particles. Minimize the risk by holding the can level and use from a distance.

● DON'T touch the sensor—EVER. Don't use a blower brush.

● DON'T blow directly with your mouth. Any spittle will have to be cleaned professionally.

Care and maintenance

Direct to computer

High-end digital cameras can be used with a computer, and not merely as a first step in the process of digital imaging. Connected to a computer through a high-speed bus, such as FireWire, or even USB, and with the help of specific software from the camera manufacturer, the camera can be operated from the computer, with some startling advantages. This kind of use is intended mainly for studio shooting, although with a laptop computer, there are no real limits to the kind of location. It makes most sense when the camera is set up on a tripod in front of a static subject, as in a still-life set, and in this kind of circumstance, the computer really can add a new dimension to photography.

The example here is an automobile shoot in a Nissan auto showroom, using available tungsten lighting, with muted daylight inevitably leaking in from outside. In film photography, the first steps would be to measure the light and the color, set the aperture and shutter speed accordingly, and choose a combination of filter and film (either Daylight or Type B). Then a Polaroid test or, if there were no Polaroid back for the camera (heaven forbid), wide bracketing of both the exposures and the filtration.

Digitally, the exposure and color balance issues are taken care of by the preview, but the striking advantages of shooting direct to the computer are that the image can be viewed large and accurately on the calibrated (of course) screen of the laptop. With the camera on its tripod, everything can be adjusted in comfort from the computer, using the appropriate software—in this case, Nikon Capture 3.5. The control panel offers access to all the essential settings: the ISO-sensitivity, shutter speed, aperture, focus, and color balance. One click of the mouse fires the camera.

The laptop's LCD screen is more accurate and convenient for judging the image than would be the camera's own small LCD screen, particularly in the critical areas of highlight exposure and color balance. Results can also be judged by looking at the histogram. Because the image that appears on the screen is not simply large but the actual shot—final if accepted—the advantage of being able to go into the real set and alter things is clear. If a client is present, this is also a very useful way of having the image approved on the spot, with no uncertainty. Even if they're not present, there are many means of instant transfer.

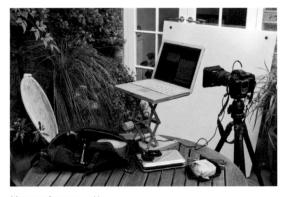

Most manufacturers provide software to enable the camera to be used directly from the computer.

1 Half of the menu options are displayed on this first camera-control screen, titled Exposure 1, *and include exposure mode, shutter and aperture settings, and compensation.*

Nikon Capture Camera Control

The D100 is connected.

Images captured by this camera will bypass the CF card and be downloaded directly on to the computer until this window is closed.

Hide Camera Control Download Options...

| Exposure 1 | Exposure 2 | Storage | Mechanical | Image Processing |

Sharpening: Auto

Tone Comp: Less Contrast Edit...

Color Mode: Mode II (Adobe RGB)

Hue Adjustment: ◄━━━━━●━━━━━► 0°

☑ Noise Reduction

AF and Shoot Shoot

Status

Download folder: Bimbo:Users:michaelfreeeman:Pictures:

29.14 GB available on this volume

Number of images downloaded in this session: 0

Last image saved:

Current task: Downloading image

2 The Image Processing *window gives access to sharpening (normally used with caution when shooting), tone compensation (affecting the contrast range, here very high in the actual scene), and the color mode for later image-editing. Hue adjustment allows further fine control over color, and noise reduction is checked by default.*

3 When the Shoot *or* AF and Shoot *button is clicked, the status window shows the downloading progress as the image is saved, not to the memory card or MicroDrive in the camera, but to a selected folder on the laptop's hard drive.*

4 In shooting a new high-performance Nissan car, the technical issues are high contrast (hold the specular highlights) and color balance (mixed tungsten and cloudy daylight), calling for a carefully chosen white balance compromise.

Canon users will find a tool called Camera Window with their application suites which can perform similar functions using a simulated LCD display. Here, for example, the exposure compensation has been selected, and can now be adjusted using the cursor keys or icons beneath. The large round button acts as the shutter release, after which the resulting image is passed to the Browser program (below).

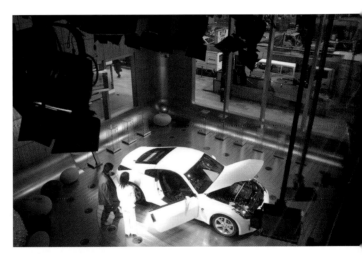

Care and maintenance

On-camera flash

For most casual shooting, flash is essentially a convenience—a way of adding light when there isn't enough in the scene. Almost all SLRs now have a built-in pop-up flash unit above the prism head and it gives serviceable, if not necessarily very interesting lighting. On-camera flash of this kind has the inevitable drawbacks of frontal lighting (almost shadowless and falls off in proportion to the distance from the camera). At the same time, on-camera flash gives clear, crisp results with bright color, so that, for example, it often works well for close-up shooting of colorful subjects. High-end digital SLRs with built-in or dedicated flash units use a variety of sophistications to improve exposure accuracy, including focus (to favor the distance to the chosen subject in a scene).

Wireless multiple flash

Some advanced detachable camera flash units feature wireless linking. The unit mounted on the camera serves as the "commander," from which any number of other, independently mounted units can be controlled. The initial flash from this unit triggers the others via their remote sensors. With the Nikon SB-800 unit shown here, flash units are grouped, and their flash modes and output levels can then be altered from the "commander," and their channels can be assigned also.

Nikon SB-800

On-camera flash limitations

1 Exposure is good for one distance only because the light falls off along the line of view. If the foreground is well lit, the background will typically be dark, while obstructions in front of the subject can easily be overexposed. *Solution*: Rearrange camera position and composition; change flash mode to fill-in so that exposure is long enough for the ambient lighting.
2 Specular reflections in shiny surfaces facing the camera. *Solution*: Change camera position; retouch highlights in image-editing.
3 Red-eye; reflections from the retina, particularly with a longer focal length lens. *Solution*: Some cameras offer

a pre-flash to make the subject's iris contract, but this adds a delay; retouch in image-editing.
4 Flat, shadowless light that gives a poor sense of volume. *Solution*: Use flash as fill-in; increase ISO sensitivity to record more ambient light.

Bounce flash

The principle of bounce flash is to aim the unit at the ceiling or wall rather than the subject, to take advantage of the much more diffused light from this reflection. It greatly reduces the light reaching the subject, and you should also check that the ceiling or wall is white, or expect a color cast. A few cameras have the facility to angle the head, but otherwise this is a feature for detachable on-camera units.

Guide number

This is the standard measurement of light output, and varies according to the ISO sensitivity. It is equal to the aperture (in *f*-stops) *times* the flash-to-subject distance (in meters, feet, or both). A typical rating, for example, might be "Guide Number 17/56 at ISO 200," meaning meters/feet. Divide the guide number by the aperture you are using to find the maximum distance at which you can use it. In this example, if you were using an aperture of *f*4, it would be 14ft (4m).

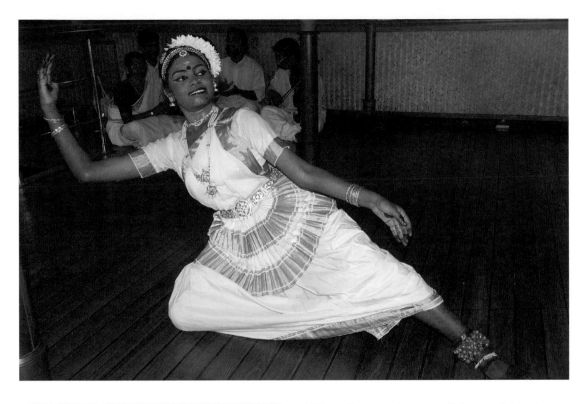

1/20th second exposure and an on-camera flash were used in this shot of a Hindu dancer.

Fill-in flash

One of the most successful uses of on-camera flash is as shadow fill. In this, the shutter speed is set low enough for the ambient lighting across the scene, and a smaller-than-usual dose of flash is added. All SLRs have a program for this in the menu, but as the exact balance between flash and ambient light is very much a matter of personal taste, the ideal is to try different variations and check the results on the spot on the LCD screen. For full control, use a manual exposure setting and lower the flash output by increments.

Slave units

Any detachable flash unit, whether intended to be mounted on the camera's hot-shoe or a larger unit as featured on the following pages, can be triggered in sync with the on-camera flash. One method is with a sync cable, the other using a line-of-sight photocell trigger. Quite sophisticated lighting set-ups are possible, yet simple to arrange.

Rear-curtain sync

A special variation of fill-in flash is streaking with rear-curtain synchronization. In this, the exposure and flash output are balanced as for fill-in, but the flash is timed at the *end* of the exposure. If there is movement, either in the subject or because you move the camera, there will be trails of light that end in a sharply frozen image. This works particularly well at night in locations where there are bright lights—for instance, a panning shot of a motorcycle with its lights on.

Choice of flash sync modes on a Nikon D100.

On-camera flash

46-47 Exposure measurement 88-89 Flash units 92-93 Tripods and supports 144-145 Shadow/highlight adjustment

Flash units

The advantages of professional, high-output flash are precise color temperature (daylight), short duration to freeze most movement, and a quantity that allows it to be diffused, reflected, or bounced, and yet still allows good depth of field. Typical studio systems are split between those in which several flash heads are served by a power unit, and monoblocs designs, in which the transformer, rectifier, capacitor, and flash tube are all housed in one self-contained unit. In addition, there are portable flash systems with a much higher output than the usual detachable on-camera units, using battery packs.

With digital SLRs, in-camera color balance and generally higher base ISO sensitivity admittedly reduce the value of these, but not much. The old disadvantage of flash—that you could never be absolutely certain of the result unless you did Polaroid tests—has disappeared. Digital SLRs make flash a dream to use.

More than anything, it is the endless variety of light fittings that make professional flash units so useful. Not only is the output high enough to survive heavy diffusion and reflection, but the low temperature at which the lights work make it possible to enclose them without risk. The better studio flash units have a slave sync built in, to do away with one

Flash meters are still useful

Despite modeling lamps, which are standard on studio units, previewing the actual lighting effect is still one of the problems with flash—and calculating aperture against output even more so. Although hit-and-miss calculation is not difficult with a digital SLR, it may still take a few exposures to arrive at the right settings. A flash meter is essential for regular studio photography, and the most useful method is incident light reading, as shown here. Incident readings are of the light falling on the subject and so are uninfluenced by the tone, color, or reflectivity of the subject itself.

set of messy cables. In a typical studio flash system, the power supply is AC at a relatively low voltage. The first part of the circuitry is a transformer to step up the voltage and a rectifier (more than one in large units) to convert the AC to DC. This uni-directional, high-voltage source then supplies the capacitor which stores the charge. When triggered, the high-voltage output in the capacitor is discharged through the flash tube. Output is measured in watt-seconds, or joules, and typical units are between 200 and 1,000 joules. To make use of the extremely high output of the mains flash capacitors, the flash tubes are much larger than in on-camera units, and one result of this is that the peak flash duration is longer than that of an on-camera flash, which is sometimes as slow as a few hundredths of a second.

Studio flash system
Serious indoor photography will make use of daylight-balanced adjustable lights and a variety of modifiers. Most of these will feature modeling lights: a continuous light to help set-up.

Fluorescent lighting system

Focusing spot

Dish reflectors

Umbrella

Dish reflectors

Snoot

Soft-box

Honeycombs

Flash units

58-59 Basic lighting situations 62-63 White balance 92-93 Tripods and supports 198-199 Altering light and atmosphere

Continuous lighting

The alternative to flash is continuous lighting, and the professional choice is between incandescent, high-performance fluorescent, and HMI. The principal advantage is that you can see exactly what lighting effect you are getting, which also makes it easy to combine with existing, ambient light. Incandescent is the traditional source, but fluorescent and HMI are becoming increasingly popular in studios.

The most efficient type of incandescent lighting is the tungsten-halogen lamp, using a coiled tungsten filament as in ordinary tungsten lights, but burning at a much higher temperature in halogen gas. As a result,

This Lupo Quadrilight delivers light at a light temperature of 5,400 Kelvin, ideal for product shots. The metallic barn doors allow control of the spread.

Handling incandescent lamps

The design of tungsten-halogen lamps varies to suit the different makes of lighting unit, but the two main types are two-pin upright, and two-pin double-ended, which is used horizontally. Use only in these recommended positions. Avoid touching the quartz-like envelope with bare fingers as the greasy deposit will cause blackening and shorten the lamp's life. Instead, use paper, cloth, or a glove. If you do accidentally touch the surface, wipe the finger-marks immediately with spirit. If you travel with units that accept lamps of different voltages (110–120 and 220–240), identify the ones fitted: using a lower voltage lamp on a higher voltage circuit will immediately burn it out and may cause damage.

The operating temperatures are high and potentially dangerous—keep at a distance from flammable materials and the light's own cable. Avoid enclosing a tungsten-halogen lamp with light housings not specially designed for it, and make sure that any fitted barn doors are always fully open. Finally, as with any lights, make sure that they are securely mounted on stands, and secure the cables with tape or by tying them down.

Above: Lowel TotaLight
Above right: Lupo 800W linear quartz-halogen lamp

light output and color temperature stay more or less the same throughout their life. Available wattages range from 200 to 10,000, but for still photography 2,000W is about the highest. Used alone, incandescent lamps simply need 3,200K "incandescent" white balance. However, used on location, they are often in combination with existing daylight, fluorescent, or vapor lighting, and in this case it is usual to filter the lamps toward daylight (*see below*).

A newer development, particularly relevant to digital photography, in which the camera's white balance settings can take care of color differences, is high-performance fluorescent. The lamps used are flicker-free, almost as bright as incandescent, color-balanced for 5,400K or 3,200K, as well as being cooler and less expensive to run (though more expensive to buy in the first place).

Combining with daylight

Continuous light is ideal for interiors, where the size of the subject and the complex relationship with other existing light sources (such as daylight through a window) make it much easier if you can see the effect precisely by eye. The important precaution with incandescent lamps is to balance the color temperature with a gel.

Choosing flash or continuous lighting

Flash: pros	Flash: cons
Freezes movement.	Small units give no preview; others have modeling lamps that call for dim ambient light to show the effect.
Cool	Fixed upper limit to exposure, beyond which needs multiple flash.
Daylight-balanced, mixes easily.	Technically complex.
	High unit cost.

Tungsten: pros	Tungsten: cons
You get what you see.	Not bright enough to freeze fast movement.
Exposure adjustments simple—just change shutter timing.	Hot, so can't accept some diffusing fittings, and dangerous for some subjects.
Mechanically simple and easy to use.	Needs blue filters to mix with daylight.
Some makes very small and portable.	

High-performance fluorescent: pros	High-performance fluorescent: cons
You get what you see.	Not bright enough to freeze fast movement.
Exposure adjustments simple—just change the shutter timing.	Bulky.
Daylight-balanced, mixes easily.	High unit cost.
Mechanically simple and easy to use.	Tube dimensions restrict light design.
Low running costs.	
Cool—none of the heat problems of incandescent.	

HMI: pros	HMI: cons
Exactly as for tungsten but cool	Expensive
	Needs a bulky balast

Fluorescent

Lupo Quadrilight and Superlights mounted

High-output, flicker-free, daylight-balanced tubes make fluorescent a realistic alternative to incandescent, with some clear advantages. The light is cool, and so convenient for still-life subjects. In these designs, several tubes are arranged in parallel with mirrored reflectors to form a light bank.

Reflector angle Incandescent light housings have a reflector behind the lamp to increase output and help control the beam. Most general-purpose housings have reflectors that give a spread of between about 45° and 90°. The beam pattern can often be adjusted either by moving the lamp in and out of the reflector, or by moving hinged panels in front.

Daylight control and tungsten conversion filters There is a wide range of heat-resistant gels available, designed to fit in front of the lamp, for raising and lowering color temperature. They fit either in custom holders or in an outrig frame, which attaches in front of the light. An alternative is a dichroic filter—a partial mirror, reflecting red back to the lamp and passing blue.

Full blue is the standard correction gel from tungsten (3,200K) to daylight (5,500K). Mired shift—131; 36% transmission.

Half blue for partial conversion from 3,200K to 4,100K to compensate for voltage reduction or to boost domestic tungsten lamps. Mired shift —68; 52% transmission.

Continuous lighting

46-47 Exposure measurement 78-79 Batteries and power 92-93 Tripods and supports 96-97 Packing

Tripods and supports

The key decision is whether or when a tripod is necessary. The two reasons are for slow shutter speeds to avoid camera shake, and when the composition needs to be precise and fixed, as in still-life or architectural shooting. Weight and bulk are an issue if you're traveling, so much depends on the type of shots you expect to do.

Tripod efficiency depends on two things: design and materials. The first essential quality for any tripod, as for any bridge, is that it stays firm and still under average conditions. The acid test is to fix the camera, use a long focal length, and tap the front of the lens while looking through the viewfinder. Common sense will show whether the slight vibration is acceptable, but to make sure, shoot a few times at around 1/60sec to 1/125sec while tapping the lens. Examine the images on the computer at 100% magnification. Torsion is another indication of tripod stability—with the camera detached, grasp the head firmly and try to twist it clockwise and counterclockwise. There should be no significant movement. Note that center-pole extensions can, if not very well built, reduce stability. This is particularly true of rack-and-pinion movements operated by a rotating lever; convenient, certainly, but not necessarily solid.

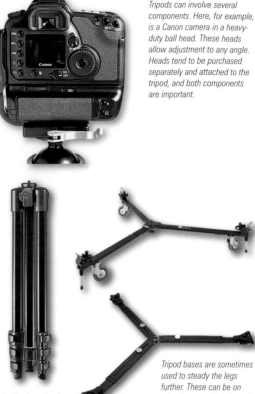

Tripods can involve several components. Here, for example, is a Canon camera in a heavy-duty ball head. These heads allow adjustment to any angle. Heads tend to be purchased separately and attached to the tripod, and both components are important.

A standard amateur's tripod folds away conveniently and compactly.

Tripod bases are sometimes used to steady the legs further. These can be on wheels too, makinig it easier to re-position heavy lenses.

Monopod 📷

A single adjustable pole can improve the shutter speed at which you shoot by about a factor of two. If you are hiking, look for a walking pole that is equipped with a $1/4$-20 inch screw thread that will accept a small tripod head.

Mini-tripod 📷

Surprisingly useful, being light enough to carry without noticing. What it lacks is elevation, but there are often surfaces to give height, such as a vehicle roof. One good technique is to press the mini-tripod against a vertical surface, such as a wall.

Tripod heads are as important as the tripod itself, and a weak head will destroy any advantage you have from a strong tripod. There are two basic designs: pan-and-tilt, in which each movement is mechanically separate, and ball-and-socket, which allows full play in every direction with one unlocking movement. Which is better is entirely a personal choice.

In a studio, a heavy, solidly built tripod is an obvious choice, and for large-format cameras a studio stand is even better. Location shooting or traveling over a period, however, puts a premium on lightweight construction. Just as there is no point in even considering a lightweight tripod that is too flimsy to hold the camera firmly (or too short for normal use), neither is there any reason to have a tripod that is over-specified for a small camera. Cost enters the equation because strong, light materials are available and they are always more expensive. The material of choice for tripods is carbon fiber (30%

lighter than aluminum, and more rigid), and for heads, magnesium alloy, but the price difference from standard is considerable. For all the above choices, if you are buying a tripod and head, compare models side by side for shake, torsion, weight, etc.

There are good impromptu alternatives to tripods, depending on how slow a shutter speed you need. Simply to hold the camera more steadily, a rolled-up cloth, jacket, or soft camera bag on a solid surface (such as a wall or part of a vehicle) works very well— if you press down on the camera or lens as you shoot, you may be able to use shutter speeds as slow as one second. Very long exposures are possible *if* your camera accepts an electronic cable release; find a solid surface at a workable height, prop the camera up with whatever is handy, and trigger the release. To avoid uncertainty in these conditions, shoot several times.

This compact tripod is perfectly acceptable for an SLR and standard weight lens.

This solid professional tripod is constructed from lightweight carbon-fiber legs. It features a geared central column with supports.

Focal length and camera shake

Camera shake is the condition that tripods and other supports are intended to correct, and its symptoms are blur of a characteristic, "doubled" kind across the entire image. As long focal lengths magnify images, they also magnify shake. Long focal-length lenses (for SLRs) also tend to be heavy, which can be an advantage on a tripod as the weight makes the set-up more solid, provided that you mount the lens near its center of gravity (use the lens's own tripod bush).

Tripod heads

Ball heads allow movement in all directions (and this one even features a spirit level) whereas 2- and 3-way heads offer more control in either direction.

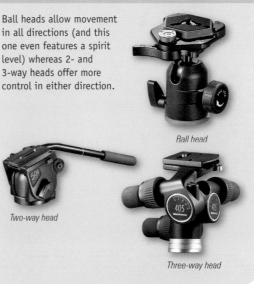

Ball head

Two-way head

Three-way head

Tripod management

- Low is more stable than high.
- Make sure that the surface is steady. Sand shifts, as do loose wooden floorboards.
- Adjust the legs so that the platform (immediately below the tripod head) is level. Do not level by the tripod head alone.
- With a long lens on an SLR, use its tripod bush rather than that of the camera, in order to get closer to the center of gravity.
- Shelter the tripod from wind.

The dangerous speeds

Fast shutter speeds don't need a tripod, and at very slow speeds, such as a second or longer, the camera has time to settle down after the shutter is released. Moderately slow speeds, however, such as 1/30sec and 1/15sec, can produce camera shake with a long focal length even on a tripod. Check for this.

Tripods and supports

Accessories and tools

Though it always depends on how lightly you need to travel, everything on these pages will come in useful. In addition to the obvious—filters, lenses, and the like—it's always a good idea to carry some basic tools and tape. When you're on the road, you may find you need to conduct running repairs, or simply use the tape to protect the memory card slot in a dusty or sandy environment. Either way, it's a matter of being as prepared as possible.

Army knife mini tools

Cleaning tools

Duct tape

Tape

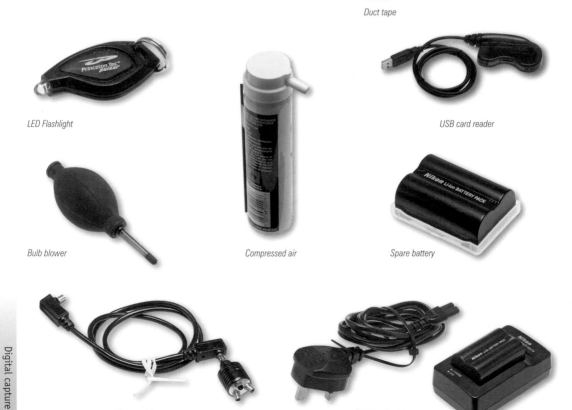

LED Flashlight

USB card reader

Bulb blower

Compressed air

Spare battery

Video cable

Battery charger

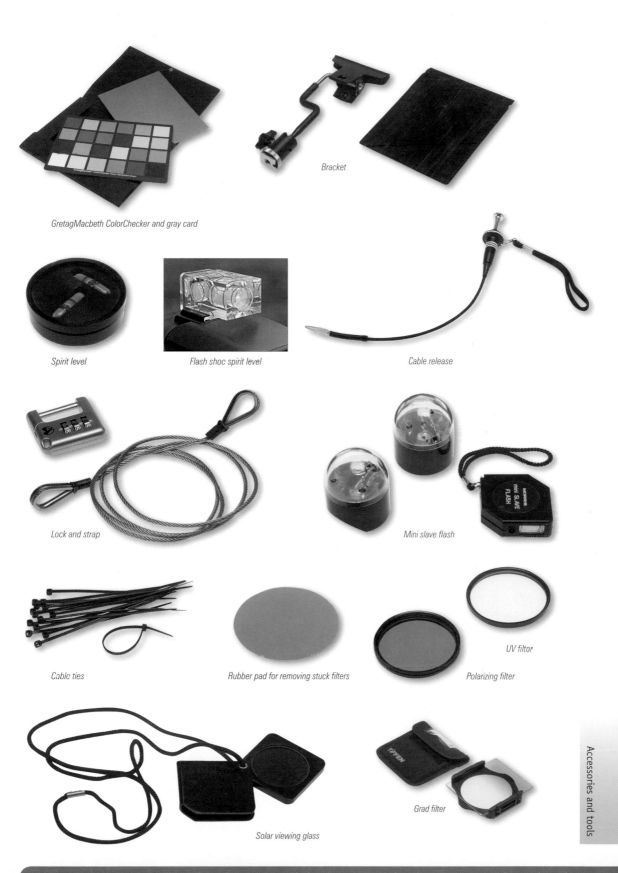

GretagMacbeth ColorChecker and gray card

Bracket

Spirit level

Flash shoc spirit level

Cable release

Lock and strap

Mini slave flash

Cable ties

Rubber pad for removing stuck filters

Polarizing filter

UV filter

Solar viewing glass

Grad filter

Accessories and tools

Packing

While many digital SLRs and dedicated lenses are lighter in weight than their film equivalents, this is more than offset by the sharp increase in the number of accessories, particularly electrical accessories. Power and cables dominate any packing list, but this also means that there is an even more marked difference between what you need to travel with and what you need for actual shooting. So it makes even more sense to consider dividing the packing between a case for transportation and a bag for shooting while simply walking around. A backpack is worth considering for hiking, climbing, and other outdoors photography. For transportation, well-padded protection is a high priority, given that digital equipment tends to be delicate.

The three worst conditions for digital equipment are water, dust, and heat, and the best protection for the first two is a properly sealed case—meaning with a gasket or rubber ring of some sort. Water shorts

Basic checklist

Body
Spare battery
Battery charger and cable
Plug adapter
USB or Firewire cable, camera-to-computer
Laptop or image bank
Memory cards
Card reader
Lenses: zooms, wide-angle, telephoto, macro, shift
Blower brush
Lint-free cloth for cleaning
Tripod
Cable release
AC/DC converter
UV filters
Polarizing filter
Neutral grad filter
Rubber pad for removing stuck filters

This Latigid (digital, written backward) case from Lightware is padded but designed to be stacked.

Rigid plastic cases, like this from Pelican, are a superbly protective environment for a camera, but their padding can be limiting.

Cases made of light, shiny metals reflect heat and are very sturdy. Some are even strong enough to stand on for a better view.

Some of Tamrac's range of camera bags are "Digitally Equipped," including a waterproof clear plastic bag sized for memory cards and batteries.

The canvas shoulder bag, aside from being something of a classic, is flexible and rugged, though perhaps less waterproof than some synthetic materials.

A convenient wearable pouch is great for small accessories like a flash or, say, a Nikon Coolwalker.

This small red pouch can be tucked anywhere, and is great for memory cards or filters.

A Stuff Sack is a lightweight waterproof bag ideal for everything from equipment to spare clothing.

A small shoulder bag, in this case a Domke, can easily hold an SLR and up to three lenses.

electrical circuits and corrodes metal parts (though there are fewer of these than there used to be). Salt water is the worst of all. Light rain simply needs wiping off. Full immersion, on the other hand, is likely to cause a write-off. If it happens, remove the lens, open everything that can be opened, and dry quickly (such as with a hair dryer or in an oven at low heat).

The danger of dust and sand is that particles can work their way into the camera's mechanism, causing scratching and jamming of moving parts—and most immediately adhere to the sensor. Even a short exposure can be damaging, so in dusty conditions keep the camera wrapped or sealed except for actual shooting. Sand on beaches is insidious because salt makes the grains sticky.

Heat can affect the electronics at temperatures of typically 104°F (40°C) and more. A bright metal case is better at reflecting heat than any other kind. In sunlight in hot climates keep cameras in the shade when you are not using them. Where the air is humid as well as hot, pack sachets of silica gel in with cameras—its crystals absorb moisture. When the silica gel has absorbed all it can (some types change color at this point), dry it out in an oven.

Ziplock plastic bags are ideal for storing small items that need to be protected from any possible damp, like these USB devices.

A padlock is a vital precaution when traveling. Regrettably there are a number of places where you should be on your guard against hotel staff and even airport workers.

Cold weather is less of a problem in itself, although batteries deliver less power and need to be replaced more frequently. Cell capacity is very low below -4°F (-20°C), and a little lower than this the electrolyte will freeze (although when it thaws, it will start functioning again). More serious potentially is condensation caused by moving equipment between cold exterior and heated rooms. After cold-weather shooting, warm the camera up slowly, or wrap it tightly in a plastic bag so that condensation forms on the outside rather than inside.

Packing

16-17 Digital SLR lenses 72-73 Memory cards 78-79 Batteries and power 94-95 Accessories and tools

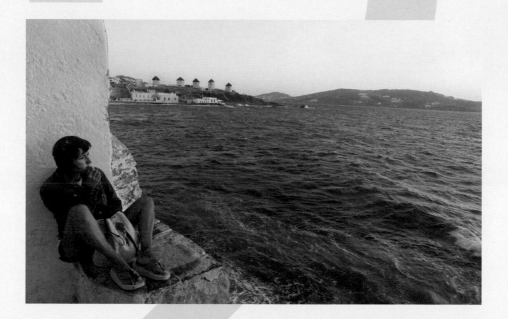

image workflow

THE IDEA OF WORKFLOW IS A NEW one for photography. There are now
far more steps in getting from the point of shooting to the final print
(the usual end-image) than there ever were even in carefully consid-
ered black-and-white photography. These steps need to be ordered.
Of special importance is smoothly integrating the mechanical side of
photography with the various procedures on the computer. Software
is, indeed, the big new addition, demanding a new set of skills so that
you can make the most effective use of it. There are several good
software packages for making adjustments to images, but Photoshop
dominates, and is constantly improving, version by version. It's
commonsense to assume that most photographers will use it, and the
examples in this book follow suit. The aim is to lay out the sequence
for handling the image as it moves from one state to another, and
from one device to another, to bring out the best in the final version.

Planning the workflow

The core of the workflow in digital photography is preparing each image to its best quality, in terms of color, dynamic range, sharpness, freedom from blemishes, and so on. Because so much can be done once the image is on a computer, for most photographers it means a radical rethink in their working method. It stands in marked contrast to shooting color transparencies, where the very little flexibility in processing means that the photography virtually ends at the moment of shutter release. If anything, it is more akin to the kind of black-and-white photography practiced with an eye to lengthy darkroom work (think Ansel Adams). Digital workflow needs to be *planned*, and that implies shooting with a good idea of what can and should be done later, on the computer.

Shooting in Raw format

Knowing the power of the imaging tools available in programs such as Photoshop, doesn't it make more sense to divide the work between the camera and the computer? If you can more accurately set the brightness range and the distribution of contrast using Photoshop, isn't it better to adjust the camera settings so that you capture the *maximum information* rather than go for the best appearance straight out of the camera? This is the thinking behind shooting in Raw format, in which most of the settings can be altered later. When you press the shutter in Raw mode, as much information as possible is transferred to the file: the highest bit-depth color your camera is capable of recording, the shutter speed, exposure program, f-stop, aperture value, ISO setting, lens, flash, and so on (each camera model creates a slightly different Raw file). Even if you are shooting normal TIFFs and JPEGs, there are many steps that can be taken on the computer to get the best out of the captured image.

Minimum workflow (excluding Raw files)

1 Shooting.
2 Transfer images from memory card to hard drive.
3 Examine the images in a browser, delete mistakes, rotate.
4 Identify selects, optimize, and caption.
5 Save and archive all images.

From capture to print

In digital photography, the image workflow typically goes like this:

1 Shooting, ideally as Raw files for later control and flexibility.
2 Transfer images from memory card to an appropriate folder on the computer hard drive: from the camera, or from the card using a reader, or via an intermediate storage step such as a portable image bank.
3 Examine the images in a browser, delete any obvious mistakes, rotate where necessary, rename and reorder if necessary.
4 Basic edit to identify selects.
*5 Make a contact sheet and/or low-res JPEGs to send to client for review, possibly with selected optimized images.
*6 Client reviews low-res images and requests optimized TIFFs of some.
7 Optimize selects by opening in a Raw editor and adjusting white balance, hue, exposure, shadows, brightness, saturation, and contrast. Save as 48-bit RGB TIFFs.
8 Continue optimization in Photoshop, adjusting black-and-white points, neutrals, curves, and the saturation and brightness of individual hues. Retouch artifacts including sensor dust. Possibly reduce noise.
9 Where necessary, perform more extensive image editing to content. If editing procedures had been pre-planned when shooting, undertake these (such as blending different layers for lighting control).
10 Proof certain images on desktop printer.
11 Embed caption information, and save and archive final images as 24-bit RGB TIFFs. Also archive raw files. Enter into image database.
*12 Deliver final RGB images to client, who signs off on them.
*13 Pre-press preparation of images, including CMYK conversion, appropriate sharpening, and dot gain.
*14 Color proofs.
*15 Corrections.
*16 Press date.

* Professional assignment.

How the image moves through the hardware

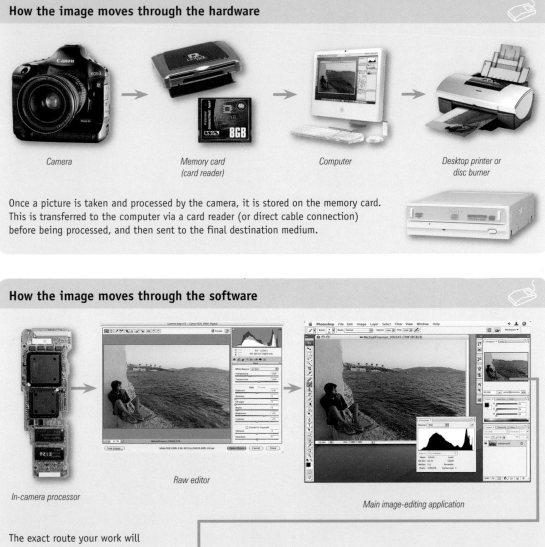

Camera *Memory card (card reader)* *Computer* *Desktop printer or disc burner*

Once a picture is taken and processed by the camera, it is stored on the memory card. This is transferred to the computer via a card reader (or direct cable connection) before being processed, and then sent to the final destination medium.

How the image moves through the software

In-camera processor

Raw editor

Main image-editing application

The exact route your work will take through software will depend on a number of things: whether you shoot in Raw, whether you choose to edit any of your files and, most importantly, what your output medium is likely to be. The first "computing" will always take place in-camera, though with Raw this will simply be saving the information to the memory card. The final step shown here—archiving—is essential for digital photographers. The discs, or whatever medium you create, are as irreplaceable as negatives.

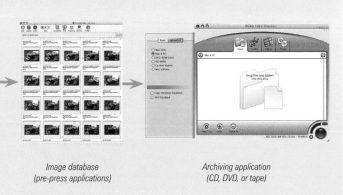

Image database (pre-press applications)

Archiving application (CD, DVD, or tape)

Planning the workflow

Computer needs

Digital photographic images are among the most demanding files for processing on a computer, for reasons of their size, complexity of detail, and the need for realistic, accurate rendering. All of this points to high specifications for the machine, as well as some consideration for the operating system (Windows, Mac, Unix, or Linux). Image editing, as we'll see, is the primary function for computers in photography, but other key software applications are for downloading, browsing, databases, printing, slide shows, scanning, archiving onto CDs, DVDs, or tape, and access to the Internet, including sending images to other computers. There are, in addition, very many plug-ins intended to work with your main image-editing software—these are independently written applications that do not stand alone, but are accessed through Photoshop or whichever image-editing program you choose.

The key performance issue is processing speed,

Check for updates

Software, from operating systems to individual applications, is usually in a constant state of improvement and adjustment. Make a regular practice of checking the software download areas of websites of manufacturers whose software you use—operating system (e.g. Windows), camera, image-editing. Some, like Mac OS X and Windows, do this semi-automatically, letting you know when updates are available.

Mac OS X Software Update utility

Application memory

For the highest performance in image editing, allocate the maximum RAM and a high cache size to the application, and run that alone. On the Mac go to *Photoshop > Preferences > Performance...* (the Preferences option is accessed from the *Edit* menu on the Windows version). For technical reasons, Photoshop is limited to accessing a maximum of about 4GB.

RAM chips, in this case in the form of a DIMM (Dual Inline Memory Module), are relatively easy to fit. Cards like this simply plug into slots inside your computer.

which depends on the chip and is measured in megahertz (MHz) or gigahertz (GHz). It is the main determinant of the cost of the machine, and for processing photographs, the faster the better—and with no upper limit. Multi-tasking is another strategy for improving the workflow, permitting operations such as batch processing to run in the background with little if any effect on other applications that you might be using. Active memory is known as RAM (Random Access Memory), and in combination with the processing speed determines how quickly you can open and manipulate images. Like processing speed, it is almost impossible to have too much, and the ideal for image-editing is about five times the size of the image file. This file size can easily grow beyond what you might expect. Take an 10-megapixel camera. The RGB image from this will be 30MB (10×3 channels) in 8-bit colour, but 60 MB if you choose to save as 16-bit. If you then start to add layers, it can become much bigger still. And you might

Graphics tablet

A cordless stylus and graphics tablet allow an intuitive way of working, particularly for digital brushwork. The stylus response can be customized to the way you work, for instance, altering the angle of tilt at which it will respond, and the tip pressure from soft to firm.

An Apple MacPro (top) and a Sony Vaio Windows-based computer (right). Both systems are powerful and flexible tools.

well want to open more than one image at a time, for comparison or compositing. At the least, you will need RAM of three times the image size if you are to work within the active memory, because the program needs to hold copies of the image while you make changes. A workaround to insufficient RAM is virtual memory, in which free space on the hard drive is used temporarily as memory—useful, but it slows down performance.

In choosing an operating system—which essentially means choosing the machine itself, consider the following: performance, ease of use/ease of interface, software availability, and cost. Of the normally available operating systems, Windows is by far the most common, although Apple Macintosh machines are more widely used by imaging professionals for reasons of speed, ease of use, and tradition. Unix and Linux are extremely robust systems (and indeed Mac OS X is based on Unix), but suffer from having a limited range of image-editing software written for them. Photoshop is available for Windows and Mac and works equally well on either platform.

Peripherals are the extra pieces of hardware that connect to the computer. What you choose depends on what is already built into the computer (perhaps a DVD writer), and on your preferred way of working (such as using a graphics tablet instead of the mouse).

Laptops on location

As most photography is on location, laptops have a special place in the workflow. Use one for downloading and image-editing while traveling, and for shooting direct to the laptop (*see pages 84-85*). Smaller laptops fit more easily into the camera bag, but the larger ones can take the place of a desktop—although the relatively narrow acceptance angle of the screen makes them less reliable for optimization and image-editing.

Archiving

External hard drives are fast becoming the only sensible archiving method, and capacities are increasing all the time. RAID units (Redundant Array of Inexpensive/ Independent Disks) are grouped hard drives with a combination of software and hardware that preserves data integrity in case of the failure of one. A simpler alternative is mirrored hard drives. Some photographers use DVDs as an extra level of archiving safety.

Computer needs

42-43 File formats 84-85 Direct to computer 108-109 Monitors 126-127 Storage and archiving

Color

Color, in the sense of making sure that the image looks the way you think it should all the way through from shooting to printing, is one of the most vexed issues in digital photography. The fundamental reason is that there is no longer a single, physical transparency or negative that everyone can refer to. Managed properly, the freedom that digital photography gives you to adjust the colors and brightness to suit your taste is wonderful. It puts the photographer firmly in charge. Badly managed, it can be a nightmare. The scenario that all of us dread is when the image has been optimized and worked on until it looks perfect on the screen, is then printed or sent for repro, and finally appears looking terrible—such as muddy, pale, unsharp, dark, contrasty, or any of the other ways that you have been assiduously trying to avoid.

Be warned that this is a bottomless issue with no single consensus among professionals about the best procedure. This does not mean, however, that it can't be managed. The key is to adapt the way in which you work to the system that you have chosen. This may be a simple closed loop in your own studio or home, in which all your photographs are printed on your own printer. Or it may involve sending images to a client or lab that has its own particular way of doing things. If you are a professional photographer, you will often be dealing with several different clients and this may simply mean that you have a set of different procedures. The rest of this chapter will work carefully through all of this.

Color management is the procedure for making sure that the appearance of a photograph remains the same (or as close as possible) as it moves through the workflow. This means that the picture you thought you took stays that way on your computer screen, on other people's computer screens, and on any printer that it is sent to. You may or may not want to get heavily involved in the process, but there is one uncontestable certainty in all this—the photographer is the

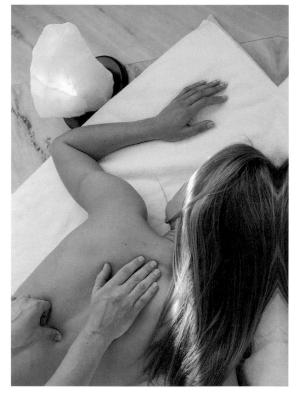

Left *The lobby of the Ice Hotel in Jukkasj Srvi, in Swedish Lapland. The entire hotel, guest bedrooms, suites, reception, hall, and bar, is maintained at a steady 23 °F (-5 °C) and survives only in winter.*

Above *This shot of a girl being massaged shows the subtle variation in skintones. Getting skin color right is important because it is a key perceptual color; one of which viewers have expectations.*

These three images depict the San Francisco Mission Church at Ranchos de Taos, New Mexico. Built in 1815, it has a cruciform shape supported by massive buttresses. Subtle changes to the color have a significant effect on the apparent look of the structure.

This polished brass plate at the Hambros bank in the City of London is given a much richer red by a passing red double-decker bus.

This military shot was taken, with the safety of a media pass, at a Tokyo naval review. Color is important in giving a sense of distance, with the less saturated shipping clearly further from the viewer.

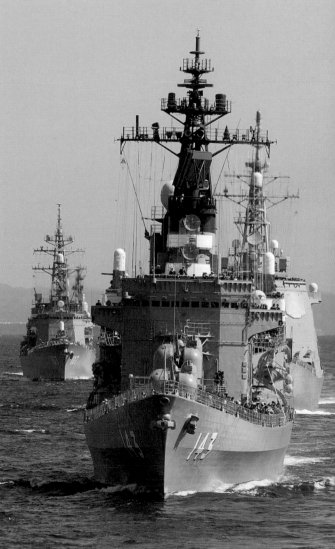

only person who knows how the colors should look. Obvious though this may sound, it sometimes gets lost in the discussion. It means, above all, that you *must* deliver the images as you would like them to appear. Nobody else can do that for you. The examples here attempt to make this important point clearer. Even having established a good color management system and having an accurate ICC profile for your camera, as described on the following pages, there still remains a wide and legitimate choice. Consider for instance color temperature. In a late-afternoon shot, would you want a white dress to appear neutral white or warm? There is a good case for either.

We already touched on color when it came to the color space settings for the camera and profiling (*see pages 64 and 68*), but the first place where you are likely to start judging it seriously is on your monitor display (*see pages 106-111*).

Color management

Color management is the process of keeping colors consistent throughout the workflow, from camera to monitor to printer. These devices vary in how broad a range of colors they can handle (their "gamut") and in how they distinguish colors. Left to themselves, they will each present different color versions of your photographs. In other words, color is *device-dependent*. What is needed is a procedure for keeping the appearance of colors the same from shooting to final display. The software that coordinates this is called a Color Management System (CMS for short), and for any serious photography you *do* need it. The good news is that nowadays color management is at least partly built into the software and devices that you are likely to be using. A perfectly

The essential components

1 A working color space that is independent of the device.
2 ICC profiles for the devices. These describe to the computer the characteristics of each.
3 A Color Management Module (CMM). This interprets the information in the ICC profiles and acts on it.

Where the ICC profiles are stored

If for any reason you want to find these profiles directly, they will be stored in different places according to the operating system.
Windows XP and Vista: Use the Color Management page in the Control Panel to locate the files.
Windows 2000: *WinNT\System\Spool\drivers\Color*
Windows NT4: *WinNT\System32\Color*
Windows 95-98: *Windows\System\Color*
Mac OSX: *Users > (your name) > Library > ColorSync > Profiles*
Mac OS9 and earlier: *System > ColorSync Profiles*

Michael's Calibrated Profile.icc

My Monitor (Apple Cinema Display).icc

Definitions

Color Management System (CMS) Software that reconciles the different color performance of the various devices in the imaging chain, from camera to printer, to ensure consistent color.
Color Management Module (CMM) Also sometimes called a Color Engine, this is the part of a CMS that does the work of mapping one color space to another.
Device profile A file that describes the color behavior and gamut of a piece of imaging equipment such as a camera, scanner, monitor, or printer. Used by a CMS to convert one color space to another. Standard profiles are called ICC profiles, after the International Color Consortium.
Color space A model, usually in the form of a solid shape to show the three axes, of how color is represented. The usual spaces are RGB and CMYK (both device-dependent) and CIE L*a*b*.
Color gamut The range of colors that a device can handle, according to its color space.
Render intent Because there are almost always some colors that will be out of gamut when changing from one color space to another, the system needs some guidance from you in how to compromise. This is the render intent, and Photoshop offers four choices. With a *perceptual* intent, the color space is simply shrunk; with a *saturation* intent the vividness of colors is preserved (more useful for graphics than for photographs); *absolute colorimetric* makes no adjustment to the brightness; *relative colorimetric* changes only those colors that are out of gamut between the two spaces, and is the normal intent for photography.

sound system comprises Photoshop Color Settings, an accurate camera profile, and monitor calibration.

A CMS maps the colors from a device with one particular gamut to another. Obviously this is at its most useful when the color gamuts of the devices are substantially different. Printing presses (and desktop printers) have relatively small gamuts; certainly smaller than a high-end digital camera. A typical CMS uses a Reference Color Space that is independent of any device, and a color engine that converts image values in and out of this space, using information from the "profile" supplied by each device. The Mac OS has a particular advantage in color management—ColorSync, which is a CMS built-in at system level.

In practice, a CMS works like this. To convert screen colors to printer colors, for example, it first converts the monitor RGB color values to those in

Image workflow

Basic workflow

The color profile workflow is very simple in concept: every piece of color information that passes through the computer is translated for the target device using profiles.

Monitor

Monitor profile

Printer

Printer profile

Scanner

Scanner profile

Press profile

Camera

Camera profile

PostScript Imagesetter (CMYK)

Computer

*A color space is a way of describing the range, or gamut, of colors that a system is capable of reproducing. If all visible color—or at least that recognized by the L*a*b* system— is shown as the large shape, only certain parts are distinguishable in RGB (the triangle) or CMYK.*

a space that is larger and device-independent, such as L*a*b*. It then converts these to CMYK values in the smaller color space of the printer, while changing some of the colors according to the render intent. The render intent determines the priorities in the process, in which inevitably some colors will change (*see Definitions box, opposite*).

All of this sounds, and can be, complex. In print production a full knowledge is critical, but for several reasons it is not something for most photographers to get too worked up about. First, the industry is gradually taking care of color management in ways that make it less necessary for individuals to get involved. Color management depends heavily on each device (camera, monitor, scanner, printer, and so on) having a profile. Camera profiles are known, particularly the high-end models that most professionals use. Preserve the profile in the images you save and send, and the client or repro house will be able to deal with it. Second, ask yourself how much you want or need to immerse yourself in print production. Given all these software tools available, and the now seamless workflow from camera through to final printing, you may think you *ought* to, but many photographers think their time and energy

is better focused on taking pictures. Third, the default settings for the camera will already be close to standard, every bit as much as a normal film camera with normal film. Moreover, you can *measure* the important color variables, meaning that as you edit the images on the computer you can easily check that neutrals are neutral and that specific colors have the right RGB numbers. If you use one make of digital camera, very little will change, and you will become increasingly familiar with its color characteristics. In other words, as long as you deliver an optimized image, with the shadows and highlights where they should be, and with no distinct color cast (unless intentional), you will have fulfilled your normal photographer's duties. What follows are the basic core skills to do just this (*see pages 112-117*).

The only important qualification is that the monitor is calibrated, because this is the color space in which most of the work on a photograph gets done. Calibration is important, fairly straightforward, and nothing to lose sleep over. And there is one golden rule—if for any reason you find yourself making major overall changes to images from a digital camera, something is wrong. You shouldn't have to, and the problem is likely to be in the monitor calibration.

Color management

68-69 Camera profiling 104-105 Color 110-111 Monitor calibration 160-161 Printer calibration

Monitors

The quality and type of the monitor is extremely important. This is where most of your judgments about your photography will take place, and all of the image editing. Spare no expense on it. The four main decisions are size, brand, and model, and whether cathode-ray or active-matrix LCD (also known as TFT).

CRT (cathode-ray tube) monitors follow the traditional television design, with electron guns at the back of the tube firing toward the inside of the phosphor-coated screen. This is tried-and-tested technology, not particularly expensive, but the necessary depth of the tube makes the monitors bulky—and large displays, such as 20in, are heavy pieces of equipment. LCD displays are the alternative, and their technology has improved to the point where the best models offer superior brightness, saturation, and sharpness, all without bulk. The Apple Cinema Displays in particular set a new standard for active-matrix LCD displays. An earlier disadvantage was the limited viewing angle, which meant that even a slight shift in your position altered the apparent brightness of the image on the screen. This was not merely inconvenient; it made accurate judgment of brightness and color very

Separate palette monitor

If you have sufficient space, consider a second, smaller monitor display for the various palettes and windows needed for the software application you are using, such as Photoshop. This avoids obscuring parts of the image, and allows you to run the image full-screen. An alternative to this is a wider-than-standard cinema display, on which the palettes can be positioned to one side of the image.

High-end LCD advantages

- High brightness and contrast levels.
- No glare from screen.
- All-digital signal means no distortion.
- Viewing angle not an issue, as it is with smaller laptop displays.
- No flicker as with CRTs.
- In some cases less power consumption than CRTs.

Ideal viewing conditions

The eye is so good at adapting to different light levels and color casts that it actually works against us in setting up the monitor. The following precautions are essential:

1 The light levels in the room should be low, meaning around half the brightness of the screen. Too bright and you will not be able to register pure black, too dark and you may end up editing the image so it is too dark.

2 The room lighting should be somewhere close to "artificial daylight"—D50/5,000K.

3 The room interior should be neutral, not brightly colored. The same applies to your shirt or blouse—it will reflect a little in the screen.

4 Set the desktop pattern to neutral mid-gray. This will give the eye a constant neutral reference.

5 An optional accessory, which you can build yourself, is a black projecting viewing hood over the monitor. This can be cut back toward the base of the screen as its purpose is to shield reflected light from above and the sides.

difficult, but now, in good displays, this has been overcome. Failed pixels, appearing as white dots, are also now less common—there should be no more than four on a new display. Laptop screens without backlighting, however, are still not up to standard for accurate color and brightness judgment. If you use a laptop for shooting and downloading, try to defer optimization until you can put the images on the main home or studio computer. Otherwise, limit yourself to adjustments that can be made by the numbers instead of visually, such as setting black-and-white points.

It is essential to calibrate monitors as a first step toward overall color accuracy. At the very least, this means representing neutral grays as neutral, and ideally this should be not only for the mid-tones but also for the blacks and whites. This is dealt with on the following pages, but the conditions under which you view the monitor are also important. There are two issues here, and both relate to the surroundings. One is the ambient light level, the other is the ambient light *color*. Perception is always relative, and both

Image workflow

14-bit monitors

14-bit processing, as in the Eizo range of monitors, gives 16 times more grayscale accuracy than 10-bit processing, and because of the gamma scale, this means a much greater degree of color detail in the shadows. However, 14-bit monitors are considerably more expensive.

brightness and colors are judged by the eye in relation to adjacent parts of the scene. If the surroundings, for instance, have a yellowish cast, the eye will tend to over-compensate and see the screen as more blue than it is. What matters most is consistency. The eye is very capable of accommodating to different light levels and color casts, perhaps rather *too* capable. As a rule of thumb, try to keep the brightness level in the room where you keep the computer at about half the level of the monitor screen. A completely darkened room will allow you to distinguish every shadow detail, but it will also push you to edit images that will appear too dark under normal conditions. A bright room will have the opposite effect. The ideal is complete artificial lighting with daylight color-corrected lamps, but this may well be impractical, not to mention less pleasant than an office with a view of the garden. Consider translucent neutral roller blinds to cut down direct sunshine. The color temperature of daylight fluctuates also, so take this into account. For the same reasons, it is best to have neutrally painted walls, and above all, a neutral gray desktop pattern.

Above *A computer in an ideal lighting environment, with soft daylight from behind the monitor (to cut down on reflections).*

Below *The La Cie Electron Blue monitor is a professional-quality CRT (Cathode Ray Tube) monitor, which even features a hood to cut down on reflections and the influence of the ambient light on the display colors.*

Monitors

102-103 Computer needs 104-105 Color 110-111 Monitor calibration 128-129 Assigning profiles

Monitor calibration

Monitor calibration is the starting point for color management. Using system level color software (introduced by Apple in 1995 as ColorSync 2 and later by Microsoft in Windows 2000), your computer will automatically go some of the way to setting the displayed colors by accessing the monitor's ICC profile. This, however, is only a starting point. At the very least, use the system's calibration set-up assistant to work through the settings (*see the sequences, opposite*). The key steps are to adjust the brightness and neutrality of the black, white, and mid-points; to set the gamma (*see below for definition*); and to set the color temperature. The resulting settings are then saved with the name of your choice as a profile.

The standard gamma for Windows is 2.2, which is higher (therefore darker and more contrasty) than the standard for Macs, which is 1.8. This means that images optimized on a Mac will appear darker and more contrasty when viewed on a Windows machine—and there are many more of these than there are Macs. Conversely, images prepared on a Windows PC will tend to look paler than expected when seen on the screen of a Mac. This is an issue mainly for Mac users, and there is a difference of opinion, even among experts, when it comes to choosing the gamma for a Mac. If you work entirely within a Mac system, then native 1.8 gamma is clearly the way to go, but if your images are likely to be viewed or reviewed on PC monitors, there is an argument for working in 2.2 gamma—because that is how others will see the photographs. There is also room for choice in the color temperature of the target white point, which for use in a normal daylit room might be 6,500K, but in a color-corrected studio could be 5,000K.

With Macs, there is a built-in Display Calibrator Assistant, which can be found in the System Preferences menu (under the Color tab of the Displays panel). Windows computers have never had a direct equivalent, although Adobe Gamma installs into the Control Panel as you install Photoshop CS2 and earlier versions. CS3 and Vista, however, do not do this, although third-party solutions may emerge soon.

Gamma

Gamma is a measure of the slope or gradient of the response of an imaging device or medium to exposure. It is the result of plotting density against log exposure, and so is one way of representing the contrast of the middle useful section of the curve. It is therefore a good way of representing the intensity output of a monitor screen relative to the input. Raising the gamma is similar in effect to moving the midtone slider in *Levels* to the left—it brightens the image without affecting the black and white points. Lowering the gamma does the opposite—it darkens the image.

Another way of putting this is that gamma is the intensity of the output signal relative to the input. The minimum input is zero and the maximum is one, so that the default value for gamma is one—output equals input in a linear curve. In practice, gamma can be set to between 0.45 (bright, weak) and 3.00 (dark, intense). Note that the human eye's response to gamma is a subjective one of brightness and contrast. Due to the different ways in which Windows and Macintosh systems process the video signal, their default gammas are different—2.2 for Windows and 1.8 for Mac.

Standard Mac gamma 1.8

Standard Windows and television gamma 2.2

Step-by-step with Mac

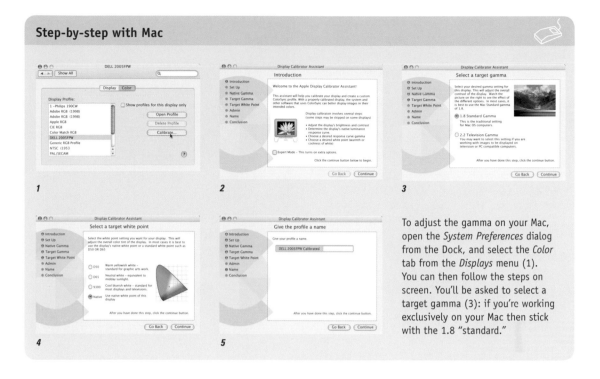

1

2

3

4

5

To adjust the gamma on your Mac, open the *System Preferences* dialog from the Dock, and select the *Color* tab from the *Displays* menu (1). You can then follow the steps on screen. You'll be asked to select a target gamma (3): if you're working exclusively on your Mac then stick with the 1.8 "standard."

Step-by-step with Windows

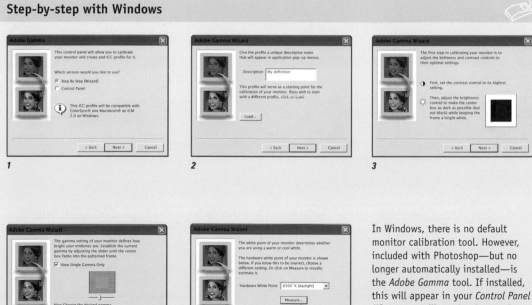

1

2

3

4

5

In Windows, there is no default monitor calibration tool. However, included with Photoshop—but no longer automatically installed—is the *Adobe Gamma* tool. If installed, this will appear in your *Control Panel* (if not you will need to locate the original install discs). Simply open it up in the usual way and (depending on your version of Windows) select the *Other Panels* or *Classic* views to locate it.

Monitor calibration

Calibration with a colorimeter

Moving one step forward in accuracy are calibration utilities that rely on a device, rather than your eye, to measure the on-screen colors. The ultimate measuring device is a spectrophotometer, but this is more than is necessary for a monitor screen, and a colorimeter with appropriate software is sufficient. The example used here is the Spyder colorimeter and OptiCal calibration software, supplied in a package. Instead of relying on your own judgment of brightness and neutrality, this method measures the actual output of the monitor and compares it with the known RGB values. From this, the software can construct a profile that is mechanically accurate. The Spyder uses eight silicon photo detectors to make the measurements; seven of these are color-filtered and the other measures neutral luminance. The theoretical advantages of an objective machine measurement are obvious, but the improvement it offers in practice depends on the type of monitor and your eye. An interesting exercise is to first calibrate the monitor by eye (as in the previous pages), then by colorimeter, and compare them by switching between the two saved profiles.

In operation, the colorimeter is positioned precisely over the screen so that it can read the color targets stored in its software. There is a difference between CRT monitors and LCDs—different baffles are fitted over the colorimeter's sensors, and while it can be stuck to a glass CRT screen with suction cups, these would damage an LCD screen. In either case, the room needs to be darkened, so that no ambient light reaches the screen to skew the readings.

This Sony Artisan CRT monitor includes as one of its features a colorimeter, with which you can keep the color display perfectly adjusted.

For LCD monitors

Set the *Curve/Gamma* and *Whitepoint/Color Temperature*—normally 1.8 for Mac and 2.2 for a PC. Recommended black luminance is 1.0 and the white luminance is 200.0. Choose Standard or Precision mode, fit the LCD baffle, and hang the colorimeter so that it lies flat on the screen in the indicated position. Run the program, during which the software will put up red, blue, green, and neutral patches at different luminance levels.

Calibrating across monitors

If you have more than one monitor with the same type of screen placed in similar viewing conditions, consider applying the same calibration to all. If you have a mixture of screens (CRT and LCD), and they are sited in different ambient brightness levels, don't bother to attempt this—calibrate each independently instead. Determine the weakest—that is, least bright—monitor, and calibrate that. Save the file with its luminance values, and copy this to the profile folder on the other computers (in this example, to the OptiCAL Targets folder). Launch the calibration program on the next computer, select the saved file, and adjust *only* the brightness and contrast controls to match the black target and white target values from the file.

CRT procedure

Set the *Curve/Gamma* and *Whitepoint/Color Temperature*—normally 1.8 for Mac and 2.2 for a PC. Recommended black luminance is .30 and the white luminance is 90.0. Choose Standard or Precision mode and attach the colorimeter to the screen in the indicated position. Run the program, during which the software will put up red, blue, green, and neutral patches at different luminance levels.

Image workflow

1 Select the appropriate settings for your monitor and computer system. The gamma Curve will normally be 1.8 on Apple Macintosh computers and 2.2 for Windows.

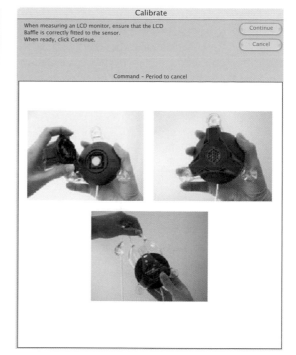

2 Follow the on-screen instructions to attach your Colorimeter. If you are using an LCD display, you'll almost certainly have to fit a special adapter to the device.

3 Allow the computer to display various colors, and measure your monitor's performance. It will cycle through a number of colors.

4 Save your new color profile, checking the Set as... option to instantly change the settings according to your new profile.

Calibration with a colorimeter

Daily downloads

Two fundamental features of digital photographs make it essential to set up a regime for processing the images at the end of each shoot. First, they have only a digital presence, not a physical one, and this puts them at a considerable risk of being altered unintentionally, deleted, or corrupted. The very simplicity and immediacy of recording digital images, which revolutionizes photography in certain ways, also makes them fragile and temporary—until they are processed and stored.

Second, there are no unique originals in digital photography. Instead, there are versions. In film photography, the exposure onto one frame of film is a unique event, and that film becomes the master image —this simplifies the issue of handling. In digital photography, there will typically be several versions of any good, useful image, including corrections and small, low-resolution images to send out for easy viewing. To avoid confusion, it is important to set this production train in motion as soon as possible.

At a convenient break in shooting, such as at the end of the day, the initial step is to download the images to a convenient and secure location. In most situations this will be your computer's hard drive, either your main studio machine or, if shooting on location, a laptop. The two usual methods are by connecting the camera to the computer or by connecting just the memory card through a card reader. In either case, it is important to choose appropriate browser software to control the downloading (also known as ingesting). In this example, the browser is Photo Mechanic, which offers a number of useful options, such as incremental downloading (adding just the new images shot on a memory card since the previous download) and sequential filenaming. The software can also be set up so that it launches as soon as the camera or memory card is connected. Alternatively, if for example you are using someone else's computer, you can copy the files from the card as you would from any external drive.

At this stage, or soon after, enter all the images into your standard filing system (*see pages 102-103*). The camera will already have numbered the images in its own way, and although on a high-end camera you can alter this to your own preferences, the file-names are unlikely to be exactly what you would like. Changing or adding to the file names while you are shooting takes time and distracts from actually taking pictures. The time and place to do this is on the computer, and if you do *not* rename the image files, there is a risk of overwriting them. It is common to have different images from different shoots sharing the same file-name—and it's a recipe for disaster.

Back-up procedures

Step three is to put into practice your back-up regime. Depending on how you plan this, you may want to make an immediate back-up, typically onto an external hard drive. It is important to remember that at this stage you are securing the raw, unedited image files, *not* retouched or corrected versions. That comes later. The browser software should allow you to rename files, even automatically (although be very careful with this if it does not allow you to undo or revert).

The procedures up to this point are the basic minimum for safety. The workflow sequence continues, although how much you choose to do daily is up to you. If you are shooting professionally for a client, you will need to present the images in a viewable way. In the first instance, it would be normal to prepare low-resolution files in a universal format, such as JPEG. If you are shooting in Raw format, the simple solution is to take the selected images that you want to deliver, and batch-process them to create smaller-sized copies in a new folder. This kind of batch-processing can be done with Photoshop, and in some cases with the camera's browser/editing software.

A daily download to a portable computer is an excellent opportunity to back up files and type up notes. Laptops like this Sony VGN-X505, weighing just 1.8lb (835g), are ideal for the traveling photographer.

Download workflow sequence

The first time your files are on a computer is the first real opportunity you get to ensure that you're using the correct file-names and that any important metadata is added. You can refine everything later, but the sooner you create back-ups, and the sooner you type up the day-to-day details from your notebook, the safer your pictures and information are.

The best way to ensure that your photographs are always safe is to follow the same procedure reliably. The sequence here uses Photo Mechanic.

1 Copy images to hard drive. First check all the relevant options as follows: a) Select the memory card b) Check incremental ingest to exclude images already downloaded; c) Create a folder as destination; d) Rename (here using a numbering sequence from the main archives); e) If necessary, set sequential numbers

2 Make one secure back-up, here to a small external hard drive (select all, then drag and drop)

3 Tag selects to make initial presentation edit.

4 Send by e-mail or FTP.

5 Batch-process copies of these selections. If you're importing Camera Raw files from the same session, you can apply your settings to the whole batch. In Photoshop's *File Browser*, select *Automate > Apply Camera Raw Settings...* either to create settings for a batch, or select one image and copy the settings from that.

6 Deliver the copies. Send copies to your client or to a secure server.

Daily downloads

Temporary storage

Digital photography has dynamically altered the logistics of shooting, and at no time is this more obvious and important than when on location, particularly for more than a day or two. No longer do you have to estimate the quantity of film you will need, or plan to replenish stock at dealers along the way. But you do have to plan for storing the images in digital media; more than that, you need to have a sensibly worked out "production flow" of image transfers that will keep pace with the way you shoot.

The numbers are easy to calculate, and start with the file size of one of your typical images (*see Memory cards, page 72*). Memory cards are relatively expensive storage media, and the faster you can transfer the images to less expensive media, the better. The most efficient strategy for long-term shooting (over a period of time, such as when traveling) is to have sufficient memory cards to be able to continue shooting until you can empty them conveniently onto a larger hard drive. The quantities depend on your individual way of shooting and on the kind of subjects that you expect to come across on a trip—parades and special events, for instance, tend to consume images faster.

This shines the spotlight clearly on portable long-term storage, and the most immediately obvious answer is to carry a laptop and download images onto its hard drive with additional small external hard drives. For additional safety, add extra levels of backup by transferring files from the laptop also to, for instance, an iPod and cell phone. An alternative is a stand-alone portable storage unit that features a small, typically 2½in, hard drive and a port that accepts memory cards directly. There are several models available, with capacities up to 80GB, that can be AC or battery-powered. These PDA-sized devices, which weigh in the region of just a few ounces, are convenient enough even to consider carrying in a shoulder bag as you shoot. All of this bypasses the computer completely. This is an improving technology, so monitor the latest developments: the first generation of portable storage devices often did not even have a viewing screen.

For short-term back-up protection, it's also sensible to aim to transfer the images, or at least those selected, onto *non*-digital media, of which the cheapest and most practical are CD-ROMs and, for larger quantities, DVDs.

Portable CD Burner

An alternative to a portable hard-drive based device is a battery-powered CD burner. These feature memory card slots and simply burn the files onto the widely-accepted disc format. A padded case for carrying a number of CDs—say 10 or 20—is a useful spacesaver, and can be bought at most music stores.

Burning CDs or DVDs

Both Windows and Macintosh computers can now burn CDs without any additional software. The process is one of simple drag and drop, though it is worth remembering that CD-Roms can only be written to once, so try to use as much space as possible.

Do you want to burn the disk "2004_05_03_backup"?
You can use the disc on any Macintosh computer or PC.
Burn Speed: Maximum

Eject Cancel Burn

You inserted a blank CD. Choose what to do from the pop-up menu.

Action: Open Finder
Name: 2004_05_03_backup
☐ Make this action the default

Eject Ignore OK

Image banks

These are essentially portable hard drives with a preview screen. The input port accepts any of the standard memory-card formats. USB or Firewire output allows the images to be downloaded to a computer at the end of a trip. Indeed, any portable hard drive can be used for image storage, even a music player such as the iPod.

EPSON P-5000
With a 4-inch LCD screen and an 80GB hard disk, the P5000 provides excellent storage and playback (it also supports many *multimedia files). Images can be copied directly from the CF or SD card slots to the hard disk, making this a handy traveling companion.*

Archos 700
While the Epson P-5000 is designed for photographers, the Archos is primarily sold as a multimedia device. Although it doesn't have a CF slot, it can copy images directly from the camera via a USB cable—a feature worth checking for on any similar device you might have.

Nikon Coolwalker
The Nikon's large 2.5in LCD is one of its greatest selling points, as is a remote control supplied for viewing images on a television screen. *Unsurprisingly it only displays Nikon Raw files, but its 30GB hard drive will quickly take any images or video from a Compact Flash card.*

Belkin Media Reader for iPod
The iPod digital music player is ubiquitous these days, and if you have one, there is no need to invest in an extra portable hard drive for your images. The Belkin adapter allows you to back up images to it via a USB socket.

This makes a laptop with CD- or DVD-burning ability useful (*see Storage and archiving, pages 126-127.*) In digitally developed countries, many film-processing labs and camera dealers offer inexpensive copying from memory cards onto CD-ROMs. If you check in advance that this service is available at your destination, it saves time and effort and removes the need to carry your own storage media. Even in less sophisticated places, if you have a card reader you could look for an Internet café or computer center, or even the business center of a hotel, that would be willing to download your images and then burn them for you onto a CD-ROM or even a DVD.

Temporary storage

42-43 File format 72-73 Memory cards 94-95 Accessories and tools 126-127 Storage and archiving

Browsers

The software needed immediately after shooting is a browser, which has three important functions: downloading images to folders in the computer, naming them, and viewing them directly. Menus and procedures vary according to the software. Browser software is normally supplied free by the camera manufacturer, but may not be as useful and well-designed as standalone software designed to work with all standard cameras and formats. With the increasing use of Raw shooting, it is important that the browser you use is capable of reading this manufacturer-specific file format, and that the software designers are committed to keeping pace with updates and new camera models.

In normal shooting the images are downloaded from the memory card to the computer through an interface cable that is normally USB or FireWire. This can be done either directly from a port on the camera, or by removing the card and inserting it in a card reader which is plugged into the computer. The transfer software, which is either part of the browser or linked to it, allows you to select which images to

Databases

Although databases can be used to browse, their real function is access and retrieval of images, and they are an essential part of managing a photo collection. In order to make the most efficient use of a database, you will need to plan from the start exactly how you allocate file-names. There are many possible ways, but whatever you choose, it must be logical and allow easy searches.

Most large image databases use a numerical identifier, but you can add a secondary description if your operating system allows more than eight characters. Searching is normally performed on keywords (*see pages 124-125*). There may be occasions when you need to save different versions of an image, and these will need either a different suffix (for instance, .jpg and .tif if you save an image in two file formats) or some extra identifier. For instance, you may want to keep both an unsharpened and sharpened version, in which case you could use something like the following: "15624_flamingo" and "15624_flamingo_sh"

Extensis Portfolio

File naming/numbering

Even if you accept the default method, the images will be given a name or number identification as they are transferred. Typically, there are three parts to this—a prefix, an identifier, and a suffix, the latter separated by a period. You may choose to assign a permanent file-name that fits into your long-term filing system as you download, or deal with this later when you have more time. In the latter case, the browser has an automatic batch-renaming program.

Rename file(s) (112 files)

Choose method:

○ Add suffix to the original file name

Suffix: Rename

Sample: imgRename.jpg

⦿ Rename with new numerical sequence

Prefix: Apri10.

Number of digits: ◄ ──●────────── ► 3 digits

Sample: Apr10.001.jpg

(Cancel) (Start)

File-naming conventions

Windows: Although in the past Windows allowed only 8-letter file names, these days there is just one practical restriction on file naming: never use a period (.) since Windows traditionally uses these as the divider between the file-name and extension (for example *name*.jpg is a JPEG file). In Windows XP and Vista, where long file-names are supported, the maximum length is 255 characters.

Macintosh: The maximum length for legacy systems (before OS X) is 31 characters. More non-alphanumeric characters are allowed than for Windows (for example the period), but if images are to be used cross-platform or transmitted by e-mail or FTP, it is better to stick to the conventions mentioned above.

transfer, to choose transfer options, specify the destination folder, and choose how the images are to be numbered or named. Take care to avoid over-writing image files with the same name, although the software will probably anticipate this and either give a warning or else assign different file-names. Some cameras are equipped with a transfer button.

Rotating images

Some cameras are able to sense when they have been turned to shoot a vertically composed image, and embed this data so that the browser can automatically rotate the image. Otherwise, you can identify and rotate vertical images manually in the browser. There is a slight risk of image degradation if you do this with JPEGs, but some browsers compensate for this by rotating JPEGs without decompressing them first. Check the browser manual for the recommended procedure.

Browsing

A browser, like *Bridge* (included with Photoshop), or external software like iView Media Pro, allows you to view images, and make changes to file information, including the metadata (*see box below*).

Metadata

This is embedded file information, some of it added by the camera, some by the user. It includes the following:

File Properties Characteristics that include size, creation, and modification dates.

Camera Data (EXIF) Added by the camera, EXIF information includes the camera settings that were used when the image was taken, such as the time, date, ISO, shutter, aperture, and other extended details. EXIF (Exchangeable Image File) format is an industry standard developed by JEIDA (Japan Electronic Industry Development Association).

GPS Some digital cameras have GPS (Global Positioning System) technology that allows the location of a photograph to be recorded.

Edit History A log of changes made to an image.

IPTC The only user-editable metadata, this allows you to add caption and copyright information to an image.

Viewing the EXIF camera data in the Nikon browser.

Editing the IPTC metadata.

Databases

Although databases can be used to browse, their real function is to access and retrieve images, and they are an essential part of managing a photo collection. In order to make the most efficient use of a database, you will need to plan from the start exactly how you allocate file names. There are many possible ways, but whatever you choose it must be logical and allow easy searches. Most large image databases use a numerical identifier, but you can add a secondary description. Searching is normally performed on keywords (*see pages 124-125*). There may be occasions when you need to save different versions of an image, and these will need either a different suffix (for instance, .jpg and .tif, if you save an image in two file formats) or some extra identifier. For instance, you may want to keep both an unsharpened and sharpened version, in which case you could use something like the following: "15624_flamingo" and "15624_flamingo_usm". Some alternative naming protocols are shown in the box "Versions." Check how your database handles attempts at duplicating filenames, as it is essential to avoid overwriting original images unintentionally. Workflow software may avoid the need by means of its non-destructive editing features.

There are several contenders, and the one featured here is Expression Media (formerly known as iView MediaPro), not least because I use it. There is a considerable amount of work involved in using a database, and it is continuing work, so selecting one demands some thought. Unless you opt for workflow software, (*see pages 122-123*) which incorporates database

Exporting images to client's exact requirements is made far easier using an image database's build in actions.

functions, your database should be the core of your picture-managing operations. The more it allows you to do, including selection, captioning, moving and copying files for distribution and so on, the more useful it will be.

One decision to make early is whether to use the database for importing/uploading/ingesting images from the camera or memory card, or whether to do this with a browser. The advantage of using the database is that it keeps one more operation under a single roof. The possible advantage of using a browser to do this is that the browser may be quicker and more flexible.

The database view makes it possible to quickly narrow down images from many thousands to just a few. By simply checking the boxes, or adding values, in the left-hand column, you refine your search.

Database tools can rename your files in batches, and add serial numbers.

Expression Media's thumbnail view is an efficient browser.

EXIF editing

EXIF data is embedded in the image by the camera, and includes time, date, ISO, shutter, aperture, and more, as already mentioned under "Metadata" on page 119. There is limited software available for altering it, because in principle this is useful information that other programs can use, such as databases, noise reduction software, and others that rely on knowing the precise settings. Nevertheless, there are reasons for wanting to make changes, and the most common is to correct the time and date—it is all too easy to forget to change the camera time and date settings when crossing time zones. Some databases permit limited adjustments; iView MediaPro, for example, has a time and date change function. Otherwise, use command-line instructions in a specialized program such as EXIFutils, but use with extreme care, as changes are non-reversible.

Databases

Workflow software

In the highly competitive software market for organizing and handling photographs, a new type of software has emerged that aims to provide a total, one-stop solution. The current main contenders are Lightroom from Adobe, Aperture from Apple, Capture One from Phase One, and DxO Optics Pro. What they aim to replace is the workflow model that relies on a browser to download, an image database to organize and Photoshop to do post-production. The advantage of one-stop software is speed and neatness, and the ability to concentrate on essentials rather than pick through the many features of the latest Photoshop that are of little value to photography. Against this, they require learning a new workflow system, creating a resistance among photographers who have invested years in learning the "traditional" photographer's workflow.

In order to streamline the workflow and create an attractive visual interface and experience for users, the major workflow software programs have, to some extent, buried the workings of the post-production tools that are more transparent in Photoshop, and there are divergent views on whether or not this is a good thing. For photographers with long experience of Photoshop and who prefer to stay firmly in control of image quality, there may be no clear advantage in changing their tried and true system, but for photographers who are either new to digital imaging, or who prefer to limit their involvement to the essentials, this kind of software may be ideal.

The main contenders in this software market vary in their approach, and are also constantly upgrading and evolving, as this is a relatively new area that still calls for user feedback. Three features that all have in common, however, are a Raw-focused approach, strong comparison and selection tools, and non-destructive processing. Assuming that most original files will be in a Raw format is sensible, given the target audience of

Typical Workflow

Import Images Workflow software will generally allow a wide range of options when importing images, including whether you create a copy of the file, move it into a folder organized by the application, or simply reference it. You can also add your copyright presets and any keywords for the batch of images you are importing.

Organize Just as with database applications, a fully featured browse view allows you to sort through your images, add and search on keywords, perform renaming operations on your files and so on. Although re-naming is permanent, most information about your images is stored in the database rather than altering the files.

Review, rank, and select Viewing images full-screen and adding ratings is a quick way to isolate good shots.

Process This is perhaps the key differentiator between workflow software and databases: that it is possible to enter into an edit mode and make changes to the image, both wholesale fixes and some local repairs.

Distribute Lightroom, for example, can generate HTML or Flash web pages, slide shows, and of course various prints including contact sheets.

Re-Order It is always possible to go to the browser and re-arrange or sort the database.

serious amateurs and professionals; compare-and-select procedures are essential for a program that promises to handle a large shoot which must eventually be whittled down to a few selects; and non-destructive processing, while nothing breathtakingly new, is one way of preserving the original files while allowing them to be processed. Key technical issues still being addressed are performance speed for various operations, open architecture, and the possibility of third-party plug-ins in the future. As it stands these can be very efficient and intuitive tools, if for no more than the ability to scan quickly through images at full-screen, identify the best, and begin that work without leaving the program. The full range of tools, all non-destructive and light on storage consumption, is a huge bonus.

A few more words on non-destructive processing—in principle, this simply means keeping the various steps in post-production, such as setting black and white points, curve corrections, sharpening, and so on, as separate instructions, and there are other ways of doing this. It happens in the camera, of course, whenever you shoot Raw. Raw converters such as Photoshop's save the settings last applied to an image as a sidecar file. Photoshop CS3 has a Smart Filters feature that appears in the Layers palette below the Smart Object layer to which they apply.

Lightroom's Develop mode offers all the same features as Adobe Camera Raw, which is no accident. Edited, the image does not affect the original file; instead a list of changes is kept in Lightroom's database. When the image is exported the changes can be implemented, or saved as a "sidecar" file which the next application can use to apply the changes. This is why there are few pixel edits, aside from some cloning (where source and target points can be referenced).

LightZone

A program which shares something of LightRoom's ethos—not to mention color scheme—is LightCraft's LightZone, a very visual image-editing application which allows you to make adjustments to keywords and similar information in its browse mode, and wholesale or local image changes using its deliberately visual interface. This includes novel ideas like using a draggable zone map (*see page 56*) when correcting exposure.

Workflow software

Captioning and keywording

At any of several stages, including browser, database, and image editor, you can add descriptive information to images in such a way that it remains embedded in them. The standard for doing this is called IPTC (International Press Telecommunications Council) and it includes entries for descriptions, keywords, categories, credits, and origins. This is important not only for cataloging, but also for selling reproduction rights in images. Captioning images may seem like a chore, but now that stock sales play such an important part in the business of photography, it is essential. Noting the key details of what you shot is useful for your own records, but the real reason is so that other people can find your images. This is very much a feature of being digital and online because the descriptions that are easily attached to the image file can be used by search engines. In pre-digital days, there were only two ways for a picture researcher or art director to find a specific photograph: call up stock libraries and ask, or look at the printed catalogs from the same libraries.

Metadata in Photoshop

Metadata can be viewed and edited either in the Metadata palette of the File Browser or in the various windows of File Info (*File > File Info...*). Having entered the IPTC information (caption under Description, keywords, copyright information, etc.) you can save this for future use in other, similar images: either save as a Metadata Template or as an XMP (extensible Metadata Platform) file from the *Advanced* tab of the *File Info* window in Photoshop.

Photoshop's File Info *display*

The Five Ws

Who Name if famous, newsworthy, or relevant. Ethnic origin. Job or position if relevant. Gender if a baby.
What Decide first whether action or object is the subject (consider which motivated you to take the picture). If action, describe it in first sentence. If object, give name (if a known building, landmark, geographical feature), description, and if a plant or animal, give the scientific name. In some cases, the concept will be appropriate—that is, an idea that you were trying to express (such as harmony, love, security).
Where Location as precisely as possible, ideally with a hierarchy (e.g. Montmartre, Paris, France).
When Date.
Why If the action is not immediately obvious to a viewer, explain it (usually in the second sentence).

Keyword tips

- Keywords supplement the caption for the purpose of searching.
- There is no need to repeat a word that is already in the caption/description.
- Too many keywords is as bad as too few. Aim for no more than 10.
- Think of what words your target audience is likely to use (for example, a natural history picture researcher may use the scientific name).
- Include different spellings and usages (for example gasoline/petrol).
- Include the plural unless it simply has an "s" added.
- Consider adding synonyms (use the Thesaurus tool in a word-processing program).

Now stock-agency websites allow the people who want pictures to search for themselves, and understanding how that happens in practice helps to sell images.

Captions sell photographs. At least, they sell content-based photographs, and the more specialized the subject matter, the more important it is to know exactly what you shot. The best time to do this is on the spot, while you can still ask, and before you forget. A notebook or tape recorder are the easiest means; inputting directly into the camera seems efficient but takes longer (*see page 76*). As part of a normal workflow, captioning fits most easily into the image editing, either before or after optimization. A successful caption is informative, focused, and succinct, and the

first skill is to identify the salient facts and then prioritize them. With stock images, the aim of the caption is to present all relevant information to other professionals rather than general readers, while the keywords add to the searchable information. All this information can be extracted by image-management programs and other databases. The time to enter the caption information is as early as possible in the inevitable chain of image versions and copies. It may be worth maintaining a master caption list in a word-processing program as a reminder of which images have already been captioned and also as a source for cutting and pasting. Several images may share the same basic information, or at least some of it—you could then copy parts of entries from the master list into Photoshop's File Info for each new image. Alternatively, save the metadata where it can be retrieved from another image's File Info dialog (*see Metadata in Photoshop, opposite*).

Two-sentence captions

Summarize the essential facts in a first short sentence, then expand on this and give the context in a second, longer sentence. Some databases and search engines designed for images have a "short description" and a "long description" entry field. A two-sentence caption can be divided easily between these fields. Nevertheless, avoid redundancy—if you wrote it in the first sentence, don't repeat it, and don't state the obvious (if a dress is red, there's no need to mention it).

Keywords

The value of a database lies almost entirely in retrieval —that is, how easy it makes it for a user to find a suitable image. As images accumulate in the database, it becomes increasingly difficult even for the person who took them to remember the details. If you want other people to be able to search through your library of pictures, for instance if you are selling them as stock photography, you will certainly have to anticipate how they might search. The software issues are highly technical, but common to all is the concept of keywords. These are words describing some aspect of an image; when someone enters a word in the search box of the database, the program will look for images that have the same word attached. The more varied yet relevant the set of keywords attached to each photograph, the better the chance of matching the searcher's request. The trick is in imagining what other people might look for, beyond the obvious description. Where there is competition, it is of great benefit to have spent just a little more time and energy adding keywords than your competitor, though obviously it's important that your database doesn't "cry wolf" by using keywords that don't describe the picture.

In this database, the fields to complete are: Short caption, Long caption, and a list of Keywords. The short caption, "Dashimaki Tamango, a Japanese egg roll" does not tread on the toes of the Keyword list: cooking, eggs, omelette, cuisine, food, yellow.

Captioning and keywording

76-77 In-camera editing 114-115 Daily downloads 118-119 Browsers and databases 126-127 Storage and archiving

Storage and archiving

Digital image files have a different kind of fragility from film. They are robust in the sense that they won't scratch or suffer other physical damage, and *can* be copied with no loss of quality, but they can be deleted and become corrupted. Their only physical presence is as recordings on digital media, such as memory cards, hard drives, CDs, and so on. Your computer's hard drive, however large, will eventually fill up, and for this reason alone it is important to move the files to other media. Moreover, having a back-up is a part of good computer housekeeping—remember that the high-volume solution for most people is an external hard-drive, and preferably more than one. Mirrored hard drives, meaning one carrying an exact copy of the other, are standard insurance. In addition, depending on the volume you shoot, yet another backup on a DVD has the advantage of being a different medium, and non-magnetic. DVDs are also universal and compatible. Most computers come fitted with a CD-writer at least, and some with a DVD-writer. The various flavors, as they are known, are described here. Backup policy involves two actions: make an identical copy of everything you store, and keep it in a different physical location.

There are many backup programs available. The simplest, but least efficient method is to simply copy all the files onto the destination. True backup software allows you to perform incremental additions, making it unnecessary to copy existing files over again. As a general rule, backup software that devotes a lot of energy to making the interface comfortable and idiot-proof performs more slowly than stripped-down, leaner programs.

Tape back-up

If you have very large numbers of images, consider the traditional back-up technology—tape. Its two considerable advantages are capacity (tens and hundreds of gigabytes, even terabytes with some systems) and cost. Security and longevity are high, and while there is constant development going on, and therefore many different formats, this is such a universally accepted back-up method that it will be around for a very long time. Formats include ADR, DLT, AIT, SAIT, and DAT CK.

Tape drive

Tape media

CD and DVD storage units

DVD writing

DVD, often thought of as *digital video disc* but more correctly known as *digital versatile disc*, is a development of the CD, with a seven-fold increase in data capacity and a basic transfer rate of about nine times that of CD. The track pitch (distance between each) is less than half that of CD, the pits are much smaller, the laser wavelength is smaller, data can be burned to and read from more than one layer (by changing the focus of the laser) and from both sides. With the same 5in (12cm) diameter, 1.2mm thick dimensions as CD, DVD has the following capacities:

- DVD-5 - 4.7GB single-sided, single-layered disc.
- DVD-9 - 8.5GB single-sided, double-layered disc.
- DVD-10 - 9.4GB dual-sided, single-layered disc.
- DVD-18 - 17GB dual-sided, dual-layered disc.

There are five recordable versions of DVD:

DVD-RAM
The first rewritable DVD format, DVD-RAM uses phase-change technology similar to that in CD-R. Of all the DVD formats this is the least compatible with different players. It has some distinct advantages in terms of re-writing and data recording, however, since it does not need to record a lead-in and lead-out each time the disc is used.

DVD-R and DVD-RW
Similar to CD-R, DVD-R (or, DVD-Recordable) is write-once. Recording takes place on a dye layer that is permanently altered by a highly focused red laser beam. As with CD-R, there are three areas: lead-in, user data, and lead-out. Also, as with CD-R and CD-RW, the write-once -R format is compatible with more DVD read-only drives than its -RW counterpart. (This is the format used by Apple's built-in DVD writer, the "Superdrive.")

DVD+R and DVD+RW
This third rewritable DVD format has the highest compatibility. Like DVD-R it comes in write-once and re-writable flavors with varying degrees of compatibility. Some drives can now write to both +R and -R formats, and are typically designated ±R. If you're buying a DVD writer, this is a good way of hedging your bets. At the moment, only DVD+R supports dual-layer burning.

Newer DVD writers, like this Sony DRX-700UL, are capable of writing dual-layer discs. The 8.5GB discs are fully compatible with the DVD9 standard.

RAID

RAID stands for Redundant Array of Inexpensive (or Independent) Disks, and is a hardware-plus-software technology designed for high storage safety. A RAID device is a stack of hard drives (typically four or five) that function as a single unit. Depending on the RAID level you choose to implement, the device can store files in such a way that if one disk crashes, all the information can be rebuilt from the remaining drives. The safer the RAID level chosen, the less the total capacity. Individual drives are hot-swappable, meaning that you can pull them out safely while the device is connected and running.

File formats and compression

While there are a number of file formats in which you can save images after optimization—see the list available in Photoshop's Format drop-down menu in the *Save As...* dialog—there is little reason for photographic images to stray beyond the two most widely recognized: TIFF and JPEG. Universal readability is important if the images are likely to be seen and used by other people, and if you want to open them in different applications. TIFF offers a lossless compression method, LZW, and this can typically reduce the file size by more than half. This is for 8-bit images; it does little for 16-bit. JPEG is both file format and compression system, and ideal for transmission. You can choose the degree of compression in the dialog box as you save, but beware of saving JPEGs more than once—this simply multiplies the artifacting.

Optimizing—the basics

There are a number of reasons for adjusting image qualities in post-production, and several occasions in the workflow, but the most basic is to have it look as you think it should. In other words, to optimize it. This seemingly straightforward idea hides the issue of how you define the *best* appearance, and in practice this is a combination of objective technical standards and the subjective ones of your personal preference. As the person who saw the scene and chose to take the photograph, only you are fully qualified to decide on what the optimal brightness, contrast, and color should be, and for this reason it is always best to perform these adjustments as soon as possible, while your memory is fresh.

The key here is the sequence—the order in which you make the several different adjustments to the image. The aim is to avoid making a change that will later be changed again, as would happen for instance if you first altered a specific hue and *then* made a global color change. The most logical approach is to work from global corrections to selective, and the following four stages do this:

1 Balance the overall color, eliminating any unwanted cast. Either identify this bias by eye and use any of the

The former metropolis of Pagan is spread over 10 square miles (25km²) on the banks of the Irrawaddy River in what we now call Myanmar (Burma). This is one of the 13,000 religious buildings that once stood there. In the top image, it is shown with a bright color temperature; in the one below it is muted to create a more ghostly and ethereal effect.

Smart optimization

It is possible to make an independent, objective adjustment that traces and eliminates a color cast, closes up the ends of the histogram to make the range from black (0) to white (255), and performs a pre-set saturation. This takes no account of the content of the image, but is a useful starting point as an unbiased suggestion of how the image might be improved. One of the reasons it works so well has to do with the psychology of perception—in a side-by-side comparison, most people prefer brighter, richer, crisper versions of an image. In Photoshop, tools to consider are those in the *Image > Adjustments >* menu, such as *Auto Levels* and *Shadows/Highlights*. There are also third-party applications that can help, such as I-Tricks 2, a stand-alone color-repair program. (*But see Make a creative assessment, below.*)

Make a creative assessment

The process of optimizing for color has one serious built-in flaw. It tacitly assumes that every image deserves the same basic standards of brightness, a full contrast range, neutral grays, and so on. Most of the time this is true, and "automatic optimization" (*see Smart optimization, above*) nearly always looks instinctively better. Yet this may not suit the purpose of the shot. For example, if part of the appeal of a landscape like the one shown here is its limited range of muted colors and softness, there is no point in closing up the *Levels* to give it a range from black to white. The very first step in optimizing any image is to assess it from a creative viewpoint. What was the effect you were aiming for when you shot? Will it suit the image to be other than normal? (*See Altering light and atmosphere, pages 198-199.*)

Optimizing steps

The iCorrect EditLab provides an excellent example of an ordered optimizing workflow. The approach can just as easily be achieved in other software; balancing the overall color, then the levels histogram, before making more personal adjustments to brightness, contrast, and individual tones.

1 *Correct the overall color balance by setting a neutral.*

2 *Set the black and white points.*

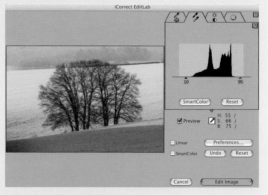

3 *Adjust brightness, contrast, and saturation.*

4 *Correct specific colors (hues) individually*

usual tools (*Color Balance* sliders, individual channels in *Levels* or *Curves*), or use a *Gray Point* "dropper" on any tone that you think should be neutral.

2 Set the black and white points. The simplest way is to close up the ends of the histogram in Levels. Otherwise, use *Black Point* and *White Point* "droppers" on the darkest and brightest parts of the image, respectively.

3 Adjust brightness, contrast, and saturation overall. *Curves* gives excellent control over brightness and contrast (*see page 142*), while saturation is most easily adjusted in the HSB dialog.

4 Adjust individual color ranges, for instance by using one of the hue ranges in HSB.

Why optimize?

- The computer display is a better place to judge image quality than the camera's LCD.
- The original camera settings are unlikely to be 100% perfect.
- The lighting conditions may not have been what you wanted.
- You may change your mind about brightness, contrast, or color.
- It's sound QA (quality assurance) procedure and guarantees consistency.

Optimizing—the basics

132-133 Optimizing tips 140-141 Histograms and levels 142-143 Curves adjustment 144-145 Shadow/highlight adjustment

Optimizing—advanced

How far you take optimization depends on the needs of the image and on how much time you are prepared to put into perfecting it. Even if you think you have a duty to do everything possible, in the real world, there may simply not be enough time to work on every photograph. In any case, optimizing is subject to the law of diminishing returns—lengthy tweaking of details may not have a significant impact. Nevertheless, the recommended procedure for a full optimization is as described here. Remember, however, that this is not cast in stone, but just an example of one reliable sequence.

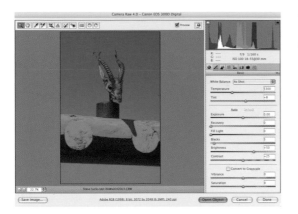

A Raw adjustment For anyone serious about good image quality, *the* first step is to shoot Raw format. The latest Photoshop *Raw* adjustment window offers an exceptional range of controls. It is possible to do almost all the work here (*see pages 134-139*).

B Assign profile This is best seen as an alternative to Raw adjustment, and it is not practical to make full use of both. If color precision is important, you may want to adjust the tonal range in the *Raw* dialog, and then assign a prepared profile.

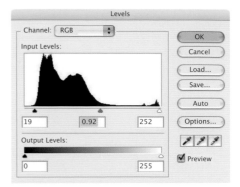

C Levels Again, if you have made good use of Raw adjustment, in particular the *Exposure* and *Shadows* sliders, going to *Levels* may not be necessary other than to check the histogram. Otherwise, the key procedure in *Levels* is to set the black and white points (*see page 140*). Any adjustments to the tones *between* these points, however, is better left to the *Curves* dialog. Moving the midpoint slider alters the brightness around the exact midtone only, while *Curves* allows you the flexibility of biasing the lightening or darkening toward the shadows or highlights.

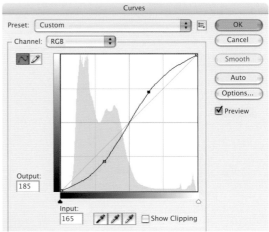

D Curves This has long been the precision tool for tonal adjustments, and is dealt with in detail later (*see pages 142-143*). Nevertheless, it now has two strong competitors in Photoshop—one is the Raw adjustment dialog (A, above) and the other is the new *Shadow/Highlight* dialog (E, above right).

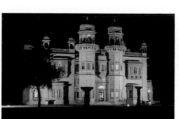

E Shadow/Highlight
This extremely useful control is slider-based in operation, designed for photographs, and actually exceeds the ability of *Curves* to manipulate contrast in the midtones. Because of its unique method of working, this is almost always worth looking at before finalizing an image (*see pages 144-145*).

F Hue/Saturation While saturation *can* be manipulated in *Curves*, the simplest control for it is the *HSB* dialog. Once again, however, Raw adjustment also allows great control over hue and saturation, and may make this step unnecessary.

G Distortion correction and cropping Distortion may occur because of tilting the camera in a situation that calls for vertical verticals, or through over-enthusiastic use of an extreme wide-angle lens, or because of lens barreling or pin-cushion aberrations. Correction usually leaves some gaps that need cropping, so that if you plan to crop the image for compositional reasons in any case, it is best to run these two operations together. Photoshop's distortion-correction tools are either those under *Edit > Transform*, or the Lens Correction filter, and there are many third-party plug-ins for dealing with lens distortion of the barreling and pin-cushion varieties (*see pages 180-183*).

H Retouch Finally, and there is little point in doing this before the above procedures, remove artifacts with the *Healing* or *Clone Stamp* tools. The main culprits are dust particles on the sensor, but you might then decide to move on to more elaborate image-editing, such as removing power lines from a landscape, or skin blemishes on a portrait.

Optimizing—advanced

Optimizing tips

Essential to remember in any form of digital correction or adjustment: there are always different ways of achieving the same result. There is no such thing as a correct procedure or sequence, and the steps listed on the previous pages are no more than my recommendation. This is partly because there are many digital tools available, even within the single software Photoshop, and partly because any evaluation of a photograph is ultimately subjective *and a part of the creative process.* Allied to this is the concept of "tips and tricks," which in other circumstances would just be sloppy methodology. Yet in optimization and image-editing generally, tips and tricks are—strange though it may seem—a *part* of the methodology. Here are some key ones.

Plug-ins

Yes, most optimization procedures can be performed in a major image-editing program such as Photoshop. The value of third-party plug-ins (and stand-alones) is that they are dedicated to the process, usually bring special expertise, and, above all, are convenient and speed up the workflow. iCorrect EditLab, for example, follows the four-stage sequence mentioned in the text, and ensures that later corrections do not interfere with preceding ones.

Evaluating a color chart

Shooting a test that includes a color chart (such as the GretagMacbeth ColorChecker on the right) vastly improves your chances of guaranteeing faithful color. Ideally, do it once for any given lighting situation (*see page 68*). For easy reference, crop into the chart and save this image as a check file. Its appearance in Photoshop should be as follows; if not, use the Raw editor so that it does—*and note the settings.*
1 The white square should be 250-245 and no higher in all channels.
2 The black square (darkest neutral) should be 5 and no lower in all channels.
3 You can distinguish all the neutrals from each other.
4 No RGB values in any square are lower than 5 or higher than 250.
5 The RGB values in the neutral squares are within 5 points of each other (e.g. 126, 130, 127, *not* 124, 132, 121).

Using color charts and gray cards

If you are using Raw format, evaluate the color chart as described in the box, and adjust in the Raw editor as closely as possible to bring its appearance into line. Then, in Levels, use the white point dropper on the white square, the black point dropper on the black, and the gray point on the mid-toned neutral. Most important of all is to note the three Input Settings for all channels. Then apply these settings to the other images shot in the same session. If you included only a standard 18%-reflectance gray card in the picture, first click the gray point dropper on it to set neutrals, then adjust the middle slider under the RGB histogram until the values, when you run the cursor over the image of the gray card, read as closely as possible to 127, 127, 127.

GretagMacbeth™ ColorChecker Color Rendition Chart

Choose the mode for the purpose

The default mode in digital capture is, naturally enough, RGB. There may be an advantage, however, in switching temporarily to Lab for editing purposes—in order to target specific image qualities. Working on the Lightness channel protects against unwanted color changes, as mentioned above, while the a and the b channels allow work on red-to-green and blue-to-yellow color ranges. Equally, RGB allows work on specific channels: the blue channel, for example, often carries more noise than the other two.

Always work at a high bit-depth

Normal 8-bit color (*see page 42*) allows 16,777,216 separate colors in an image, well beyond the eye's ability to discriminate. However, any major change to the contrast, brightness, or colors, such as you might make with the *Curves* or *Levels* tools will destroy some of these as it shifts certain pixel values. The tell-tale sign is in the histogram—after an adjustment there will typically be white line gaps and black spikes above, instead of a smoothly curved, solid-black mass. The way to avoid this is to edit in 16-bit. It's double the file size and overkill for a final image, but there are sufficient color steps (well over 281 trillion of them) to accommodate any changes. If you shoot in Raw, Photoshop will automatically convert the image into 16-bit. Otherwise, if you have an 8-bit image, it is still worthwhile converting it to 16-bit for editing. But in this case, convert to Lab mode and edit the *Lightness* channel for the least damage (*see below*).

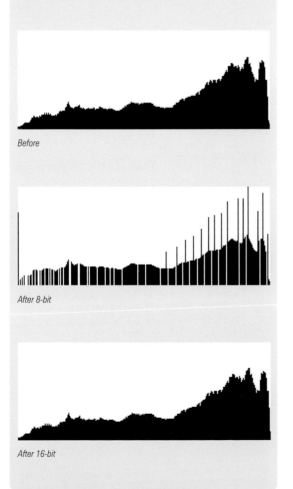

Before

After 8-bit

After 16-bit

Setting up Photoshop for profiles

If you plan to use a managed color workflow in Photoshop, you will need to calibrate your monitor, using either the visual method (*see page 111*) or using a colorimeter (*see pages 112-113*).

The first time you launch Photoshop after installing, you're asked "Do you wish to cutomize the color settings?" The default setting is *Web Graphics*, which is designed to maintain color graphics consistently on screen. It may be that you don't need to alter this at all; however, if you're planning another kind of workflow, click *Yes* to be taken to the *Color Settings* dialog. If you're not installing Photoshop for the first time, you can access the dialog via *Edit > Color Settings...* (or on older Mac versions via the Photoshop menu).

In order to maintain consistency, ensure that you use the same settings in any other color-managed applications that you use. Colors might also seem different in non-color managed software.

Go to *Color Settings* and make sure that the highlighted fields are as shown here. Adobe RGB (1998) is in any case the working space of choice for photographs. Under *Color Management Policy*, for RGB choose *Convert to Working RGB*; this ensures that images always appear in this standard color space. The two options at the bottom of the window give you the opportunity to discard unwanted profiles and to assign the one of your choice.

Optimizing tips

Working with Raw files

Aside from the possible disadvantage of demanding more post-production time, Raw format is, where available, the professional choice. The simple reason is that the data and settings are stored separately on capture, meaning that later, in Photoshop, you have complete access to the original, "raw," data. Moreover, this image information remains at the maximum bit-depth of which the sensor is capable (typically, 12-bit, 14-bit, or 16-bit—*see page 42 for the importance and implications of this*). If you have any need at all to optimize or alter the image, Raw is the obvious choice.

There are some decisions you need to make about fitting Raw adjustments into your workflow. The first is, which software to use? One possibility is the image editor offered by the camera manufacturer, with the advantage that this should be thoroughly integrated with the camera's sensor and processor. Alternatively, Photoshop has a Camera Raw plug-in, and its advantages are: first, that as you are probably going to be working in Photoshop anyway, you might as well start here, and second, that it has more sophisticated controls than most camera manufacturer software, odd though this may seem. Ideally, test the two side-by-side with different images and decide for yourself.

Photoshop's Raw converter (originally offered as a plug-in for version 7, now regularly updated and included with Photoshop updates) enables extensive changes to be made to the image. These dialog tabs, in combination with the Adjust *tab (see opposite), illustrate the choice available. It is sensible to use these tabs according to the* Sequence of adjustments *(see box, right).*

Sequence of adjustments

Camera Calibration window
1 Compensate for errors in reading the camera's profile, ideally by loading a pre-prepared profile (*see page 139, The real camera profile*)

Basic window
2 Set White Balance, adjusting with Temperature and Tint sliders
3 (optional) Choose Auto adjustment to see what the software recommends, but don't necessarily use this
4 Adjust Exposure for the overall brightness, favoring the high values, paying attention to highlight clipping (set the clipping warning on)
5 Adjust Recovery, if necessary, to recover clipped highlights by reconstructing from remaining one or two channels
6 Adjust Fill Light if necessary to open up shadows, being careful not to overdo this
7 Adjust Blacks if necessary, effectively to set the black point
8 Adjust Brightness if necessary, to alter overall tonal range (this compresses or expands shadows and highlights without clipping them, provided that the slider is used moderately)
9 Adjust Contrast to fine-tune contrast in the mid-tones
10 Adjust Vibrance and/or Saturation to achieve the desired color saturation. Favour the Vibrance control, which has built-in protection against clipping when particular hues approach full saturation

Tone Curve window (optional)
11 If necessary, make fine adjustments to the tonal distribution after working in the Basic window

HSL/Grayscale window
12 Tweak individual colors if necessary

Detail window
13 Adjust Sharpness only if aiming directly for a specific output
14 Reduce noise in a high-ISO image by adjusting Luminance Smoothing to control luminance (grayscale) noise and Color Noise Reduction to control chrominance noise. Otherwise, perform this in a specialist noise-reduction program

Lens Corrections window
15 Correct color fringing due to lens defects with the Chromatic Aberration R/C (red-cyan) and B/Y (blue-yellow) sliders
16 Correct cornershading if necessary (typically with a wide-angle lens), using the Vignetting Amount and Midpoint sliders

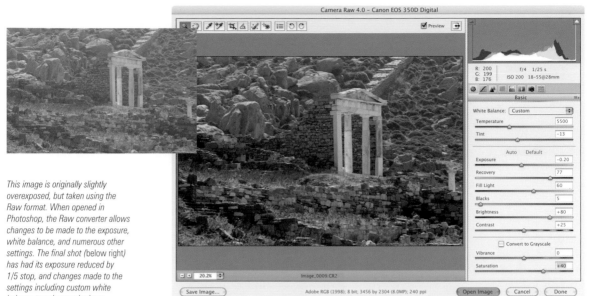

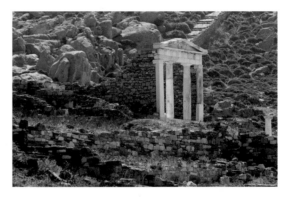

This image is originally slightly overexposed, but taken using the Raw format. When opened in Photoshop, the Raw converter allows changes to be made to the exposure, white balance, and numerous other settings. The final shot (below right) has had its exposure reduced by 1/5 stop, and changes made to the settings including custom white balance to enhance shadows.

What to change?

Another decision is *which* adjustments to make at this stage, and which later with the normal Photoshop editing tools. The *Exposure* and *White Balance* adjustments are clear winners in Raw, because they can restore original data, while some others, such as *Sharpness*, are usually best left until later, as they use essentially the same algorithms. More difficult to decide is the contest between Raw adjustment and camera profiling. If you use profiling software to create a specific camera profile (*pages 68-69*), this is only good for images that have *not* been adjusted during opening. Basically, you can't have both. One alternative is to restrict the Raw adjustments to tonal range (that is, *Exposure*, *Shadows*, and *Brightness*, in Photoshop's Camera Raw plug-in) and then assign the profile. Another is to use the *Ca librate* dialog to make the same profile adjustments (*see The real camera profile, page 139*). If you are having problems with the way in which the plug-in reads non-neutral colors, this may be sufficient reason for using the camera manufacturer's Raw adjustment software instead.

Photoshop CS automatically opens a Raw file by displaying an adjustment window, as shown. This offers all the original camera settings and possibly more, depending on the camera, although the menu structure is different. This is where to begin, and in many cases, this set of dialogs can take care of all that you need to do to an image—one-stop optimization.

Raw converters

Third parties offer Raw converter software, and camera manufacturers often supply their own.

Nikon

Canon

Working with Raw files

42-43 File format 68-69 Camera profiling 138-139 Advanced Raw 180-181 Correcting lens distortion

Photoshop's basic Raw workflow

For many images, the Raw Adjust window is the only dialog that you may need. Note that the Workflow Options, formerly grouped in the lower left corner, are now accessed from a clickable line at the bottom—these are color space, bit-depth, and size and resolution. The Raw adjust controls, from top to bottom in the order in which you would normally use them, are White Balance (Presets plus color temperature and tint sliders), Exposure, Recovery, Fill Light, Blacks, Brightness, Contrast and two color saturation controls, Vibrance and Saturation.

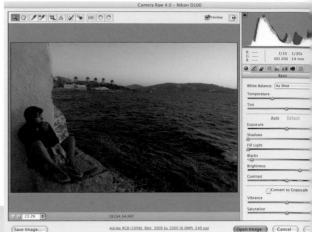

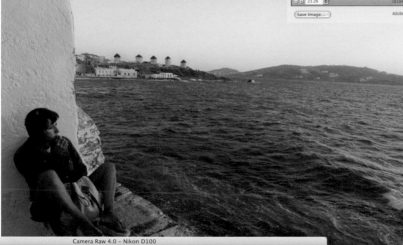

Above *The image as opened in the* Raw Adjust *window.*

Left *The final image, after adjustment.*

Below left *After a color balance adjustment is applied.*

White balance

This is why it matters not at all what white balance setting you choose when shooting—simply set it here. There are three ways of doing this, offering much greater control than in-camera. The simplest is the drop-down menu which replicates the choice in the camera menu, and the default is "As Shot." Alternatively, use the color temperature slider, which operates on the Kelvin scale (*see page 63*), fine-tuning afterward with the Tint slider—this adds magenta to the right (+) or green to the left (-). Thirdly, use the dropper (*White Balance* tool) in the top left of the main window to select a tone in the image that you know or want to be neutral gray. The sliders can be used at any time to make further adjustments.

Second-chance exposure

This feature alone makes Raw editing worth it: the ability to re-visit the shoot and select an exposure setting up to 2 *f*-stops brighter or darker—a total of 4 stops real range. Ideally, work from the top down through the adjustment sliders. Watch the highlights as you drag the Exposure slider first. Also consider holding down the Alt/⌥ Key as you move the slider. This reveals any highlight clipping as colored areas out of a black base, and so is an ideal way of setting the white point—in the same way as you would do it in Levels, but better, as here it is on more of the image data. Typically, for a normal image, show just the beginnings of clipping. As the colored areas show individual channels, only pure white (the combination of all three) indicates complete (255,255,255) clipping. As long as only one or two channels are clipped in the highlights, the Recovery slider can restore pixels by reconstructing from the remaining channel(s). Follow with the Blacks slider, where holding down Alt/⌥ shows shadow clipping out of a white base. Use this to set the black point, as shown.

White point

Black point

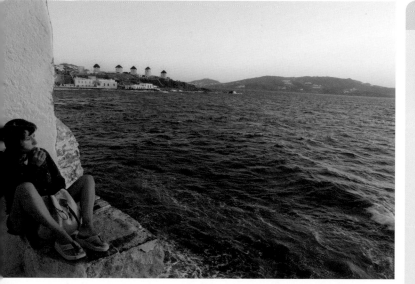

Midtone adjustments

Following the all-important exposure adjustments, use the Brightness slider to alter mid-tones within the set black and white points. Follow this with Contrast, which also works principally on the mid-tones. Fill Light performs similar work to the Shadow/Highlight control in opening up shadow detail, and runs the same risk of false appearance if used aggressively. Saturation control has a new slider, called Vibrance, which minimizes clipping as full saturation in any one hue is approached, so this is generally a safer alternative for photography than the Saturation slider.

Raw adjust window

Advanced Raw

Good Raw converter software offers extra tools beyond exposure, brightness, tonal range and color. Extras such as sharpening, noise reduction, lens aberration control, vignetting, perspective distortion, rotation to straighten up a horizon, tone curve, even black-and-white conversion and split toning, are becoming the norm as more photographers shoot Raw and the Raw converter industry becomes more and more competitive. The number and type of extra features varies with the program. A sign of the direction being taken toward comprehensive post-production within the Raw converter dialog is the arrival of rudimentary retouching tools. Expect more features and more sophistication to be added.

Which editing software?

While Photoshop has all the tools necessary, the editing software available from the camera manufacturer has the advantage that it is designed to work with their specific Raw files. This is offset by weaker software engineering relative to, say, Adobe. The market for raw conversion has expanded and become more competitive recently, and there are now many choices, not least among the new class of workflow software, including Lightroom, Aperture, DxO Optics and Capture One. Ideally, download demo versions of different Raw converter software and compare the results for your camera. Because Raw format allows alterations to be made to the original exposure data received by the sensor, use it before image-editing tools.

Saving and loading

The image opened in Raw can be saved in a number of file formats (TIFF is normal) but not in the original camera Raw format. In other words, you cannot overwrite the original, which is a good thing. An open-source Raw format, DNG, promoted by Adobe, is a saveable format, but there are differences of opinion as to its usefulness. It can be seen as a step away from the orginal Raw, but in a different direction from TIFF and JPEG. As for the adjustments you make during opening, these *can* be saved, and in such a way that they can be re-applied to other images if you like. There is a choice of two places in which to save them. The default is the Camera Raw database. In Windows this is usually located in the user's *Application Data* folder as *Document and Settings/user name /Application Data/Adobe/CameraRaw* (Windows), and in Mac OS in the user's *Preferences* folder as *Users/ user name/Library/Preferences* (Mac OS). The advantage of saving here is that the images are indexed by file content, so that the settings stick to the image even if you rename or move it. The alternative is in a sidecar ".xmp" file, which uses the same name and is stored in the same folder. If you want to archive the Raw image files *with* their settings, this is the better choice. With sidecar files stored on a CD or DVD, make sure that you copy them to your hard drive along with the images before opening.

Lens defects

Two of the more common lens defects are chromatic aberration, in which a lens focuses different wavelengths (that is, different colors) differently, and vignetting, in which the light transmission falls off radially, toward the edges of the frame. The chromatic aberration correction here is very useful if the problem exists, while the vignetting correction is one of several alternatives (*see Tonal artifacts, page 178*). Actually, chromatic aberration manifests itself in a number of ways depending on the lens, and the Camera Raw adjustment deals with one of them, called complementary fringing. In this, the fringe colors are strongest alongside high-contrast edges in the image, and close to the corners of the frame. They differ in color between the side closest to and the side furthest from the center. The R/C slider controls red-cyan fringing, the B/Y slider blue-yellow. The *Vignetting Amount* slider lightens the corners when moved to the right (+), or darkens when moved left (-). The *Midpoint* slider alters the spread of the lightening; moving right (+) restricts the effect toward the corners, moving left (-) broadens it toward the center.

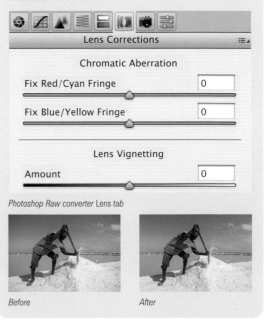

Photoshop Raw converter Lens tab

Before *After*

Sharpness and noise

Given that sharpening is always best performed at the end of image-editing, or just before printing (*see Sharpening policy, page 148*), this is not really the place to do it—unless you know that it is the very last step in your workflow. The *Sharpness* slider works on the same principle as the Photoshop *Unsharp Mask*, with the simplification (or sophistication, depending on your point of view),

that the Camera Raw plug-in here calculates the threshold automatically, based on the camera model, ISO sensitivity, and exposure compensation. The two sliders below reduce luminance and chrominance noise respectively, and the effect can be seen in these thumbnails. That said, a third-party noise filter applied later (*see pages 176-177*) may make a better job of this.

Sharpness: 25
Luminance Smoothing: 0
Color Noise Reduction: 0

Sharpness: 25
Luminance Smoothing: 0
Color Noise Reduction: 25

Sharpness: 25
Luminance Smoothing: 25
Color Noise Reduction: 25

The real camera profile

The function of the *Calibrate* dialog is to compensate for the way in which the plug-in reads the camera profile. Photoshop relies on a generic camera profile, and your particular camera may differ from this. In the case of a Nikon D100 here, the difference is most visible in a pinkish cast to highlights. Some trial and error is needed to arrive at the ideal adjustment, but once you have determined this it should perform well for all images from the same camera. As a guide to greater accuracy, consider first measuring the changes made by camera profiling

software, and then replicating these manually in the Raw plug-in *Calibrate* dialog. Use a ColorChecker image to do this. The pairs of channel controls work in the same way as the *Hue/Saturation* sliders under *Image > Adjustments*. Use the hue sliders first, sliding right (+) to move clockwise around the color wheel and left (-) to move counter-clockwise. Run the cursor over the color patches to check the RGB read-out.

Before

The GretagMacbeth ColorChecker is a useful guide when profiling your camera.

Photoshop Raw converter Calibrate *tab* *After*

Histogram and levels

A histogram is simply a column graph. In digital photography, a standard 8-bit scale of 0-255 shows 256 columns from pure black at left (0) to pure white at right (255), and normally, in camera displays and Photoshop, they are packed together so that they join and there are no gaps. Pixel brightness is plotted across the bottom on the X axis while the number of pixels that contain a particular tone is plotted up the vertical Y axis. At all stages of the photography workflow, this is the single most useful representation of the tonal qualities of an image. In Photoshop it appears as a palette (*Windows > Histogram*), and as an image-adjustment dialog (*Image > Adjustments > Levels*). A reasonably exposed (that is, problem-free) photograph has a nice, smooth distribution to the shape of the histogram, peaking somewhere near the middle and tailing off toward the left and right; these tails almost reach but do not crush up against the edges.

Typically, the first time a digital photograph is opened on-screen you would go immediately to *Levels*

Photoshop's Histogram *palette shows the overall image tonal balance, as well as separate histograms for each color channel.*

From this original, follow one of the three different routes to image correction using the Levels dialog. You can reach the dialog using Image > Adjustments > Levels… or as an adjustment layer.

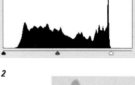

Input Levels: 0 | 1.00 | 255

1 *Look at the histogram and move the white input slider left to the first group of pixels and do the same (to the right) with the black slider. It will then look like the one in step 3.*

Input Levels: 0 | 1.00 | 214

2

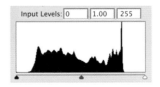

Input Levels: 0 | 1.00 | 255

1 *This method involves selecting the light point, dark point, and midtone from the image using the eyedroppers at the bottom right of the Levels dialog. Start with dark point.*

2

Input Levels: 0 | 1.00 | 255

Click Auto in the Levels dialog, or skip this dialog altogether by clicking Image > Adjustments > Auto Levels

Final

to check the distribution of tones. Indeed, for any non-Raw image this is the first port of call for optimization. Unless you are looking for a special tonal effect, such as a flat effect with limited tones (for example a delicate landscape on a foggy day) or a graphic high-key treatment (for example, a fashion shot that deliberately washes out skin tones to emphasize lips and eyes), then the key procedure in *Levels* is to set the black and white points. This stretches or compresses the tonal range so that the darkest shadows are located close to black, and the brightest highlights (excluding light sources and specular reflections) close to white. I say "close to" because it's customary to set these limits to slightly less than full black and white.

After this operation, which aims to fill the scale with the range of tonal values, you can use the *Midpoint* (gray) slider to do two things. One is to remove any color cast. To do this, click on the gray point dropper to activate it, then click on a point in the image which you know *should* be neutral or which you would *like* to be neutral. The second action is to adjust "brightness." In fact, what it adjusts is gamma, by relocating the mid-tone (128) to a darker or brighter position; all the other tones are dragged in proportion automatically, but the end-points stay the same. As a rough guide, move the *Midpoint* slider toward the center of the bulk of the histogram. However, there is more flexibility if you do this in *Curves*, and it may be worth moving to that dialog for the next step in optimization, where you can also use the gray point dropper to remove a color cast. Note that if you have opened and adjusted a Raw image in the Camera Raw plug-in, there should be no need to make any adjustments in *Levels*—and possibly not in *Curves* either.

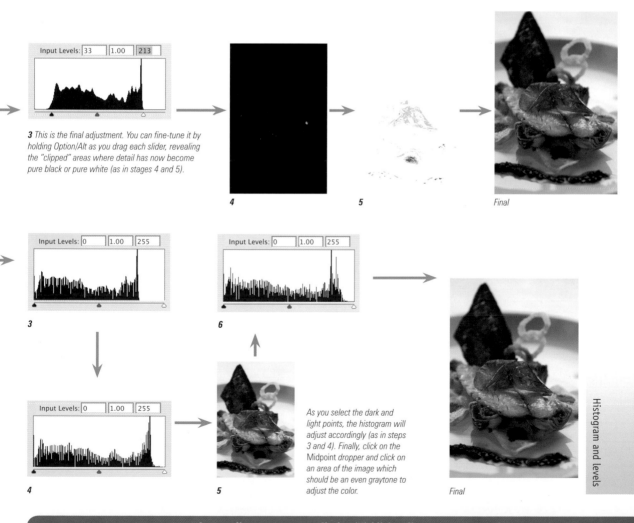

3 This is the final adjustment. You can fine-tune it by holding Option/Alt as you drag each slider, revealing the "clipped" areas where detail has now become pure black or pure white (as in stages 4 and 5).

4

5

Final

3

4

5

6

As you select the dark and light points, the histogram will adjust accordingly (as in steps 3 and 4). Finally, click on the Midpoint dropper and click on an area of the image which should be an even graytone to adjust the color.

Final

Histogram and levels

142-143 Curves adjustment 144-145 Shadow/Highlight adjustment 196-197 Altering tonal range

Curves adjustment

The *Curves* dialog in Photoshop (and many other applications) is based on the idea of the "characteristic curve," originally developed as a way of describing the response of film, but now applied to digital. The characteristic curve plots exposure against density on a graph, and the shape of the curve reveals such things as how contrasty the response is. In the *Curves* dialog, this is changed to a graph in which the horizontal is the Input (the original density of pixels) and the vertical axis is the Output (the changes you apply). The curve appears by default as a straight diagonal line. Because you can select any number of points on the curve and then drag them toward darker or lighter, this is a more flexible tool than Levels. Open it by going to *Image > Adjustments > Curves*.

Clicking on any part of the image shows on the graph as a small circle, which is a useful way of seeing how the tones are distributed. Command-clicking (Mac) or Ctrl-clicking (Windows) *adds* these points to the graph, so that you can then use them to drag that part of the curve lighter (higher) or darker (lower). Mid-tones are in the center, shadows are down to the left, and highlights up to the right. Dragging points alters the shape of the curve and, just as with a characteristic curve, an S-shape indicates a more contrasty image, and a reverse S the opposite—a flat image. This is much more easily understood visually than in a description, and the selection of sample curves best explains the possible corrections.

Measuring average

A useful check is to look at the image as if you were metering through the camera viewfinder. For most photographers, judging the average part of the scene before shooting is intuitive, and it works also in retrospect. The values shown in the *Info* palette in Photoshop are pixel-by-pixel, so what is needed is a method for averaging an area. Draw a square selection around an area that you judge ought to be average. Either a *Gaussian Blur* or *Median* filter is a useful way of averaging the selection, but the problem is that increasing the filter's radius will make it search outside the selection. The answer is to make a new file of the selected area alone. The procedure is *Copy*, then *New File*, then *Paste*. Apply the blur filter with as high a radius as necessary to create an even tone, and measure this (you don't need to apply the filter). Use HSB values in the *Info* palette and expect a *Brightness* value close to 50%.

Sampling and adjusting

In this example, Cmd/Ctrl-clicking is used to sample the tones in this image that we want to adjust. The three control points are added, and are then dragged to make the highlights brighter and shadows darker—in other words, to increase the contrast.

Original

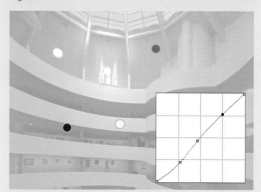

Three points on the image and their markers on the adjusted curve.

Final image

Basic correction curves

These curves are starting points for some common corrections. Individual images, however, should always be assessed on their own merits, and these curves will often need tweaking. Note that all the variations shown here are within the set black point and white point limits. Although these can be adjusted using the *Curves* tool, by dragging the end-points, I prefer to do that in *Levels* (*see page 140*).

Overall lightening

Lightening that favors shadows

Lightening shadows while holding other tones

Lightening that favors bright areas

Lightening bright tones while holding other tones

Overall darkening

Darkening that favors shadows

Darkening shadows while holding other tones

Darkening that favors bright areas

Darkening bright tones while holding other tones

Moderate contrast increase

Major contrast increase

Slightly less contrast

Much less contrast

Auto curves

Photoshop has a few preset correction algorithms that might be worth trying out on certain images.
- **Enhance Monochromatic Contrast** The same as the *Auto Contrast* command. Brightens highlights and darkens shadows while maintaining color relationships.
- **Enhance Per Channel Contrast** The same as the *Auto Levels* command. Maximizes the tonal range in each channel, and so quite dramatically, with color shifts likely.
- **Find Dark and Light Colors** The same as the *Auto Color* command. Maximizes contrast while minimizing clipping by searching for the average lightest and darkest pixels.
- **Select Snap Neutral Midtones** Finds the color closest to neutral in an image, and then adjusts the gamma to make it exactly neutral.

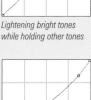
Enhance monochomatic contrast

Enhance per channel contrast

Find dark and light colors

Select snap neutral midtones

Curves adjustment

Shadow/Highlight adjustment

Introduced with Photoshop CS, this an extremely valuable tool for optimizing images, and can replace curves adjustment. It is slider-based, and so carries the advantage of being quick and easy to use, although with the possible disadvantage of "hiding" some of the information. In particular, it works differently from the other optimization tools, with algorithms to control effects across specific tonal ranges. Its primary intent as designed by Adobe is to lighten shadows realistically, in particular for backlit images. However, its algorithms for altering the contrast *in the midtones alone* are possibly more important for many photographers.

What makes this dialog special is that the lightening and darkening that you can apply is based not simply on a range of tones but also on a sample drawn from the surrounding pixels, what Adobe calls the local neighborhood. All adjustments need to be judged visually rather than by values. To get the most out of this powerful tool, first assess the image and the changes you would like to see made. Then work down through the slider controls from top to bottom, if necessary going back to tweak the effects. Beware of over-correcting, as artifacting is likely—halos around edges and banding, as well as unrealistically light shadows. Open by going to *Image > Adjustments > Shadow/Highlight...* and make sure to tick the *Show More Options* box.

Shadow/Highlight dialog

Amount
This adjusts the strength of the effect, and has to be used in conjunction with the next two sliders.

Tonal Width
This specifies the range of the shadows. 50% takes it up to the mid-point, which will usually be too much. Decide from the image itself which shadows need lightening or highlights darkening. Too high a width will cause artifacting and also look unnatural.

Radius
Until you have experience with this control, it is the least intuitive of the three. It sets the radius around each pixel that is sampled, in order to decide whether it belongs in the shadow group or the highlight group, and is measured in pixels. Moving the slider to the right enlarges the sample area. Adobe recommends a radius approximately equal to the size of the subject of interest.

Adjustments
Color Correction
This affects only the areas that have been changed with the sliders above, so the strength of its effect depends entirely on how strong an adjustment you have made. Move the slider right for more color saturation, left for weaker.

Midtone Contrast
For many of us, this is the most important control, because it achieves an important effect not possible any other way. In most photographs, the middle range of tones contains the important elements. You can easily find many images in which you would like to increase the contrast in this zone without deepening the shadows or lightening the highlights. There is a limit to how closely

you could achieve this with *Curves* (*see pages 142-143*). With this Shadow/Highlight dialog, however, you can treat the Shadows and Highlights groups of sliders as a way of protecting them—the Midtone Contrast slider then works on the remaining parts of the image.

Black Clip and White Clip
Normally you will not want to clip shadows or highlights, as this simply loses image data.

Shadows/Highlights

Shadows
Amount: 43 %
Tonal Width: 48 %
Radius: 49 px

Highlights
Amount: 33 %
Tonal Width: 29 %
Radius: 39 px

Adjustments
Color Correction: +28
Midtone Contrast: +20
Black Clip: 0.01 %
White Clip: 0.01 %

OK
Cancel
Load...
Save...
☑ Preview

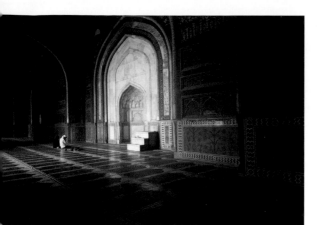

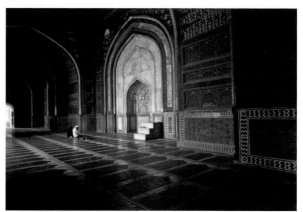

In this image the Shadow/Highlight tool has been applied to bring out detail in the shadowy foreground and, at the same time, enrich the detail in the brightly lit areas (right).

Shadow/Highlight midtone effects

Working from this original image of the raised insignia on a traditional British Royal Mail post box, we can clearly see the effect of altering the *Midtone Contrast* slider. This sub-tool allows you to alter the whole tone of the image.

The original

Make your initial changes to the Shadows *and* Highlights *sections. The* Midtone Contrast *slider is set at zero by default.*

Moving the Midtone Contrast *slider up to plus 50 enhances contrast around the midtones while tending to darken shadows and lighten highlights.*

Conversely by moving the Midtone Contrast *slider to minus 50, the insignia tends to blend into the background, looking softer overall.*

Shadow/Highlight adjustment

One-stop optimization

Image-editing software is available to perform all the necessary tonal and color optimization steps at once, using a nest of dialog windows. The advantages are that you can move back and forth from one setting to another before committing yourself to applying the changes, and that the changes are applied in one go rather than sequentially (with less risk of damage to the image). The examples shown here are iCorrect EditLab.

You don't need to go to the expense of adding extra plugins to Photoshop, however, if you can develop and stick to a suitable workflow. iCorrect EditLab essentially provides a structured workflow through the standard image corrections—color balance, levels, brightness, and contrast, and selective hue adjustments. All of these can be achieved individually in Photoshop, so whether the software has value for you is a personal decision.

iCorrect EditLab

This third-party plug-in, which can also be used for creating ICC camera profiles, uses a systematic approach to present a sequence of four operations, following the order set out in Optimizing—basics (*see pages 128-129*).

The special feature of this is that if you follow this order, from left to right, none of the changes you make affect the previous operation. An auto feature called *SmartColor* is useful as a starting point for each operation.

1 Color balance, to remove global color casts. This is done by clicking on neutral objects in the image or by moving sliders. Result: color balance fixed.

2 Black point and white point selection, to alter the range of the tones —usually stretching it to fit the scale. Result: range fixed.

3 Global brightness, contrast, and saturation controls, to redistribute the tone values between black and white, and between neutral and fully saturated colors. Result: tone distribution fixed.

4 Hue-selective editing, to alter brightness, saturation, and hue—yet constrained to user-defined hue regions. Corrects non-neutral colors. Result: individual colors fixed.

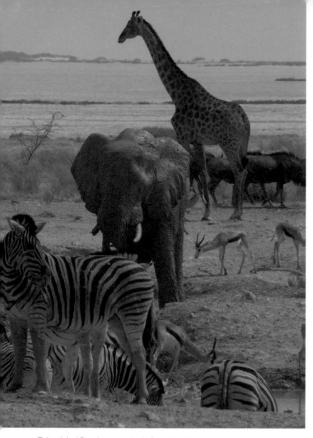

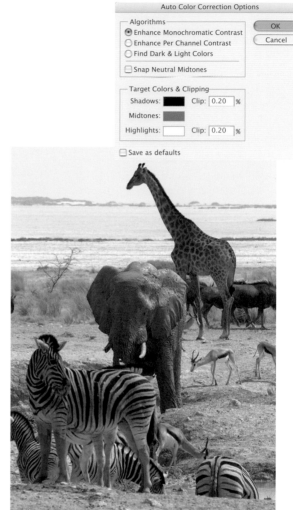

Auto Color Correction Options

Algorithms
- ● Enhance Monochromatic Contrast
- ○ Enhance Per Channel Contrast
- ○ Find Dark & Light Colors

☐ Snap Neutral Midtones

OK
Cancel

Target Colors & Clipping

Shadows: ▮ Clip: 0.20 %

Midtones: ▮

Highlights: ▯ Clip: 0.20 %

☐ Save as defaults

This original Raw image, typically flat and underexposed to avoid clipped highlights, was processed through two automatic algorithms. One was the proprietary SmartColor *option in iCorrect EditLab Pro 4.5, the other was* Enhance Monochromatic Contrast *available in Photoshop's Levels and Curves under Options… (see also pages 142-3).*

Enhance Monochromatic Contrast *available in Photoshop's* Levels and Curves *under* Options...

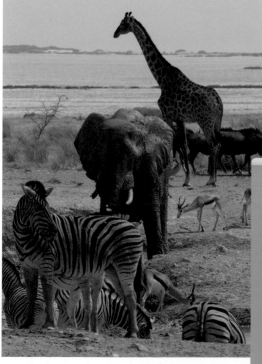

SmartColor option in iCorrect EditLab Pro 4.5

One-stop optimization

Sharpening policy

Sharpness is widely misunderstood as a concept, and frequently misused on digital images. It is a *subjective* impression, not a measurable detail of the photograph. Sharpness is the *perception* of how hard and distinct edges are, and because this is subjective there are several ways of influencing it. A high-contrast image, for example, tends to look sharper at a glance than a photograph with muted tones. There is also no good measurement of sharpness. Most evaluations are in terms of "too sharp" and "not sharp enough." This isn't to say that these are *poor* descriptions, just that they don't transfer well from one viewer to another. It reinforces the principle that the photographer should make the judgment.

The factors that give an impression of sharpness are acutance, contrast, resolution, and noise. Acutance is how abruptly one tone changes to another across the image. The more abrupt the edge between one area of pixels and another, the higher the acutance. Contrast has an effect in that an edge between black and white looks sharper than an edge between two grays. Resolution is the degree of detail (*see page 40*), and more detail looks sharper than less. Noise breaks up the image and lessens detail, although sometimes it can have the opposite effect and add to the sharpness simply by being itself sharp and definite.

Because sharpness and sharpening are such perceptual issues, we have to consider how the photograph is going to be seen—under what conditions, at what distance, and what size. Because some of the sharpening controls are measured in pixels rather than percentages, the size and resolution of the digital image do matter—a 1-pixel radius has a much greater effect on a screen-sized 640×480 image than on a

What affects digital sharpening

1 Image size.
2 Quality of image detail.
3 Reproduction size.
4 Printer quality and settings.
5 Viewing distance.
6 Your taste.

Delivering sharpened or unsharpened?

I'll mention this again in the last part of the book (*see Section V: Delivery*), but if your photograph is going to be printed by someone else, either as a photographic print or as repro, it is absolutely essential that the other people in the workflow know whether or not it has been sharpened. If it has not, you and they should agree on how it will be sharpened. Because of all the variables (*see What affects digital sharpening, above*), it is clearly better *not* to sharpen before delivery, but take no chances that this is understood. In repro, the image may go through several people, including the picture editor, designer, and printer, and there is a risk that the sharpening information gets lost, with the result that the image finally appears soft.

high-resolution 3,000×2,000 image. The condition of the original image is also a factor. A detailed, high-quality image, for example, needs a different kind of sharpening technique (finer, more detailed) than does an image that suffers from, say, low resolution, slightly soft focus, or noise.

The Taj Mahal at sunrise, photographed from the opposite bank of the Yamuna River. Built between 1632 and 1643 by the fifth Mughal Emperor Shah Jahan, the Taj Mahal, in Agra, Uttar Pradesh, is the tomb of the emperor's favorite wife, Mumtaz Mahal. This is a good example of a low-contrast image.

Image workflow

This image of a pair of opera singers was taken under bright tungsten stage lighting, so has a great deal of contrast, and therefore needs stronger sharpening.

Ultimately, two things stand out. One is that each photograph needs to be sharpened in a way that is appropriate to it; judge every photograph—or at least every set of similar photographs—on its own merits. The other, important point, is that sharpening should be the last action you perform on an image before it is displayed—whether as repro, fine art print, or on the Web. Sharpening can only be judged on its appearance as intended. And *never* sharpen an original, only a copy. If you are shooting Raw, then the Raw files are your true originals, but their optimization represents an investment of time and skill, and you may consider saving the finished TIFF in its unsharpened form. Sharpened versions for various purposes can be given a slightly amended file-name (such as adding "sh"). Note that repairing focus blur and motion blur involves sharpening, but this should not be confused with the sharpening discussed here.

Varying degrees of sharpness

Sharpening an image should ideally add to its overall impact, not make it appear unnatural or add artifacts to it. Tell-tale signs of over-sharpening are high levels of what appears to be grain, even in areas outside the image's main focused areas, and pixellation around detailed areas.

Original

Sharpened

Over-sharpened

Sharpening policy

Sharpening techniques

Like so many other operations in digital imaging, the ultimate measure of success in sharpening an image is visual and subjective. There are, certainly, some technical, measurable qualities—avoiding halos, for example—but once these have been taken care of, it is still a matter of judgment. You may disagree with some of the results here and on the following pages, and that is as it should be. Your taste is the final arbiter.

Although Photoshop also has *Sharpen*, *Sharpen Edges*, and *Sharpen More* filters, these are rough and ready, and allow no fine-tuning. They are best ignored. The usual professional sharpening tool is the *Unsharp Mask*. As a way of increasing sharpness, this sounds like an oxymoron, but the apparent illogicality is because the term is a holdover from pre-digital days. In film-based repro, an out-of-focus copy of the image was sandwiched with it as a mask, and the result, as if by magic, was a sharper image. The expression, often shortened to USM, has stuck. The digital process, however, is quite different, and works by re-sampling pixels so that the contrast between neighbors is increased. At pixel level, an edge looks like an area of dark pixels against an area of light ones. Reducing the transition between them, making the dark pixels darker, and the light pixels lighter are the three ways of heightening the contrast, or sharpening. Most sharpening techniques, including USM, can be adjusted to suit different images by three variables: amount, radius, and threshold (*see Basic USM operation, opposite*). In practice, getting these right for you is complicated by a set of factors that includes the size and quality of the image, viewing distance, and your own taste. Proprietary sharpening applications such as Power Retouche Sharpness Editor and nik Sharpener Pro! take a more sophisticated approach than USM, include more variables, and can protect sensitive areas of a photograph such as intricate detail.

What can go wrong with sharpening

Almost all sharpening inadequacies are a result of *over-sharpening*. Under-sharpening is also an error of a kind, but difficult to measure because it relies on personal judgment. Common faults are as follows, and can be avoided by readjusting the amount, radius, or threshold, or by using one of the more advanced techniques (*see pages 152-153*).

Halo Also known as *negative contour*, this is an edge effect in which a too-bright or too-dark band of one or more pixels separates two tonal areas.

Aliasing Anti-aliasing is the well-known software technique for softening the "staircase steps" that occur on diagonal lines and edges in digital images (due to the square structure of pixels). Sharpening can remove the anti-aliasing.

Color artifacts Unwanted colors appear at the margins of other colors, particularly in high-contrast and low-quality images.

Local extreme artifacts Clumps of almost-black or almost-white pixels.

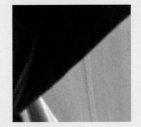

Halo effect

Color artifact

Basic USM operation

The three standard settings are *Amount*, *Radius* (also known as Halo Width), and *Threshold*, and between them they provide good, though not perfect control over the sharpening. Be aware that there are a number of sharpening algorithms, of which Photoshop's USM is just one. Most aim to heighten local contrast.

Amount This, expressed as a percentage, is the intensity or strength of the sharpening. Opinions vary, as this setting depends very much on personal taste, but for high-resolution images, values between 150% and 200% are normal.

Radius This is the distance around each pixel that is used for calculating the sharpening effect. A small radius will sharpen a narrow edge, a larger radius a broader band. It affects the coarseness of the sharpening and is measured in pixels. The wider it is, the wider that edges will appear, and if it is set too wide, a "halo" appears along edges (hence the alternative name Halo Width). For high-resolution images, a radius of between 1 and 2 is normal.

Threshold This controls the level of difference between adjacent pixels that will be sharpened, and serves as a kind of protection for smooth areas with fine texture and little detail. With the threshold at 0, everything is

sharpened. Raising it a little prevents the sharpening being applied to areas in the image where the difference between pixel values is small, such as sky and skin. It concentrates the sharpening more on the distinct edges, which are usually considered more important, and without it, the smooth areas can appear "noisy." It is measured in levels between 0 and 255. Setting the threshold to 4, for example, restricts the filter to areas where the difference between adjacent pixels is greater than 4—for instance, neighbors 128 and 133 would be sharpened, but 128 and 130 would not. For a high-resolution photograph, values between 2 and 20 are typical, reflecting the difference in image content.

The original

The result of sharpening with a Threshold *setting of zero.*

The result of sharpening with a Threshold *setting of 10.*

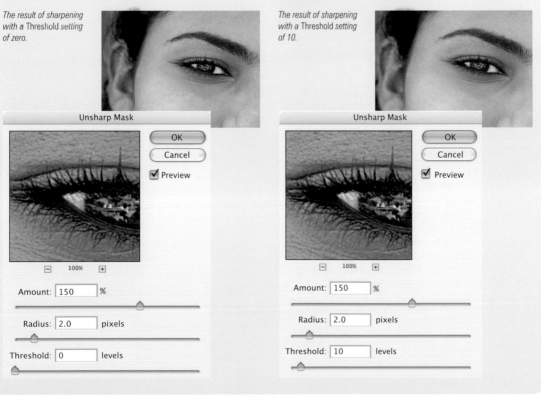

Unsharp Mask		Unsharp Mask	
	OK		OK
	Cancel		Cancel
	☑ Preview		☑ Preview
⊟ 100% ⊞		⊟ 100% ⊞	
Amount: 150 %		Amount: 150 %	
Radius: 2.0 pixels		Radius: 2.0 pixels	
Threshold: 0 levels		Threshold: 10 levels	

Sharpening techniques

Advanced sharpening

There are various ways of improving sharpening, which ultimately means achieving a distinct subjective impression of sharpness *without* the artifacts. The most important principle is to apply sharpening selectively, because the varying amounts of detail in most photographs call for different degrees of sharpening. The *Threshold* control shown on the previous pages is the standard means of applying selectivity, but there are others. Typically, the most sharpening is wanted along edges and in areas of fine detail, and the least (indeed, often none) is wanted in smooth areas and especially in zones that are out of focus. An important caveat is that some areas may have such intensity of detail that they react badly to sharpening—brightly lit foliage is a particular case.

Selective sharpening can add to the quality of an image, especially where the background might be blurred.

Color protection

One of the less desirable side-effects of strong sharpening is a color shift along the edges. A good solution, worth considering as your default sharpening technique, is to convert the image to Lab and sharpen just the *Lightness* channel. This, as you can see by looking at the *a* and *b* channels, contains almost all the textural detail. The gentleness of the color gradations in the two color channels is preserved. Convert back to RGB when finished (Lab is also used by Photoshop as its conversion color space, and switching between the two loses no quality).

Multipass sharpening

There is less risk of artefacting if you sharpen twice at a lesser amount than once fully. Moreover, two (or more) passes allows you to aim the sharpening at different parts of the image. For instance, the first pass could be gentle but with no threshold, to subtly improve fine texture, followed by a second pass that is stronger and aimed at the edges, while setting a threshold to protect the smoother areas. This works with whatever sharpening technique you use, but clearly needs experiment and experience. The advantage of doing this is that the second pass multiplies the sharpening effect, while only *adding* to the artefacting. So, if you sharpen once at 100% and a second time at 125%, the sharpening effect will be 100 + (2 x 2 x 125) = 600%. The artefact generation, however, will be only 100 + 125 = 225%.

Protecting intricate areas

The soft, smooth parts of an image are not the only areas that need protection from over-sharpening. Some subjects, notably foliage, that already have high contrast because of sharp lighting, contain so much detail that they can react *too* much to an otherwise normal filter setting. In Photoshop you can use the *Find Edges* filter to seek these out. Third-party plug-in nik Sharpener Pro! has a built-in non-adjustable protection algorithm for such strongly detailed areas.

Having identified the areas to select, you can do this in a number of ways. One is manually, by airbrushing in a masking layer to create a selection. Another is to use another filter to find the areas to be sharpened—the example shown opposite uses the *Find Edges* filter. Because the level of detail usually varies between channels, another technique is to apply sharpening to one channel only. An extension of this is to protect colors from sharpening by switching modes from RGB to Lab and applying the sharpening filter to the *Lightness* channel only. Finally, and most conveniently, consider third-party sharpening software that is usually available as plug-ins to Photoshop. Two specialist programs in particular, nik Sharpener Pro! and Intellisharpen II, use advanced algorithms.

Another advanced approach to sharpening is to apply the filters twice or more at a low level. Multipass sharpening, as it is known, is the best way to apply any sharpener for high-quality results, because it reduces the risk of artifacts. It calls for experiment, but once you are familiar with its effects, it becomes easy to execute. Batch processing makes it more convenient.

Find the edges

Basic USM as offered in Photoshop does not seek out the edges in an image, yet these tend to contribute most to the impression of sharpness. The *Threshold* setting with a high radius will concentrate sharpening, to some extent, on the edges, but there are more focused techniques.

1 Using the Channels *palette, identify the channel with the most contrast in. In this photograph, the white spots are most clearly distinguished by the blue channel. Duplicate the channel you identified by dragging it to the* New Channel *(turning paper) icon at the bottom of the* Channels *palette.*

2 Working on the newly copied layer, select the Filter > Stylize > Find Edges *filter. This will highlight the edges only, and by working on the new channel, it won't affect the image itself. Since we're looking to highlight the edges, not the majority of the image, click* Image > Adjustments > Invert *before clicking the* Load Channel as Selection *button (dotted circle) at the bottom of the* Channels *palette.*

Unsharp Mask

OK
Cancel
☑ Preview

100%

Amount: 150 %

Radius: 2 pixels

Threshold: 0 levels

4 With the selection still active, apply the Filter > Sharpen > Unsharp Mask *(USM) to the image. It will only work on the selected areas.*

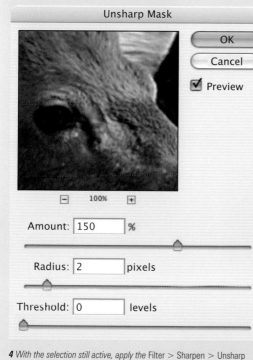

3 Switch back to the Layers *palette and click on the background layer to make it active again. You should see your newly made selection imposed on top of the original image, rather than the altered channel.*

5 The final image, with extra sharpening applied to the selected areas.

Advanced sharpening

Upscaling techniques

For how long upscaling stays an important issue remains to be seen. As the resolution of sensors increases, it becomes easier to deliver images at whatever size is needed. For the time being, however, there are regular demands in printing to use digital images larger than their optimum size, and because there are no exact limits to enlarging, there is a gray area in reproduction. The typical question is, how much is it possible to enlarge a digital image and still have an acceptable level of detail? There is a 300 dpi rule of thumb in repro, but it is no more than that—a safe industry standard. The two principal factors are the line frequency (line screen) of the printer, and the percentage of this that the digital image should be. Newspapers print at 85, most magazines at 133-150, high-quality illustrated books at 200, and a few art books higher still. The percentage is very much a matter of opinion, but generally between 150% and 200%. In other words, even excluding the low quality of newspapers from the calculation, the acceptable resolution for a digital file could be between 200 and 300. And this determines the size.

Upscaling using interpolation

Going beyond these limits involves interpolation (*see Dedicated upscaling, pages 156-157*), and there are good arguments for doing this yourself so that you can check and guarantee the result. The important choice is the method, meaning the interpolation algorithm. Within Photoshop, the choice is simple for photographs—Bicubic. It gives a smoother tonal gradation than the other two (Nearest Neighbor and Bilinear) and also better suits the complex structure of a photograph, usually lacking exact straight edges. It's important to realize that there is *always* a loss of quality in upscaling. How much is acceptable is a matter of opinion. Some users believe that incremental upscaling (say, 10% at a time) gives superior results, as with sharpening, although I have seen no side-by-side comparison that bears this out.

Resolution vs sharpness: an uneasy relationship

The standard definitions of resolution and sharpness seem to separate them quite clearly—but in practice they are intricately linked. Resolution in an image is the amount of detail recorded and so is objective, while sharpness is the appearance of definition, and so is perceptual and even a matter of opinion. That would seem to set them apart, but in upscaling they converge. The confusion arises because the whole process of creating a larger image from a smaller version involves guesswork and optical tricks. Digitally, both processes use interpolation, which means re-calculating the values of existing pixels. Sharpening can certainly help in creating the impression of greater detail around edges, but it needs the usual care, and adds to the variables. In practice, upscaling with sharpening can take time and involves multiple choices.

Interpolation algorithms

Original

Photoshop provides three core interpolation algorithms. *Nearest Neighbor* is the simplest, expanding pixels into square blocks of pixels, which can be quite ugly. *Bilinear* and

Nearest Neighbor

Bilinear

Bicubic, on the other hand, soften the edges using data from the surrounding pixels, creating smoother edges similar to anti-aliased text.

Bicubic

Going beyond Photoshop, there are proprietary applications that promise better results. One approach is a suite of algorithms that analyze the detail in an image and apply different methods to different areas— maintaining sharp edges, for example. PhotoZoom is one of these. Another approach is to convert the image to a dimension-free image format so that it can be output at a larger scale. Genuine Fractals is an example of this. Comparisons between these different methods vary depending on the image. There is, nevertheless, a difference in quality between interpolation algorithms, and the best do not blindly apply the same techniques to every part of an image, but discriminate according to the tonal, color, and textural differences. Two dedicated programs are shown on the following pages.

This is an original image of a castle and a detail from the same image with no interpolation performed on it.

Mosaic composites for increased resolution

With a static subject and time, there is a simple workaround to increase resolution when shooting—take a series of overlapping images with a longer focal length, and then stitch these tiled images together. (*See pages 206–207 for stitching.*)

This image (and detail) were taken from an original of half the size, then interpolated.

Overlapping images before trimming.

Filling in the gaps like this tends to create unsharpness. Upscaling is analogous to stretching, and most methods fail to hold the sharpness of edges. In enlarging an edge, normal resampling adds an intermediate value between the dark and light pixels, as shown here, and this softens the appearance. After upscaling, a second sharpening operation may be necessary, and this can only be judged by eye. Using a proprietary upscaling technique may complicate matters because it might incorporate edge sharpening.

Safe limits for repro sizes

Line frequency	3-megapixel image	6-megapixel image	12-megapixel image
60	17.7 x 11.8in	25 x 16.6in	35.5 x 23.5in
85	12.5 x 8.3in	17.7 x 11.7in	25 x 16.6in
133	8 x 5.3in	11.3 x 7.5in	16 x 10.6in
200	5.3 x 3.5in	7.5 x 5in	10.6 x 7.1in

Upscaling techniques

24-25 Tiled images 40-41 Resolution 206-207 Stitching

Dedicated upscaling

Perhaps surprisingly, there is a limited choice of software that tackles enlargement intelligently and specifically. The three currently available cross-platform programs are PhotoZoom (a reincarna-

PhotoZoom

Formerly marketed as S-Spline, and still using the same S-Spline algorithm, PhotoZoom from Shortcut is designed solely for image enlargement. It uses adaptive interpolation so that the parts of the image that need sharpening the most (with detail) are given more sharpening than featureless areas, and it does this by analyzing the structure of the image. As the designers say: it "works, so to say, more 'aggressively' in areas with high contrast (and this is exactly where details need to be preserved most), while it interpolates more gently in smoother areas."

PhotoZoom Pro asks the user to select the detail level of the image.

The S-Spline interpolation method is being selected.

A detail from the center of this mountainous landscape has been taken and blown up using the various upscaling tools.

This image was blown up using PhotoZoom's S-Spline method.

tion of the Dutch software S-Spline), Genuine Fractals, and SmartScale by Extensis. Genuine Fractals is not, strictly speaking, dedicated to upscaling, but rather was developed as a scaleless image file format. Nevertheless this is probably its most valuable use. What all three have in common is that the algorithms they use for interpolation are much more complex than that for Bicubic—the Photoshop default for photographic images. As large-format inkjet printing becomes more popular, with 17 × 11 in (A3 and A3+) sizes almost standard, this high-quality interpolation acquires new importance.

Original

Genuine Fractals

Photoshop Bicubic

Photoshop Raw converter

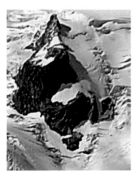
Ncap high sharp mode

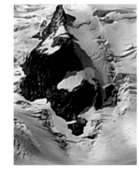
Ncap Raw mode

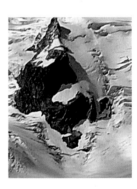
SmartScale

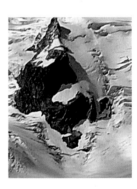
PhotoZoom S-Spline

Genuine Fractals

Lizard Tech's Genuine Fractals's Photoshop plug-in is designed to be used either to scale up images, or as an alternative and space-efficient way to save files. In the former case, it is especially good at creating larger files from smaller originals, at up to 600% without serious loss in quality. In the latter case it can create lossless archives of your image files.

Genuine Fractals dialog

A simple 200% scaling

<div align="right">Dedicated upscaling</div>

Printers

Most desktop printers now employ inkjet technology, and a period of sustained research and improvement has overcome most of the inherent deficiencies. First developed in the late 1980s, inkjet printing works by spraying minute droplets of colored ink (typically 50 microns in diameter) through a series of nozzles onto paper. This is now the standard for desktop printing, and with the latest archivally coated papers, archival pigment inksets, and professional profiling, exhibition-quality printing is within everyone's reach. These last three qualifications are very important (*see pages 160-165*).

Nevertheless, dye-sublimation ("dye-sub") printers are making a comeback, particularly for small-format prints (such as 4×6in) and "direct" printing from the camera that bypasses the computer. The great advantage of dye-sub prints is that they have the same look and feel as traditional silver-halide color prints, are fade-resistant and water-resistant. This appeals greatly to the amateur market, and so has uses in social and wedding photography. The cost per print tends to be higher than for inkjet, but the simple, rapid, clean operation, and the consistency of the results may outweigh this. There is, however, less choice of paper types and textures than there is for inkjet printing. For people who like the familiarity of a true photographic color print, this is the technology of choice because of its continuous-tone printing.

Continuous ink system

Dye sublimation printer

Inkjet printer

Continuous Ink Systems

An economical alternative to ink cartridges in an inkjet printer is a CIS (Continuous Ink System). This comprises bottles of ink stacked alongside the printer, to which they feed by means of tubes. These tubes are attached to cartridges which replace the originals. Air is first expelled from the system by using a vacuum pump on each tube line immediately before attaching it to the ink bottle. The cost advantages, however, are to some extent offset by the inconvenience of set-up and maintenance.

High-end machines

Size and cost set certain digital printing technologies apart, as they are usually accessed through photo-finishers. The most popular technology is laser-exposed photographic paper that is wet-processed, the entire procedure contained in a single large unit. For customers who prefer traditional silver-halide color prints, this is, aside from the cost, the ideal solution.

Dye sublimation

In this process, quite different from inkjet printing, the color is supplied on a long ribbon of transparent film in a cartridge that is the width of the print. For each printing, the ribbon carries a print-sized band of yellow, magenta, cyan (and in some printers, black) dyes, one after the other. Heating elements in the print head activate as the film passes over it, and these cause the dyes to vaporize and permeate the paper, where they spread slightly and solidify. The result is a continuous-tone image with a more photographic appearance than the tiny dots of inkjet printing. The paper travels forward and backward through the printer three or four times to receive each color and a protective coating. Precise register is critical. Because the ribbon cartridge must match the print size, cartridge and paper are supplied together—there is just enough film for the paper, and so no question of color running out. There are fewer cleaning issues than with inkjet, although any dust or particles on the head or paper will create white specks in the finished print.

Inkjet technology

Machines capable of photo-realistic results now use six or more inks, and the print head assembly has the corresponding number of nozzles. A stepper motor moves it across the paper, one line at a time, which is why high-resolution printers working at 1440 dpi take several minutes to deliver a single print.

Giclée?

This odd term crops up occasionally on American websites, purporting to refer to high-quality printing, as in "giclée fine art prints." It is, in fact, pretentious nonsense. A French term meaning "squirted," it is totally unsuited to its intended application, which is inkjet printing. Companies offering this as a service should be approached with caution.

Laser printer

Printers

Printer calibration

As we've already seen with cameras (*see pages 64-71*) and monitors (*see pages 110-113*), and will see again with scanners (*see pages 216-219*), profiling is the professional way of compensating for the individual behavior of machines. With cameras, profiling is useful only when the lighting conditions are completely predictable, as in a studio, but with printers it is *essential* for color accuracy, and not only makes an immediate difference (startling for many people seeing it for the first time), but eases the workflow enormously.

Just as with any other device calibration, there are two levels of accuracy in calibrating your printer, depending on the system of measurement. You can use your eye and judgment, or you can use an objective measuring device. Obviously, the latter will give you better accuracy, particularly because printers produce colors in such a completely different way from all the other devices in digital photography. They

The profiling sequence

Whether you have a custom profile made professionally, or tackle it yourself, the procedure is as follows. The cost of the measuring devices and the experience needed to use them makes professional calibration almost essential for high-quality printing.

1 Choose known, reproducible settings for the printer.
2 Print a standard test target.
3 Wait for the recommended time for the ink colors to stabilize (at least an hour in most cases).
4 Measure the print in detail with a spectrophotometer, in conjunction with profiling software.
5 The profiling software compares the measured print with the known values of the test target, measures the deviation, and constructs an ICC profile that compensates for that deviation.
6 The profile is saved and made available to your computer's system and to Photoshop (including for Softproofing).

Start-to-finish profiling

This procedure is typical of services offered, and at its least expensive is done by correspondence rather than a site visit. In other words, the photographer is responsible for printing targets and ensuring the right settings. The software and hardware obviously varies; this worked-through example is from color-management consultant Udo Machiels of Atmos Design in England. The printer being profiled is an Epson 2100, fitted with a Lyson pigment inkset. The end product was a set of profiles for specific printer-paper-inkset combinations.

1 Flush out lubricants. With a new machine, it is usually important to do this. In this case, the supplied Epson ink cartridges are used to print out the following full-saturation bands of the seven ink colors 25 times on 12 x 9in format paper.

2 Install inkset. The original cartridges are then replaced in this case with a Lyson pigment CIS inkset, chosen because of its preferred quality. The original Epson inks are then flushed out with another 25 printings of the same banded image.

3 A TC9.18 test target is then printed out on a number of different papers— ones that will be used on this printer. The first three to be profiled are Lyson Smooth Fine Art, Professional Color Photo Gloss, and Professional Photo Satin. Each needs its own profile.

5 GretagMacbeth's Profile Maker profile-building software is then used to take the deviations just measured and create a set of instructions to the printer that will correct its performance. This is in the form of a text file.

6 The profile is loaded into the appropriate folder in the computer used for printing, and accessed at print-time through the Photoshop Print Preview dialog.

4 When dry, the targets are then measured with a GretagMacbeth Spectrolino/Spectroscan.

Printer profiling variables

A custom profile is only good for an exact combination of the four elements below, and if you change the brand of ink, for example, or the type of paper, you cannot expect the original profile to work as well.

1 *Printer—a major variable.*

2 *Paper—in particular, some papers are more absorbent than others, and their whiteness will affect the white balance. Coatings from the same manufacturer tend to be similar.*

3 *Inkset—with inkjet printers there is a difference between dye-based inks and pigment inks. In any case, the composition varies considerably from manufacturer to manufacturer.*

4 *Resolution—there may be a difference depending on whether you print at 720 dpi, 1440 dpi, or 2880 dpi.*

use process colors (cyan, magenta, and yellow, plus other inks such as black, gray, and light magenta) *and* the image is reflective. In order to measure these, a spectrophotometer is needed—an expensive piece of equipment that calls for skilled use and the appropriate software.

Even more than with other devices, printers can vary in their color performance, between individual machines of the same model, and according to the paper-ink combination that you choose. So, although they come supplied with generic profiles that your computer can read, these may be only roughly satisfactory. A custom profile is strongly recommended, so

that the output matches what you expected from the monitor display, and to make the full use of the inks to reproduce the maximum number of colors. Because a spectrophotometer is an essential part of the process, it is usually more practical to pay for a profiling service. In this, the profile-maker will supply you with a digital test target and instructions on how to use it. Having made a print of this, you send it to the profile-maker, who measures it accurately and returns to you the ICC profile as a file to load into your computer's profile library. This takes the place of the original printer generic profile, and you should notice an immediate improvement in your color print output.

Printer calibration

66-67 Standard targets 104-105 Color 106-107 Color management 112-113 Calibration with a colorimeter

Printing

Printing workflow is highly specific to the machine and the software, but, once the calibration has been done, should be completely straightforward. An important variable is the choice of medium, usually but not always paper (there are various canvas and plastic options). Many traditional high-quality paper manufacturers have moved quickly to produce coated inkjet versions of long-established paper types. For fine-art printing a major choice is between mat and glossy paper surface, the former being generally more subtle, the latter capable of higher contrast. Paper texture is another consideration.

Printer driver

OEM (Original Equipment Manufacturer) printer drivers are those supplied with the printer, and naturally each has its own operational procedure. Step one is page set-up, including size, orientation, and scale, followed by the many print dialog settings (presets, number of copies, layout, printer colour management, and so on). Utilities include nozzle checks, cleaning and alignment, and on a professional machine these can also be accessed physically via buttons on a control panel. For the reasons given below, printing photographs to a professional standard argues very strongly for not using the OEM driver, but instead investing in dedicated RIP software. In this case, utilities are best accessed through the control panel.

RIP vs OEM driver

RIP software has the following advantages for the extra, usually substantial, cost:

- ensures use of full color gamut for every combination of ink and paper
- optimizes ink output
- efficient, automatic management of print queues
- every step in the workflow can be customized

RIP software

RIP stands for Raster Image Processing, and RIP software is dedicated to managing the printing workflow, and bypasses the printer driver. It costs considerably more, but has several advantages that make it essential for any professional printing set-up, whether for making match prints to accompany digital files sent for repro, or for fine-art gallery prints. OEM drivers are aimed at a general user market, and offer ballpark settings for the make of machine, not for individual idiosyncracies. RIP software allows profiles to be built for your preferred combinations of ink and paper, so that the full color gamut possible is used. Not only this, but RIP software can manage the individual inkhead flow to achieve the ideal ink laydown. This is particularly important with dark areas of the image that use a number of heads, because it ensures that just enough ink is laid down, and no more, thus saving ink and also preventing the potential loss of color saturation caused by over-inking. In terms of workflow, RIP software manages this with great efficiency, and allows a queue of images to be printed unattended—images can be rotated, re-sized, nested together with adjustable margins, and more—all of this managed at run time. All professional printing services use RIP software, and it should also be considered a must for individual photographers who use professional-level machines. There are a number of RIP software manufacturers, among whom are Shiraz, Wasatch, ErgoSoft, Onyx, ProofMaster, Colorbyte, and PosterJet.

A RIP driver program is still accessed through the computer's Print dialog.

Test targets

There are a number of standard test targets, and in addition, professional calibration services may use others that include a number of generic types of photograph (such as portrait, product shot, and landscape) as well as grayscales and color patches. After profiling, you can check the accuracy of your system by comparing your print with a verification print supplied by the profile-maker.

The Image Xpert Inc test target is designed for laser printers.

Atmos test chart

The Antelligent RGB Testchart. Antelligent offers an Internet service whereby you download and print their target, then mail it to them. They reply with an ICC profile for your device.

The TC9.18 test target, as used in the example on page 160.

Printer calibration

Proof, contact, display

The two key uses for desktop printing in photography are for proofing the image and for making a final display print. With the major improvements in inkjet technology, it's now practical to do both yourself, and on the same machine. The value of a proof print is partly that it gives you the confidence to know that your optimization and image-editing has been successful, and partly as a guide for other people, including clients, to show that this is how the image should be. In this latter sense, the proof print (also known as a validation print), takes the place of a color transparency or C-type print—a physical, "handleable" version of the photograph that everyone can refer to without a computer. There is still the matter of similar or dissimilar viewing conditions, but even with this variable most people are comfortable with a print. If you are sending a digital file out for some more work, such as repro or a display print on a professional machine using a non-inkjet process, it is valuable to send a proof print with it. Even if there are deficiencies in your proof print, you can note these on the print itself (for example, "denser blacks if possible").

Printed contact sheets are still useful despite on-screen lightbox display—and some clients prefer a physical sheet. The quality is less important than that needed for proofs and displays. Most browsers and databases have an option for printing contact sheets, but check the quality first. Photoshop's Contact Sheet automated function (under *File > Automate*) resizes and positions copies of the full-size originals, which takes time but gives good results.

Rigid backing

Display prints are the key final product for much photography—indeed, for all except web publishing and repro in books, magazines, brochures, and so on. The steps between a finished print and its display are crucial and can be costly. The one essential is to mount it on a rigid backing so that it remains flat, is protected against scuffing, and can be hung. Beyond that there are many options, of which the most traditional are an overmat (also known as a mat or window mat), glass cover, and a frame. Less traditional approaches include laminating and sandwiching between metal and acrylic. How you mount the print on its backing depends on the thickness of the paper, the type of backing, and on whether you opt for an

Paper types

Inkjet printing frees us from the limited choice of silver-halide papers, and there is a huge choice of supply, in terms of cost and, importantly, paper quality.

A key factor is the surface finish of the print—the way in which the ink reacts with the paper. Here, it's important to understand the difference between a traditional silver-halide print, which is still the yardstick for many people, and an inkjet print. In silver-halide printing, glossy, satin, and matte refer to the final appearance, so that with glossy, for example, the sheen sits above the image. Remember that it is the variation of reflection that gives the extra contrast range on this kind of paper—blacks reflecting darkness look denser than they do in a matte print. The gloss is constant, irrespective of the density of the image. With inkjet printing this is not the case. When you look at a glossy inkjet print and move around it to catch the different reflections, the blacks are more heavily inked on top of the paper, and so look more matte than the whites. In a high-contrast print, the surface varies with the tonal values, and for some people this can look disturbing and not quite right. This is a powerful objective argument for using fine art matte paper, which absorbs the ink more equally so that the image looks truly embedded in the paper.

Paper types

overmat. This last (*see opposite*) is a thick cardboard window that can enhance the appearance of the image, and offers the opportunity to attach the print lightly without adhesive. In this case, use mounting corners or hingeless strips to attach the print to the overmat, then hinging tape to attach this to the mounting board. Basically, the overmat keeps the print in place.

Other than this, dry-mounting is the normal method, and it avoids the archival problems of liquid adhesives, which can cause staining. There are two basic alternatives, both using a backing sheet of

Mounting and finishing

Exhibition and display prints are mounted or matted on a stiff board. The difference between mounting and matting is the way in which a print is attached to the board. When a print is mounted, it is stuck on the face of a mounting board. When a print is matted, it is attached to the back of the board and the image is placed behind a cut opening. When matted, a print is often taped into place, thus the matt can be temporary. Generally, prints that are framed are matted. In both cases, the board enhances the picture by providing a broad border as well as protecting the edges against damage.

Keep it simple

When you are preparing a print for exhibition or display, your goal should always be to show the print to its best advantage. Simplicity is the best strategy. Elaborate artwork or fancy lettering can often detract from the photograph. Generally, prints for display purposes are mounted or matted on special card stock to make them stand out from their surroundings. Card stock used for mounting photographic prints should be free of acid or sulfur that can deteriorate the print quality. Card stock is available in various sizes, colors, textures, and weights. There are no hard-and-fast rules for mounting prints, but the card stock should complement the print. The mount should be large enough to balance and support the picture, and the texture and color should complement the overall tone.

The way the print is placed on the mounting board is important. Prints mounted at odd angles or in a corner of the mount unbalance the photograph. The bottom border on most mounts is the widest border of all. Normally, prints are mounted so the top and side border of the mount are equal. To provide balance, you should ensure that the bottom border is 25 to 35% wider than the top and side borders. There are two types of adhesives for mounting prints: wet and dry.

Wet method

Liquid adhesives, such as rubber cement and spray-on adhesives, can be used to mount prints. These two adhesives are easy and clean to use. After they dry, the excess adhesive can be removed easily by rubbing it lightly. The drawback to using rubber cement and spray-on adhesives is that they are not permanent. In time, the print may loosen and peel off the mount. Rubber cement is an ideal adhesive for temporary mounts used in displays or for copying. Gum arabic, glue, or paste should be avoided whenever possible. These adhesives are known to stain the print or smear out from around the edges of the print. This causes smudges on the mounting board.

Dry method

One dry print-mounting method uses a pressure-sensitive adhesive. These adhesives come in a variety of sizes in both rolls and sheets. These adhesives form a permanent bond and are easy to use for resin-coated papers. To use these materials, you simply apply the print to the sticky surface of the mounting material. You then peel off the protective backing and apply it to a mounting board. If the print is not aligned correctly, you can remove the print and re-apply it. Once the print is correctly in place, you must apply pressure to the print and mounting board. Normally, this is done by running the print and mounting board through a specially designed roller assembly. This assembly applies pressure to the materials being mounted. The pressure-sensitive adhesive material contains tiny beads of adhesive. The pressure breaks these beads and releases the adhesive. Once pressure is applied to the materials being mounted, a permanent bond is formed.

A dry-mount press can also be used to mount photographic prints. With a dry-mounting press, heat is used to fuse a mounting tissue between the print and the mounting surface. A dry-mount press is designed to provide uniform pressure and heat. Even pressure is an important aspect of good, dry mounting. Adequate pressure helps squeeze out air from between the adhesive, print, and mounting board. You should operate the dry-mount press at the temperature recommended by the manufacturer of the mounting tissue. It is better to use a slightly lower temperature to mount prints than a temperature that is too high. Excessive temperatures may cause damage to the print. When temperatures are too high for coated papers, the resin blisters or bubbles.

adhesive: heat-sensitive and pressure-sensitive. In the former, a dry-mounting press is used to heat and fuse a mounting tissue between the print and the mounting board. The pressure must be even to squeeze all the air out between the adhesive, print, and mounting board, and the temperature must be carefully controlled—too hot and the print will be damaged. Pressure-sensitive adhesives also are available in rolls and sheets. They are simple to apply. Attach the sticky side to the back of the print, peel off the backing and apply the mounting board. The print can be re-positioned at this stage, and once in place you run the print and board through a roller assembly, which breaks the beads of adhesive in the sheet. This creates a permanent bond.

Proof, contact, display

8-9 How digital changes photography 50-51 Dynamic range in practice 158-159 Printers 226-227 Client issues

image editing

YOU MIGHT CONSIDER THAT SOME of the procedures just dealt with, such as setting black and white points, using curves, and adjusting neutrals, are part of image editing, not least because they use Photoshop or similar software, but I have a particular reason for keeping them separate. As explored in other books, such as *Digital Photography Special Effects*, the scope of image editing is almost without limit. Photographs, once digitized, can be manipulated to any degree, even out of all recognition. Nevertheless, the focus of this book remains photography rather than effects imagery, and it's important for everyone to decide how far the image editing should legitimately go. Section II, Image Workflow, concentrated on the process of moving the image as shot through to its final appearance as a print or on-screen, with no interference in its content—which is about as close as we can get in digital capture to "straight" photography. This section goes to the next level of adjusting the image, which involves new creative decisions for the purposes of repair, correction, enhancement, or frank alteration.

Color spaces and modes

A color space is a model for describing color values, and has a "gamut," or range of colors that it is capable of recording or displaying. By convention, the usual way of illustrating this is as shown on the opposite page. Some spaces are bigger than others, with obvious advantages. A perfect illustration of why color space matters and why it is sometimes less than ideal is the very problem of showing what it looks like on a printed page. The combination of paper and printing inks actually shows fewer colors than in real life, which makes CMYK the smallest color space in normal use. The diagrams here are, of necessity, inaccurate. The area outside the marked spaces contains color subtleties that are impossible to show in print.

Because RGB is standard for digital cameras and computer displays, the most commonly used color spaces are variants of this. A high-end camera allows you to choose which space to work in, as do image-editing programs. Despite the several possibilities, there is at the moment just one recommended space for professional photography, and that is Adobe RGB (1998). The reasons are that it has the largest range for an RGB space and is widely accepted for prepress work. The other RGB spaces offered are all designed for specific *non*-prepress uses, principally matching monitor types and printing directly from the camera or memory card.

RGB may be standard, but there is a larger color space available for digital imaging, and it has striking advantages. This is CIE Lab (strictly speaking, L*a*b*), developed in 1976 by the Commission Internationale

L*a*b* and human perception

Although the eye receives its color information in much the same way as a sensor, through red, green, and blue pigments, we actually perceive color in a much more complex way. We sense brightness, and we also sense color *opposites*. Red and green oppose each other, as do blue and yellow. There's no such thing as green with a hint of red, or blue tinged with yellow. This is the system adopted by L*a*b*, which has three axes to define a color. This makes it intuitive, and also device-independent, unlike RGB.

Which color space?

Adobe RGB (1998) A fairly large range, and the most commonly recommended space at the moment for photography. Good for images that will later be converted in prepress to CMYK for printing (as most professional photographs are).

sRGB IEC61966-2.1 This stands for Standard RGB, but it is smaller than Adobe RGB (1998) and so not recommended for professional photography that will be used for prepress. Its advantage is that it matches the average PC monitor, and is standard for low-end printers and scanners.

ColorMatch RGB Matches Radius Pressview monitors, but smaller than Adobe RGB (1998).

Apple RGB Designed to look good on most Mac monitors, and used in (usually) older desktop applications, such as Photoshop 4.0 and earlier. Smaller than Adobe RGB (1998).

Choose the color mode

Briefly, color spaces are the theory, color modes are the practice, and can be selected in an image-editing program (*Image > Mode >* in Photoshop). Because the four modes normally available—RGB, HSB, Lab and CMYK—separate the qualities of color in different ways, they each have certain advantages for particular photographs:

RGB The standard mode, by virtue of being used in all digital cameras. Widely accepted. The three colors are highly familiar, so easy to manipulate channel by channel, using *Curves* or *Levels*.

HSB Separates the colors into the three dimensions of *Hue, Saturation, and Brightness*—the method most similar to the way in which we see. Therefore, highly intuitive.

Lab The largest color space available, and useful in that its three channels are divided between *Lightness* (L), a color axis from red to green (a), and another from blue to yellow (b). The *Lightness* channel is especially useful for adjustments independent of hue.

CMYK Used in printing, with a fourth black channel added to make up for the lack of ink density on paper. The smallest color space, and so not particularly good to work in.

d'Eclairage, and was designed to match human vision as closely as possible—at least in the way we perceive and appreciate color. Thus, it uses three channels, one for brightness and the other two for opposing color scales. L* stands for luminance (that is, brightness), a* for a red-green scale and b* for a blue-yellow scale. Being a large color space, it is also useful for converting colors from one model to another, as nothing is lost. Indeed, Adobe Photoshop uses L*a*b* internally for converting between color modes. With all this going for it, L*a*b*'s only drawback is that RGB just happens to be more widely used. At least, you can use it in image editing, and convert RGB to and from it with impunity—it allows some special procedures (*see Noise reduction by channel, page 174*).

As for CMYK, which is where most professional photographs end up, the advice is straightforward. Don't use it to edit or archive images. If you do, the image will just lose color information. Like sharpening (*see pages 148-153*), CMYK conversion is best done from RGB at the last step. And, incidentally, best done by prepress professionals.

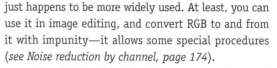

Two color spaces compared: Adobe RGB (wireframe) and CMYK Press (solid), represented in 3D and viewed from different angles. You can see that in some places, the CMYK space—which is generally smaller—exceeds the RGB, for example in the yellows.

Color spaces and modes

Repair

The most basic image repair in digital photography is the retouching of specific details. These may be artifacts, of which the most common is shadow of dust on the sensor, or they may be objects within the scene that for one reason or another you do not want. In either case, the method you choose for repairing will depend entirely on the nature of the blemish; there is no overall ideal technique. As dust is a recurring problem with digital SLRs (because constant lens changing exposes the interior of the camera to the environment), you should regularly check images at 100% magnification. One way of speeding this up is to check at intervals; then, when you find a new dust artifact, go back through the preceding images until you reach the point at which it first appears. In general, there are fewer of this kind of artifact in digital capture than with scanning. Object removal is more subjective, and depends on what you want from the image. Typical examples are shown here and on the following pages. As the examples across the whole book show, you can often facilitate repair by planning for it in advance, at the time of shooting.

Blur repair

Small amounts of motion blur can be reduced by analysing the image and attempting to reverse the process. Currently only one commercial product, Focus Magic, tackles this. Motion blur smears the image in one direction over a number of pixels that is constant for the entire image, and the user enters these two settings after examining the image in close detail. Focus blur is radial, and the radius can be measured by finding a point of light in the image.

Extending the image

Particularly after rotating an image or applying perspective correction (*see pages 182-183*), you may want to extend the image slightly on one or more sides so as not to lose important detail. This works most successfully with continuously patterned textures such as foliage, flooring, and sky. Cloning of one kind or another is the usual method, with the *Patch* tool being especially useful.

Work on a duplicate layer

For the greatest control, make a duplicate layer and retouch that. You then have the option of fading the effect so that some of the texture that might have become lost in retouching can show through from the original, underlying layer. The opacity slider in the *Layers* palette is the usual way to do this.

Object removal by time-lapse

If the objects that you want to remove from a scene appear temporarily, consider shooting more than one frame over a period of time. For example, when I was shooting at Ephesus in Turkey, it was clear that there would never be a moment before the site closed in which it was empty of people (which I wanted). The answer was to take a sequence of frames from exactly the same position and hope that between them all the movement of tourists would reveal all the temporarily hidden bits. Ideally, you would lock the camera down on a tripod for this, but as I did not have one with me, I simply shot handheld. Interestingly, this added only a little extra time during image editing to rotate and move each image in a layer so that it aligned with the ones underneath. The beauty of this technique, although time-consuming, is that the repair can be true to the original—it is not necessary to clone.

Image recovery

Not, thankfully, a common problem, but it can happen that a memory card fails with images on it that have not yet been downloaded. Cards can become corrupted by removing them from the camera before an image has been completely transferred, by low battery level, by fluctuations in power flow to the camera, and by accidental deletion. Recovery software is supplied with some memory cards—download it to the computer and save under *Utilities*. Image Rescue from Lexar, shown here, offers three levels of search:

High Level Search The fastest method, using existing file system information on the card to locate and recover deleted images, and the method to try first.

Low Level Search If the above fails to recover the data, this slower method scans the card for image data patterns and attempts recovery even if the file system data is corrupted or the card has been reformatted.

Extensive Search This last-resort method scans every block of memory, and will sometimes recover image fragments as well as complete images.

Image Rescue main dialog

Object removal by parallax

This technique takes advantage of parallax in revealing parts of a scene that are hidden from one viewpoint. If the subject of interest is partly obscured by something in front of it (for instance, a sign or a lamp-post), take a second picture after stepping to one side. The amount you need to move to reveal the originally hidden part depends on the distance between subject and obstruction as well as between you and the subject. Then combine the two images in layers, align them, and erase the unwanted parts.

Patch Tool

A variant of the *Healing Brush*, and so one kind of cloning tool, *Patch* works as its name suggests, by blending a freehand-drawn sample area over the target. The tool matches the texture, lighting, and shading of the sample to the target.

Cloning

This is the basic and well-known retouching tool in image editing, and works by sampling one area and painting it over the target area. First, set all the options, beginning with the brush size and hardness. These depend on the size of the area to be retouched and on the level of detail (the more precise the detail, as in brickwork, the higher the hardness). *Normal Mode* is the default, but others, like *Color* or *Lighten* increase the possibilities. *Opacity* can also be altered, also *Flow*, while checking the *Aligned* box maintains the same distance and angle between the sample and the target. If the *Aligned* box is unchecked, the sample is drawn from the same group of pixels each time that the brush is applied. On the whole, cloning is an intuitive process, and becomes easy with experience.

Repair

Repair

Healing Brush

This extremely useful tool is a smart version of the *Clone Stamp*, and is used in the same way, by Alt-clicking (Windows) or Option-clicking (Mac) a nearby area to use as the sample for replacing an artifact. This tool then calculates an appropriate blending of the sample into the target.

As with normal cloning, set the size of the brush to slightly larger than the blemish, and the hardness according to the level of textural detail (close to zero for skin, sky, etc.). Set the *Mode* to *Normal*, *Source* to *Sampled*, check *Aligned* but do not check *Use All Layers*. Because this is a complex but automated procedure, judge its success by eye. For instance, if the area you are working on is very close to a sharply contrasting edge, as in the example shown here, the Healing Brush will be influenced by this tonally different area. In cases like this, go back to the *Clone Stamp* tool.

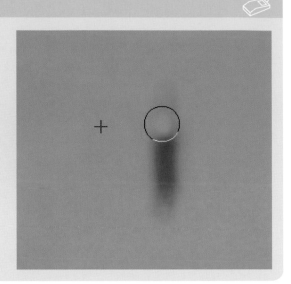

Using filters

Applying a filter to a selected area of the image to remove artifacts is a procedural method—that is, it applies a set procedure in which you define what counts as an artifact and how it should be replaced. In principle, this is quite different from the one-at-a-time repair. It has the advantages of dealing with many artifacts at once, allowing you to proceed a step at a time and to preview the effect before applying it. However, used indiscriminately, it can have some unpleasant side effects on parts of the image that you *don't* want to change, and it is normally essential to make a selection first. The most useful repair filter is *Dust and Scratches* under *Filter >*

Noise. It has two controls. One sets the radius of the area around each pixel that is used to find differences; adjust this first to the smallest setting that removes the artifact. The second is a threshold slider that determines how different the tones must be before they are treated; adjust this to as high as possible while still removing the defect, so that the rest of the image is unblurred.

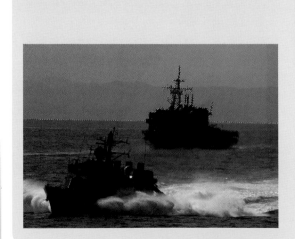

Using a dust map

The pattern of dust on a sensor is likely to remain the same for a number of images. Therefore, on the same principle as fixed-pattern noise reduction (*see page 174*), it is possible to use a map of the dust and apply it to a succession of images. If, during your normal dust-checking procedure (*see pages 82-83*), you discover that you have a noticeable pattern of dust, shoot an overexposed, de-focused frame at minimum aperture against a plain background, such as a white wall or the sky. Save the image. Open this image in Photoshop and enhance the pattern by the following means. Convert the image to *Lab* mode, then duplicate the *Lightness* channel. Working on

just this channel, go to *Levels* and increase the contrast so that the dust artifacts are prominent. This new channel can then be used as a selection for other images. Open one of these, go to *Select > Load Selection…* and choose the retouched channel from the dust-map image. This will help to identify the artifacts easily, and any retouching you now undertake will be restricted to just these tiny areas. Experiment with a procedural effect such as a median filter to replace the dust artifacts with average tones from their neighborhood.

Some camera manufacturers are beginning to introduce in-camera dust-reduction processing on this principle.

Repair

Noise repair

Noise is a complex issue, and has several causes (*see page 60*), which makes it difficult to tackle at the stage of capture. Its appearance depends very much on the person viewing. This means that there does not exist a single global procedure for reducing or eliminating it. In practice, some noise is best dealt with in the camera—notably fixed-pattern noise—but the most useful place for noise reduction is here, in post-production.

To repeat the key characteristic of noise, it is embedded in the image *perceptually*—that is to say, it can be distinguished from subject detail only by judgment, and that differs from person to person. Not only this, but noise does not even necessarily damage a photographic image. Photographs are not slices of reality; they have their own textural qualities, and one of these that has become accepted is a certain amount of graininess from film. There are many well-known images (to name one example, the sequence of D-Day landing photographs by Robert Capa) that draw some of their power from graininess.

One implication of this perceptual relationship with detail is that noise reduction has side effects on the rest of the image, usually softening, and the creation of artificial-looking textures. Because of this, most noise-reduction filters incorporate some kind of threshold setting, to protect detail below a certain level. The problem is that a hard threshold, which leaves finer detail untouched, works on size rather than *visual importance*, and this can create an even more unnatural effect, and draw attention to the repair process.

The algorithms used in different software vary. One common procedure is blurring (*see Average versus Median box, opposite*). Another is frequency analysis,

(*see page 60*)

Assessing noise in Photoshop

Use this technique on a small selected area of an image to see the noise artifacts more clearly.

1 *Open the image and choose a smooth, mid-toned area, where noise will be most apparent.*

2 *Open the* High Pass *filter (Filter > Other > High Pass) and zoom in on the area to 100%. Apply at a radius of 3 pixels.*

3 *Apply* Auto Levels *(Image > Adjustments > Auto Levels) to increase the contrast. This will exaggerate the visibility of the noise.*

4 Desaturate *(Image > Adjustments > Desaturate) to show the luminance Noise separately from the chrominance Noise.*

Noise reduction by channel

Opinion is divided on this, but the majority view is that if a particular type of noise appears most in one channel, apply the filter to that alone. In an RGB image, the blue channel often has the most chrominance noise. Converting to Lab makes it possible to isolate luminance noise by selecting the *Luminance* channel, or checking to see whether the a or b color channel has the most chrominance noise.

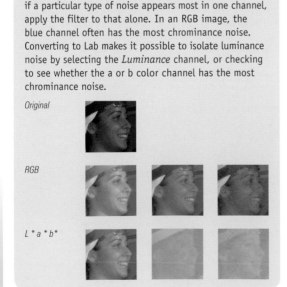

Original

RGB

*L * a * b**

Blind Area artifacting

This is probably the biggest side-effect problem in noise reduction. Simply put, if you apply the filter settings that work for an area of low detail (such as skin in a portrait) to an area of high detail (such as hair), there will be much greater destruction of apparent detail. The eye will not see, in other words, the level of detail it expects. The cause of this is the logarithmic response of the eye to detail—in other words, when you examine different areas of a "noisy" picture, there is actually more real image detail embedded in the noise *in the detailed areas* than you perceive. Removing the noise indiscriminately leaves a false impression in these detailed areas.

Original *Filtered* *Original* *Filtered*

also known as the Fourier Transformation, in which the image is converted to frequencies; these can then be searched for structures that don't conform to known ones representing lines, edges, and patterns. None of these methods can work alone, however; all need guidance from the user. In other words, when using any noise-reduction filter, the best you can hope for is to adjust the settings and choose the best-looking compromise.

Average versus Median

Most blurring filters take an average approach, meaning that they sample an area of pixels (the size depends on the radius you set), and find the average value. A median filter may appear to do the same sort of things, but in fact it chooses the most representative pixel. In an extreme case, if an area of 100 pixels is sampled, in which there are 51 black and 49 white, average blurring will return a gray pixel, while a median filter will choose black. The disadvantage of average blurring is that it reduces rather than obliterates completely blown-out hot pixels, while a median filter will replace them. The disadvantage of median filters is that they can introduce large, unnatural, painterly artifacts.

Hot Pix Original *Hot Pix Gaussian* *Hot Pix Median*

Collateral damage from noise reduction

This is a checklist of the most common unwanted side-effects from over-correcting noise:

1 Blurring	Unacceptable softening and loss of detail.	
2 Painterly artifacts	Banding and areas that are unrealistically smooth.	
3 Blind Area artifacting	Loss of expected detail in high-detail image areas (*see box, opposite*).	
4 Remaindered pixels	Aberrant pixels that stand out, often due to sampling too small an area.	

Selective noise reduction

The eye is more forgiving of noise in areas of detail, like the edges of these skirts, than it is in the flatter areas. This gives us a handy get-out clause, since these are also the areas that the filters have a harder time coping with. To achieve this:

1 Duplicate the layer you wish to apply the filter to.

2 On the higher layer, with a soft-edged brush, erase those areas to which you would like to apply the filter. (It is a good idea to turn off the visibility of the background while doing this.)

3 Apply the noise reduction filter to the lower layer. The effect will only be visible through those areas you erased from the layer above.

Noise repair

60–61 Sensitivity and noise 76–77 In-camera editing 170–173 Repair 176–177 Three noise reduction filters

Noise reduction software

Each of these software filters offers a different approach with different algorithms. For best results, images should have had *no* in-camera processing aside from long-exposure, fixed-pattern noise reduction (in most cameras this option, when turned on, cuts in only beyond a certain exposure time). As with other filters, the results are also better in a high bit-depth (16-bit rather than 8-bit). How significant the differences are between these filters depends on the viewer's level of discrimination.

Photoshop Camera Raw

Currently, dedicated noise reduction in Photoshop is available only for Raw images. Otherwise, the *Median* filter (*Filter > Noise > Median*) offers a rather basic solution. Here, luminance and chrominance noise are filtered separately.

Photoshop's Raw plug-in

Neat Image

Like Noise Ninja, Neat Image uses camera profiles for a range of ISO settings, but can also construct a profile from any given image, provided that there are some featureless areas from which to make the analysis. It works as a plug-in, and the basic procedure is either to load the appropriate noise profile for the image (profiles are available on the Neat Image site for downloading), or to construct a profile using the Auto Profile feature. This should be sufficient if the noise profile is accurate, but it can be further tweaked, beginning with the Y (luminance) slider.

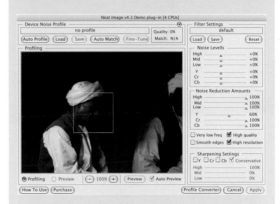

Noise Ninja

This software uses a proprietary technology based on wavelet theory, and relies on camera profiles created for specific ISO settings. The company provides these profiles free for most mid- and high-level cameras, but Noise Ninja can also construct an Auto Profile on the fly from the loaded image by analyzing noisy areas. If the profiles have been downloaded and installed, Noise Ninja will automatically find the correct one for the image. This can be further refined according to taste. The software is available as a standalone program and as a plug-in.

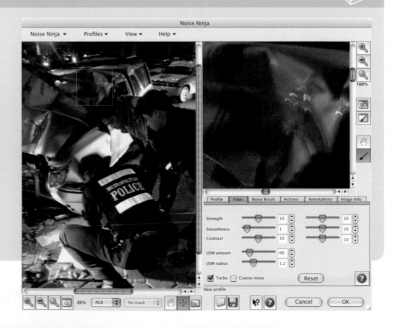

Dfine

A plug-in from nik multimedia featuring four methods with sub-procedures. The key controls are for luminance and chrominance noise, with the facility to load camera profiles.

Luminance noise with a specific camera profile

This is an immensely valuable feature—the ability to load specially constructed camera profiles, and by ISO sensitivity range. This is the first method to use if a profile is available—and may be sufficient.

Chrominance noise

Includes JPEG artefacting correction.

Noise profiles

It is possible to save and load specific profiles, in this case for a Nikon D100 ISO 800-1000

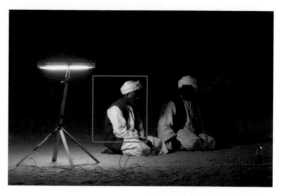

The original image, showing lighting conditions. The images below show the cutaway area using the Dfine noise reduction routine at various settings, and the Power Retouche and Photoshop results for comparison.

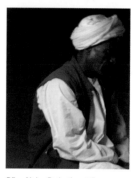

Dfine Noise Reduction at 0

Dfine Noise Reduction at 05

Dfine Noise Reduction at 10

Power Retouche

Photoshop

Noise reduction filters

60-61 Sensitivity and noise 134-135 Working with Raw files 174-175 Noise repair

Tonal artifacts

Yet another kind of image defect that is a candidate for removal is an area that is noticeably lighter or darker than the rest of the image. The causes are various, and the most common are shown here. In all these cases, the key to successful removal lies in making an accurate selection of the area, and it is at its edges that this creates the most difficulties. Most tonal artifacts have edges that are moderately soft, and matching the selection to this is never easy. With a hard edge you can use paths, and with a very gently graded fall-off you can successfully use a gradient tool, but the in-between levels of softness need much more attention.

Chromatic aberration

Not wholly dissimilar from moiré in its appearance, chromatic aberration can be tackled in a similar way. For Raw images, Photoshop's Camera Raw plug-in has a filter specifically designed to reduce the effect (*see pages 138-139*).

Moiré

This is an interference effect most commonly caused by the sensor pattern (*see pages 34-5*). Moiré is particularly insidious because its wavy pattern that varies in both tone and color embeds itself thoroughly in the image, crossing detail and soft areas alike. Always re-shoot if you can (if you notice the effect, you can change the camera angle). Otherwise, repair is time-consuming and involves altering small areas of color channel by channel. Use the procedure for Newton's Rings, a scanning artifact (*see pages 224–225*).

Vignetting

Original image, suffering from mild corner shading.

nikColor Efex Pro Darken Center tool

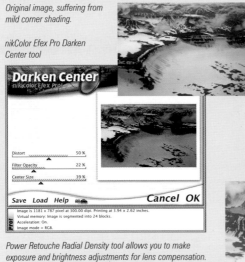

Power Retouche Radial Density tool allows you to make exposure and brightness adjustments for lens compensation.

Wide-angle lenses tend to produce images that are slightly darker toward the corners. Known as vignetting, this is caused by the difference in distance that the light rays have to cover once it leaves the rear element of the lens. With digital capture this is exacerbated by the depth of the photosite wells on a sensor, causing cornershading (*see pages 32-37*). This is easily solvable, and simply needs a radial gradient selection. There are a number of filters and tools that do this, including the Photoshop Camera Raw plug-in, camera manufacturers' editing software, third-party plug-ins such as PowerRetouche Radial Density and nik Color Efex Pro! Darken Center, and a radial gradient applied in Photoshop in *Quick Mask* mode.

The final image with its vignetting removed.

Flare artifacts

Lens flare is more often than not asymmetrical, with the effect strongest closest to the light source. For this generalized kind of flare, typical of longer focal lengths, the solution is first to create a gradient mask (in Photoshop, *Quick Mask* mode, and then an appropriate

setting of the *Gradient* tool), then apply the necessary tonal correction with *Curves, Hue/Saturation, Brightness/ Contrast*, or whatever. With flare polygons, the procedure is more complicated, as this example illustrates.

1 The affected region

2

3

4

5

6

Lens shade cut-off

With a wide-angle lens and camera-mounted flash (particularly built-in flash heads that sit lower on the camera than attached units), the lens shade is quite likely to cast a shadow over the foreground. Test to see at which focal length this happens—a particular danger with wide-angle zoom lenses in which the cut-off occurs only at the wider end of the range—and remove the shade. If the damage has already been done, the solution is to lighten and increase contrast in the cut-off area, and for this you need an accurate selection in Photoshop. To make one, photograph a white surface by flash alone (2), and use

the resulting image as a mask. Invert it and copy it into the faulty image as an *Alpha* channel (3), and then load it as a selection to make the corrections (4). In most situations the cast shadow will be over the ground, so for complete accuracy shoot this blank masking frame by aiming the camera at a similar angle to the white surface.

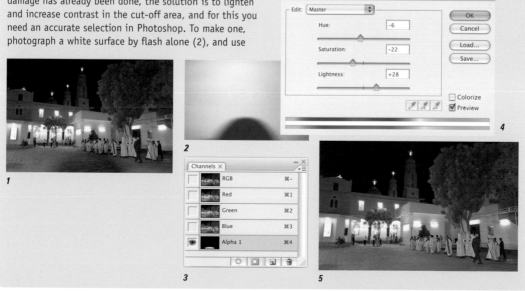

1

2

3

4

5

86-87 On-camera flash 138-139 Advanced Raw 184-185 Color adjustment 198-199 Altering light and atmosphere

Tonal artifacts

Correcting lens distortion

Geometric lens distortion is nothing new, but now it is more significant. There are a number of reasons, not all due to digital imaging. Smaller sensor sizes make very short focal lengths necessary, and these, facilitated by modern lens technology, are built into zoom lenses that have larger ranges than ever before. Gone are the days when prime lenses were obviously superior in image quality, but it is more difficult to correct distortion in a zoom—on a lens with a large range, it's quite likely that there will be barrel distortion at the wide-angle end, with pincushion at the other, longer-focus end. Wide-angle zooms are understandably popular, but the penalty is distortion. Because distortions *can* be corrected digitally, there is no excuse for ignoring them, and this becomes yet another addition to the workflow. Lens distortion can be corrected with software, although currently the choice is small. Because lenses have individual distortion characteristics—and more important, with zoom lenses the distortion varies with the focal length—correction software has to be able to interpolate several parameters, including the radial amount of distortion. Of course, lens distortion matters only if it is noticeable, as it is chiefly along long, straight lines close to the edges of the picture. If it doesn't disturb you visually, there may be little point in correcting it.

In principle, both barrel and pincushion distortion are corrected digitally by applying the opposite radial distortion, and to an extent you could use one of the basic tools, such as Photoshop's *Distort* filters. These, however, do not allow for the variation in the amount between the inner and outer parts of the frame. Lens-distortion correction filters can allow for the different optical characteristics of different makes of lens. The degree of distortion always increases outward from the center, but the way this progresses varies from lens to lens. Without taking this into account, you can end up with corrected straight lines at the edges but under- or over-correction nearer the center.

Software solutions

Correction software is judged by its effect on straight lines, and, to a lesser extent, on symmetrical shapes such as circles. A grid overlay is essential for measuring

Worth correcting or not?

Remember that lens distortion does not always have to be corrected. Its effects are most obvious—and least acceptable—on long, straight lines close to the edges of the frame, particularly if they look as if they should be parallel to the edges. If the scene contains no long, straight lines, there may be no compelling reason to do anything to the image. Natural scenery, for example, usually has no clear geometry. With the exception of fish-eyes, most lenses require a small amount of correction; make a visual assessment first.

Image geometry—three procedures

There are three main kinds of correction that you may need to make to the geometry of an image:

Type	Characteristics	Procedure
1 Lens distortion	Bowing inward or outward around the center (radial).	Lens correction plug-in filter that applies the opposite radial distortion, weighted appropriately between center and edges.
2 Perspective distortion	Convergence of parallels, vertically or horizontally.	*Edit > Transform > Perspective* filter.
3 Rotation	Tilted clockwise or counter-clockwise (around the z axis).	*Edit > Transform > Rotate* filter, or *Image > RotateCanvas*.

It may not be immediately clear in which order to apply these, and much depends on the specific image. However, in principle, correcting lens distortion first will leave straight lines that are easier to judge for perspective and rotation.

Image editing

This image of a storage unit has had no correction applied to it.

This image has had LensDoc correction applied to it.

Before and after shots

the effect of the filter, either in the filter window or on the applied result in Photoshop—or both. Adjust the spacing of the grid so that the lines are close to those lines in the image that are most important. Image distortion is very demanding of processing ability, and final image quality depends on good interpolation algorithms.

The ideal method is to analyse each lens, map its distortion (and, if a zoom, at every focal length), and then reverse its effect in the program. Essentially this is what DxO Optics Pro does, and it is completely effective. The only drawback is that it is entirely dependent on the time-consuming analysis that the software manufacturer makes, and there is no way of adjusting, tweaking or creating a user profile of any other lens. An alternative approach is taken by Andromeda's LensDoc, which works by defining points along a line in the image that need to be straightened, then straightening that curve. Andromeda also have a method for users to profile distortions for themselves, though this is very time consuming

This is a custom target for lens correction, ideal for profiling a lens.

An alternative to the custom target is to photograph an image with a number of straight lines in it.

Expanding to fit

After correction, the image will need cropping to remove the new curved edges, unless the software offers the option of stretching the image to fit the original frame. For this reason, do *not* crop an image before applying lens correction. The software assumes symmetrical correction around the center of the image, so cropping beforehand results in a skewed correction.

Correcting lens distortion

Rotation and perspective correction

Aside from the barrel or pincushion lens distortion, the other two common kinds to deal with are rotation (tilted horizon) and perspective ("keystoning," or convergence of either verticals or horizontals). Both result from failure to level the camera while shooting. In reportage it may be irrelevant while in more formal, precise kinds of photography, such as architecture, it looks distinctly wrong. All are the results of axial distortion, which is why we deal with them together here.

The tools for correction are straightforward and available under *Edit > Transform*. However, they each call for a large amount of interpolation in re-calculating pixel values, with the potential for damaging the image, particularly if you make several independent corrections. It's important, therefore, to minimize the number of filter applications—and also, if possible, to do them in 16-bit rather than 8-bit. A lens correction plug-in, Andromeda LensDoc, also fixes these corrections, and in one operation, which is an advantage. Otherwise, choose an order for running the filters that avoids the need to go back and repeat any of them. If there is a clear horizon or a *long* horizontal line in the image, fix this first. The reason is that perspective correction is a symmetrical procedure, so that it is important to apply it to a straightened image. An alternative is to work as much as possible in *Distort*, as this single tool allows you to move each of the control points independently.

Graded transforms

Applying distortion can either squeeze or stretch parts of the image. With perspective correction you will have effectively squashed the appearance of a building by stretching the upper part outward. A rather involved but very effective second correction is to then stretch the upper part of the building upward *progressively*. To do this, make a grayscale displacement map that grades from mid-gray (no displacement) below to black at the top. The actual tones, their position, and the percentages in the displacement filter's dialog box are a matter of trial and error. The visible distortion occurs only in the *transition* areas between gray and black.

Grayscale displacement map
Made to the same proportions as the image, but much smaller, at 1000 pixels wide. A vertical black gradient is applied over a mid-gray background.

Accessing the filter
A percentage value is applied to the vertical axis only.

Combined perspective and rotation

The problem with an image that combines both kinds of distortion is that one affects the other. In a case like this, with no visible horizon and short horizontals, there is no obvious reference for the center vertical—applying the *Perspective* filter will over-correct one side or under-correct the other, or both. An easier, one-step procedure may be to use the *Distort* filter (also under *Edit > Transform*), as this allows the corners to be dragged independently.

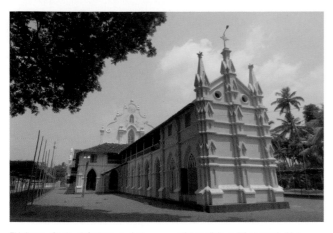

 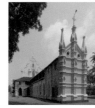

This image of a church features very heavy vertical convergence distortion. Beneath are two alternative corrections, the first with strict parallels, and the second with a slight distortion remaining for a more natural effect.

Perspective—grid

Corrected perspective 1

Corrected perspective 2

Distortion from rotation

This kind of distortion can be avoided by leveling the camera, and if it is going to be an issue, this is much better than solving the problem later in Photoshop.

As the diagram shows, rotation around the z axis tilts the horizon, and around the y axis causes converging verticals. Rotating around the x axis creates converging horizontals, and this is only occasionally seen as an error (for example, in a wide-angle architectural interior that is clearly intended to be squared-up and face-on).

Perspective correction

Aiming the camera upward toward any straight-sided object (buildings are the most common) causes a keystoning perspective effect in which the parallel verticals appear to converge. For perceptual reasons, this usually looks wrong in an image. With the *Perspective* tool (*Image > Edit > Transform*), and the grid switched on to judge the alignment (*View > Show*), drag either of the top corner control points outward or the bottom points inward. This will re-size the image progressively in one direction, and if you drag the top corners it will result in upscaling toward the top. This will then cause a slight deterioration, for which you can compensate by a small amount of *Unsharp Mask* sharpening applied to a linear gradient selection. You will then usually need to crop the image back into a rectangle, or add more background (*see page 203*). Alternatively, consider selecting the outline of the building and applying the perspective control to that alone, leaving the background undistorted.

Rotation and perspective correction

92-93 Tripods and supports 180-181 Correcting lens distortion 202-203 Compositing 206-207 Stitching

Color adjustment

Having optimized the image in the sequence described in the last section, you should by this point have all the colors more or less "correct." Nevertheless, there may be any number of subjective and creative reasons for wanting to make further adjustment. There are also many tools and dialogs for making these adjustments, within Photoshop (from the *Image > Adjustments* menu) and through third-party plug-ins (like nik Color Efex Pro!) and other software applications. All rely on a basic operation, which is to select a range of pixels and then map these values to a new range of values. To do this in one step—that is, through one tool—there needs to be a method of selecting pixels based on their values: hue, saturation, and brightness.

To make any other kind of selection, such as on the shape of an object in the photograph, you would first need to use one of the selection tools (*see page 188*). You may find the *Select > Color* Range facility in Photoshop very useful if you are looking to alter regions of color. Unlike the *Hue/Saturation* tool's color range selection, its *Fuzziness* can be altered.

Hue/Saturation

Because this tool uses the color mode most closely related to the way we judge colors—hue, saturation, and brightness—it is one of the most useful for making controlled adjustments. It helps to keep in mind that the color bar is a straightened-out version of the color wheel, with hues defined by their angle (0°–360°, as on a compass). By default, the entire color range—called *Master*—is selected, but the changes can be restricted to individual colors from a drop-down menu, and even further refined by sampling colors from the image while you are in one of these ranges. The sliders that appear on the color bar can then be adjusted. The two vertical bars determine the range of colors selected, and the two outer triangle sliders determine the fall-off or fading from this range.

The Hue/Saturation dialog presents a number of options. You can adjust the colors in the image using these tools, or apply a color to them by checking the Colorize button.

Alternatively, you can opt to affect only a certain range of colors. You can select the range using the droppers, or from one of the pre-defined ranges from the Edit: drop-down menu.

Strengthening blacks only

This approach, adopted by a third-party plug-in, PowerRetouche Black Definition, is quite distinct from the usual color adjustments. It allows the black component of colors to be deepened independently of the color component, and compares most closely with color correction made on a printing press. You *could* perform this operation on the black (K) channel of a CMYK image, but with the disadvantage of having first to convert to a smaller color space and then working in monochrome on the channel. This plug-in offers control over the grayscale range and over the degree of saturation in the colors that it affects.

Before *After*

Power Retouche Black Definition filter

To correct just certain colors in an image, first create a new Hue/Saturation *adjustment layer.* Choose to edit any color group other than "All," then, using the dropper buttons, define the exact range of hues you wish to affect. The + and - droppers extend or contract the range; the plain one sets the center hue. You may then adjust that range (here, for example, the saturation near blue was reduced).

Targeted color cast

One of the most useful kinds of selection is to be able to target a particular brightness range. This has a special bearing on photography in dealing with color casts of light sources, such as a fluorescent lamp reflecting brightly off the surrounding wall or ceiling. This is most relevant to different types of lighting (*see page 62*).

Enlarge the pixel sample area

The *Eyedropper* tool features prominently in many color adjustments as the normal way of sampling color information from a photograph. By default it measures single pixels, but in a multi-megapixel photographic image, there is likely to be too much variation at pixel level. It's generally more useful to set the sample area to a larger size. Click on the dropper tool in the **Toolbox**, and then select either 3 by 3 Average or 5 by 5 Average from the *Options* bar.

Match Color

This tool is designed primarily to allow the colors in one photograph to be matched to another—either the overall balance or a specified range. Of course, if you have already efficiently optimized the photographs, this should not really be necessary. Nevertheless, *Match Color* facilitates other kinds of change, including the removal of color casts and altering selected colors. Because it works on the principle of target and source, it works well with memory colors (*see Using Match Color, page 186*).

The Photoshop Image > Adjustments > Photo Filter... *tool allows you to simulate the effect of certain filter colors, or create a color of your choice using the* standard Color Picker. *This is a very photographer-friendly approach, since the concept is one long-established in film photography, with the benefit of an undo option.*

Color adjustment

104-105 Color 168-169 Color spaces and modes 186-187 Memory colors

Memory colors

Certain kinds of color are more fixed in our minds than others, meaning that we have finer discrimination and stronger opinions about whether they are accurate or not. To an extent, this varies from person to person, and depends on particular interests, but there are a few standard sets that most of us recognize. They are known as memory colors because they seem to be embedded in our visual memory. Naturally, they play an important role in image-editing because they are an immediate key to assessing the color accuracy of a photograph. For memory colors, we can say whether they are "right" or "wrong," and to what degree, and we can do this intuitively. Measurement is important in optimization, as we saw, but as color is ultimately a matter of perception, never underestimate the importance of subjective judgment. If it looks right, it is right.

The two most important memory colors are those with which we have most familiarity: neutrals and skin tones. Following this, there are green vegetation and sky tones. Your color memory also depends on the environment in which you grow up—if you live in New Mexico or North Africa, you will be more attuned to the colors of sand and rock than if you live in northwest Europe.

Neutrals

Objects and surfaces in a photograph that *should* be neutral include concrete, steel, aluminum, automobile tires, asphalt, white paint, black paint, midday clouds.

Using Match Color

This adjustment tool in Photoshop uses a source-and-target method, which makes it ideal for handling memory colors. To restrict changes to memory colors *only*, you should first make a selection, in this case by using the Magic Wand Tool set to an appropriate Tolerance and then going to *Select > Similar*. The Fade slider controls the strength of the adjustment, and if you apply Match Color to a duplicate layer rather than to the original, you can further fine-tune the effect by adjusting the opacity. By checking the *Neutralize* box, the tool will perform an adjustable shift toward neutral. Otherwise, use a known sample. In the example on the right, the aim was to shift the more blue-green vegetation toward yellow-green.

Adjusting the memory colors in a photograph involves matching them to known samples. At it simplest, this means relying on your memory at the time of correction, but you can refine the process by referring to samples that you already accept as accurate. One way is to open a second image that is already well-adjusted and use it for reference. Another is to build a set of color patches that represent memory colors that are correct for you. There is also software that deals specifically with memory colors. The adjustment approach is basically that of *source* and *target*.

Specialist memory color software

iCorrect Professional makes a special feature of memory colors, and comes with four pre-defined ones: neutrals, skin, foliage, and sky. Because such colors cover a range, the software allows for this by defining each with three parameters:

1 Hue Defined as an angle between 0 and 359 degrees on a color wheel, as specified by international CIE color standards (not Photoshop's HSB system).

2 Chroma A value between 0 and 100 defining the amount of saturation a color has. Neutral colors (black, white, gray) have zero chroma. Vivid colors have high chroma. Also specified by CIE standards, not Photoshop's HSB.

1 ∆ Hue (Delta Hue) A value between +10 and -10 that controls the way that the hue changes between dark and light tones. If zero, there is no change from light to dark. If negative, the hue angle decreases as lightness increases. If positive, the hue angle increases as lightness increases. Using ∆ *Hue* instead of simple *Brightness* allows the software to deal naturally with a range of tones in the chosen memory color.

These pre-sets can be adjusted to customize them, by altering the position and the angle of the line that runs through the color map. You can also create new memory color settings and define them by opening photographs that you know to contain the "right" colors and clicking on these to sample them. These pre-sets are constructed from a range of similar colors, and in use also you can sample up to five areas, ideally from light to dark.

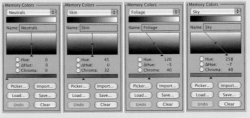

Pre-set memory colors in iCorrect Professional.

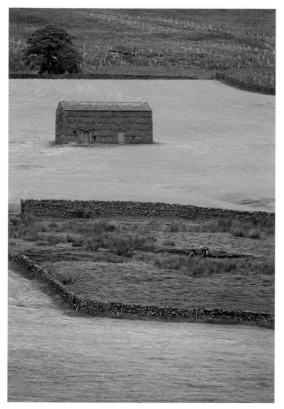

In some color areas, our camera is more sensitive to the subtleties of shade than your eye. Areas susceptible to this are often fabrics with organic dyes, and it is not uncommon for greens to appear neutral or on the warm side.

Green grass, captured here under the clear, even light of an overcast English sky. Grass and plants are a crucial memory color, especially in temperate climates like England, and much of Europe and the United States. In the mind, the color memory colors tend to become slightly more saturated—in other words, the grass is always greener.

Memory colors are only understood by the mind in the context that we see them in. Place the red from this light somewhere on its own and it is simply a red color, but in this image, the red (and indeed yellow and black) clearly need to appear strong, since they represent commmonly understood warning colors.

Measuring colors directly

If you have access to a colorimeter or spectrophotometer, and the exact color of an object is important, as in product photography, measure it directly. Save the sample in a separate file. If you use iCorrect Professional, the measurements can be saved more accurately as a plain, unformatted text (ASCII) file in the form shown below. Use an application like TextEdit or Simple Text rather than MS Word, which will format it.

Lab
73.12 12.34 -8.98
55.80 21.19 -17.34
29.11 15.78 -10.65

For detailed instructions, follow the manual. The measurement can then be imported and used to adjust the color as photographed.

Neutral tones, like those of this gull's gray and white feathers, are important to both the human eye and computer color correction. The mind's use of memory colors might be likened to a complicated form of white balance correction (see pages 62-63).

Memory colors

62-63 White balance 104-105 Color 184-185 Color adjustment 226-227 Client issues

Selection methods

Central to image-editing, and often the first step after making simple global corrections, is selecting the area that you are going to manipulate. As we've seen, there are several ways of making a selection based on the values of pixels, but often, in a photograph, what you really want to do is to outline an object. For this, pixel values are certainly of some help—after all, what makes an object visible against its background, whether it is a person, tree, building or a piece of jewelry, is difference in tone or color—but guiding this kind of selection needs much more of a personal touch. For this reason, there are several tools to choose from, and quite often, you will need to combine more than one.

Edge control

The softness of an edge can be altered by feathering (*Select > Feather...*), which adds a transition border just beyond the edge, effectively creating a blur. Depending on the size of the image and the nature of the object, the feathering may need to be as little as one or two pixels. *Layer > Matting > Defringe* and *Layer > Matting > Remove Black Matte* (and *Remove White Matte*), are other tools for removing the effect of the background.

Auto-selectors

Auto-selection works by searching for edges—that is, contrasting pixel values—in the neighborhood of the point clicked. You can set the tolerance to determine how different pixels need to be.

Magic Wand
This is the most widely used auto-selection tool. Having set the tolerance, click either within the object or outside, close to an edge. Extend the area by Shift-clicking to keep on adding to this selection—or Alt-click (Windows) or Option-click (Mac OS) to subtract. As you work around the edge, you may need to adjust the tolerance to suit the changing similarity/contrast between the object and its background.

Magnetic Lasso
Using the same principle as the Magic Wand, this tool jumps in toward an edge as you draw an approximate outline at a distance. Then it makes a temporary conversion to paths with control points, which can be dragged and adjusted before the final selection appears.

Knockout software

If the ultimate objective of making a selection is to replace the background or composite in some way, the best solution may be to use knock-out software. This, available within Photoshop as *Filter > Extract* and as third-party applications such as Extensis Mask Pro and Corel Knockout, not only removes the image beyond the outline, but sets a degree of transparency along the edge to allow for interaction with the background. Good knockout software skillfully used can handle very subtle edges, such as hair, fur, and foliage.

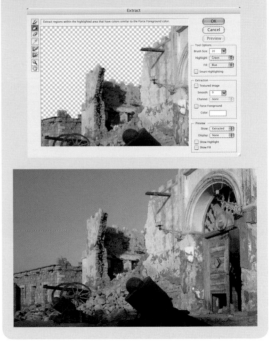

Ultimately, tracing the outline of an object means being sensitive to the edge qualities. Probably the most important of these is precision—how clean and well-defined the edge is. Different selection methods are needed for different extremes, and there are also a number of ways of altering the edges after making the selection. Another edge quality that becomes important if you make changes like replacing the background is its interaction with its surroundings. The edge of a rounded object, particularly if it is shiny, will pick up color from the background. This may not be obvious in an unaltered image, but if you paste the selection onto, say, a black background, the colors it had picked up would be carried with it. In a less extreme change, the result might just look subtly wrong.

Cut-outs

As you can see from magazines and illustrated books, there is a demand in publishing for cut-out images, in which the objects float on the page without background. This can be done at the repro stage by the printer, but it may be better to do it yourself. Although it adds to the workflow, you are in a better position than anyone to know how the edges of an object should look, and for stock sales it may help the saleability of the image if you supply it with a clipping path. If you shoot knowing that the image will be cut out, you can save time by not bothering with a precise background, although the background should certainly be neutral, otherwise the edges of the object will pick up colored reflections. Most cut-outs are used against white, but some against black or a color, and it is worth checking the appearance of the finished image against different backgrounds before you save your work.

Drawing a path
Paths are lines connecting points placed by the cursor, and are independent of resolution. They work particularly well with hard, regular, and geometric edges. Curves on a path are known as Bézier curves and these can be adjusted by pulling and rotating pairs of "handles" attached to each point. Once complete, a path outline can be converted into a selection, and then saved and used in the normal way. You can also generate a path from a selection made in another way (with the selection active, click *Make Work Path* at the bottom of the *Paths* palette), and adjust it from there.

Working at 200% magnification for accuracy, the pen tool is used to draw a path around the mask, working fractionally *inside* the edges so that the final clipped image can be used against any color of background.

Making a selection
As part of the procedure for checking accuracy, the path, when complete, is converted into a selection. This is then inverted.

Checking against black
The inverted selection is temporarily filled with black (or any other color) to see how the edges behave. If the path had been more open, some of the original background would have been included.

Clipping paths
Finally, the working path is converted into a clipping path that the PostScript interpreter in a page layout program can read. The flatness value determines the margin of error when printed, and the precise value depends on the printer.

1

New Path — Name: Path 1 — OK — Cancel — *2*

3

Make Selection — Rendering — Feather Radius: 0 pixels — Anti-aliased — OK — Cancel — Operation — New Selection — Add to Selection — Subtract from Selection — Intersect with Selection — *4*

5

Clipping Path — Path: Path 1 — Flatness: device pixels — OK — Cancel — *7*

6

8

Selection methods

Composite focus

This technique, if you plan for it first at the time you shoot, allows you to deepen the focus, and is valuable if you want good depth of field in an image but for various reasons have to shoot with a wide aperture. For instance, the light may be insufficient, you might be using a telephoto lens, need a fairly high shutter speed for handheld shooting, yet prefer to keep the ISO sensitivity low for good image quality. In close-up and macro, there are optical limits that make it impossible to capture the full depth sharply in some scenes. The technique of composite focus involves shooting more than one frame of the same view, but with the lens focused at different points, and then compositing these images as layers. For example, if you focus first on the foreground, whatever the aperture setting, there will be a band of sharp focus in front of and behind this. Moving the focus deeper into the middle ground in a second shot gives you another, different, sharply focused zone. And so on. Often, just two frames will be sufficient.

Copying and registration

Compositing then involves copying each image into its own layer, but in perfect register with the others. This is slightly less easy than it might seem, because objects in focus in one layer will be out of focus in another, and only the parts of the scene that overlap in sharpness are useful as a guide for positioning. Of course, if you use a tripod, which is highly recommended, the layers will be automatically in register. However, for spontaneous handheld shooting, the technique still works, but just takes longer at the

1 Original image with gargoyle in focus.

2 Original image with buildings in focus.

3 The close-focus version is pasted on top of the far-focus shot. The compositing here was complicated by the extreme differences in depth of field, using a moderate telephoto. As a result, the out-of-focus gargoyle-like head was larger than the in-focus version, creating a shadowy halo that was removed.

image-editing stage. With the layered images in register, erase the blurred areas in each with a soft brush. Complete success depends on having some overlap in the different depths of field, so that there is always a sharply focused area to replace a blurred one. As a precaution, it is better to over-shoot than to risk having a zone that is unsharp.

One problem that is worse at close shooting distances is difference in scale. Because the lens has to move forward when you focus closer, on the foreground, it is closer to the object and magnifies it. You may need to re-scale it to be smaller. Another difficulty is when a foreground object sticks up in front of a distant part of the scene. An out-of-focus image is larger than a sharply focused one, because of blurring, which extends its area, and this blurred edge can obscure part of the distance. One answer is to re-scale, making the sharp foreground image *larger*. Otherwise cloning may be necessary.

Erasing technique

If you have more than two layers, have only two visible, including the background. Work on the top layer, brushing out the blurred areas. This has to be done manually, judging by eye, one brushstroke at a time, because focus and depth of field are not the only image qualities affecting sharpness. A smooth area, for example, may be in focus but show no detail. Do the erasing one stroke at a time, continuing until the brushstroke that reveals a softer rather than a sharper result—undo this last one. An alternative to erasing is to *add* sharp focus by using the *History Brush* to revert selectively to a state or snapshot in which the top layer obscures the background.

4 *The upper layer is repositioned so that it is in register with that beneath it.*

5 *A selection mask is created around the in-focus head with a mixture of the Magic Wand tool and mask painting, then the selection edges are smoothed (using the Refine Edge toolbox's Smooth slider) for photo-realism.*

6 *The selection on the upper layer is deleted to remove the out-of-focus distance, and the selection is left active.*

7 *On the lower layer, the selection is expanded to take in the shadowy halo.*

8 *This expanded selection is blurred to match the shadowy halo.*

9 *Using this selection, the shadowy halo is lightened using Curves.*

10 *Finally, the upper layer, which contains only the in-focus head, is lightened.*

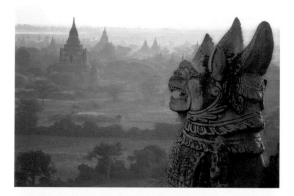

Selective focus

Digital techniques can also help in the reverse situation to that on the previous pages—when you want to narrow the depth of field so that just a few points in the image are sharp. Known as selective focus, this is a standard shooting technique which, according to fashion, is used to concentrate the viewer's attention on one small area of texture and detail, leaving the rest of the image a soft wash of color. How narrow you can make the zone of sharp focus depends on the combination of the widest aperture of the lens and the image size, and in a digital SLR this is usually deeper than you might want for the effect. Traditionally, in shooting for selective focus you would use a fast lens wide open on a large-format camera. The relatively small size of most sensors works against this, giving *more* not less depth of field. In addition, light levels may be too bright even at the slowest ISO sensitivity to allow the widest aperture. There are specialist soft-focus lenses that can help to some extent; they induce controlled soft front-focus or soft rear-focus and are intended for a particular kind of portraiture. But the most complete solution is digital.

Fortunately, softening the focus is a form of blurring—image degradation, in other words—and this is straightforward in image-editing. There are two basic methods: freehand and procedural. Freehand brushing allows detailed creative control, which can be important in this effect. Procedural techniques depend on first creating a mask that is then used as a selection for blurring. You can combine the two—procedural first, then touching up with brushwork. There are different blurring algorithms, as you can see from the Photoshop *Filter* menu, but few are designed to replicate true optical blur, with its blurred circular highlights. One answer is to apply two levels of blur—one overall and another to the highlights. For an even more realistic effect, the blur should increase with distance from the plane of sharp focus, and for this you would need to create a gradient ramp from near to far —a map of the depth in the scene. There is no automated way of doing this, and it involves masking out the areas that you want to keep *in* focus. But for complete realism, consider using the same technique described for composite focus. Shoot a sequence of frames at different focus points, so that you have a choice of true, optically de-focused areas. It's better to end up with too many than too few. With close-up shooting, there may be a problem with scaling (*see page 190*).

Original 1
In this series of three images, an attempt has been made to capture as much of the foreground food parcel in focus as possible. In this image, the back of it is in sharp focus.

Original 2
In this image, the middle areas are in focus.

Original 3
Here the foreground is in sharp focus, including the texture of the leaf and its contents.

Focus effect
The three original images are placed on top of each other in Photoshop, with Original 1 as the background image, and the others above.

With layer visibility temporarily turned off, the areas in poor focus are erased from the top two layers. When the visibility is turned back on, the sharper focus will be revealed.

The final Layers palette shows the patches in the two foreground layers.

The final image creates an area of selective focus longer than the depth of field that was available in the studio, helping to bring the parcel to the fore of this image and distinguish it from those completely out-of-focus in the background.

Focus effect plug-ins

Selective focus effects can also be achieved using certain plug-ins. The palm of this hand was made the center of attention using the Focus filter of AutoFX's comprehensive DreamSuite. It can create dramatic zoom and rotation effects too. Alternative, and less expensive, options are provided by nixColor Efex's Classic Blur, Power Retouche's Soft Filter, and of course making a selection in Photoshop, then applying the *Gaussian Blur* filter.

Selective focus

Altering tonal range

As we saw in optimization (*see pages 128-133*), redistributing the tones in an image is the most important part of digital post-production. There are two basic possibilities, although many techniques within them: altering the *limits* of the tonal range, and changing the positions of values *within* the range. For a number of reasons, optimizing an image as part of the normal workflow may not do the best job possible, and extra techniques may be needed. One is simply that the scene has too great a range of brightness, so that highlights and/or shadows are clipped. If you shoot in Raw, you have an extra four *f*-stops of grace, but if in TIFF or JPEG, the blown highlights or closed shadows are irretrievable—unless you plan for this in advance at the time of shooting. Aside from all the photographic solutions, such as adding lighting and altering the composition, it is possible to cover a much greater range of brightness by combining more than one exposure. The technique has limitations in that the camera needs to be locked down on a tripod, and it takes time, but it is immensely valuable for otherwise impossible picture-taking situations. The most common of these is a room interior with daylight coming through a visible window, a situation in which you would normally be using a tripod in any case. The set-up involves shooting at least two frames, one for the midtones and one for the highlights (*see pages 52–53*). In a more extreme situation, shoot three frames, one each for shadows, midtones, and highlights. Using layers in register, the well-exposed areas from each are combined. Note that there are several ways of doing this, including using the *Blending Options* dialog on the *Layers* palette, and that the one shown here is simply one that works for me.

Another reason why normal optimization may not be able to cope with the tonal distribution is that the lighting may be uneven. A particularly common situation is strong backlighting without flash;

Using a gradient map

If the range brightness changes steadily across the image, enter *Quick Mask* mode, choose a linear gradient, and apply this.

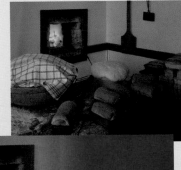

3 Return to normal mode and use Curves to lighten the darker area.

1 In the original, the lighting falls off from one side to the other.

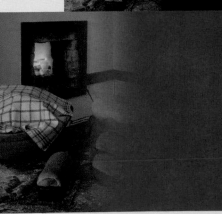

2 In Quick Mask *mode, apply a linear gradient.*

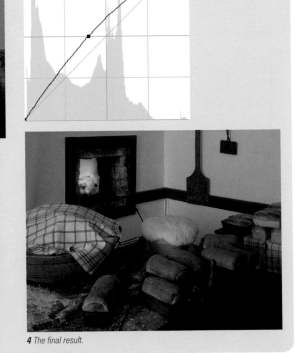

4 The final result.

Restricting the range with a mask

The same kind of masking as used in a highlight mask can also be used to protect areas from change. Here, the problem is to enhance brightness, contrast, and saturation in the shadowed ceiling area without affecting the brighter tones. First, a highlight mask is made by adjusting *Levels* in a duplicate *Lightness* channel, then this is inverted as a selection. Quite strong changes can now be made safely.

Photoshop's *Shadow/Highlight* control was designed primarily for this. Another is a gradual light fall-off from one side to another, as happens in a daylit room interior with a single window left or right. For this, and the many other situations with uneven lighting, the answer may be to first make a selection, then apply standard tonal control such as *Levels* or *Curves*.

Shadow/Highlight

This is a sophisticated tool for lightening shadows, darkening highlights, and confining contrast adjustment to a range of midtones (*see page 144*).

Freehand selection

Using any selection method (*see pages 188-189*), select the area you want to lighten or darken. You can also apply contrast changes within this area.

Compressing the range with a highlight map

This multi-exposure technique effectively combines different tonal ranges into one. Note that it does *not* extend the tonal range, but rather compresses a greater range of brightness into the normal scale.

1 Open the exposed-for-midtone and exposed-for-highlight images.

2 Copy the exposed-for-midtone on top of the exposed-for-highlight image.

3 In the original exposed-for-midtone image, change to Lab mode and duplicate the *Lightness* channel.

4 Using *Levels*, sharply increase the contrast to isolate just the highlights that you want to preserve in the final image. This may need two applications of *Levels* and possibly some retouching.

5 Return to the layered composite image, go to *Select > Load Selection* and choose the duplicate *Lightness* channel that you have just manipulated.

6 Hit the Delete key.

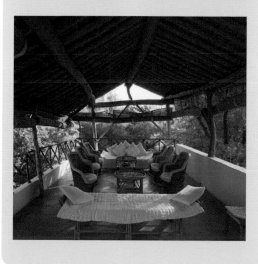

Altering tonal range

50-51 Dynamic range in practice 142-143 Curves adjustment 198-199 Altering light and atmosphere

HDRI

igh Dynamic Range Imaging, or HDRI, promises wholly new ways of handling and interpreting scenes that contain a range from shadows to highlights that is beyond the ability of a normal sensor to capture. A high dynamic range image is any that exceeds the ability of a standard camera to capture it in a single frame, and exceeds the range of a standard display device (essentially, an 8-bit monitor). For instance, a typically bright, sunlit scene containing highlights and shadows has a dynamic range in the order of 2,500:1, and while the human eye can accommodate this (though it does it by scanning the scene rapidly and building up a cumulative image), a digital sensor cannot completely manage it. This is because, while a typical 12-bit sensor shooting Raw theoretically has a dynamic range of 4,000:1, its practical range is closer to 1000:1, mainly because of noise. If the sun appears in the shot, the dynamic range will shoot up to something in the order of 50,000:1. Another typical high dynamic range scene is an interior with a view to a sunlit exterior, and this type of situation can reach 100,000:1.

If the camera remains steady, a sequence of frames at different exposures can capture all the detail. The software exists to combine such a sequence into a single HDR file format. There are several HDR formats, but typically they are 32 bits per channel, and instead of this extra bit depth being pre-assigned to a range of values, as happens with 8-bit and 16-bit images, it is used in quite a different way. The bits are assigned to decimal points, so that any real-world tonal value can be given a precise digital value, and for that reason, this is known as floating point coding. A number of commercial programs exist for generating an HDR 32-bit floating point image file automatically from a sequence of exposures (normally shot about 2 f-stops apart). They include Photoshop, Photomatix, Photosphere, HDR Shop and AHDRIA/AHDRIC. HDR file formats include Radiance RGBE (.hdr), which is the most widely used, OpenEXR (.exr) and Floating Point TIFF, among others.

HDRI handles the contrast between bright lights and nighttime gloom in an unusual but interesting way.

Created from a sequence of five exposures beginning with 5 seconds at ƒ34, which reveals all the shadow detail, and ending with a 1/15 seconnd shot, which holds just the brightest tones. These merge to reveal detail in both the light cubes and their surroundings.

The resulting HDR image contains all the information, but is essentially unviewable due to the limitations of the display media. Most monitors have a bit depth of 8 and can at best handle a dynamic range of about 350:1, while few papers do better than about 100:1 and matte paper is even worse. Thus there is a second step involved in HDR photography, which is to compress, somehow, the data in the 32-bit image down to 8 bits per channel. This is where HDRI becomes tricky, because there is in principle no ideal way to do this. Something has to go, and a satisfactory result depends on the way the tones were distributed in the original scene, on the range of exposures taken in order to create the HDR image, the algorithms and techniques used for compressing, and on top of all this the taste and judgement of the person doing it. The net result is deep unpredictability and many different appearances of output. The process of assigning the original huge range of values from deep shadow to bright highlight is known as tone-mapping, for obvious reasons, but the methods vary according to the software. Photoshop offers four routes: Exposure and Gamma, Highlight Compression, Equalize Histogram and Local Adaptation, of which only the last offers a useful "photographic" result. Photomatix, the leading dedicated HDR software, offers the choice of Tone Compressor and Details Enhancer, with the latter preferred. What Photoshop's Local Adaptation and Photomatix's Details Enhancer share in common is that they are both "local operators" rather than "global operators." Global operators apply similar changes to all pixels, regardless of where they are in the scene, and because of the inherently high range of values, this rarely works well. Local operators

take account of the neighboring pixels, because the human eye is particularly sensitive to local contrast (this is the principle behind Photoshop's Shadow/Highlight feature, explained on page 144).

All this is by way of explaining why tone-mapping an HDR image is unpredictable and often difficult to get exactly as you would like. Nevertheless, HDRI is hugely powerful, can enable photography of a kind that was previously impossible without the help of lighting, and indeed makes existing-light photography to a high degree of professionalism perfectly viable.

HDRI

Altering light and atmosphere

These more invasive techniques make it possible to alter the perception of how a scene was lit. Of course, it's impossible to analyze a photograph in such a way that you can reconstruct the original elements—that can only be done by using some form of 3-D modeling performed on multiple capture; a method, incidentally, that is used in motion-picture special effects. Instead, these procedures rely on some visual sleight-of-hand to give the *impression* of sunlight, mist, or whatever effect is being created. Most of them are, indeed, special effects, and so not to everyone's taste.

Adding flare

Although flare is usually something to avoid, it also gives a kind of atmosphere and actuality to a scene. There may be occasions for adding it digitally. There are several flare filters available, including the one in Photoshop (*Filter > Render > Lens Flare...*), but the danger is over-familiarity. Many of these filters have simply been used too often. The most comprehensive and sophisticated is Knoll Light Factory, shown here. It offers a great variety of types of flare, which can be combined. For the fullest control, apply the filter to a black-filled layer rather than directly onto the image. Then use the layer blending options.

Before

After

Depth maps for atmosphere

Atmospheric effects such as fog and mist can be simulated easily by adding a grayish fill layer at a weak opacity, but the key to this technique is the more complicated process of varying the opacity with distance from the camera. This calls for a depth map, also known as a z-map because it follows the z axis in 3-D terminology. For a typical outdoor scene, this will be a linear gradient ramp from bottom to top (foreground to background), but any vertical objects will need partial protection.

Targeted color casts

On the principle that it is the highlights in a scene that convey the strongest impression of the light source, restricting changes to these alone can convincingly change the perception of sunlight. PowerRetouche has a white balance plug-in that allows the range of warming or cooling to be applied precisely according to brightness.

1 Original

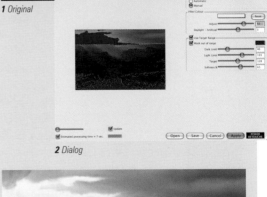

2 Dialog

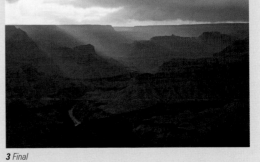

3 Final

Sunlight simulation

Increasing contrast and saturation in a photograph shot
in dull, cloudy weather can go a surprising distance in
giving the impression of brighter weather. There is also
a dedicated application called the *Sunshine* filter in the
nik Color Efex suite that uses a set of complex light-
casting algorithms in addition to saturation, warming,
and brightness controls, adjustable in the degree to which
they spill over into surrounding areas. This filter works
best on landscapes with no prominent relief, because the
one thing it cannot calculate is shadows. This finishing
touch you would have to apply yourself, by painting
into a layer that is then combined at a lower opacity.
In practice, a few prominent shadows are often
sufficient to be convincing.

3 *The original image treated with the first of the Sunshine filter's three light-casting algorithms.*

4 *Light-casting algorithm B.*

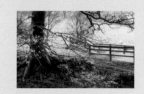

5 *Painting shadows into a separate layer. Guesswork is needed here, but as no-one else knows how they would appear, they need only to be plausible rather than accurate.*

1 *The original scene.*

2 *The Sunshine filter dialog in nik Color Efex Pro!.*

6 *Shadow layer combined with the image above.*

Black-and-white conversion

The least complicated way of extracting a black-and-white image from a color file is to convert it in one step to grayscale (*Image > Mode > Grayscale* in Photoshop). This misses some very useful possibilities. In black-and-white photography, strong colored filters over the lens alter tonal relationships, an effect used particularly in landscape photography. A strong filter in one hue blocks other hues from entering the lens; so, for example, a red filter will darken a blue sky. The same effect is possible digitally in post-production, meaning that you do not have to decide at the time of shooting. Excluded is UV (Ultra Violet) filtration, polarizing, and infrared effects.

Favoring basic hues has some predictable effects, well-known in traditional black-and-white photography. Concentrating on red darkens blue skies, enhancing the appearance of individual clouds, helps to penetrate distance, and strengthens shadows (which are lit mainly by blue skylight on sinny days). Orange and yellow have similar effects with less strength. Red and orange also lighten Caucasian skin that has pinkish tones, and lighten freckles. Green has the opposite effect on skin, and also lightens green vegetation, although much of this is less saturated green than many people imagine. Favoring blue has the opposite effect on the sky—rendering it pale and any bluish haze over a landscape stronger, and so increasing the sense of depth. Largely, this is a matter of identifying the main component in a colored surface; favoring the same color digitally lightens, favouring the complementary (opposite on the color circle or wheel) darkens.

Photoshop's Channel Mixer control (*Image > Adjustments*) gives full control over the proportions of the channels, although this is not as intuitive as the newer CS3 Black and White dialog. Checking the Monochrome box at bottom left gives a grayscale view. Either set the individual channel sliders so that their values add up to 100%, or adjust the Constant slider, which lightens or darkens the range overall. The Black and White dialog is even more useful. Six sliders (Reds, Yellows, Greens, Blues, Cyans, Magentas) adjust the brightness or darkness of these colors in grayscale. Alternatively, there are presets to use as starting points. Also, particularly intuitive, clicking, holding and dragging left or right on any part of the image directly alters the grayscale tone of that particular color (and the sliders in the dialog window respond in real time, showing what adjustments are being made). Finally, clicking the Tint box enables a traditional "toning" by means of Hue and Saturation sliders. All in all, this is a one-stop conversion method that suits almost all needs.

Beyond conversion, there are other procedures for subtly altering the monochrome appearance, including duotones, tritones and quadtones. Split toning involves the application of slight color differences to different parts of the tonal range–for instance, one color to the shadows and a second to the highlights. This is easiest to perform in adjustment layers, using blending options to vary the way in which the layers combine.

The Black and White tool allows color groups to be individually boosted or darkened, or a preset can be selected from the top drop-down menu.

Nix B/W Conversion filter with the hue slider at 65°.

By combining the two black-and-white conversions (made with different channel mixes) of these red shoes, using the masking area (below right), the final conversion (bottom right) has detail in all areas.

Black-and-White Studio filter

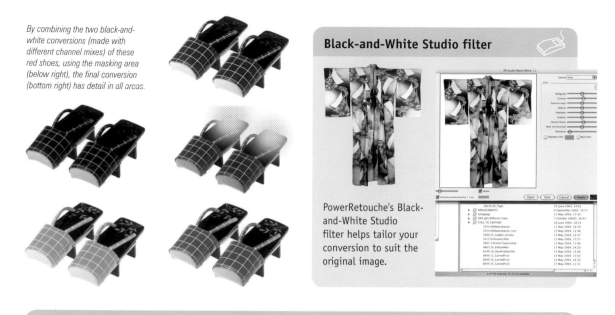

PowerRetouche's Black-and-White Studio filter helps tailor your conversion to suit the original image.

Channel Mixer in monochrome

For even more control, use Photoshop's *Channel Mixer* control *(Image > Adjustments > Channel Mixer)*. Checking the Monochrome box at bottom left gives a grayscale view. Either set the individual channel sliders so that their values add up to 100%, or adjust the *Constant* slider, which lightens or darkens the range overall.

Red +200%, Green -100%, Blue 0%

Red -16%, Green 0%, Blue +200%

Red 0%, Green +100%, Blue -20%

Red +90%, Green 0%, Blue 0%

Black-and-white conversion

Compositing

Compositing involves combining two or more images into one—a departure from straight photography into special effects. There are different methods and different purposes, but one of the major distinctions in photography is whether or not the final effect is intended to look realistic. Compositing two photographs for an obvious graphic effect, such as a transition from one scene into a completely different one, is by no means the same as placing one element into a second photograph in such a way that it fools the eye into believing that this was the actual shot.

Three techniques

Basically, there are three classes of technique, the first two used mainly for graphic, non-realistic composites, and the third for realism. Terminology varies, but according to my definition, the simplest is ghosting, in which one image shows through another. The proce-

dures are mainly those that affect layers—opacity and blending options. A second technique is a transitional blend from one object to another, so that the two appear fused together. The third and most complex set of techniques involves putting together selections from photographs so that they combine seamlessly with undetectable edge transitions.

Ghosting

This is one form of compositing that does *not* rely on selection. One entire image is overlaid on another, but is made partly transparent. Some of it, for example the brighter areas, is visible, but the underlying image also shows through. The most direct technique is to reduce the opacity, but the many blending options (*see pages 204-213 for the full range*) extend the options. The way to get the best out of ghosting is to experiment widely with all these options and judge by eye which effects work best for you.

Blending

The idea here is to create a transition zone from one object or texture to another, so that while the results may not be believable, they are at least visually realistic.

Techniques include deletion with a very soft, large brush by hand, and creating a gradient in *Quick Mask* mode that can then be used as a selection for deletion.

Original hand

Original multi-tool

Taking the hand first, the multi-tool was dropped above it in the same image. The next step was to make suitable adjustments to its hue and saturation to make the images seem to match.

Only then was the tool scaled and rotated to fit onto one of the fingers. The final stage was to mask out an area of the tool layer to reveal more hand underneath. Masking gives the chance to retry until the join seems right.

Seamless composites

For photo-realistic, believable compositing, most of the effort and skill goes into the preparation of selections (*see pages 188-189*). These include knockout techniques, which are designed specifically for dropping one selection onto a new background layer, and which take special care of the edge transitions (*also pages 188-189*).

1 This image has a disappointing, typically English, sky.

2 This is a much more dramatic sky that can easily be appended to give the landscape a little more life.

3 Using the Filter > Extract tool, the areas of the image that we are to maintain are selected and the sky removed.

4 Using a mask, areas which must merge with the tones of the new sky are marked, including the water in the foreground.

5 The lake area is masked and a copy of the sky flipped to place over it.

6 The finished merged shot is much more pleasing to the eye.

Compositing

Layer controls

The *Layers* palette in Photoshop offers a huge variety of options for blending—more, in fact, than are needed for realistic photography. Many of them are intended for graphics and typography rather than photography. Because there are so many options, they tend to be passed over by most photographers, but the appropriate control can solve some problems at a stroke.

Opacity and Fill

These two percentage sliders both affect the transparency/opacity of the selected layer, and determine the extent to which the underlying layer shows through. The *Opacity* slider does just as its name suggests. The *Fill* slider affects the opacity of anything painted or drawn on a layer without affecting the opacity of any layer effects that have been applied to it.

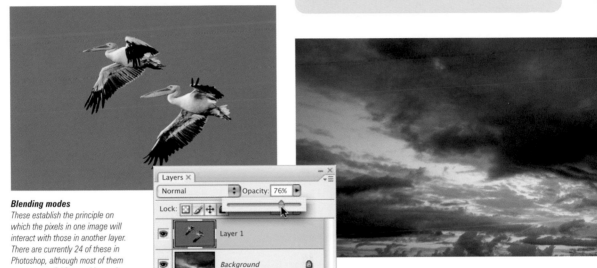

Blending modes
These establish the principle on which the pixels in one image will interact with those in another layer. There are currently 24 of these in Photoshop, although most of them are more useful for graphics and illustration rather than photography.

Blending options

This dialog box (*Layer > Layer Style...*) allows full control over blending between layers, including access to the blending modes.

Normal
The default mode. Pixels in the upper layer obscure those in the lower layer.

Darken
Selects whichever pixel is darker at each location, from the upper or lower layer. Pixels in the upper layer that are lighter than those underneath are replaced, but those that are darker do not change.

Dissolve
Randomly replaces pixels in the upper layer with those from the lower layer, depending on their opacity.

Multiply
Multiplies the pixel values in the two layers, so that the result is always darker.

Color Burn
Darkens the underlying color to reflect the color in the upper layer by increasing the contrast.

Linear Burn
Darkens the underlying color to reflect the color in the upper layer by decreasing the brightness.

Lighten
Selects whichever pixel is lighter at each location, from the upper or lower layer. Pixels in the upper layer that are darker than those underneath are replaced, but those that are lighter do not change. The inverse of Darken mode.

Screen
Multiplies the inverse of the upper-layer and lower-layer colors. The result is always a lighter color. Similar in effect to projecting two photographic slides on top of each other.

Color Dodge
Lightens the underlying color to reflect the color in the upper layer by decreasing the contrast. The inverse of Color Burn mode.

Linear Dodge
Lightens the underlying color to reflect the color in the upper layer by increasing the brightness. The inverse of Linear Burn mode.

Vivid Light
Burns or dodges the colors by increasing or decreasing the contrast, depending on the colors of the upper layer. Where the color in the upper layer is lighter than 50% gray, the image is lightened by decreasing the contrast. Where the color in the upper layer is darker than 50% gray, the image is darkened by increasing the contrast.

Soft Light
Darkens or lightens the colors, depending on the colors of the upper layer. Where the color in the upper layer is lighter than 50% gray, the image is lightened. Where the color in the upper layer is darker than 50% gray, the image is darkened. The effect is intended to replicate shining a diffused spotlight on the image.

Hard Light
Multiplies or screens the colors, depending on the colors of the upper layer. Where the color in the upper layer is lighter than 50% gray, the image is lightened strongly. Where the color in the upper layer is darker than 50% gray, the image is darkened strongly. The effect is intended to replicate shining a hard spotlight on the image.

Overlay
Multiplies or screens the colors, depending on the underlying color. Highlights and shadows below are preserved, and its colors mixed with those of the upper layer to reflect the lightness or darkness of the base.

Linear Light
Burns or dodges the colors by decreasing or increasing the brightness, depending on the colors of the upper layer. Where the color in the upper layer is lighter than 50% gray, the image is lightened by increasing the brightness.

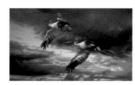

Pin Light
Replaces the colors, depending on the blend color. For upper layer color lighter than 50% gray, darker pixels are replaced. Pixels lighter than the blend color do not change. Where upper layer color is darker, pixels lighter than this are replaced..

Hard Mix
Exaggerates colors to the maximum after making a Vivid Light style blend.

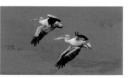

Luminosity
Creates colors that have the hue and saturation of the lower layer and the luminance of the upper layer.

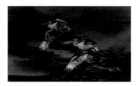

Difference
Subtracts either upper layer colors from the lower layer or vice versa, depending on which has the greater brightness value. White in the upper layer inverts the color values in the lower layer; black in the upper layer produces no change.

Exclusion
Similar to Difference mode but lower in contrast. White in the upper layer inverts the color values in the lower layer; black in the upper layer produces no change.

Hue
Creates colors that have the luminance and saturation of the lower layer and the hue of the upper layer.

Saturation
Creates colors that have the luminance and hue of the lower layer and the saturation of the upper layer.

Color
Creates colors that have the luminance of the lower layer and the hue and saturation of the upper layer. This preserves the gray levels and is useful for coloring monochrome images and for tinting color images.

Layer controls

Stitching

Because of the popularity of creating panoramas, there is a wide choice of stitching software available, some of it freely distributed with camera and image-editing software (including Photoshop's *Photomerge* and Auto Align tools), some of it available separately. All perform the three basic procedures of stitching (warping images to fit each other), equalizing (blending tones and colors), and rendering (output to an editable image file format). However, the techniques, algorithms, and interfaces vary greatly and, it has to be said, the quality also varies greatly. The easiest way to get an overview of

the current crop of stitching software and determine which may best suit your needs is to access one of the websites dedicated to reviewing stitching software, such as *www.panoguide.com*. In most cases, the three steps—stitching, equalizing, rendering—are partly automated, and how successful this is without user intervention depends mainly on the amount of detail in the images. The example here uses Realviz Stitcher software, and the actual steps will be different in other applications. An added sophistication of this program is multi-resolution spline blending to correct for the kind of ghosting due to parallax errors.

A selection of software

ArcSoft's PanoramaMaker automatically (with manual "fine tuning" if desired) processes images to form horizontal or vertical panoramas, up to 360°, and can export them as image files for further editing, or QuickTime VR files for viewing on a computer.

Photoshop and Photoshop Elements are both now supplied with a built-in facility to join images called *Photomerge*, which can be found in the *File > Automate* menu. It, too, has automatic stitching, though no QuickTime VR facility.

Shift-lens stitching

The editing procedure for shift-lens stitching is as follows (Steps 1 through 4 were the procedure for shooting):

5	Open and save files. If these are Raw files, they will need converting first. Consider using batch processing for this; place the Raw files temporarily in a separate folder to make it easier to select them. Also consider doing some optimization at this stage (although the stitcher software's equalizing routines will perform a kind of optimization).
6	Import files into the stitching program.
7	Stitch. As in the example sequence opposite, use a flat stitch option (appropriate for a long focal length) to stitch the images.
8	Equalize and render. As a precaution, in case you need to rework badly stitched areas, render at 100% of the original resolution—you then have the option of pasting in patches of the original images. If you plan to correct barrel distortion, you may want to avoid cropping the image at this stage, to keep radial distortion corrected.
9	Open in Photoshop for repair, such as patching in areas from the original files, *before* optimizing the image with *Levels*, *Curves*, etc.
10	Correct distortion. There are potentially two stages for this, depending on how accurate you were in leveling the camera, and whether or not distortion is actually visible (in the form of converging verticals or horizontals). If so, sort this out first, then apply barrel distortion correction.
11	Optimize.
12	Retouch.

Basic sequence

These three images were shot with digital stitching in mind. A sensible precaution is to manually set the exposure and other settings to remain the same for each shot so that the overall color tones will appear even

 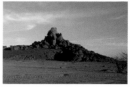

1 Select and prepare images for stitching. They must have identical dimensions and be in a file format that the particular stitching software recognizes.

2 Load images into the stitching program. If the program is partly automated, you may need to load them in the right order.

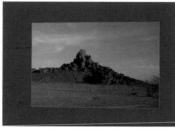

5 Drag the second image to align it with the first as closely as possible by eye, then instruct the program to complete the stitch.

4 Position the first image.

3 Set the parameters: stitching method, camera focal length, etc. This depends on the software.

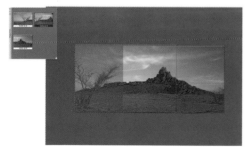

6 Continue with the rest of the images.

7 If a 360° panorama, close the panorama by making the recommended adjustments.

8 Equalize the images so that they blend in tone and color.

9 Set the parameters for rendering (size, file format, etc.), and render.

10 Open in an image-editing program and retouch.

208-209 Stitching repair and optimization 210-211 QuickTime panoramas

Stitching

Stitching repair and optimization

With a scene that has plenty of detail, shot from a distance with a normal or telephoto lens so that there are no parallax effects, with similar exposures for all frames, and enough overlap, the stitching software should be able to deliver a perfect result. These are ideal conditions, and in others there is likely to be some image repair necessary. The stitching algorithms vary between programs, and this often means applying different priorities to elements in the picture. Because stitching involves shape distortion, there must often be some compromise. For instance, in distorting two overlapping images to fit, straight lines might become slightly bent—that depends on the software. Repairs to be expected are ghosted edges due to an inaccurate stitch, and warped lines that should be straight or otherwise regular. In these cases, it may be worth re-doing the stitch. If the problem persists, repair as shown. There may be less optimization needed than with normal images, because the equalization and rendering procedures do some of this automatically (for instance, some software sets the black and white points).

Extending the image

With tiled images in particular, there are likely to be gaps and indents around the edges. The simplest technique is to crop in, but where the missing areas should have little texture or else an adjacent repeatable pattern, it may be worth adding to them with the *Clone Stamp* tool or the *Patch* tool.

Warped lines

Re-doing the stitch is not likely to make any difference here. Use the copy-and-paste technique (*see Ghosted edges, right*), or clone.

Ghosted edges

These are particularly likely with parallax problems— misalignments of details close to the camera. The ideal software solution is multi-resolution spline blending (Enblend is the original software, but Stitcher now incorporates this). Otherwise, possible solutions are as follows:

1 Re-do the stitch, particularly if a forced stitch was called for because the automatic stitching failed. Re-position the control points or, if there is a choice of rendering algorithm, try a different one.

2 Re-do the stitch with fewer or more frames.

*3 Copy and paste the original frame that best covers the offending area. The difficulty here is that you will need to distort the image (*Edit > Transform > Distort in Photoshop*) and adjust the tones and colors.*

4 Use cloning to replace the ghosted edges.

Distortion

After stitching your images, and depending on the software that you use to do it, you may find that things don't appear the way you'd hoped. You should try these steps as a first resort.

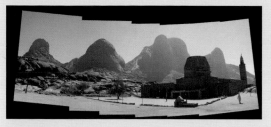

1 The original image is made of a number of overlapping pictures, but the overall effect is not an even panorama.

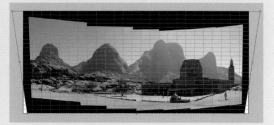

2 The first step is to correct the perspective so that the leftmost and rightmost edges appear more correct.

3 Using the Power Retouche Lens Corrector, the remaining barrel distortion is eliminated.

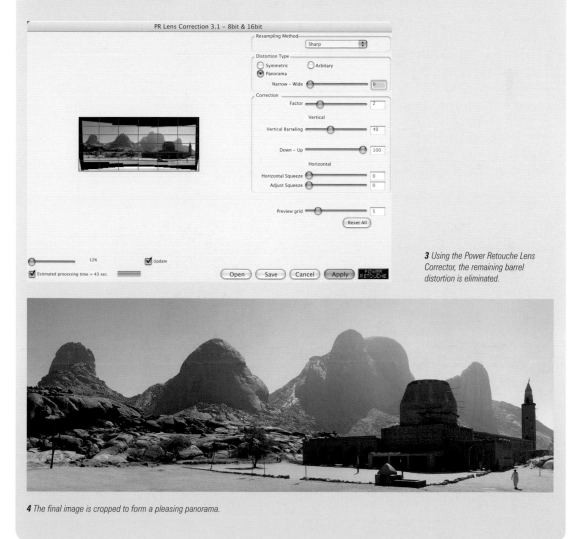

4 The final image is cropped to form a pleasing panorama.

24-25 Tiled images 180-181 Correcting lens distortion 182-183 Rotation and perspective correction 206-207 Stitching

Stitching repair and optimization

QuickTime panoramas

For Web use, tiled panoramic images can be viewed as a form of movie, with movement controls that allow the viewer to pan around the image. By shooting and stitching a complete 360° sequence, the scene can be viewed round and round in a form of loop. This is a cylindrical projection, joined at the ends. By shooting rows above and below this, you can also create a global view of the entire space surrounding the camera—a spherical projection. The basic procedure is as for planar stitching, but more demanding because you need, at the end, to be able to close the panorama successfully.

Closing the panorama

Once you have shot and saved the sequence, assemble the images in the stitcher software in the usual way, but with the additional step of closing the panorama. This means aligning the first and last frames, and different software programs have different solutions for doing this. One method of closing the gap or widening it to ensure a perfect closure is to alter slightly the focal length setting for the stitched images.

Shooting a spherical projection

For a full 360° x 180° view of the scene you need to shoot the images in rows. That is, in addition to capturing images in a 360° panorama, you shoot additional rows of images with the camera tilted up and down. The number of rows depends on the FOV of the lens, and the example here is for a 35mm efl lens (*see the last row of the table*). Figure A shows the pitch (tilt) for three rows of images. Figure B shows the rotation plan—12 images per row shot every 30°. It is usually easiest to set up the camera first for the horizontal (middle) row. Level the camera, shoot one image, rotate the pan head by the appropriate amount and shoot the second image. Continue until the row is complete. Next shoot the upper row, first tilting the camera to the appropriate pitch, then shooting and rotating until that row is complete. Follow this with the lower row.

Finally, to complete the sphere, you will need two "polar" shots, one straight up (+90° pitch) the other straight down (-90° pitch). To avoid capturing the tripod legs in the latter, one method is to use a horizontal extension to the tripod head, another is to shoot handheld at arms' length, and a third is to remove the legs in image editing.

Planning the sequence

The number of images, the degrees of rotation between them, and the number of rows depends on the field of view (FOV) of the lens. This in turn depends on its focal length *and* whether you are shooting horizontal or vertical format. The following are needed for a spherical 360° x 180° view.

EFL equivalent focal length (focal length for 23.7 x 15.6mm sensor)	Number	Distribution of images camera pitch from horizontal x number of shots at that pitch (degrees between shots)
15mm (10mm)	14	+90° x 1 (n/a), +30° x 6 (60°), -30° x 6 (60°), -90° x 1 (n/a)
17mm (12mm)	18	+90° x 1 (n/a), +30° x 8 (45°), -30° x 8 (45°), -90° x 1 (n/a)
20mm (14mm)	26	+90° x 1 (n/a), +60° x 8 (45°), 0° x 8 (45°),-60° x 8 (45°), -90° x 1 (n/a)
24mm (16mm)	29	+90° x 1 (n/a), +50° x 9 (40°), 0° x 9 (40°),-50° x 9 (40°), -90° x 1 (n/a)
28mm (19mm)	32	+90° x 1 (n/a), +45° x 10 (36°), 0° x 9 (36°),-50° x 9 (36°), -90° x 1 (n/a)
35mm (24mm)	50	+90° x 1 (n/a), +60° x 12 (30°), +20° x 12 (30°), -20° x 12 (30°), -60° x 12 (30°), -90° x 1 (n/a)

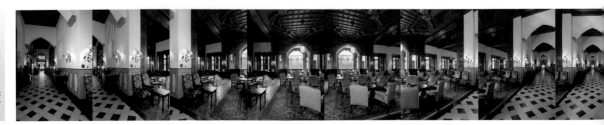

Before creating a QuickTimeVR file, you'll need to take all the images at a uniform size, at regular angles and at the same focal length. You need to tell the software this information as you begin.

As with other Internet formats, compression is everything. In order to keep the file size to a minimum, and thus reduce download times, you can reduce the file size and quality. It might be worth experimenting to see which settings are most appropriate, or creating two files of different quality for uses with slower and faster connections.

Handheld shooting

This is perfectly possible, provided you take every precaution to keep the framing consistent horizontally as you pan; any errors up or down will simply reduce the height of the finished panorama. Plan the amount of rotation with a dry run first. As you pan, do not turn around the center of your body, but around the camera, as shown by the red dot below.

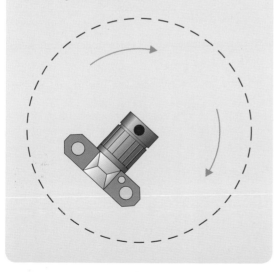

Once created, you can view your panorama using Apple's free QuickTime player. This lets you pan and tilt around the whole panorama.

The individual images that are joined together to make the QuickTime VR.

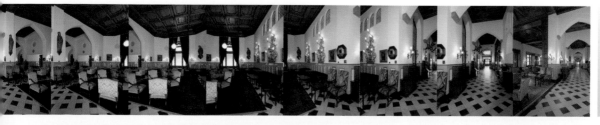

QuickTime panoramas

24-25 Tiled images 92-93 Tripods and supports 206-207 Stitching 208-209 Stitching repair and optimization

Effects filters

There is a huge variety of special imaging effects available, though most of the plug-ins and standalone applications are, to be frank, pointless for photography. With special effects of any kind, the usual rule is to first decide on the effect you need, and then look for the procedures to achieve it. In other words, not to waste time just playing with effects filters to see what happens. Photoshop itself has a number of special effects filters, some of which are for technical uses as part of other procedures (such as *Find Edges* for sharpening, *see pages 152-153*) as well as for creating unusual final effects. The software here is a selection only, and includes effects that are in some way geared to photography and photo-realism.

Mr Contrast

Flaming Pear's Mr Contrast is a plug-in designed to emphasize the details of an image, in some cases to create hyper-real effects. Its controls can be used to simulate the look of prints from lith film, deform illumination, or exaggerate infrared effects. It even features a random option if you're feeling lacking in creativity, and is also compatible with Photoshop's 16-bit color mode.

In these images it is used in a more deliberate manner to add sharper contrast to this photograph of an elephant against a background of temple ruins.

The user interface

Original

Final 1

Final 2

Flood

Flaming Pear's *Flood* filter can be used to quickly simulate flood effects without all that tedious waiting around for the greenhouse effect to run its course. The filter allows adjustments to the water level's horizon, the perspective of its reflection, its waviness and other key effects. Placing objects in front must still be done by hand, however.

The original image here features a series of family memorial arches in the Anhui Province of central China. These "paifang" were erected during the late Ming (1368-1644) and Ching (1644-1911) dynasties by prosperous mercantile communities such as the Tangyue.

Using the filter, the level of the water, its choppiness and reflectivity, and the perspective of the reflection are adjusted until they look right.

The finished picture creates an alarming impression of a flood, which certainly attracts a second glance even if it isn't wholly convincing.

Liquid Metal

The original image

The Liquid Metal *filter is part of the DreamSuite, and is designed to simulate metals, plastics, or semi-translucent glass. The filter can be applied to existing shapes, or even in random splatters along a path.*

The plug-in features an Add Metal Brush, allowing metal effects to be drawn from the pointer according to Edge Radius *and* Polish *settings.*

Effects filters

146-147 One-stop optimization 152-153 Advanced sharpening 156-157 Dedicated upscaling 198-199 Altering light

film to digital

SCANNING IS NOT, OF COURSE, DIGITAL CAPTURE. It is digital conversion, yet for all of us making the changeover from film to digital, it is an important part of the process of putting out work into the same place. In order to take advantage of all the digital imaging opportunities, from image editing to online delivery, existing film has to be scanned. The technology is established and sound, and the demand from photographers to do their own scanning has led to affordable equipment that works at levels of quality acceptable to the industry. Because there is a range of machines and of quality, it's important to compare results before committing yourself to a particular scanning workflow. As with so much in digital imaging, start with defining what you actually need —the end image—and work backward from there to see what you need to buy. With fine-grained film, the rule of thumb resolution is in the order of 4000 dpi, which for 35mm film will deliver a full-sized digital image in RGB of around 50MB. Your films can then be stored safely, while their scanned versions fit smoothly into your digital files.

Scanners

There is an enormous range of desktop scanners available, designed to meet many different needs. Scanning film images is at the high end of this range, a much more demanding process than scans of documents or prints. As with digital capture from a camera, the minimum standards in tonal range and color fidelity are high, and the resolution also. Color film, as you can see if you examine a slide under high magnification, is very rich in visual information, and a 35mm slide can easily produce a crisply detailed 50MB file. Probably less important than finding the highest quality and resolution among scanners is to know the *necessary* quality for your particular work and presentation. Just as the ability to produce 200MB RGB scans is irrelevant if your client or agency needs only 50MB files, the extra cost of a slightly wider dynamic range and the extra time involved in learning and operating an advanced scanner may be wasted if the delivery medium is not up to the same standard. At the least, scanners for professional photography are worth a cost-benefit analysis—both capital costs and operating costs.

Drum scanners

These are the professional choice, but can be much more expensive and need greater attention than the other types available. In operation, the film is taped to the circumference of a transparent drum, which then spins. A photomultiplier converts the reading from a narrow beam of light into a digital signal, at one pixel width for each revolution. They offer the highest possible resolution (8,000 to 18,000 ppi) and density ranges (almost the practical maximum of 4.0D).

ICG Drum scanner

Flatbed scanners

Like slide scanners, flatbed scanners also use CCD linear arrays, but are designed for larger originals than 35mm film. They feature a glass platen on which the original is placed face down. The CCD array is a row of receptors covering the width of the bed, and onto which the scanner optics focus a thin slice of the picture. In the specifications it is common to see different resolutions given for the width and length, for example "1,200 x 2,400 dpi." This means that along the length the CCD array is simply being stepped in half-width increments, which is not a true resolution. The lower figure is the one that matters. Density ranges can be in the range of 3.7-3.9D.

Canon CanoScan D1250U2F

Slide scanners

Designed specifically for film, these are the normal choice for photographers. Even though they use a CCD array instead of the photomultipliers in a drum scanner, the latest high-end models scan to professional quality. The CCD array is linear—a row of receptors —as opposed to the rectangular matrix of a camera's sensor. A light source, typically a modified LED, is shone through the film and focused by a lens onto the sensor array. The lens is critical for resolution and image quality. Ideally, the resolution of a slide scanner should be at least 4000 dpi so that it approaches the resolution of the film. The density range should be close to 4.0D. One design (Imacon) flexes the film slightly for greater scanning accuracy with large format.

217

Scanner comparison

This is a picture of an old wine merchant's insignia on St James' Street, London. The top copy was scanned with a drum scanner, the closest to the original image that we can achieve here. The center image was scanned using a Nikon CoolScan 8000 ED, and the lower one was scanned using the same device in its 16-bits per channel mode.

Scanner comparison

These images were also scanned using a drum scanner (top) and a Nikon CoolScan 8000 (bottom). Both are scanned at 8-bits per channel. The drum scanner's tones are more subtle and have greater dynamic range.

Necessary resolution

Up to a point, the higher the better. The point is, as usual, set by the final use, and commercially there are some expected standards. Corbis, one of the largest stock agencies, recommends the following guidelines.

Editorial and Royalty-free sales

Film size	File size	Resolution	Pixel dimensions	Print size @ 300 dpi
35mm	30-35MB	300 dpi	2800 x 4200	9.33 x 14in
120	35-40MB	300 dpi	3450 x 3450	11.5 x 11.5in
4 x 5	35-40MB	300 dpi	3000 x 3450	10 x 12.5in

Commercial sales

Film size	File size	Resolution	Pixel dimensions	Print size @ 300 dpi
35mm	50-55MB	300 dpi	3400 x 5100	11 x 17in
120	50-55MB	300 dpi	4200 x 4200	14 x 14in
4 x 5	55-60MB	300 dpi	4000 x 5000	13 x 17in

Scanners

40-41 Resolution 42-43 File format 104-105 Color 218-219 Basic scanning 220-221 Bit-depth and dynamic range

Basic scanning

The detailed step-by-step procedure will vary according to your scanner and software. Provided that you scan in a high bit-depth (more than 8-bit), you will be able to continue optimization in Photoshop or any other image-editing application without quality loss. That said, the best place to optimize is within the scanning process itself. All the tools are within the software, from setting white and black points to color adjustment, usually presented in the correct order. The sequence is important, as we saw for optimization (*see page 128*).

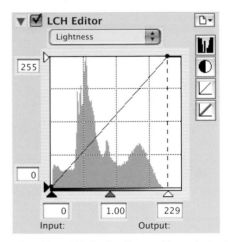

3 Set file size and output resolution. *There is usually a choice in how you define these, but the important value is the file size in megabytes (other values, such as dpi resolution, can be changed later, in Photoshop). You may want to save these settings for future use on other images.*

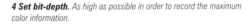

4 Set bit-depth. *As high as possible in order to record the maximum color information.*

1 Load preview. *Adjust the preview window so that the image appears as large as possible, still leaving room for the toolboxes and palettes.*

2 Rotate *(if a vertically composed shot)* **and crop to the desired area**. *The importance of cropping to within the film rebates is to ensure that these dense edges do not appear sampled in the histogram.*

Dust and scratches

This is a constant issue with film. Precaution number one is to clean the film and the scanner, and work in a room that is as dust-free as possible. If particles have adhered to the film during processing, consider washing the film carefully (but only if you are confident about handling and drying film). Many scanners, with the help of their software, have an option for finding and removing dust and scratch artifacts from the scanned image. There may be some slight loss of sharpness as a result, but this is a valuable time-saver. The technique called ICE involves using a separate infrared channel during the scan to identify physical differences in the film surface.

5 Set white and black points. *The essential precaution here is not to clip highlights or shadows. It is safer to have the range sitting clearly within the scale than risk losing image data.*

6 Adjust the brightness. *Adjust the tonal gradation within the limits just set. Effectively this brightens or darkens the image. (See box on Gamma and brightness opposite.)*

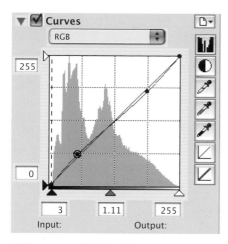

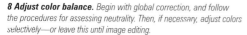

7 Adjust contrast. Bearing in mind that the gamma values just adjusted to change the brightness have an effect on contrast, use the appropriate tool (such as Curves), to optimize the contrast. Be cautious with raising contrast because of the risk of losing image data. If you are scanning in a high bit-depth, it will be easier to raise contrast in Photoshop than to lower it.

8 Adjust color balance. Begin with global correction, and follow the procedures for assessing neutrality. Then, if necessary, adjust colors selectively—or leave this until image editing.

9 Adjust saturation. Or leave until image editing.

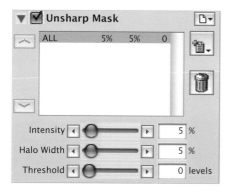

10 Set low or no sharpening. *(See Sharpening policy, pages 148-149.)*

11 Scan and save.

Gamma and brightness

Brightness adjustment is usually performed by dragging the midpoint slider in the *Curves* or *Levels* (or their equivalents, depending on the scanning software). Strictly speaking, this does not change the brightness of the image as a whole, because the end-points—highlight and shadow limits, which you should already have set in the previous operation—do not move. Rather, it shifts the bulk of the tones in the image up or down the scale. This is the gamma value. For color transparencies, gamma values of between 1.8 and 2.0 are normal. A low value will give a darker and higher contrast preview. A high value will open up the shadows and give a lighter and lower contrast preview. Gamma values for reflective media such as a print are, incidentally, better if much lower—between 1.6 and 1.8.

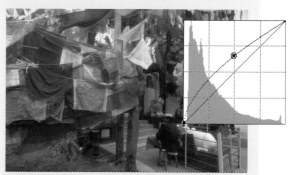

High gamma value
Moving the Midpoint slider to the left raises the output values of mid-tones and raises the gamma, so brightening the appearance.

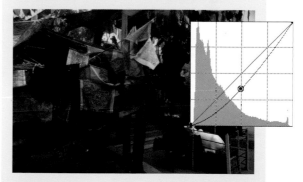

Low gamma value
Moving the mid-point slider to the right lowers the output values of mid-tones and lowers the gamma, so darkening the appearance.

Basic scanning

Bit-depth and dynamic range

Image quality in scanning, as in digital camera capture, is highly dependent on the number of colors than can be distinguished (bit-depth) and on the range of brightness that can be captured (dynamic range). Only scanners that allow at least 12-bit color depth and a dynamic range of at least 3.2 are worth considering for film transparencies.

Multi-sample scanning

Because of the large amount of image data in film, a single scan pass may not bring out all of the detail, particularly in the darker tones. Some scanners allow for multiple passes to extract the maximum color and tonal information, with the additional benefit of reducing noise. Each extra pass adds to the time, so you may want to restrict this treatment to special images.

Analog gain

On some scanners you can adjust the amount of light passed through the film—hence analog rather than digital gain. This is useful for very dense film images, in which the normal exposure may be insufficient for the sensor to pick up deep shadow detail. Use with caution, as it can also over-expose the image.

Compressing a wider range

On the same principle as a two-frame exposure with a digital camera, one for the shadows and midtones and the other for the highlights (*see pages 194-195*), there is a technique for dealing with high-contrast film images even if the dynamic range of the scanner is not all that it could be. Make two scans, the first adjusted to open up the shadows as much as possible, the second adjusted to get as much information out of the highlights. Open both images in an image-editing program and combine—follow the Altering tonal range procedures (*see pages 194-195*).

A starting image of the Bank of England, in this case at the darker end of the spectrum.

The other, lighter, starting image has some clipped highlights.

1 These areas of the lighter scan are those clipped highlights that we will restore from the darker scan.

Bit-depth

8-bit color, although perfectly acceptable for final delivery of an image, is accurate to only 1 part in 256 per pixel, and so falls far short of the potential of your original film image. 12-bit measures to an accuracy of 1 part in 4026, and so is much better. 14-bit measures to 1 part in 16,104 and 16-bit to 1 part in 64,416. Most scanners that work in 12-bit and 14-bit deliver the scan as 16-bit for opening in Photoshop's 16-bit mode. Because higher bit-depth scans are more accurate in resolving subtler distinctions in color, they also give smoother and better gradated tones.

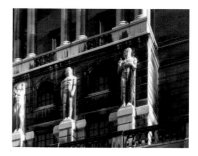

2 To create our highlight mask, first switch to Lab mode by clicking Image > Mode > Lab Color. Its channels are very useful for examining areas of Lightness.

3 Make a copy of the Lightness channel by selecting it in the Channels *palette* and clicking Duplicate Channel….

4 On that duplicate layer, move the darktones slider so that almost all of the histogram falls beneath it. This will create a very dark image, with the remaining image highlights picked out as white (or very close to white).

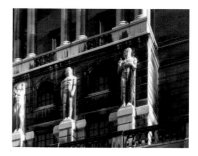

5 Select the lighter regions, perhaps using the Select > Color *Range* tool, and save the selection (Select > Save Selection…).

6 Now create a single image as a combination of the darker image with the lighter one in the layer above. We couldn't do this from the outset as we neeeded to be in Lab mode to find the lighter areas.

7 Discard the layer and continue to work on the image as normal.

8 Load the selection you created earlier.

9 To ensure that the clipped highlights are covered, view the selection in Quick Mask mode (press Q to toggle this). If necessary, click Command/Ctrl + Shift + I to invert the selection. You may also want to Feather the selection to soften the edges.

10 With the lighter layer selected, press delete. Here the lower layer's visibility is switched off so those areas removed are easier to see.

11 The resulting picture (with both layers' visibility restored) with merged highlight and shadow images has a higher dynamic range as a result.

Bit-depth and dynamic range

50-51 Dynamic range in practice 168-169 Color spaces and modes 194-195 Altering tonal range

Grain and fading

The two most common *intrinsic* problems of film are its grain structure and, in the case of color, a tendency to fade with age. Both of these can be tackled at the scanning stage, and also later, in image editing. Grain is an inevitable by-product of the process of recording images on film, in which silver halide crystals, typically measuring about 0.001 mm in diameter, undergo an electro-chemical change and darken, according to the light they are exposed to and the processing development they receive. No film is free of grain, and in a high-quality, high-resolution scan, the remains of this grain structure will be visible. Although superficially it has a similar appearance, grain is not noise, and the distinction is not well served by the sloppy interchange of the two terms. One obvious practical difference is that camera-specific noise algorithms (*see pages 176-177*) do not work with grain, which is an embedded part of the scanned image.

Fading is less predictable, and a function of age. Film dyes are not completely stable, and tend to fade over time, particularly with prolonged exposure to light. Moreover, they fade asymmetrically, meaning that the three different colored dyes used in standard tri-pack color film fade each at a different rate. The result is a loss of maximum density, a de-saturation overall, and a color cast. Fortunately, these are all parameters that digital image editing can deal with, up to a point. Modern films are much more stable.

The origins of grain

The active ingredient in film is a silver halide, in the form of a mass of crystals distributed as evenly as possible in the gelatin layer that makes up the body of an emulsion. The silver and halide components are held together in a lattice arrangement by electrical bonds; and when light photons strike, they disrupt the electrical status quo by adding energy to the crystal. An electro-chemical change is triggered in the crystals, and the pattern of changes across the entire surface of the emulsion forms a latent image (in color film there are three layers of emulsion). Processing makes this latent image visible by converting silver halide to black silver. The individual crystals are too small to be resolved by the naked eye, even in an enlarged photo-graph—what you see is a pattern of grain clumps. In color film, the silver is replaced with dye, and so the visible structure in a developed image is made up of

Restoring faded colors during scanning

Good scanning software offers the option to attempt to recover original colors from film that has faded with age. Like grain reduction, this too can be dealt with later in image editing, but the scanning operation is the better place to start. In this example, the *ROC* (Restoration of Color) function is activated in Nikon Scan.

Before *After*

Reducing film grain during scanning

Film grain differs from camera sensor noise in that it is structural. This, and the fact that scanning is performed on a computer with much greater processing power than a camera, makes it logical to attempt grain reduction during the scan. Later, you can also use software to reduce it even further. Grain reduction is an option built in to most good scanning software, and is definitely a factor in choosing a scanner. The processing adds to the overall scanning time, and you should decide at the start whether or not it is actually undesirable. Although we become used to the essentially "clean" nature of digital photographs (at least at low sensitivity settings), film graininess can also be thought of as an integral part of the image.

Enlargement showing grain (before). *Enlargement showing reduced grain (after).*

dye clouds. To make a film more sensitive to light, a greater area of each grain needs to be exposed, with the result that faster films are more grainy in appearance. At the extreme, high-speed films have a texture that noticeably interferes with the content.

Battersea Power Station, on the south bank of the River Thames in London. The picture has a great deal of grain, which needs correcting.

Reducing grain in post-production

Film grain can also be reduced with the same software used for noise reduction (*see pages 176-177*). One reason for doing this is that the scanning noise reduction may have been insufficient. Another is to confine the noise reduction to a specific area of the image, such as the sky, by first making a selection. This kind of masking essentially protects edge detail, and is also incorporated in some software, such as the PowerRetouche Noise filter.

This software also tackles the specifics of film grain rather than generalized noise problems—in the example here, the film grain leveling algorithm is Luminance Noise. This is designed to remove color artifacts without affecting sharpness and grayscale tonal values, and works on the low-level color mosaic effect caused by the dye clouds. It works best when the filter sampling radius can span at least the size of the dye cloud.

It can sometimes help to apply grain reduction unevenly or not at all to some areas. Layers are invaluable on these occasions.

In this example, only the sky has had noise reduction applied, since the detail is more important in the other areas.

The Dfine Noise filter can distinguish luminance noise from chrominance noise and allows you to make adjustments to each separately.

This is the resulting image from the Dfine filter.

The Power Retouche Noise filter can be set to preserve details by not acting near perceived edges.

Grain and fading

Optimizing scans

Certainly, the aim of efficient scanning is to get it right in one go, but almost inevitably some correction is necessary in prepping the image. At the very least, the scan that has been performed in one application needs to be assessed in Photoshop, which is the standard production application. Basic optimization is as for digital capture (*see pages 128-133*), although there are some specific issues. One special advantage is that you have the physical transparency as a reference.

Newton's rings

Not to be confused with moiré, although they look similar, these multi-colored banded artifacts are caused by contact between the film and glass, which affects the angle at which the light waves are reflected. They are a potential problem with flatbed scanners, but not tray-fed slide scanners. They are difficult to repair, and the best way to deal with them is to re-scan, making sure that the film is not touching the glass. If you have to repair them digitally, do the following. It often helps to separate tonal correction from color correction, and work on one at a time. For tonal correction, first find the channel in which the pattern is most obvious—this is usually the *Lightness* channel in *Lab* mode. If the moiré is in a featureless area, such as the sky, try painting a selection in *Quick Mask* and then applying a blurring or median filter. Or, open *Curves* and within this selection Ctrl-click (Windows) or Command-click (Mac) on a dark band and then a light band; then drag these points slightly to minimize the contrast. Otherwise, work on the most prominent parts of the pattern with a brush, lightening and darkening as necessary. After tonal correction, look for the color channel in which the moiré is most obvious (R,G, or B, or in Lab, a or b), and apply similar corrections to those above. All of this is time-consuming.

Retouching

Depending on whether or not you used a dust-and-scratch removal option during scanning, there may be more detail repair needed on a scan than on a digital photograph. Dust and scratches on the film surface will be more sharply focused than dust on a camera sensor. Nevertheless, they call for the same procedures (*see pages 170-173*), although if there are a lot of blemishes, the Photoshop *Dust & Scratches* filter may be the first choice. The larger the film size, the more dust there is likely to be, and as always the image needs to be examined at 100%.

Viewing conditions

Comparing the scan with the original calls for matching viewing conditions between the computer screen and the slide. Consider the ambient viewing conditions for the monitor (*see page 108*). Add to this a Color-corrected lightbox, which has daylight-balanced, flicker-free lighting—and importantly, with a relatively *low* light output. Ideally, it should match the brightness of the monitor. It is also important to mask down to the film area, otherwise the bright surrounding area will skew your judgment. Small lightboxes are available for 35mm slides.

Film to digital

Optimizing sequence

It helps to have a regular order of doing the different actions so that the results are consistent.

1. Rotate.
2. Crop.
3. Set range.
4. Adjust overall color.

5. Adjust brightness.
6. Selectively adjust color.
7. Retouch.
8. Save as....

Creating and assigning profiles

Although scanners have embedded profiles supplied by the manufacturer, you may still want to create a custom profile. Custom scanner profiles are more consistently useful than camera profiles (*see pages 68-69*), and are created in much the same way. The reason is that the light source is always the same, and the major variable is the film type, for which reference files are available at film manufacturers' websites. There is, however, the additional expense of a color target for *each* film type. The standard target for scanning is the IT8, available from film manufacturers and some independent sources, as both film and print, but not color negative. At the bottom left is a date code, which identifies the reference file that you need.

1 Purchase the target(s) and download the reference files from the film manufacturer (for example, for Kodak, at *ftp://ftp.kodak.com/gastds/Q60DATA/*).
2 Scan the target. Make sure that:
 a. The whites are not clipped. Specifically, that grayscale path 1 is less than 255, ideally about 250.
 b. There is a measurable difference between each grayscale patch on the 22-patch scale.
 c. Always scan in more than 8-bit, both for profile making and normal scans.
3 Open the image file in the profiling software. I use EditLab, a Photoshop plug-in, already described for camera profiling. Select the IT8 chart type and appropriate reference file.
4 Position the grid.
5 Create and save the profile.
6 After each normal scan, assign the profile using the same method described on pages 128-129.

IT8 Color chart

IT8 Color chart on a light panel

SEBASTIÃO SALGADO

ENGLISH ESPAÑOL FRANÇAIS PORTUGUÊS

Este site recebeu o prêmio **Top Ten Cool Sites** por sua excelência educacional, para o bimestre Outubro/Novembro de 2002, do Exploratorium, primeiro museu de ciências da Web.

delivery

DIGITAL IMAGES EXIST IN A KIND OF LIMBO—as digital files they are accessible only through the computer, and they become useful only when you either print them or send them for others to see. In professional terms, delivery is as important a procedure as any other in the digital workflow. Getting it right is the photographer's responsibility, not the recipient's, and professionalism at this stage keeps everyone happy. This is still an area of evolving technologies, and you may need to make extra effort to ease the process for clients, not all of whom are necessarily quite up to speed. This section encompasses the technical, procedural, and legal aspects of digital delivery. The technical aspects are critical but gradually getting easier as the industry adapts to increasing user demand to send and receive images online. In light of the comparative ease of digital transfer, the legal issues, especially copyright, become much more significant for the photographer. There is a strong commercial flavor to this last section of the book, since digital images are an ideal merchandise for the digital age.

Media and format

There are only two universally recognized image file formats, TIFF and JPEG. The only reason for using any other is when you have prior agreement with your client or whomever you are sharing the files with. TIFF files can also be compressed without loss using LZW (*see page 44*), and this will typically reduce the file size to about 60% of full size (the final size depends on the color variation in the image, so line art is reduced more than photographs). JPEG is both a format and a file compression system, and particularly good for online delivery (*see pages 230-231*) or when you have large numbers of images. Maximum quality (that is, levels 10-12 in the Options dialog when saving) is virtually indistinguishable from a TIFF. Nevertheless, the usual precautions apply when opening and saving a JPEG, because it *is* a lossy system—never re-save as a JPEG, otherwise you will be applying compression on top of compression (like copying a copy on VHS). Not all clients and recipients are familiar with this, and it may be worth making the point in any attached notes.

Another use for JPEGs, and an important addition to the delivery of high-resolution images, is the preparation of small FPO (For Position Only) images. The function of these is that they open easily and take up little space, and so are ideal for use in page layout programs by publishers and designers. Between 700

Printed contact sheets show good detail, which can be examined with a loupe (magnifying lens). Clients may prefer these to digital files.

Photoshop can generate contact sheets as page-sized Photoshop documents (PSDs), though it takes a few moments.

Preparing hi-res images for delivery

In a professional context, the following procedure is reliable:

1 Save the original, optimized and captioned, as a TIFF.
2 Make a small copy as an FPO and save this as a JPEG with Medium or High compression. Consider using batch processing for this, once you have assembled all the images for delivery.
3 If the images are destined for online delivery, make a full-sized copy of the TIFF original, saved as a JPEG at Maximum compression, following normal file-name protocol (*see box, opposite*). Again, consider batch-processing this operation.
4 Prepare your Terms and Conditions (*see page 237*) and any other information, as a plain text Read_Me file (*not* in MS Word).
5 Copy the relevant files to CD or DVD, or upload if for online delivery.
6 Archive the TIFF original.

Creating an Action

If you need to perform the same process on a number of images, you can create an *Action*. Simply click the *Create New Action* button, record your steps using the video-style control buttons, and save it. You can then access it and apply it to folders of images from the *File > Automate > Batch...* menu dialog in Photoshop.

Watermarking

There are two kinds of watermarking, both with the objective of deterring unlawful use. One is visible, with the advantage that an overlaid symbol or lettering can make an image completely unusable (and the disadvantage that it seriously detracts from the appearance of the image). The other is hidden, using techniques to bury a readable code into the image without damaging it (too much), and this is useful mainly for tracking images and proving their origin. Photoshop comes supplied with a hidden watermarking system by Digimarc, accessed under *Filter > Digimarc*. There is, nevertheless, a fundamental argument against bothering with either—there are many other, simpler ways of stealing images, of which by far the most common is scanning a printed page.

File-name protocol

This is essential for cross-platform compatibility. The standard points to follow are:

● The only punctuation in a file-name should be a dash (-), underscore (_), or the dot (.) before the extension
● When sending a JPEG file, add the file extension .jpg
● Use lower case throughout
● In a sequence of similar images, use a number sequence to differentiate, e.g. grandcanyon-01.jpg, grandcanyon-02.jpg

Photoshop has a built-in contact sheet generation tool accessed by clicking File > Automate > Contact Sheet II *then using the dialog to select the images, size of thumbnails, and other details.*

and 1000 pixels along the longer side works well for FPOs, and as image quality is not critical, they can be given JPEG compression to High quality (levels 8-9) or even Medium quality (5-7) rather than Maximum. For online delivery (*see pages 230-231*), it is usual to compress the full-sized image as a JPEG, so there is obviously room for confusion with two or more versions of the same image in the line. Consider writing "fpo" into the filename for the small images, and certainly put them in their own "FPO" folder.

In addition to the digital files, you may need to prepare two kinds of hard copy. One is a physical contact sheet, and this depends very much on the way your client likes to work. With a large number of images, it can be much quicker to flick through them as contact sheets than scrolling through a database. Using Photoshop or other software, compiling contact sheets from a folder of images can be done automatically, although the scaling-down, positioning, and printing takes time.

Media and format

Online delivery

Sending images electronically extends the digital workflow seamlessly—whether to deliver an assignment quickly, submit images to a stock agent, update a personal website, or to archive images for safe-keeping on a remote server. The alternatives are File Transfer Protocol, Wi-Fi, e-mail, cellphone-to-modem and satellite transmission. In all cases, the first essential step is to prepare the images in a format suitable for transmission, and this almost inevitably means JPEG.

FTP

Although you can use FTP with your Web browser, there are also specialized programs for transferring files and decompressing them, such as CuteFTP and WS-FTP for Windows, and Fetch for Macintosh. And some photo agencies use their own programs from a website that their photographers can access easily. Typically, to upload an image you would already have been given the host address, your own user ID and a password for security. Using a program like Fetch, you dial up the host server, enter your ID and password, and then drag and drop image files onto a window. The program does the rest. If you are carrying a laptop with you on your travels, you simply need to have the software installed, and be able to establish an internet connection.

FTP set-up

Fetch, a popular FTP program

All you need to ensure is that you have internet access in the destinations to which you are traveling. Note that as laptop and PC ownership increases, internet cafés tend to decline. This has already happened in Japan, where there are very few because most people have their own access.

A professional alternative favored by hard-news photographers is "cellphone-to-modem," in which a cellphone handset is connected to a laptop, and images are sent using software such as Hyper Terminal, Timbuktu pro (both for PCs), Z-term, Microphone, and Global Transfer (the last three for Macs). Picture desks at newspapers and some magazines have a number dedicated to this. Transfer speeds can be slow, unless the cellphone is capable of High Speed Data and is used on a high speed network.

Satellite

Inmarsat, a long-standing satellite communication company, launched the Regional-BGAN portable satellite modem in early 2003. Combined with the D2H and WT-1 the Regional-BGAN provides a complete wireless travel solution in 99 countries covering Europe, the Middle East, the Indian subcontinent, and North, Central, and West Africa. Inmarsat plan to increase the Regional-BGAN coverage to include 86% of the Earth's surface and this is due for launch in 2007.

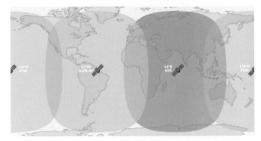

Map of Regional-BGAN coverage (Pacific region satellite yet to launch).

The Regional-BGAN satellite modem weighs only 3.5lb (1.6kg) and is smaller than some currently available laptops. The unit allows internet communication via a satellite in geo-stational orbit 23,000 miles (37,000km) above the Earth at rates up to 144 kbit/sec using a secure shared channel. Under normal conditions the rechargeable battery will allow 3 hours of operation. The unit is compatible with both Mac OS X and Windows PCs, and requires only basic configuration to use. An important requirement is that the unit must face southeast in order to connect to the satellite. It can be connected to your computer via Ethernet or USB cable.

File Transfer Protocol (FTP), a standard internet protocol, is the simplest way to exchange files between computers on the internet (in information technology, a protocol is the set of rules used in a telecommunication). It uses the internet's TCP/IP protocols. (Transmission Control Protocol/Internet Protocol). It is widely used, particularly for software and large files,

Computers can connect to the internet via cellular phone networks either via a phone or an adapter card. These Sony Ericsson models, for example, both use the GPRS enhanced data transmission common on established mobile networks, as well as the new, faster "3G" EDGE "broadband" system.

E-mail

This is the simplest way of sending images, but the least efficient for large, repro-quality files.

An e-mail application is useful as long as file sizes are kept down.

and for images. Most people's experience with FTP is to download files from websites, but it has a special value for photographers in enabling them to send images to another computer, where they can be archived safely. Many photo agencies now use FTP for photographers to send digital images to their server.

Online services

Although there is an extensive "social networking" side to many photographers' sites, which may range from unnecessary to downright tedious, the primary function of a service like Flickr—online hosting—can be used to to transfer files from a laptop to the internet, where it can be accessed by anyone. As the images are hosted on a secure external server, they are effectively backed up as

soon as you've uploaded them. Better yet, there are many uploading applications for both OS X and Windows that save the need for accessing a cumbersome web interface. The primary downside, other than the need to carefully check security settings so your images aren't available to everyone, is that most services only accept JPEG rather than Raw files, so your editing must be done in the field.

The Flickr uploader tool is simple, but can safely be left to handle an entire batch of images.

Your images are stored in a catalog, and the whole file can be downloaded from any location. You can set privacy and copyright settings so, if you prefer to make your images available for others on a Creative Commons license, you may do so (though this is very much at your own risk).

Online delivery

Wi-Fi set-up

This naturally varies according to the make of camera, and the example here is for the Nikon WT-1 transmitter attached to a D2H camera. There are four stages to the configuration: the network, the host computer, its receiving software, and the transmitter.

Wireless network

1 Choose between a stand-alone Wireless Access Point (base station), or a combined WAP-and-router. The latter is easier to configure, though slightly more expensive.

2 If using a wired connection to the host computer, connect the cables.

3 Enter any necessary security codes, such as an ESS ID and WEP Key.

4 Configure the web connection (most devices have a built-in web server).

Belkin wireless router (base station).

Configuring the web connection using the built-in web menu.

Host computer

1 Connect the computer to the base station or router, by cable or wireless.

2 Go to the network connections menu.

3 Choose either wireless/Airport or wired connection (Ethernet or local area connection).

4 Set to receive an IP address automatically.

Network protocols

A protocol is similar to a language—a set of rules—that enables different computers on a network to communicate. The three most common networking protocols that you are likely to come across are:

HTTP (Hyper Text Transfer Protocol), used for accessing World Wide Web pages. This is why web addresses start http:// in your web browser.

TCP/IP (Transmission Control Protocol/Internet Protocol) used by all computers on the Internet for various kinds of information. A feature of TCP/IP you'll come across a lot if you set up networks is IP addresses, like this: 192.168.0.1. A computer can be connected to more than one network, and have a different IP address for each connection.

FTP (File Transfer Protocol), used for moving files—in our case images—between computers.

Windows network TCP/IP settings dialog

Delivery

The Nikon D2H with Nikon's WT-1 wireless attachment. The attachment allows the camera to connect to wireless networks in the area and transmit images directly to it. The camera lines them up as they're taken, then sends them on. There is flexibility in terms of antenna, the black node to the right being the standard WA-S1. An optional larger antenna with an extended range (the WA-E1) is available too.

Manually configuring the camera

Wireless transmitter

1 If available, use the configurator set-up program supplied with the transmitter: launch the application on a computer, enter the information required, save the file, put this onto a memory card, insert into the camera and choose "Load settings."

2 Otherwise, configure manually, as in the sequence shown.

This sequence is specific to the Nikon D2H. Other cameras and transmitters will have their own procedures. In this example, there are three menu sections: Wireless, TCP/IP, and FTP.

Wireless section: enter Communication mode (ad hoc or existing network), SSID (name of network), Encryption (if any), Channel.

TCP/IP section: enter IP address, Gateway, DNS (Domain Name Server address), MAC address.

FTP section: enter server IP address (normally, the address of the host computer already set up as above).

FTP software

1 Use either the built-in FTP server on a Mac OS X machine, or download and install third-party software for more features (*see page 230*).

2 Enter user name and password, and note these for later entry into the camera menu.

3 Define the necessary privileges.

Mac built-in FTP set-up

Wi-Fi setup

Permissions, releases, and copyright

Your right to take a photograph, own the image once taken, and use it afterward are three interlinked issues, all extremely important—particularly if you are going to display the image in public and/or sell it.

Important changes in the last few years, including changes in copyright law, the internationalization of image sales and use, and the huge growth in stock sales, make this an urgent matter. Copyright, which covers the legal ownership of, among other things, images, is very much linked to permission to use the images commercially—from a financial point of view, the value of copyright is that you have the freedom to sell reproduction rights. That is increasingly how photographers earn an income.

Photographing with an army or militia is a dangerous situation, as any photojournalist will tell you. For your own safety, obey all their instructions, however irksome they may seem. The subtleties of copyright or any other law are overridden by the practical reality of firearms.

Right to shoot

First let's look at possible restrictions that photographers face in being able to shoot. The two main categories of legal restriction are privacy and national security, but underlying this are cultural and religious restrictions that in some countries are every bit as important. The law varies considerably between countries, but in the US, for example, you can photograph property that is in a public place or (this is important) visible from a public place. So, you can stand in a public street and photograph houses—but this is a separate matter from your right to use the picture (*see below*). Stepping onto private property to photograph brings you, of course, into trespass. Note that in the US, buildings constructed after December 1st, 1990, are protected by copyright—yet this does not prevent you from photographing them under the above conditions.

Indeed, it is important to be clear about the distinction between right to shoot and right to use, dealt with below. A good example is a work of art in a private collection. Unless the copyright has been assigned, it remains with the artist, so that you would need permission from the owner of the work to photograph it, but permission from the artist or artist's estate to use the photograph.

Your right to photograph people depends on the privacy laws of the country or state in which you are shooting, and as this varies you may want to check beforehand. Most countries in the world do not in fact have well-defined laws covering this. But in general,

you should not have a legal problem in a public place. You may well, however, face cultural restrictions, for example against photographing women in a strictly Islamic nation.

National security affects your right to shoot in obvious ways. Anything military is likely to be restricted, and ignoring this in some countries (for instance Greece, China, and Iran) will bring unpleasant consequences. If traveling, make yourself aware of unexpected restrictions in this area—in India, for example, all bridges are considered strategic.

Copyright

Copyright in a photograph is a set of rights held exclusively by the copyright owner—the rights to use the photograph in certain ways and the rights to prevent others from doing the same. Within this broad definition, there are many different *specific* definitions of copyright according to the country. Indeed, jurisdiction is an issue, and while most photographers go by the copyright law in their own country, it is also possible to, for instance, register copyright in another country (as commonly happens with the US Copyright Office for reasons given below). Because the US is such a dominant market for photography, much advice about copyright assumes US jurisdiction, but it's important to be aware of the copyright laws that will affect *you*. The rights usually include those of reproduction, display in public, distributing copies, and derivatives. Some countries also distinguish between economic rights (through which you can gain financially from your photographs) and moral rights (which

Photography inside airports is potentially risky, especially in light of the post September 11th security precautions. Before taking shots, like this of a Boeing 747 painted with Pokemon characters, it might be appropriate, if only as a courtesy, to contact airport security and get permission.

Some countries have blanket prohibitions on photographing sites such as bridges–in this case, the Howrah Bridge in Kolkata.

Be cautious around "no photography" signs. Many military installations should not be photographed, and these rules can be enforced very rigidly. In 2001, for example, 12 British plane-spotters were arrested in Greece—a European Union country—as spies.

cover your being identified as the creator, alteration of the image, and destruction of the image).

To qualify for copyright, a work has to fulfill two criteria. It must be tangible and it must be original. This applies, therefore, to many other creative works, including painting, sculpture, and writing. First, tangible. The work must be fixed in some way—on paper, on film, as a digital file. This may seem obvious, but what is *excluded* is an idea. Just because you have the idea for a photograph or any other creative work, as in suggesting it to someone else, or even sketching it out, does *not* give you any rights to it. It is a commonly held belief, and wrong, that you can copyright an idea. In some countries, including the US, there is an important practical distinction between work that has been published and work unpublished. To be published means that the public has had the opportunity to see it—it has been distributed or somehow made available.

US copyright law has improved greatly in recent years to the advantage of photographers. Under the original Act, copyright was granted for only 56 years from either the date of publication or registration, whichever was first, and otherwise did not apply at all. This was amended in 1976 to the life of the creator plus 50 years, and in 1989 amended to date from when the work was created or fixed, with no need to register. Nevertheless, registration is an important feature of US copyright law, because once performed, it allows you to claim statutory penalties and recover lawyers' fees. Without it, you can claim only compensation for actual damages, and you have to prove them.

As a relatively litigious society, the US has laws, including those for copyright, that provide for stiff penalties for infringement—and the means to pursue them. For this reason, many non-US photographers choose to register their images with the US Copyright Office. There are a number of ways of doing this, explained on the site *http://www.loc.gov/copyright/ fedreg/*. This site also contains a wealth of information on the whole subject. You can submit applications in bulk, and for digital photographs it is usual to do this by preparing CDs with many images. You should distinguish between published and unpublished images.

Two areas of caution are transfer of copyright and work for hire. Copyright is a commodity that can be bought and sold. You can transfer the copyright in an image to someone else, but under what circumstances would you? One insidious circumstance is a copyright transfer clause in a client's purchase order—something you might overlook but which will lose you the rights to your own image, for 35 years under US law. Work for hire exists either automatically when an employee takes photographs for an employer, or when a photograph is commissioned and this is stipulated in the contract, and you never own the copyright to the image. If you agree to a work-for-hire clause in a contract, the fee you receive should reflect this loss of copyright.

Right to use

While copyright establishes ownership of the image, it does not automatically confer the right to publish it in any way that you like. In a commercial environment dominated by stock sales, what most

Permissions, releases, and copyright

228-229 Media and format 230-231 Online delivery 238-241 Release forms 242-243 Websites

Permissions, releases, and copyright

The Duomo and Palazzo Vecchio, Firenze (Florence), Italy. This view was taken from the Forte de Belvedere, with the evening light adding an attractive color to the buildings it touches.

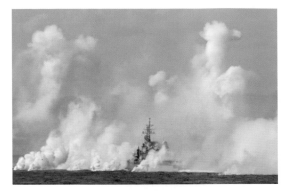

Capturing exciting military images, like this of a naval training maneuver in the bay of Tokyo, is key to selling them. However, it's essential to stay on the right side of the law and not to risk your photographs, or even your liberty.

This shot of a young customer enjoying a chic restaurant was captured with available light. The clean, happy, almost wholesome feel is important to potential clients.

This shot of an exclusive bar in Tokyo captures its dimly lit, yet warm feel, while deliberately not concentrating on any one subject. Since the bartender is facing the camera and wearing white, the service is subtly emphasized.

The professional approach

If you are setting up a shoot with a model who has already agreed to it, whether professional or not, the simple, straightforward procedure is as follows:

● Fill in the release completely, including the compensation (financial or otherwise) for the model or property, the address and phone number, and if possible have it witnessed.
● Have the model or property owner sign the release before you start shooting. Date the release and have a new release each time you shoot, even with the same person, and however well you know them.
● Attach details of the shoot, including the location, to the release, ideally with a printed image.
● Give a copy of the release to the model to avoid future dispute.
● Keep the release accessible and in a safe place.
● Enter details of the release, including name and address, in the IPTC Metadata of the image.

photographers really need is the right to use images freely rather than just the copyright. The content of your photographs may well have its own rights and restrictions, and these vary according to how you want to use them—that is, sell the rights to use them. This because copyright also exists in some of the subjects that you might photograph, for the reasons explained above. It applies in particular to fine art, so photographing a sculpture in a park does *not* give you the rights to sell that image commercially. For this, some form of release is necessary (*see pages 238-241*).

In terms of use, the overriding distinction is between commercial and editorial. Generally speaking, in most countries you can publish (and earn the fee for doing so) any photograph that is not obscene (another legal matter entirely) for editorial, journalistic purposes, on the grounds of free expression and being in the public interest. This is known as "fair use," but it is always open to interpretation and you should

Terms and conditions

This is the last crucial step in delivering images commercially. Accompanying any images you send is a document—both paper and as a digital text "Read Me" file —that summarizes the limited rights that you are offering and protects you from the consequences of misuse. There is no standard format, but the document here has worked for me over the years. Most of what is included is commonsense and will come as no surprise to anyone in the business, and its chief value is that it makes it difficult for a client or recipient to claim ignorance if anything does go wrong. Clause 6 (b) valuably links payment to use. Note that one of the big changes since the days of film is that the physical image is no longer of any intrinsic value, so loss and damage reparations are irrelevant. Replacing this, however, is the concern of usable digital copies remaining in the client's archives, from where they might easily be re-used at a later date— even in all innocence by someone who knew nothing of this original delivery. Finally, note the clause about jurisdiction, which in my case is England, and in your case should be where you live.

<Photographer's Name>
Terms and Conditions

The digital photographs accompanying this document are made available to you under the following conditions:

1. Acceptance of this delivery constitutes acceptance of the following terms.

2. You may not assign or transfer this agreement or any rights hereunder without express written agreement by <Photographer's Name>.

3. Only the usage agreed between <Photographer's Name> and you is permitted. You may not use the images subsequently or in any other way.

4. Following the agreed use, you must destroy all copies of the images. If the images have been delivered on physical media such as CD or DVD, you must destroy that media.

5. No Model Releases, Property Releases, or other releases exist unless specified in writing. If you use a photograph for which no release was requested and agreed, you will indemnify <Photographer's Name> against all claims and expenses due to its use.

6. This submission is for EXAMINATION ONLY unless use has already been agreed. Images may not be reproduced, copied, projected, transferred onto electronic media, or used in any way without (a) express permission stating the rights granted and the terms thereof, and (b) payment of invoice in full. The reasonable and stipulated fee for any other use not previously agreed will be twice our normal fee for such use.

7. You must provide proper copyright protection on all uses. The adjacent credit line "<Photographer's Name>" and the copyright credit line "© <year of first publication> <Photographer's Name>" must accompany each use (the copyright notice need not be adjacent).

8. Invoices must be paid within thirty (30) days. Accounts exceeding this period will be billed maximum allowable finance charges. You agree to pay all collection costs and legal fees which may be incurred in collecting any fees due or for loss, damage, or destruction.

9. If none of these photographs is selected and used, we will charge a research fee of US$65, plus delivery costs.

10. All matters arising from this delivery shall be governed and interpreted by the laws of England and the parties bind themselves to submit to the jurisdiction of the High Court of England.

WARNING—COPYRIGHT PROTECTION *The photographs which you have received are COPYRIGHTED by law. Any use beyond the strict terms of our agreement constitutes an infringement. If you would like to change the use agreed on, or use the photographs in another manner, please obtain our prior approval in writing. Please notify us within 48 hours if this list appears incorrect, otherwise it is assumed to be correct.*

Permissions, releases, and copyright

228-229 Media and format 230-231 Online delivery 240-241 Release forms 242-243 Websites

Permissions, releases, and copyright

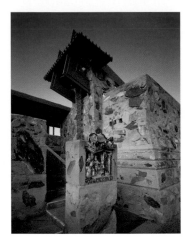

Exercise caution when photographing "sculptural works." In the US, for example, even buildings completed after 1990 are protected by copyright.

This spectacular diamond confection houses the Dresden Green, one of the world's most famous stones.

Photographing a model, even where the ultimate purpose is to create an artwork like that on page 246, will still require a model release.

avoid being over-confident about any specific situation. There are important exceptions, including privacy laws (particularly stringent and enforced in France, for example), but the idea is that if you are simply disseminating information through publishing a photograph, then the subject of the image has relatively little say in the matter. This is, of course, a variable area depending on the national law. Commercial use, however, "for the purposes of trade," means using the image to sell a product, as in advertising, and this *does* need permis-

sion of identifiable subjects. It is important because if you sell the reproduction rights to photographs—a huge part of the photographic industry— the fees are many times higher for commercial use than for editorial. Securing permissions where they are necessary is the key to financial success in stock photography, as every stock agency constantly drums into its contributing photographers.

Releases make images much more marketable. If they include people and private property, signed

SHORT MODEL RELEASE

In exchange for consideration received, I hereby give permission to _____ to use my name and photographic likeness in all forms and media for advertising, trade, and any other lawful purposes.

Print Name: _____

Signature: _____

Date: _____/_____/_____

(If Model is under 18) I, _____, am the parent/legal guardian of the individual named above. I have read this release and approve of its terms.

Print Name: _____

Signature: _____

Date: _____/_____/_____

releases are necessary if you want to license the images for any kind of commercial use, and a lot of sales fall into this category. A properly executed model release gives you the right to license images of the model for purposes of trade or advertising. A property release allows you to exploit the commercial use of a property, which belongs to the owner—this is a matter separate from invasion of privacy.

Finally, in the spirit of covering our backs from all legal action, be aware that laws change, so treat this summary as a starter guide to copyright and permissions. Investigate further according to your images, how and where you want to sell them, and your jurisdiction.

Release forms

One form of insurance against legal problems in using a photograph commercially is to acquire a signed release—for a person, a model release; for a place, a property release. These documents when signed are effectively permissions granted by the person or owner for you to use the images commercially. Remember that for your own personal use, or for editorial use, you do not normally need a release. These releases are for use for commercial gain, which includes advertising and stock photography. In the stock photography world, images are often marked with abbreviations denoting their release status, as in the list overleaf.

ADULT MODEL RELEASE

In consideration of my engagement as a model, and for valuable consideration hereby acknowledged as received, I hereby grant _____ , his heirs, legal representatives, and assigns, those for whom _____ _____ is acting, and those acting with his/her authority and permission:

a) the absolute unrestricted right and permission to copyright and use, re-use, publish, and re-publish photographic portraits or pictures of me or in which I may be included, in whole or in part, or composite or distorted in character or form, without restriction as to changes or alterations, in conjunction with my own or a fictitious name, or reproduction thereof in color or otherwise, made through any and all media now or hereafter known for illustration, art, promotion, advertising, trade, or any other purpose whatsoever.

b) I also permit the use of any printed material in connection therewith.

c) I hereby relinquish any right that I may have to examine or approve the completed product or products or the advertising copy or other matter that may be used in conjunction therewith or the use to which it may be applied.

d) I hereby release, discharge and agree to save harmless _____ , his/her heirs, legal representatives or assigns, and all persons acting under his/her permission or authority, or those for whom he/she is acting, from any liability by virtue of any blurring, distortion, alteration, optical illusion, or use in composite form, whether intentional or otherwise, that may occur or be produced in the taking of said picture or in any subsequent processing thereof, as well as any publication thereof, including without limitation any claims for libel or invasion of privacy.

e) I hereby warrant that I am over the age of majority and have the right to contract in my own name. I have read the above authorization, release and agreement, prior to its execution, and I fully understand the contents thereof. This agreement shall be binding upon me and my heirs, legal representatives and assigns.

Print Name: _____

Signature: _____

Date: ____/____/_____

Address:_____

Witness:_____

Permissions, releases, and copyright

MR Model released.

PR Property released—for private property, including homes, cars, boats, and pets. Also in some countries for certain public buildings, for instance in France, and modern constructions (after December 1st,1990) in the US.

NR Not released (or NMR, NPR).

NA Not applicable—many images simply do not contain subjects that need permission, including still-life, abstracts, landscapes, and overall city views.

NRec Not recognizable—a useful and sometimes overlooked category in which the subject cannot be identified. A person might be turned away, or small, or blurred. Judgments on this are obviously subjective.

Included here are a short model release, full adult and minor releases, and a property release. The problem is that presenting a daunting document to someone who has no experience may cause them to refuse when they otherwise might have agreed These documents can be downloaded from our website. If you carry a laptop on location, consider having these, or your own versions, saved on the hard drive or a CD as PDF documents that can be printed on demand.

PROPERTY RELEASE

For valuable consideration hereby acknowledged as received, I the undersigned, being the legal owner of, or having the right to permit the taking and use of photographs of the property designated as _____

hereby grant to _____ , his/her agents or assigns, the full rights to use such photographs and copyright the same, in advertising, trade, or for any other lawful purpose.

a) I also permit the use of any printed material in connection therewith.

b) I hereby relinquish any right that I may have to examine or approve the completed product or products or the advertising copy or other matter that may be used in conjunction therewith or the use to which it may be applied.

c) I hereby release, discharge, and agree to save harmless _____ , his/her heirs, legal representatives, or assigns, and all persons acting under his/her permission or authority, or those for whom he/she is acting, from any liability by virtue of any blurring, distortion, alteration, optical illusion, or use in composite form, whether intentional or otherwise, that may occur or be produced in the taking of said picture or in any subsequent processing thereof, as well as any publication thereof, including without limitation any claims for libel or invasion of privacy.

d) I hereby warrant that I am over the age of majority and have the right to contract in my own name. I have read the above authorization, release and agreement, prior to its execution, and I fully understand the contents thereof. This agreement shall be binding upon me and my heirs, legal representatives, and assigns.

Print Name: _____

Signature: _____

Date: ____/____/____

Address:_____

Witness:_____

MINOR MODEL RELEASE

For valuable consideration hereby acknowledged as received, I the undersigned, being the parent/legal guardian of the minor child named below, hereby grant _____ , his heirs, legal representatives, and assigns, those for whom _____ is acting, and those acting with his/her authority and permission:

a) the absolute unrestricted right and permission to copyright and use, re-use, publish, and re-publish photographic portraits or pictures of the below-named minor or in which the said minor may be included, in whole or in part, or composite or distorted in character or form, without restriction as to changes or alterations, in conjunction with the said minor's or a fictitious name, or reproduction thereof in color or otherwise, made through any and all media now or hereafter known for illustration, art, promotion, advertising, trade, or any other purpose whatsoever.

b) I also permit the use of any printed material in connection therewith.

c) I hereby relinquish any right that I may have to examine or approve the completed product or products or the advertising copy or other matter that may be used in conjunction therewith or the use to which it may be applied.

d) I hereby release, discharge, and agree to save harmless _____ , his/her heirs, legal representatives, or assigns, and all persons acting under his/her permission or authority, or those for whom he/she is-acting, from any liability by virtue of any blurring, distortion, alteration, optical illusion, or use in composite form, whether intentional or otherwise, that may occur or be produced in the taking of said picture or in any subsequent processing thereof, as well as any publication thereof, including without limitation any claims for libel or invasion of-privacy.

e) I hereby warrant that I am over the age of majority and have the right to contract on behalf of the said minor. I have read the above authorization, release and agreement, prior to its execution, and I fully understand the contents thereof. This agreement shall be binding upon me and my heirs, legal representatives, and assigns.

Minor's Name:_____

Parent or Guardian:_____

Signature of Parent or Guardian: _____

Date: ____/____/_____

Address:_____

Witness:_____

How to secure a release

What prevents many photographers from securing a signed release is the sheer embarrassment of asking the person just photographed to allow anything to be done with their photograph for no obvious advantage. And this is a real problem. Obviously, the best procedure is to get permission *before* shooting, and get it in writing. That way there is no confusion in anyone's mind and you are not wasting your time. However, while this is normal when dealing with professional models, in the many other impromptu situations you encounter, it may be impossible or inappropriate. In such a situation there are some ways of getting to grips with the issue:

● Don't necessarily ask them to sign the release on the spot. If you think you might meet with resistance, take their name and address and offer to send a print.
● Then fulfill your promise and send a good signed print, but with it include the model release and ask them to sign and return it (in a prepaid envelope).
● Explain briefly in writing how the picture may be used.
● Offer a financial return, for example an outright payment, a share of the proceeds of repro rights sales, or perhaps buy something from them.
● Enter the details in the IPTC Metadata (*File Info* in Photoshop).

Permissions, releases, and copyright

Websites

Digital photographs are among the very few entities ideally suited to the internet, and websites are a perfect medium for them. Unlike other products, they are not represented by images on a web page—they are themselves. Websites are easy to construct and maintain, and have two essential uses for photographers—as a portfolio and as a sales site. The first is the more obvious, and needs less attention —it's simply a matter of designing a number of pages that will frame your chosen images to best advantage. To these you can add captions, a biography, and whatever else you consider useful information. Additional sophistication and functionality is possible, such as animation, links, and the paraphernalia of smart web design, but given that you are displaying that most static of images, a still photograph, these extras may actually detract from the experience of

NetPublish

Imaging software companies are getting in on the act of helping users with web publishing. The image database Extensis Portfolio 7 includes a program called NetPublish which makes it extremely simple to post a catalog of images as a fully functioning web page. All you need is the server.

viewing your site. Also take into account the lowest common denominator of the visitors you expect to your site—if you construct it so that it looks good only when using a Flash player and/or QuickTime VR, you will definitely put off people who don't have these installed—and who can't be bothered to install them.

Web page templates

Constructing a website involves the use of HTML (Hyper Text Mark-up Language), and there is a great deal of software available to help, and many instructional books. This is not the place to attempt any instruction on that. And if you are prepared to accept a boilerplate design, most service providers offer web page templates that you can use. Try using a template to begin with and then, with time and experience, editing it later in HTML. Web design, like any programming activity, tends to be time-consuming.

Websites really acquire value when you use them to display and sell images. This is now the principal way in which stock photography is handled, as a visit to a major agency site such as Corbis or Getty will

iWeb is one of the many tools to create simple websites which you might consider, especially since it is included free with Mac OS X.

A website shouldn't just sell images, it should sell the photographer. My site, for example, includes a bibliography of the titles I've photographed for, or written. Not only does this help build confidence among stock customers, but you can give the address to potential clients.

My website's opening page includes a regularly changed picture from my collection and a search facility.

When the user searches on a keyword, the site displays thumbnails of possible matches.

1 As well as a shopping cart for buying images, my site includes a lightbox facility. This allows designers…

E-mail your lightbox "Things Japanese" to a friend or colleague.

1. Send To:*
client@dcmain.com

2. Message::
Studio shoot from 1 June 2004 – Japanese objects

3 ☑ Read only:
check this box to prevent recipient from changing your lightbox.

4. ☐ Allow Hires Downloads

Send Lightbox ●

I've decided not to e-mail this lightbox, please take me back.

*= Required field

2…to select images they feel would be appropriate for a project, then send them to their clients via e-mail…

Reply | Reply all | Forward | Move to Trash ◆

From: into@michaelfreemanphoto.com
Date: 4 Jun 02:39 (EDT)
To: michael@michaelfreeman.com
Subject: lightbox from

There is a lightbox waiting for you.
Please click on the link below to view your lightbox:
http://www.michaelfreemanphoto.com/bin/Cklb?vmo=10863311941187.freemanphoto.Things–Japanese

NOTE: If your e-mail program hard wraps text, you may have problems viewing the URL above. Make sure the entire URL is highlighted before you click it or copy and paste it into a web browser so the URL is all on one line and visible on the URL line.

Change message text width in Settings

3…the designer's client then receives an e-mail like this, with a uniquely generated web address, which they click on…

4…and the web link from the mail opens a page of thumbnails from which the client can make purchases.

5 Clicking on any of the thumbnails opens a larger image which, until purchased, has copyright information added.

show. The simplest but least effective way to do this is to invite clients to contact you offline—by phone, e-mail, or fax. Better is online purchase, for which images are the perfect commodity—stored as JPEGs they transmit easily—and for this you need use an online credit card payment service, for example PayPal or WorldPay. Setting up an account is straightforward. Also consider using your website as a means for communicating with clients during an assignment. It is often easier to upload images to your own site and then invite other people to view them than to rely on sending images directly to them. You can then both view the same page of your website at the same time, and discuss the images over the phone.

A commercial site

This is my own website, part of a network called IPN (Independent Photographers Network), with a central server in the US. I upload images via FTP to my site, where I can then edit them for availability and releases, and place them in "feature" groups. Clients, or anyone else, can browse the site and make searches. Purchasing involves adding an image to a shopping cart, just as in any online sales site. The pictures in the cart can then be priced with an online pricing tool into which the various usage parameters are entered, such as language, page size, type of media, and so on. Billing is also online. Some 30 other photographers in the network share the same system.

Websites

40-41 Resolution 102-103 Computer needs 234-241 Permissions, releases, and copyright 246-247 Stock sales

Website styles

Here are the home pages for several well-known professional photographers.

Yann Arthus-Bertrand

Rio Helmi

Jay Dickman

Enrico Ferorelli

Bob Gothard

Romano Cagnoni

Ed Kashi

Douglas Kirkland

Ira Block

Monique Stauder

Bob Sacha

Sebastião Salgado

Cary Wolinsky

Michael Yamashita

Website styles

Stock sales

Photography as a commercial enterprise covers a huge range of activity in two sub-groups, commercial and editorial. Commercial photography includes, among others, advertising, PR, social photography, industrial photography, annual reports, and more. Editorial photography covers news journalism, feature journalism, books, magazines, educational and web publishing. All of this has undergone a major overhaul and transformation in recent years with the shift toward the use of stock photography and away from assignments. This is a natural progression stimulated by two things: the exponential growth of available imagery (for which

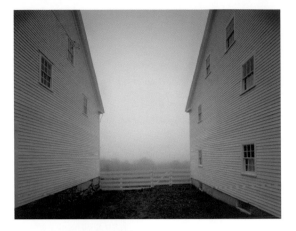

Good stock photography is often not very specific, like this shot of traditional American farm buildings.

Assignment work, on the other hand, will be for a more specific purpose; in this case to illustrate the power of the mind.

Calculating rates for stock

The co-existence of many online stock agencies has had the effect of regulating prices somewhat. If you visit a number of large agency websites as a potential customer, you can compare rates for images and see that they tend to be similar. Price calculators available on the Internet can give guidelines as to prices (search for "stock photo price calculator" in Google or another search engine).

For editorial use, the parameters are:
- Type of publication (book, magazine, newspaper, website, etc.) and sub-group (for example, trade book, textbook).
- Territorial rights (world, US and Canada, UK and Commonwealth excluding Canada, and so on).
- Language rights (English, English and one other, all, etc.).
- Size and position of image (full page, half-page, cover, etc.).
- Print-run.

For commercial use, the parameters, more diverse than for editorial, include:
- Type of commercial use (for example, advertising, corporate, packaging).
- Industry (for example, automotive, financial services, retail and department stores).
- Media (including print, billboard, television, Web, packaging, point of sale, calendar).
- Size.
- Circulation or quantity or number of insertions or time.

Avoid using the terms "buyout" and "all rights" because they are vague and open to interpretation. You are always selling specific limited rights, and these should be spelled out precisely.

read pictures already taken) and the efficiencies of large-scale international marketing.

Stock libraries began as small businesses, and most were personalized. This cottage industry mentality changed with the acquisition of libraries by other, larger companies, notably Corbis and Getty Images, and any photographer interested in selling rights to images should at least study the websites of these two giants (*www.corbis.com* and *www.gettyimages. com*). Online sales and distribution make millions of photographs instantly accessible, but the dynamics of presenting images for sale and searching for images is changing. As anyone familiar with the internet knows, the problem is that there is too much of everything. This favors large stock agencies but is not necessarily good for individual photographers, unless you have a very tight specialty with an active market (for example, medical photography).

Nevertheless, the old axiom of stock photography still holds true—it is a volume business. The more images you have available on offer, the higher your returns will be—given of course that they are of marketable quality.

RM and RF

These are the industry terms for two very different kinds of stock photography. RM stands for Rights Managed, meaning all that we have been talking about here—the licensing of specific one-time rights to images. RF stands for Royalty Free, covering images that a client can purchase for a higher than normal price and then use in any way at all as many times as wanted, with the exception of re-sale. RF images were controversial when they were first marketed in the 1990s, but are now simply another kind of image product.

This neon sign, taken in downtown Bangkok, could have been anywhere. This should be reflected by the choice of keywords; make sure you include general terms like neon, nightlife, and lips.

A spectacled Buddha receiving last-minute preparation.

For stock photos, don't be afraid of taking the clichéd shot—this one sells far more copies than the one on page 148. (The Taj Mahal was built between 1632 and 1643 by the fifth Mughal emperor, Shah Jahan, as the tomb of his favorite wife.)

Assignment rates

These vary greatly, depending on whether the shoot is for advertising (highest), corporate, or editorial (lowest). Within each group there is a range of customary rates, with which you ought to be familiar before negotiating or quoting. Most jobs break down into the following components:

- Fee (comprising shooting fee, prep, travel, and post-production, for photographer and others, including assistant).
- Photographic expenses (including equipment and lighting rental, digital post-production, deliveries).
- Talent, props, sets.
- Studio or location costs.
- Travel, accommodation, meals.
- Miscellaneous (insurance, gratuities, etc.).

Digital capture has had a major effect on assignment expenses in that it does away with film purchase and processing but substitutes digital post-production, which as we've seen throughout this book, can be a major activity. There is still no consensus within the industry as to how this should be charged, because there are new benefits and liabilities on both sides of the job—photographer and client. The computing side of digital capture has increased the capital expenditure for photographers, with a need to replace obsolescent equipment frequently. Also, the client receives digitized, optimized images, which saves on repro costs. Knowing that digital post-production will take considerable time on top of shooting—more even than processing and mounting film—it is essential to agree with the client beforehand how this will be charged. There is a strong argument for basing the charge on the time spent, whether by the photographer, assistant, or an out-sourced digital bureau.

In the business of taking and selling photographs, remember that there is no governing body and no statutory regulations. It is a market like any other, so instead there is negotiation, tempered by "the practice of the trade." Organizations such as the NUJ (National Union of Journalists) in the UK and ASMP (American Society of Media Photographers, formerly the American Society of Magazine Photographers) bring valuable pressure to bear on publishers by virtue of the size of their membership. They also publish guides to fees, reproduction rates, and business practice.

Stock sales

Glossary

Aberration The flaws in a lens that distort, however slightly, the image.

Aperture The opening behind the camera lens through which light passes on its way to the CCD.

Artifact A flaw in a digital image.

Backlighting The result of shooting with a light source, natural or artificial, behind the subject to create a silhouette or rim-lighting effect.

Banding An artifact of color graduation in computer imaging, when graduated colors break into larger blocks of a single color, reducing the "smooth" look of a proper graduation.

Bit (binary digit) The smallest data unit of binary computing, being a single 1 or 0. Eight bits make up one byte.

Bit-depth The number of bits of color data for each pixel in a digital image. A photographic-quality image needs 8 bits for each of the red, green, and blue RGB color channels, making an overall bit-depth of 24.

Bracketing A method of ensuring a correctly exposed photograph by taking three shots: one with the supposed correct exposure, one slightly underexposed, and one slightly overexposed.

Brightness The level of light intensity. One of the three dimensions of color in the HSB color system. *See also Hue and Saturation.*

Buffer Temporary storage space in a digital camera where a sequence of shots, taken in rapid succession, can be held before transfer to the memory card.

Calibration The process of adjusting a device, such as a monitor, so that it works consistently with others, such as a scanner or printer.

CCD (Charge-Coupled Device) A tiny photocell used to convert light into an electronic signal. Used in densely packed arrays, CCDs are the recording medium in most digital cameras.

Channel Part of an image as stored in the computer; similar to a layer. Commonly, a color image will have a channel allocated to each primary color (e.g. RGB) and sometimes one or more for a mask or other effects.

Clipping The effect of losing detail in the lighter areas of your image because the exposure was long enough for the photosites to fill (and record maximum values).

Clipping path The line used by desktop publishing software to cut an image from its background.

CMOS (Complementary Metal-Oxide Semiconductor) An alternative sensor technology to the CCD, CMOS chips are used in ultra-high resolution cameras from Canon and Kodak.

Color temperature A way of describing the color differences in light, measured in Kelvins and using a scale that ranges from dull red (1,900K), through orange, to yellow, white, and blue (10,000K).

Compression Technique for reducing the amount of space that a file occupies, by removing redundant data.

Conjugate The distance between the center of the lens and either the subject or the sensor.

Contrast The range of tones across an image from bright highlights to dark shadows.

Cropping The process of removing unwanted areas of an image, leaving behind the most significant elements.

Delta E (ΔE) A value representing the amount of change or difference between two colors within the CIE LAB color space. Industry research states that a difference of 6 ΔE or less is generally acceptable.

Depth of field The distance in front of and behind the point of focus in a photograph in which the scene remains in acceptably sharp focus.

Diffusion The scattering of light by a material, resulting in a softening of the light and of any shadows cast. Diffusion occurs in nature through

mist and cloud cover, and can also be simulated using diffusion sheets and soft-boxes. *See Soft-box.*

Dynamic range A measure of image density from the maximum recorded density to the minimum, so an image with a DMax (maximum density) of 3.1 and a DMin (minimum) of 0.2 would have a dynamic range of 2.9. Dynamic range is measured on a logarithmic scale: an intensity of 100:1 is 2.0, 1,000:1 is 3.0. The very best drum scanners can achieve around 4.0.

Edge lighting Light that hits the subject from behind and slightly to one side, creating flare or a bright "rim lighting" effect around the edges of the subject.

Extension rings An adapter that fits into an SLR between the sensor and the lens, allowing focusing on closer objects.

Extraction In image editing, the process of creating a cut-out selection from one image for placement in another.

Feathering In image editing, the fading of the edge of a digital image or selection.

File format The method of writing and storing information (such as an image) in digital form. Formats commonly used for photographs include TIFF, BMP, and JPEG.

Filter (1) A thin sheet of transparent material placed over a camera lens or light source to modify the quality or color of the light passing through. **(2)** A feature in an image-editing application that alters or transforms selected pixels for some kind of visual effect.

Focal length The distance between the optical center of a lens and its point of focus when the lens is focused on infinity.

Focal range The range over which a camera or lens is able to focus on a subject (for example, 0.5m to Infinity).

Focus The optical state where the light rays converge on the film or CCD to produce the sharpest image.

Fringe In image editing, an unwanted border effect to a selection, where the pixels combine some of the colors inside the selection and some from the background.

***f*-stop** The calibration of the aperture size of a photographic lens.

Gamma (also written "Ψ") is a fundamental property of video systems which determines the intensity of the output signal relative to the input. When calculating gamma, the maximum possible input intensity is assigned a value of one, and the minimum possible intensity (no input) is assigned a value of zero. Output is calculated by raising input to a power that is the inverse of the gamma value (output = input $(1/\Psi)$).

Graduation The smooth blending of one tone or color into another, or from transparent to colored in a tint. A graduated lens filter, for instance, might be dark on one side, fading to clear at the other.

Grayscale An image made up of a sequential series of 256 gray tones, covering the entire gamut between black and white.

Halo A bright line tracing the edge of an image. This is usually an anomaly of excessive digital processing to sharpen or compress an image.

Histogram A map of the distribution of tones in an image, arranged as a graph. The horizontal axis goes from the darkest tones to the lightest, while the vertical axis shows the number of pixels in that range.

HMI Hydrargyrum Medium-Arc Iodide—a recently developed and popular light source for photography.

Hot-shoe An accessory fitting found on most digital and film SLR cameras and some high-end compact models, normally used to control an external flash unit.

HSB (Hue, Saturation, and Brightness) The three dimensions of color, and the standard color model used to adjust color in many image-editing applications. *See also Hue, Saturation, and Brightness.*

Glossary

Glossary

Hue The pure color defined by position on the color spectrum; what is generally meant by "color" in lay terms. *See also Saturation and Brightness.*

Inverter A device for converting direct current into alternating current.

ISO An international standard rating for film speed, with the film getting faster as the rating increases, producing a correct exposure with less light and/or a shorter exposure. However, higher speed film tends to produce more grain in the exposure.

Kelvin (K) Used to measure the color of light based on a scale created from the color changes that occur when a black object is heated to different temperatures. Normal midday sunlight is considered 5,000K. Lower temperature light (less than 5,000K) is more red or yellow, while higher temperature light is more blue.

Lasso In image editing, a tool used to draw an outline around an area of an image for the purposes of selection.

Layer In image editing, one level of an image file to which elements from the image can be transferred to allow them to be manipulated separately.

Local contrast The contrast range found in smaller areas of a scene or an image.

Luminosity The brightness of a color, independent of the hue or saturation.

Macro A mode offered by some lenses and cameras that enables the lens or camera to focus in extreme close-up.

Mask In image editing, a grayscale template that hides part of an image. One of the most important tools in editing an image, it is used to limit changes to a particular area or protect part of an image from alteration.

Megapixel A rating of resolution for a digital camera, related to the number of pixels output by the CMOS or CCD sensor. The higher the megapixel rating, the higher the resolution of images created by the camera.

Midtone The parts of an image that are approximately average in tone, falling midway between the highlights and shadows.

Modeling lamp Small lamp in some flashguns that gives a lighting pattern similar to the flash.

Monobloc An all-in-one flash unit with the controls and power supply built in. Monoblocs can be synchronized to create more elaborate lighting setups.

Noise Random patterns of small spots on a digital image that are generally unwanted, caused by non-image-forming electrical signals.

Pentaprism Abbreviation for pentagonal roof prism. This prism has a pentagonal cross-section, and is an optical component used in SLR cameras. Light is fully reflected three times, so that the image displayed in the viewfinder is oriented correctly.

Photomicrography Taking photographs of microscopic objects, typically with a microscope and attachment.

Pixel (PICture ELement) The smallest unit of a digital image—the square screen dots that make up a bitmapped picture. Each pixel carries a specific tone and color.

Plug-in In image editing, software produced by a third party and intended to supplement the features of a program.

ppi (pixels-per-inch) A measure of resolution for a bitmapped image.

Prime lens One with a fixed focal length. *See also Zoom lens.*

Rectifier A device for converting alternating current into direct current.

Reflector An object or material used to bounce available light or studio lighting onto the subject, often softening and dispersing the light for a more attractive end result.

Resampling Changing the resolution of an image either by removing pixels (lowering resolution) or adding them by interpolation (increasing resolution).

Resolution The level of detail in a digital image, measured in pixels (e.g. 1,024 by 768 pixels), lines-per-inch (on a monitor), or dots-per-inch (in a half-tone image, e.g. 1,200 dpi).

RGB (Red, Green, Blue) The primary colors of the additive model, used in monitors and image-editing programs.

Saturation The purity of a color, going from the lightest tint to the deepest, most saturated tone. *See also Hue and Brightness.*

Selection In image editing, a part of an on-screen image that is chosen and defined by a border in preparation for manipulation or movement.

Sensitometer An instrument for measuring the light sensitivity of film over a range of exposures.

Shutter The device inside a conventional camera that controls the length of time during which the film is exposed to light. Many digital cameras don't have a shutter, but the term is still used as shorthand to describe the electronic mechanism that controls the length of exposure for the CCD.

Shutter speed The time the shutter (or electronic switch) leaves the CCD or film open to light during an exposure.

SLR (Single Lens Reflex) A camera that transmits the same image via a mirror to the film and viewfinder, ensuring that you get exactly what you see in terms of focus and composition.

Snoot A tapered barrel attached to a lamp in order to concentrate the light emitted into a spotlight.

S/N ratio The ratio between the amplitude of the signal (S) to be received and the amplitude of the unwanted noise (N) at a given point in a receiving system.

Soft-box A studio lighting accessory consisting of a flexible box that attaches to a light source at one end and has a diffusion screen at the other, softening the light and any shadows cast by the subject.

Soft proofs Refers to proofs on the monitor.

Spot meter A specialized light meter, or function of the camera light meter, that takes an exposure reading for a precise area of a scene.

TFT (Thin Film Transistor) A kind of flat-panel LCD with an active matrix for crisper, brighter color.

Tonal range The range of tonal values in an image. The histogram feature in an image-editing application displays tonal range. When an image has full tonal range, pixels will be represented across the whole of the histogram. Analyzing variation and deficiencies in the distribution represented in the histogram is the basis for making tonal corrections.

Telephoto A photographic lens with a long focal length that enables distant objects to be enlarged. The drawbacks include both a limited depth of field and angle of view.

Transformer A device that converts variations of current in a primary circuit into variations of voltage and current in a secondary circuit.

TTL (Through The Lens) Describes metering systems that use the light passing through the lens to evaluate exposure details.

Value A particular color tint. Also a numerical value assigned to a variable, parameter, or symbol that changes according to application and circumstances.

White balance A digital camera control used to balance exposure and color settings for artificial lighting types.

Zoom lens A camera lens with an adjustable focal length giving, in effect, a range of lenses in one. Drawbacks compared to a prime lens include a smaller maximum aperture and increased distortion. *See also Prime lens.*

Glossary

Index

Index

Acknowledgments

The author would like to express his thanks to the following, for their help in the creation of this title:

Allan Currier at SmartDisk
Jan Esmann at PowerRetouche
Hugo Eijkelhof at Shortcut
Geraldine Joffre at Photomatix
John Goodwin and Jerry Lunn at Hama
Charley Hayes at Nikon UK
Wayne Huelskoetter at PictoColor
Christina Laursen at Phase One
Matt Littler at Nova
Udo Machiels at Atmos Design
Hannah Newberry at Extensis
Nick Peart at Adobe
Dirk Schoettke at nik multimedia
Graeme Shiplee at Hi-Touch Imaging
Arun Soni at Filmplus, London
Liz Tjostolvsenat RealViz
Cliff Weems at Auto FX

Useful Websites

Adobe (*Photoshop, Illustrator*)
www.adobe.com
Alien Skin (*Photoshop Plug-ins*)
www.alienskin.com
Apple Inc.
www.apple.com
Association of Photographers (UK)
www.the-aop.org
British Journal of Photography
www.bjphoto.co.uk
Brunel Microscopes
www.brunelmicroscopes.co.uk
Calumet www.calumetphoto.com
Corel (*Photo-Paint, Draw, Linux*)
www.corel.com
Digital camera information
www.photo.askey.net
Epson www.epson.co.uk
www.epson.com
Extensis www.extensis.com
Formac www.formac.com
Fractal www.fractal.com
Fujifilm www.fujifilm.com
Hasselblad www.hasselblad.se

Hewlett-Packard www.hp.com
Iomega www.iomega.com
Kodak www.kodak.com
LaCie www.lacie.com
Lexmark www.lexmark.co.uk
Linotype www.linotype.org
Luminos (*paper and processes*)
www.luminos.com
Nikon www.nikon.com
Nixvue www.nixvue.com
Olympus www.olympus.co.uk
www.olympusamerica.com
Paint Shop Pro www.corel.com
Pantone www.pantone.com
Philips www.philips.com
Photographic information site
www.ephotozine.com
Photoshop tutorial sites
www.planetphotoshop.com
www.ultimate-photoshop.com
Polaroid www.polaroid.com
Qimage Pro
www.ddisoftware.com/qimage/
Ricoh www.ricoh-europe.com
Samsung www.samsung.com
Shutterfly (*Digital Prints via the web*)
www.shutterfly.com
Sony www.sony.com
Umax www.umax.com
Wacom (*graphics tablets*)
www.wacom.com